COMPLETE ADOBE® PHOTOSHOP® CS4 FOR DIGITAL PHOTOGRAPHERS

COLIN SMITH AND TIM COOPER

Charles River Media

A part of Course Technology, Cengage Learning

Complete Adobe Photoshop CS4 for Digital Photographers Colin Smith and Tim Cooper

Publisher and General Manager, Course Technology PTR: Stacy L. Hiquet

Associate Director of Marketing: Sarah Panella

Content Project Manager: Jessica McNavich

Marketing Manager: Jordan Casey

Executive Editor: Kevin Harreld

Project and Copy Editor: Kim Benbow

CRM Editorial Services Coordinator: Jen Blaney

Interior Layout: Shawn Morningstar

Cover Designer: Mike Tanamachi

CD-ROM Producer: Brandon Penticuff

Indexer: Valerie Haynes Perry

Proofreader: Ruth Saavedra

© 2010 Course Technology, a part of Cengage Learning.

ALL RIGHTS RESERVED. No part of this work covered by the copyright herein may be reproduced, transmitted, stored, or used in any form or by any means graphic, electronic, or mechanical, including but not limited to photocopying, recording, scanning, digitizing, taping, Web distribution, information networks, or information storage and retrieval systems, except as permitted under Section 107 or 108 of the 1976 United States Copyright Act, without the prior written permission of the publisher.

For product information and technology assistance, contact us at

Cengage Learning Customer and Sales Support, 1-800-354-9706

For permission to use material from this text or product, submit all requests online at cengage.com/permissions

Further permissions questions can be emailed to permissionrequest@cengage.com

Adobe, the Adobe logo, Photoshop, and Lightroom are either registered trademarks or trademarks of Adobe Systems Incorporated in the United States and/or other countries.

Microsoft, Windows, and Internet Explorer are either registered trademarks or trademarks of Microsoft Corporation in the United States and/or other countries.

All other trademarks are the property of their respective owners.

Library of Congress Control Number: 2008935839 ISBN-13: 978-1-58450-685-0 ISBN-10: 1-58450-685-7

Course Technology 20 Channel Center Street Boston, MA 02210 USA

Cengage Learning is a leading provider of customized learning solutions with office locations around the globe, including Singapore, the United Kingdom, Australia, Mexico, Brazil, and Japan. Locate your local office at: international.cengage.com/region

Cengage Learning products are represented in Canada by Nelson Education, Ltd.

For your lifelong learning solutions, visit **courseptr.com** Visit our corporate website at **cengage.com**

Printed in the United States of America 1 2 3 4 5 6 7 11 10 09

ABOUT THE AUTHORS

Colin Smith is a best-selling author, trainer, and award-winning digital artist. Colin is also known as a pioneer of HDR photography. He is founder of one of the world's most popular Photoshop resource sites, PhotoshopCAFE.com, which boasts over 20 million visitors.

With over 15 years of experience in the creative industry, Colin was formerly senior editor and creative director for *VOICE* magazine. He is a regular columnist for *Photoshop User* magazine. He has been featured in most major imaging magazines including, *Computer Arts, Macworld, After Capture, Digital Photographer, Advanced Photoshop, Photoshop Creative, PSD Photoshop,* and a host of others.

Colin's work has been recognized with numerous awards, including Macworld Digital Design and three Guru awards at Photoshop World 2001 and 2002. He has been nominated twice for the Photoshop Hall of Fame. He's authored or co-authored more than 18 books on Photoshop. Colin is also the creator of the *Photoshop Secrets* video training series (PhotoshopCD.com). He is in high demand across the United States as a lecturer, presenting his Photoshop techniques to photographers and graphics professionals across the nation. He has been a speaker at such conferences as WPPI, Photo Imaging and Design Expo, Flashforward, NVISION, Photoshop World, DL Expo, Creative Suite Conference, Cre8, Create Chaos, Deviant Art Summit, and many more. In 2008, Colin was the featured speaker for a sold out multi-city tour (Flash Summer Camp) sponsored by Adobe and Lynda.com. Colin has consulted for such companies as Adobe Systems, Edison International, Apple, and Disney Studios.

Tim Cooper worked as an electrician before moving to Montana from New Jersey in 1991 to discover his love of photography. After attending night classes at the Rocky Mountain School of Photography, the passion was born, and he attended the Summer Intensive program the following year.

Tim began his career as a commercial and assignment photographer working with clients such as The North Face, Vasque boots, 3M, and The International Heart Institute. His editorial and commercial photographs have appeared in such

publications as *Travel & Leisure*, *New York Times Magazine*, *Outdoor Photographer*, *Fly Rod & Reel*, as well as Northern Lights and private clubs as covers, advertising, art, and editorial illustration.

In addition to commercial work, Tim has also been involved with the Rocky Mountain School of Photography since 1993. He has taught workshops, classes, seminars, and has held the positions of errand boy, electrician, carpenter, coordinator, stamp licker, and consultant, as well as director of education, director of the black-and-white program, and director of digital imaging. Tim currently teaches various workshops, classes, and seminars for the school in addition to writing and consulting on both photographic and digital technologies. He is the author of the training videos *Perfect Exposure for Digital Photography, Perfect Composition for Digital Photography*, the digital book *Capture Process Print*, and is the co-author of *Complete Photoshop CS3 for Digital Photographers*.

TABLE OF CONTENTS

	Introduction	X
CHAPTER 1	GETTING STARTED USING BRIDGE	1
	Considerations Before Shooting	2
	Resolution	2
	File Formats	3
	Digital Zoom	4
	Composition/Exposure	4
	Flash/Lighting	4
	ISO	5
	Take a Lot of Pictures	5
	Adobe Bridge: Organization and Automation	6
	Downloading Your Images into Bridge	, 7
	Building a Custom Metadata Template	8
	Launching Bridge	9
	Navigating Bridge	11
	Customizing the Bridge Windows	12
	Different Views	12
	Managing Your Workspace	22
	Stacks Feature	22
	Rotating Images	25
	Opening Images with Bridge	26
	Rating and Labeling Images	27
	Rating	27
	Labeling	27
	Organizing Contents of Folders	29
	Using Favorites	30

	Using Keywords	31
	Organizing Keywords	31
	Assigning Keywords	32
	Searching the Keywords	32
	Working with Collections	33
	Metadata	35
	Exif	36
	Viewing the Data	36
	Adding Information to the Metadata	37
	Batch Renaming	38
	Exporting the Images to a CD-ROM	39
	Automation	40
	Output	40
	PDF Creations	40
	Creating a Contact Sheet	41
	Web Gallery	46
CHAPTER 2	FROM BRIDGE TO PHOTOSHOP:	
12K 2	THE ADOBE RAW CONVERTER	49
	ISO	50
	File Format and Bit Depth	51
	White Balance	51
	Picture Styles and Camera Settings	53
	16-Bit Images	54
	Using Camera RAW	56
	The Basic Tab	57
	The Tone Curve Tab	67
	The Detail Tab	68
	HSL/Grayscale Tab	69
	Split Toning Tab	72
	Lens Corrections Tab	74
	Calibrate Tab	76
	Presets Tab	76
	Cropping and Straightening Images	78
	New Local Adjustments	84
	Multiple Local Adjustments	87
	Camera Raw to Photoshop	93
	What Is a Smart Object?	95
	Working with Multiple RAW Images	96
	Batch Processing in Bridge	98

CHAPTER 3	CROPPING AND PERSPECTIVE	101
	Why Crop?	102
	Cropping Out Unwanted Detail	102
	Changing Composition and Emphasis	105
	Cropping for Perception	105
	Practical Cropping	107
	Straightening	107
	Auto Cropping (Crop and Straighten Photos)	110
	Increasing the Canvas Size with the Crop Tool	112
	Removing Perspective	113
	The Lens Correction Filter	115
	Fixing Distortion	120
	Straightening a Horizon	122
CHAPTER 4	TONAL CORRECTION AND ENHANCEMENT	127
	Photoshop's New Interface	128
	Overview of Adjustment Layers	130
	Using Adjustment Layers	134
	The Anatomy of a Color Picture	135
	Histograms	136
	The Histogram Panel	140
	Adjusting the Tone of Your Photographs	143
	Brightness/Contrast	144
	Shadows/Highlights	145
	Levels	149
	Exposure	152
	Auto Settings	153
	Curves	156
	Correcting Images with Curves	163
	Tips for Using Curves	174
CHAPTER 5	COLOR CORRECTION AND ENHANCEMENT	175
	Additive Color	176
	Subtractive Color	177
	Color Correction Tools	177
	Color Calibration	178
	Adjusting Color in Your Images	179
	Auto Color	180

	Color Balance	181
	Color Correction Using Variations	184
	Hue/Saturation	190
	Advanced Color Correction	194
	Match Color	194
	Advanced Color Correction with Lab Color	199
	Advanced Color Correction with Levels	202
	Advanced Color Correction with Curves	206
	Reusing Adjustments Settings	209
CHAPTER 6	LOCAL ENHANCEMENTS:	
	SELECTIONS AND MASKS	211
	Adjustment Layer Mask	213
	Simple Local Adjustments	214
	Selections	218
	A Photographer's Selection Tools	222
	The Magic Wand	222
	Quick Selection Tool	226
	Selections with the Color Range Command	228
	Refining Selections	235
	Refining Masks	240
CHAPTER 7	SIZING AND PRINTING YOUR IMAGES	251
CHAITER 7		
	Resizing Things	252
	Resolution	252
	Image Interpolation	254
	Sizing an Image for Print Sizing Your Print for the Web or Email	258
	Batch Sizing Images for Email	261
	Increasing the Image Size Beyond 200%	263
	Printing Proportions	264 265
	Printing Your Photographs	266
	Color Management	267
	Printing Colors as Accurate as You See Onscreen	267
	Setting Up the Soft Proof	268
	Creating a Test Print	272
	Choosing Paper	272

CHAPTER 8	SHARPENING AND NOISE REDUCTION	275
	Sharpening Your Images	276
	Unsharp Mask	276
	Fading the Sharpness (Optional)	279
	Sharpening Using Lab Mode	280
	Smart Sharpen	281
	Noise Reduction	286
	Reducing Luminosity Noise with Smart Blur	290
	Color Noise Reduction Using Lab Mode	292
CHAPTER 9	IMAGE RETOUCHING	297
	Spot Healing Brush	301
	Wrinkle Reduction	303
	Enhancing the Eyes and Teeth	307
	Removing the Red from the Whites	308
	Enhancing the Iris	309
	Soft Focus Filter	314
	Method 1	314
	Method 2	316
	Removing Red Eye	318
	Removing Tattoos and Birthmarks	320
	Reducing Noses	322
	Eyes Wide Open	324
	Method 1	324
	Method 2	326
	Fixing White Wedding Dresses and Black Tuxedos	327
	Color Balancing Skin	331
CHAPTER 10	FRAME AND COLOR EFFECTS	335
	Frame Effects	336
	Using Quick Mask to Create an Edge Effect	346
	Creating a Double Matte Effect	350
	Colorizing Effects	354
	Color to Grayscale	354
	Converting to Sepia Tone	357
	Using the Black and White Adjustment	359
	Altering Color Locally	361

CHAPTER 11	SPECIAL EFFECTS	
	Smart Filters	368
	Natural Media	370
	Depth of Field Effects	376
	Depth of Field with a Layer Mask	376
	Depth of Field Using Lens Blur and Depth Map	378
	Using Patterns to Create Scan Lines	384
	Adding Color	386
	Using the Image Warp Tool	405
CHAPTER 12	COMBINING IMAGES FOR CREATIVE RESULTS	407
	Removing an Object from Its Background	408
	Using Color Range	408
	Extracting Images Using the Extract Tool	413
	Rules for Compositing Two Images	418
	Combining Images to Create an Advertisement	420
	Adding a Cast Shadow	424
4	Creating a Panoramic Image	428
	Merge to HDR (High Dynamic Range)	434
	Shooting	435
	Other Tone-Mapping Options	438
	Collaging Techniques and Blending Modes	454
	A Blended Collage Using Layer Masks	454
	Advanced Blending	457
	Summary and Conclusion	460
	INDEX	461

INTRODUCTION

I am very excited to be bringing you the fourth edition of *Complete Adobe Photoshop CS4 for Digital Photographers*. In the previous edition, I brought my good friend and amazing photographer, Tim Cooper, onboard. I met Tim while lecturing at the Rocky Mountain School of Photography several years ago. He was then the director of education and director of the digital program. Tim has a lot to offer, since he has been teaching photography for over 15 years. Tim is a real expert in things like shooting, experimenting with color, and printing photos. You will find his input a real boost to this already excellent book. (Okay, so I'm biased.) We have discovered so many new things and better ways of working that we can't wait to share with you.

Recently I spoke to a photographer friend who has been shooting film for many years, and after she finished explaining why film is better and that digital is not ready for the professional photographer, treading very carefully, I took a few moments to discuss the advantages of digital. A little time passed, and I forgot about our conversation. Suddenly the phone rang, and it was her: "I want to invite you to my newest exhibition. By the way, I'm now shooting digital, and I love it!" These are the words photographers are saying all over the world—the "digital revolution" is in full swing.

It is a pleasure to write this book at such a critical and pivotal time in the history of photography. Right now, there is a revolution under way—the explosion of digital photography. Every day people say, "I'm taking the plunge. I'm going digital." In this mass exodus from film to digital, there is one tool right in the center—Adobe Photoshop has become the new darkroom. This neo darkroom has many advantages: the results are instant, the possibilities have been greatly expanded, and it smells much nicer without all the messy chemicals involved in traditional development! In addition, this new darkroom is more accessible than ever before: Not only do professionals have access, but now it is within the reach of all photographers.

Adobe has acknowledged this digital revolution with a plethora of features designed especially with you—the photographer—in mind. Everything is streamlined, from importing and organizing your images, to new correction tools and better ways of enhancing images, to enhanced 16-bit/HDR support, to overhauled Camera Raw functionality, an all new Bridge application, and much more. This leads to a couple of questions: How can you learn all this, and even more important, what's the best tool to use for each job? No stone is left unturned in *Complete Adobe Photoshop CS4 for Digital Photographers*. We examine all the new features in Photoshop CS4 as well as the best ways you can use them to make your images look better.

As well as a ton of brand new content, we have rearranged portions of the book to provide a real-world logical workflow. In many cases we have offered different workflows to help you do things more efficiently. We have gone through every word and clarified and improved the content as well as adding all new examples with better images. We have also included all the working images on the CD so that you, the reader, can follow along with ease. We are very proud of this book that you hold in your hands, and we know by the time you have finished it you will never approach your images the same way again. You will keep this book close by as a constant reference as you work on your precious photos.

INTENDED AUDIENCE

This book is written with two groups of people in mind. The first group is the mass of photographers who have made the transition from film to digital. The new darkroom called Photoshop is now sitting on your desktop. But there are so many options and dialog boxes, where do you start? *Complete Adobe Photoshop CS4 for Digital Photographers* shows you how to process your images and produce professional results. New challenges abound with digital, and this book is your guide to overcoming these obstacles and producing the results you want. Professional-level techniques help you develop an efficient workflow. In many cases, several different methods are presented for each challenge. This allows you to choose the method that works best for your needs and to develop your own workflow.

The second group this book addresses is amateur photographers and hobbyists. Perhaps you have been using a personal computer for years and are already somewhat familiar with Adobe Photoshop, or maybe you have never even seen Photoshop before. This book reveals the secrets to producing clearer, sharper, and more professional-looking images. Photoshop is a vast program that can perform many tasks. It can be very intimidating, and perhaps you're thinking that only the "pros" know the techniques to perform the tasks that you need to bring out the best in your images. The mysteries are revealed in this book, bringing within your reach the results you have always dreamed of. But you will go beyond just cleaning up your images. You will learn how to manipulate images digitally and do things that were impossible with film. You will learn how to apply special effects and even how to get the best results while printing.

This is not a book for those people who want to learn to take photographs. Many books on the market can help you choose cameras and shoot better pictures. A few tips are mentioned in Chapter 1 to make your images more friendly for use in Photoshop. When you have finished clicking the shutter and uploading your images to a computer, you are ready for this book. This book is about Photoshop and what happens to your images after the shutter stops and the mouse (or Wacom tablet) clicking begins.

TOPICS COVERED

Chapter 1, "Getting Started Using Bridge," explores file formats, resolution, ISO, and other shooting considerations. The chapter then delves into Adobe Bridge, the asset management program included with Photoshop CS4. This is an application in itself and is newly designed to make everyone's life easier. This tool provides a way to organize, label, and view your images in one place. You can attach information to images so that they can be searched and categorized. To top it off, you will be able to automate many tasks and save many hours of work by letting Photoshop do the hard work for you. You can then present your images on slide shows, the printed page, and over the Internet.

Chapter 2, "From Bridge to Photoshop: The Adobe Raw Converter," begins with a more in-depth look at the photographic file. Here you will learn the advantages of shooting and processing 16-bit RAW images. Photographers shooting JPEGS will be happy to hear that the power and ease of the Raw Converter is now available to them. Chapter 2 enables you to gain a complete understanding of the Raw Converter as well as learn the best methods for processing your images.

Chapter 3, "Cropping and Perspective," walks you through the technical and creative aspect of cropping your images. You will also learn how to correct common photographic problems such as chromatic aberration, exaggerated perspective, lens distortion, lens vignetting, and tilted horizons.

Chapter 4, "Tonal Correction and Enhancement," takes you to the core of the digital darkroom. This is where you learn about histograms and use them as a visual cue to help you correct your images. Are the images too dark, too bright, or lacking in contrast? You will learn the techniques to tame overexposed images, open up the shadows, and brighten up dull images. You may be surprised at just how much detail Photoshop can bring back to a bad image.

Chapter 5, "Color Correction and Enhancement," takes a look at strategies for bringing out the best color in images. We look at color correction, such as removing color casts and warming and cooling the appearance of photos. You can even inject new life into faded images by using the methods taught in this chapter.

Chapter 6, "Local Enhancements: Selections and Masks," unveils the secrets of crafting a truly fine photograph. Since the earliest days of the chemical darkroom, the ability to work on specific areas of an image has separated the snapshooter from the artist. This chapter takes the complex subject of masking and presents it in an easy-to-understand fashion.

Chapter 7, "Sizing and Printing Your Images," enables you to create prints that not only match your monitor, but also your vision. This chapter shows you how to resize your photo to retain maximum image quality for both print and the Web. Tired of having prints that look nothing like what you saw on your monitor? Learn how to make use of printer profiles to ensure that your printer's output matches your monitor.

Chapter 8, "Sharpening and Noise Reduction," empowers you to present your images like a pro. Although a great improvement over their predecessors, digital cameras come with their own set of problems, such as image softness and noise. This chapter will introduce you to these problems and show you how to fix them using tools like the Noise Reduction filters, Smart Sharpen, and Unsharp Mask.

Chapter 9, "Image Retouching," takes you on a journey as we retouch images. This is where you will perform digital cosmetic surgery: reduce wrinkles; remove redeye, tattoos, freckles, acne, and birthmarks; shrink noses and waistlines; and generally flatter the people we take pictures of.

Chapter 10, "Frame and Color Effects," kicks off some of the more creative content in the book. We look at the best ways to convert color images to grayscale as well as sepia tone effects. You will change the depth of field on an image using the advanced features of the exciting new Lens Blur Filter. You will also frame your photos with different kinds of borders and edges.

Chapter 11, "Special Effects," is a lot of fun. You will explore special effects, such as turning photos into hand-drawn images and paintings. We create trendy effects and fake effects that could only be performed with expensive filters in the past.

Chapters 12, "Combining Images for Creative Results," teaches you how to combine your images in different ways. From producing panoramic images to creating collages and animations, you will discover that the journey doesn't have to end with a single photograph. Photoshop has given you the power to do amazing things with your images, and this book puts that power into your hands.

CHAPTER

GETTING STARTED USING BRIDGE

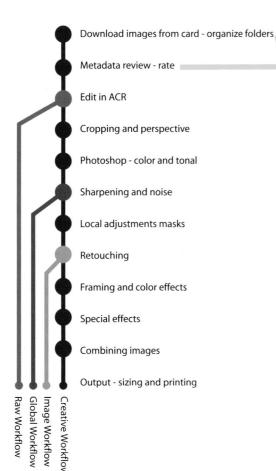

IN THIS CHAPTER:

- Considerations Before Shooting
- Adobe Bridge: Organization and Automation
- Launching Bridge
- Navigating Bridge
- Customizing the Bridge Windows
- Managing Your Workspace
- Rotating Images
- Opening Images with Bridge
- Rating and Labeling Images
- Organizing Contents of Folders
- Using Keywords
- Metadata
- Batch Renaming
- Exporting the Images to a CD-ROM
- Automation
- Web Gallery

The focus of this book is on the post-capture phase of photography. There are plenty of good books available on the art of photography that will help you capture great images. You should be aware before shooting, however, of a few considerations that affect your output and ability to work with your images. This chapter will introduce you to a few tips, and then go on to explain different file formats and the best time to use each. We'll follow up this intro section with a look at how to import and browse your images using Bridge—the powerful browser software that ships with Photoshop.

We'll also show you how to use metadata to tag, organize, and search for your images, making this often-painful process a snap. Next we'll help you shave hours from your work schedule as we introduce the many different tasks that can be automated from within Bridge. These will include such time-saving processes as creating a gallery of images to upload to your Web site, generating contact sheets, and even protecting photographs by producing PDF files from them.

CONSIDERATIONS BEFORE SHOOTING

This section will introduce such issues as resolution and image formats. We will look at the kinds of settings recommended to get the best possible images from your camera. This is just a brief introduction; we will get into more detail throughout the book.

Resolution

Resolution is one of the biggest factors in enabling you to output nice, sharp prints. The most obvious resolution consideration is that the more pixels in the image, the larger you can print the final image. If the resolution is insufficient, the print will suffer from pixelization. In extreme cases, pixelization looks like LEGO structures. Photoshop does, however, have some very impressive interpolation technology that enables you to enlarge your images substantially and still have an acceptable quality print. Still, printing a sharp, clean 20×24 image from a 4-megapixel capture is a little ambitious.

Another resolution consideration is cropping. If an image is taken with a higher resolution than is needed, you will have plenty of overhead, or reserve pixels, to work with. This overhead is very useful when cropping away precious pixels.

The bottom line is this: If you want flexibility with your images, always shoot with the maximum resolution available on your camera. It is much easier to downsize a large file than it is to upsize a small file. After all, why buy a 5-megapixel camera capable of shooting 2560×1920 pixels and shoot only at 640×480 pixels? Of course, there are always exceptions, such as limited storage space and instances

in which images are not needed in a high resolution (when emailing a snapshot or for use on a Web site, for instance). Keep this in mind for now, and we will discuss resolution and resizing in more detail in Chapter 3, "Cropping and Perspective."

File Formats

Cameras offer different types of image formats. The types of file formats used by cameras and the best times to use them are discussed briefly in the following sections.

JPEG

The Joint Photographic Experts Group format (JPEG or JPG) is standard on all cameras. Pronounced "jay-peg," this is the most common type of compression used on photographic images today. There are different levels of compression used; a high amount of compression produces a very small file size, but the image will suffer from artifacts, blurring, and damage to the color. This is usually the kind of result you can expect from the low-quality setting on a camera and is not recommended. The high-quality setting will use a low amount of compression, and the file size will be a little larger but still substantially smaller than an uncompressed image. The quality of the high-quality JPEG is very good. When using compression or compressed format types such as JPEG, you should be able to shoot with the highest quality JPEG setting on the camera and fit an acceptable number of images on your card without too much quality loss. The quality of these JPEGs on newer cameras is surprisingly good, and you would be hard-pressed to notice the effects of compression.

RAW

The second is RAW format, which is offered by higher-quality and more expensive cameras. The RAW format retains the pixel information directly from the camera's charged coupled device (CCD) or complementary metal oxide semiconductor (CMOS) sensor (a digital camera's version of film) and saves it unprocessed by the camera. The image is tagged with the camera's settings, but these settings are not embedded. This enables you to process the images on a computer later and adjust the settings while importing the image (see Chapter 2, "From Bridge to Photoshop: The Adobe Raw Converter"). RAW files are the digital equivalent of a negative. Photoshop has some sophisticated tools for working with RAW images. Another advantage of shooting in the RAW format is that images can be captured in 16-bit. We examine RAW and 16-bit in the next chapter. If you possess a camera that supports RAW, this is the best setting to use for most shooting.

TIFF

TIFF was a popular format with older, higher-end digital cameras. It is one of the most common uncompressed file formats used for photographs and graphics on the computer. If you do not have a RAW setting on your camera, TIFF is a good alternative to JPEG. I do recommend using RAW rather than TIFF if it is available. TIFF images do not suffer from the results of image compression like a JPEG. A disadvantage of using TIFF, however, is very slow captures with long rendering times on the camera. Because there is a much bigger file to write to the card, this causes a long delay between pictures. In addition, the memory card fills up quickly. Experiment for yourself by shooting some images in TIFF and JPEG; then examine them carefully to decide which format works best for you. In reality, you will probably alternate between the two settings. The slow rendering time of TIFF files could cause you to lose too many shooting opportunities of live action or fast-paced activities, such as sporting events.

Digital Zoom

I never use the digital zoom on my camera—I always use the optical zoom. The digital zoom basically crops and interpolates the image to make it appear closer. This can be performed with better quality in Photoshop later when you are not dealing with camera shake. Our advice is to stay clear of the digital zoom on your camera.

Composition/Exposure

When starting photography, the two most important considerations are exposure and composition. All imagery is based upon proper or desired composition. You can't fix a bad composition in Photoshop, so the old adage "garbage in, garbage out" certainly applies here. Proper exposure is important because it will influence how you work in Photoshop. Good exposures require less time at the computer —a welcome advantage to the photographer who wants to spend more time taking pictures. For easy-to-understand instruction on these topics, check out the training videos *Perfect Composition* and *Perfect Exposure* by Tim Cooper at www.PhotoshopCAFE.com.

Flash/Lighting

Lighting, and the use of flash, are complete subjects unto themselves. Two good books in the actual photography phase of image capturing are *Complete Digital Photography* by Ben Long (Charles River Media, 2007) and *Shooting Digital: Pro Tips for Taking Great Pictures with Your Digital Camera* by Mikkel Aaland (Sybex, 2006).

Although natural light is the most commonly used for general photography, the use of studio lighting, flash (also called strobe), and reflectors that fill the darker areas are techniques that add polish. Even a large piece of simple white foam-core board can be used effectively to bounce extra lighting into a scene. When a flash is used, you can diffuse it with a gel or tissue paper to soften the light and produce more pleasant overall lighting on the subject. Also, if you are using a flash, make sure that you are close enough to the subject for the flash to be effective. Check the manual's specifications for recommended shooting distances for that model of external flash. An external flash can also be used effectively to lighten a shadowed portion of the scene. This technique is called *fill flash* and best results will occur when you dial the power down on your flash unit to a setting of –1 or –2.

ISO

The ISO (International Standards Organization) setting controls the sensitivity of your camera to light. With a film camera, we chose films with low ISOs of 100 or 200 for bright, sunny days and film with high ISOs of 400 or 1000 for overcast days, night shooting, or indoor situations. If the lighting situation changed, then we needed to change our film. With digital cameras, there is no need to change film! You simply change the ISO setting to suit the current lighting condition. If you have your camera on full Auto mode, the camera itself may change the ISO setting on the fly to help you record your photo. The downside to this advantage is that on the digital camera, there is only one sensor; so increasing the sensitivity (raising the ISO from 100 to 1000) doesn't produce a "real" effect. It just pushes more power through the sensor making it more sensitive. This may result in an overly grainy look to your images. This digital grain is referred to as noise. Although camera manufacturers are continually increasing the quality of their high ISO images, it's best to learn how to work with your f-stops and shutter speeds to manage your exposure settings. This gives you the ability to choose when you need to increase the ISO.

Take a Lot of Pictures

The more images you take, the better photographer you will become. With digital photography, the expense of developing pictures is eliminated, which can be very liberating. When traveling (especially abroad or to exotic locations), many people suffer from having to pay to develop 10, 20, or more rolls of film. While traveling, the expense of developing can weigh heavily on the decision of whether to shoot an image. Now, however, this is a concern of the past. Your memory cards store images, as can devices like the Apple iPod. At the time of this writing, the iPod can hold as much as 120 gigabytes of data. That's a lot of images.

The more images you take, the more you have to choose from. When in doubt, go ahead and click! Do try to steady the camera as much as possible, and use a tripod whenever possible.

FIGURE 1.1 Tool of the trade: the digital camera.

ADOBE BRIDGE: ORGANIZATION AND AUTOMATION

Bridge is a file and asset management system that spans all the applications in the Adobe Creative Suite. With it, you can work with photographs, Illustrator files, multipage PDFs, QuickTime movies, Flash SWFs and FLVs, InDesign documents, and more. Although it has ties to all of the applications within the suite, it is a standalone program that can operate independently. Don't worry if Photoshop is the only application you own from the suite because Bridge is included with the purchase of Photoshop. In its most simple use, Bridge could be compared to a PC's Explorer window or Apple's Finder window. You could consider it a glorified browser—a way to organize, review, and get your photos into Photoshop. Of course, that's the simple explanation. In reality, it is far more powerful. In this chapter, we will explore its plethora of features and time-saving conveniences.

Bridge shares many of the same features with another Adobe application called Photoshop Lightroom. Lightroom is an image editing application built around a central database. Although specifically geared toward photographers, Lightroom lacks some of the more robust image editing found in Photoshop. Because it is a database, however, the organizational and retrieval aspects of the program operate somewhat faster than Bridge. Some photographers will choose Lightroom for

this very reason. Others will want the full compliment of editing options provided with Photoshop. Some photographers (such as Colin and myself) choose to use both. Although Lightroom may offer a speed increase in finding and organizing your images, it is not dramatically faster than Bridge. For photographers who are not handling massive amounts of images, Bridge is, has always been, and remains a fine tool for getting your images into the computer, as well as sorting, organizing, and completing your initial edits.

Downloading Your Images into Bridge

Let's start by downloading some images. Photoshop CS4 has a Photo Downloader to ease the process of moving your images onto the computer. The Photo Downloader can place them into a folder of your choice, create subfolders, divide your images up by date, rename them, and even make copies and save them elsewhere! Unlike some other programs out there, the Downloader is simply using the Bridge application to download images to a folder (that you choose) on your computer. It is *not* importing them into the program. Your images are still accessible from any other program that can do so. To download your images via the Photo Downloader, follow these easy steps:

- 1. Plug your camera into your computer or remove the memory card and plug it into your memory card reader. (I prefer the latter for speed and saving your camera's battery.)
- 2. From the File menu, choose Get Photos from Camera. First you will see the box that asks you if you want Photo Downloader to automatically launch whenever a camera or card reader is connected. Choose Yes if you plan to always download your images via Bridge. Next, you will be faced with the Photo Downloader dialog box in Figure 1.2. Click the Advanced Dialog button.
- 3. Figure 1.3 shows the full Photo Downloader dialog box. Start at the top and work your way down. If there are any files on the card (or in your camera) that you do not want to download, uncheck the box next to the thumbnail. The Downloader will ignore these images. Alternatively, you can simply click on the image to select it; Ctrl+click (Cmd+click for Mac) to add to the selection, or Shift+click to select contiguous images. Once the desired images are selected, you can just click on any check box to include or remove them from the download.
- 4. The Get Photos From drop-down menu allows you to choose the location to get your photos. Choose a folder from the Location settings to store your photos.
- 5. In the Create Subfolder drop-down list, decide if you want to leave all of the images in one folder or create subfolders by shot date.
- Under Rename Files, choose from a custom name or a host of variations on date shot and custom name.

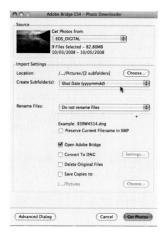

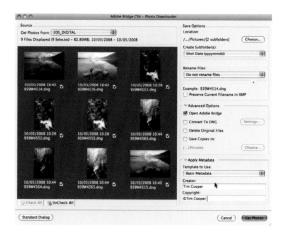

FIGURE 1.3 The advanced Photo Downloader dialog box.

- 7. In the Advanced Options section, you can opt to open Bridge, convert your files to DNG, and even save copies to another location.
- 8. The Apply Metadata section allows you to apply a template (previously made by you) to all of the images that you are downloading. This feature is worth the price of the upgrade alone! Figure 1.3 shows that I will apply my Basic Metadata template, which includes all of my generic information to the downloaded images. If you want to skip the template, you can add your name as the creator and the copyright holder, as seen in Figure 1.3.
- 9. Click Get Photos, and let the download begin.

Building a Custom Metadata Template

It is a good idea to apply your custom metadata template (including copyright) immediately on import. By doing this, your name, phone number, address, email address, and so on are preserved with the rest of the metadata. This step saves you the worry of whether or not you have embedded this information. To create a custom metadata template:

- 1. Click on any image to select it. Choose File > File Info. You will see the dialog box shown in Figure 1.4 with the Description tab active.
- 2. Fill out the Copyright Notice, as shown in Figure 1.4. Using "All Rights Reserved" is a good overall notice that will go a long way toward informing people that your images are not to be stolen or used in any way. Of course, it can't stop them from doing this, but it will give you some legal recourse. The best way to protect your images is to register them with the U.S. Copyright Office and use technology like Digimarc, which digitally watermarks your

images (www.digimarc.com). To type the copyright symbol (©) on a PC, hold down the Alt key and type 0169 on the numeric keypad. To type the copyright symbol on the Mac, type Option+G.

- 3. Click on the IPTC tab and fill out the appropriate boxes, as shown in Figure 1.5.
- 4. To save this as a template, click the Import button at the bottom, and then choose Export from the drop-down menu. You will be prompted to name your new template. Give it a meaningful name, and click Save. That's it! Your copyright template is ready to be applied to your images upon download.

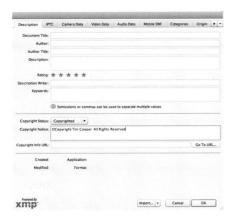

FIGURE 1.4 The Description tab.

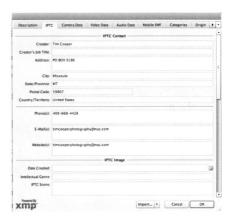

FIGURE 1.5 The IPTC tab.

LAUNCHING BRIDGE

Now that your images are downloaded, it's time to take a peek at them! Bridge is where most people go to begin working with their pictures. From here, the sky is the limit. Because it is a separate application (although heavily linked to Photoshop), I keep both Photoshop and Bridge shortcuts on my desktop. This way I can launch either program without launching the other. If you only have Photoshop open, and you want to launch Bridge, the easiest way is to click the Launch Bridge button on the option bar. This button, as shown in Figure 1.6, resides in the upper left of the option bar and remains as a permanent feature.

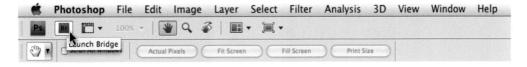

FIGURE 1.6 The Launch Bridge button.

To launch Bridge, click the Launch Bridge button. You can also launch Bridge by using any of the following:

- Choose File > Browse in Bridge.
- Use the shortcut keys Ctrl+Alt+O (Cmd+Option+O for Mac).
- Choose the Bridge application from the Start menu on the PC or the Applications folder on the Mac.
- Drag a folder of images into the Bridge icon. This will launch Bridge and show the contents of the folder simultaneously.

Bridge is divided into four main regions (as shown in Figure 1.7):

- Navigation: Locate images and folders on your computer and external drives.
- **Preview**: Preview the images in the folders.
- **Information:** Find all your image and camera information.
- **Filtering:** Quickly sort through your images to find the one you need. By hiding or showing images that meet certain criteria, you can make your job much easier.

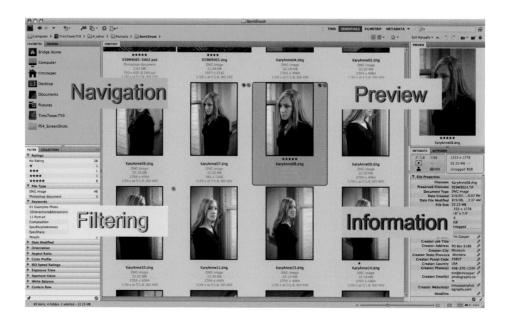

FIGURE 1.7 Adobe Bridge.

NAVIGATING BRIDGE

Bridge functions very much as a visual navigation tool. You will notice that the Folders pane looks and acts a lot like Explorer in Windows or like Finder on the Mac. You can navigate to any folder using the Folders pane; click on a folder to display its contents. When you are in a folder, thumbnails will be displayed in the main Content pane, as shown in Figure 1.8.

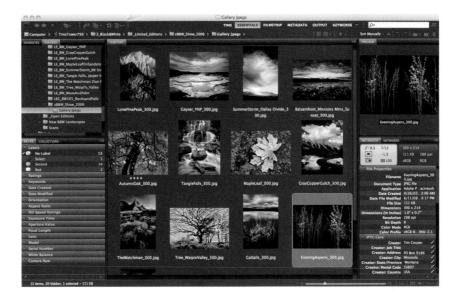

FIGURE 1.8 Clicking on a folder to reveal its contents.

Bridge has received a big face-lift with CS4, and it's now easier than ever to locate your photos. The old menu bar at the top of the screen has been replaced with the new multifunctional option bar shown in Figure 1.9. The bottom of the option bar shows you the full path to your current folder. In this case, it starts at Computer and ends at Sunflowers. Clicking on any one of these folders displays the contents in the Content pane. Similarly, you can click on the down arrows to access these "parent" folders as well as your Favorites folders, as seen in Figure 1.10.

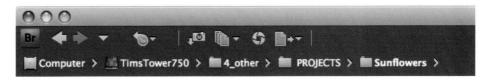

FIGURE 1.9 The New option bar in Bridge.

If you are tired of scrolling up and down in your folder view to go back and forth between two folders, you will like the new horizontal arrows circled in yellow in Figure 1.11. These allow you to snap back and forth between folders very quickly. Circled in red in Figure 1.11 is a quick shortcut to all of the recent folders you have visited. By default, Bridge shows you the 10 most recent places you have been. You can increase or decrease this number by visiting the General section of the Preferences. Go to Edit > Preferences on Windows or Apple > Preferences on a Mac.

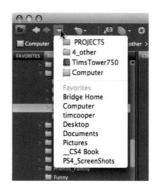

FIGURE 1.10 Going to parent or Favorites folders.

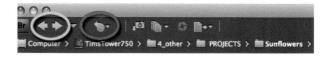

FIGURE 1.11 Moving back and forth between recent folders.

CUSTOMIZING THE BRIDGE WINDOWS

Customizing Bridge Windows in CS4 is easier than ever. If you double-click the name on one of the tabs, such as Filter, Folders, Preview, or Metadata, the pane will collapse or expand. This allows more screen real estate for the things that are important to you. Figure 1.12 shows the Filter pane collapsed to provide more space for navigating the Folders pane.

You can also resize panes by clicking and dragging the middle dividers. This is handy for making a bigger preview to see a bit more detail. Figure 1.13 shows the Metadata and Keywords panes collapsed and the middle divider moved. The preview will expand to fill the Preview pane and will scale to the window size. This is a great configuration for viewing large previews of all the images in a folder.

Different Views

There are many ways to view images inside Bridge, and these can be quickly changed by clicking on the buttons at the top of the window, which are labeled Essentials, Filmstrip, Metadata, Output, Keywords, Preview, Light Table, and Folders.

Or if you are fond of keyboard shortcuts, Ctrl (Cmd for Mac) F1 through F6 will show these views as well. (F5 does a voiceover on Mac; try it—it is . . . odd.) The views are listed in the following sections.

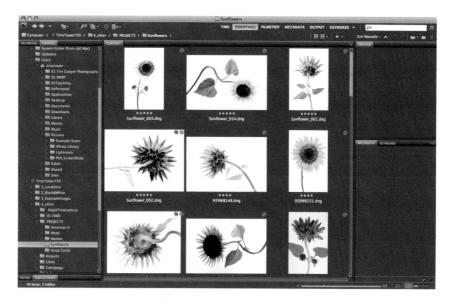

FIGURE 1.12 Collapsing panes to provide more space.

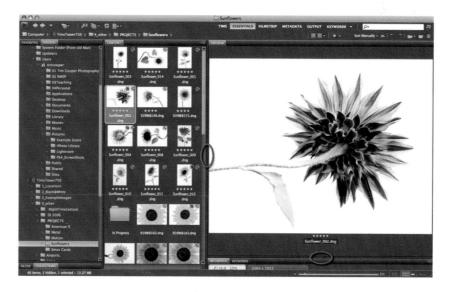

FIGURE 1.13 Drag the pane dividers to resize them.

14

Essentials

This is the default view. Bridge has a dynamic slider that allows you to resize the thumbnails on the fly. Slide the lever and watch your thumbnail size change. Click the grid icon in the lower-right corner to lock the images into a thumbnail grid. This keeps the images from being cut in half at the top and bottom of your Content pane. As Figure 1.14 shows, you have access to all of the panes that Bridge offers.

FIGURE 1.14 Essentials view with thumbnail size slider.

Filmstrip

Click the Filmstrip button or press Ctrl+F3 (Cmd+F3 for Mac). This view shows the thumbnails as a horizontal filmstrip with larger previews. This is a digital lightbox view, which is very useful for photographers looking through collections, searching for that "perfect" image. The Preview pane is nice and big, and moving through your images is as easy as moving the slider bar at the bottom. Figure 1.15 shows the horizontal Filmstrip view. Click on the menu circled in red to change the way your thumbnails are displayed.

To view two images side by side, use Ctrl+click (Cmd+click for Mac) or Shift+click, or drag a region with the mouse on the second thumbnail that you want to view. It will appear in the Preview pane next to your initial image, as shown in Figure 1.16.

FIGURE 1.15 Filmstrip view.

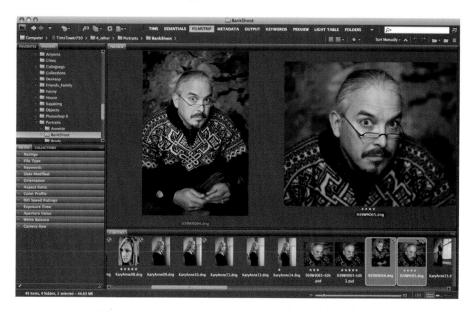

FIGURE 1.16 Viewing more than one image in the Preview pane.

As nice as the view is here, there is only one way to determine if an image is critically sharp: viewing it at actual pixels (100%). In the past, you had to open the image to determine if it was perfectly sharp. CS4 includes a Loupe tool that lets you make that determination immediately. Simply click on any portion of the image in the Preview pane, and you will see the Loupe tool appear (see Figure 1.17). Move it around the image to view that portion at actual pixels. If you just see squares of color, give it a second to load. You can watch the loading process at the bottom.

Some hints to working with the Loupe tool include the following:

- Move the Loupe by clicking inside the Loupe and dragging it to the desired location. Clicking inside the Loupe makes it disappear. Click on the image again to get it back.
- Click on the second image, and you will now have two Loupes active (see Figure 1.18).
- You can change your view inside of the Loupe from 100% to 800% by rolling your mouse scroll wheel, or pressing Ctrl+Plus key (Cmd+Plus key for Mac). Ctrl+Minus key (Cmd+Minus key for Mac) will zoom you back out. Use 100% for the most accurate view.
- If you want to move multiple Loupes simultaneously, press the Ctrl key (Cmd for Mac) while you are moving one Loupe.
- The pointed end of the square shows you what area you are viewing.
- Dragging the Loupe too close to an edge may make it change its orientation so that you can get a full view—very cool.

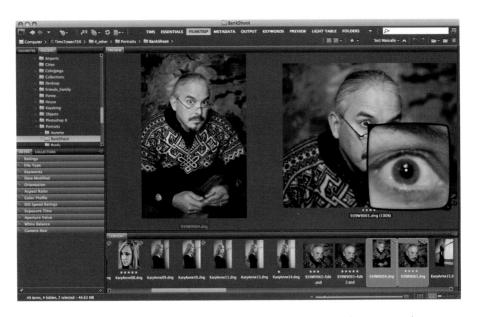

FIGURE 1.17 Click on the image in the Preview pane to activate the Loupe tool.

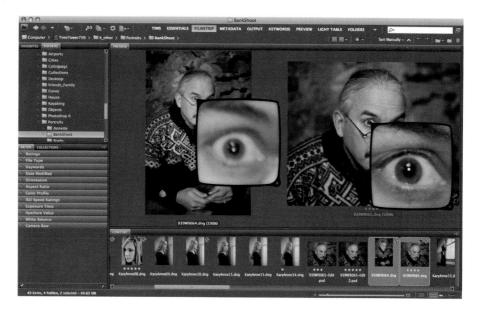

FIGURE 1.18 Two active Loupes.

Metadata View

Click the Metatdata button or press Ctrl+F3 (Cmd+F3 for Mac). This is the view to use when looking for information about your files. Clicking once on an image in the Content pane will highlight it. When an image is highlighted, its properties can be viewed in the Metadata pane to the left. In this view, the image Green-Metal is selected, as shown in Figure 1.19. You can see the file information revealed to the right of the image, such as file name, date created, size, type, and rating. To the left in the Metadata pane, you'll see two new areas introduced in CS3: the Camera data and the File data. These boxes sit at the top and give relevant info about the file at a glance. For a more exhaustive collection of info, scroll down. The bar running across the top of the Content pane can be adjusted to your taste. You can move the fields by clicking on the name of the field and moving it to another location. Change the size of the field by clicking and dragging the line in between.

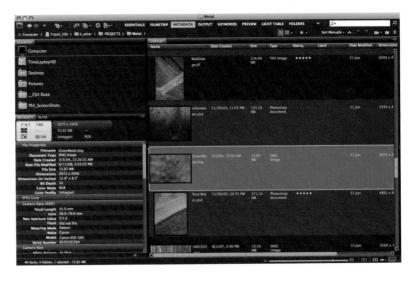

FIGURE 1.19 Metadata view.

Keywords View

For now we will skip over the Output view and look at the Keywords view. The Keywords view is very similar to the Metadata view. Pressing Ctrl+F5 (Cmd+F5 for Mac) will get you there. Figure 1.20 shows this view with its large Content pane on the right with important info about each file. Click on any image, and you will see the attached keywords to the left in the Keywords pane. (More on keywording later in this chapter.)

FIGURE 1.20 The Keywords view.

Preview

This is almost identical to the Filmstrip view, with the exception that the thumbnails run vertically rather than horizontally. In both views, the Favorites, Folders, Filter, and Collections panes are visible. Each show a large preview of the selected image, but in this view your image is somewhat bigger. Selecting multiple images will result in larger previews of them all.

Light Table View

For those of you who are accustomed to laying down a page of slides on a light table, this is the view for you. It removes all of the panes except for Content and shows your thumbnails at a decent size (see Figure 1.21). It's good for a quick look at your images.

FIGURE 1.21 The Light Table view.

Folder View

Press Ctrl+F3 (Cmd+F3 for Mac). This view focuses on your Folders and Favorites panes. This is a great view if you are working on locating photographs. You can collapse the Favorites pane from this view so that the whole left side of Bridge is one long folder tree. (The Tab key toggles the Folder and Favorites panels off and on—very handy in this view, but it works in the other views as well.)

The down arrow to the right of the Folders button (circled in red in Figure 1.22) is another way in which to reach the desired view. Simply click on the arrow, and you get a drop-down menu listing all of the available views. This is a good feature for folks with a lower resolution monitor, which may not show you all of the view options.

FIGURE 1.22 Thumbnail quality and preview generation.

Circled in blue in Figure 1.22 is the down arrow for the drop-down menu that controls thumbnail quality and the way they get generated. By default it is set to Always High Quality. This is a good general setting. If you find that your thumbnails are loading up too slowly for your taste, choose Prefer Embedded (Faster). Your thumbnails won't be color managed, but they will load up quickly. If you want fast zooms to 100% on your Loupe, choose Generate 100% Previews. This makes your Loupe views faster but takes up more disc space.

Slideshow Mode

This is a great way to view your images very large and without the distraction of other images. Press Ctrl+L (Cmd+L for Mac) to launch the slideshow. The image that is highlighted in the folder will be shown by itself on the screen. To view the next image, press the right arrow key. In this way, you can view an entire folder of images one at a time with a large preview. To check for sharpness, click on the image, and it will blow up to actual pixels (100% magnification). Click and hold to drag the image around the screen. Press the Escape key to return to the normal Bridge view. To check out all of the features of the slideshow, press H, and a list of options will appear.

Review Mode

This is my favorite addition to Bridge. This view makes it very easy to quickly examine a folder of images. Click on a folder of images and press Ctrl+B (Cmd+B for Mac) or choose Review from the Views menu. This mode floats all of your selected photos on a gray background while you review the front image. The absence of Bridge's clutter makes it much easier to focus on the photos. Clicking the right arrow key brings the next image forward and pushes the previous image back into the floating circle of images (see Figure 1.23). Pretty slick. Press

the H key, and a shortcut menu will appear on screen. Here you will find the keys that allow you to rotate, rate, label, and even create a Quick Collection from your picks. Press the H key again to remove the shortcut menu.

FIGURE 1.23 Review mode.

Clicking the down arrow (circled in red in Figure 1.23) removes the foremost image from the view. It doesn't delete the image from the folder, it just removes it from the view. This is a great way to make a collection of your favorite images from that folder. You begin with a selection of images or the whole folder. Go into Review mode. As you look through your images, you rate or label them. Use the down arrow to remove them from the view. When you are finished, you are left with only your favorite images showing. Press the Quick Collection icon circled in blue in Figure 1.23, and these images will always be at the ready from your Collections tab. The Loupe tool also works normally in this view. That is very helpful when trying to decide between images. The combination of the cool factor with the usability of the Review mode makes it a likely favorite among photographers.

Content View Control

With the new option bar at the top of the Bridge window, Adobe has given us many ways in which to view our photos. They did take it one step further, however. Figure 1.24 shows four new icons in the lower-right corner of the Bridge window next to the thumbnail slider. These buttons control how your images will be shown in the Content pane. From left to right they are Lock Thumbnail to Grid, Traditional Thumbnail view, Details view, and List view. Don't be fooled by the names, though—these buttons only change the way the thumbnails look within

the Content Pane. This means that you can choose the Folders view, if you like that layout of panes, but then choose to see your photos in the Details view within the Content pane. This creates a whole new level of customization to Bridge.

FIGURE 1.24 Content view buttons.

MANAGING YOUR WORKSPACE

We have just looked at many ways to customize the way that Bridge looks and works. Depending on what you are doing, you may prefer a different setup. The solution is to come up with several different setups, one for cataloging images, another for light table work, and perhaps another for navigation. Don't feel that you have to conform to the preset views offered by Adobe. You can create different views that are more comfortable for your personal workflow.

You can save your customized views and recall them in an instant using the Workspace menu. To save a workspace, follow these steps:

- 1. Arrange the size and location of the tabs and views to suit your taste. Do this manually or by starting with the preset views.
- 2. Choose Window > Workspace > New Workspace.
- 3. Give your new workspace a name, and click Save. It will then appear to the left of the Essentials view.
- 4. To recall a workspace, choose Window > Workspace, and choose your workspace from the drop-down menu or click on it in the option bar.

Stacks Feature

The new stacks feature introduced back in CS3 gives you the ability to put your images in stacks, just as if you were working on a light table! This enables you to reduce clutter by grouping similar images into stacks. For example, you may have three different exposures of the same subject. If you have no reason to view them all at the same time, just put the most appropriate one on top and choose to have the others stacked below. Likewise, you may find that you have many variations of the same image or perhaps a group of photos that you plan to merge to HDR or a set of shots for panoramas. The possibilities are endless. Figure 1.25 shows a folder that contains several sequences of images that will later be used to create an HDR image. To clean up this folder, you can create several stacks.

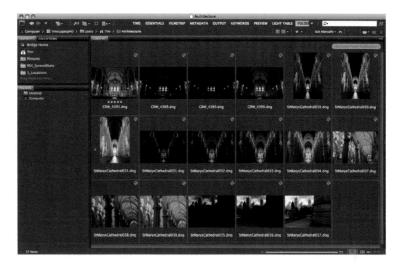

FIGURE 1.25 Folder that can be cleaned up with stacks.

- 1. To create a new stack, select the images, and press Ctrl+G (Cmd+G for Mac). To choose other images to add to the stack, Ctrl+click (Cmd+click for Mac) on the images and drag them into the stack.
- 2. Once they are in a stack, a number will appear in the upper left indicating how many images are in the stack, as shown circled in red in Figure 1.26. Click on the number to expand the stack. Click on it again to collapse the stack.

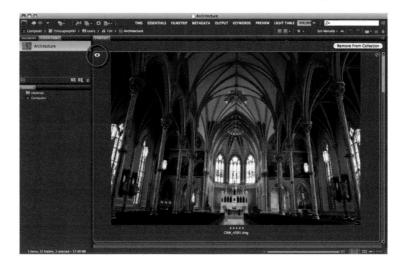

FIGURE 1.26 A stack of images.

- 3. Change the image on the top of the stack by opening the stack and moving your favorite to the front position. Close the stack, and the chosen image will be on top.
- 4. Figure 1.27 shows the same folder after the images have been organized into stacks. This looks much better.

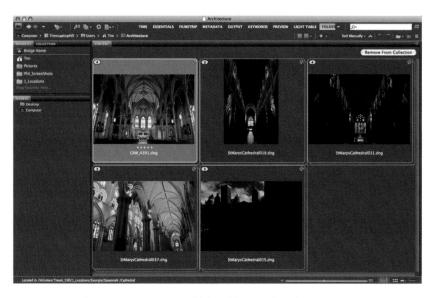

FIGURE 1.27 A folder with several stacks.

A few hints for working with the Stacks feature:

- If you already have a stack made, you can add to the stack by dragging an image and dropping it onto the stack.
- Applying a label or rating to a stack will apply it to all of the images within that stack. This works when it is either expanded or collapsed.
- Double-clicking on a stack when it is collapsed only opens the top image. Double-clicking when it is expanded opens all of the images.
- When you are in collapsed mode, if you have 10 or more images in a stack, you get a small gray bar across the top with a dark circle in the left corner. Click and drag this circle to the right, and the stack plays a little slideshow of the images within the stack (see Figure 1.28).
- If your folder contains images that have been shot for HDR or panoramas, there is a quick way to get them into individual stacks. From the Stacks menu, choose Auto-Stack Panorama/HDR. This feature searches through the folder and finds images that have been shot for either merging to HDR or panoramas.

- You can remove an image from a stack by expanding the stack and rightclicking on that image. Choose Ungroup from Stack from the Stack flyout menu, or simply drag it out of the stack.
- To move a different image to the top of the stack, expand the stack. Click and drag the desired image to the front of the row. Collapse the stack, and the new image will be on top.

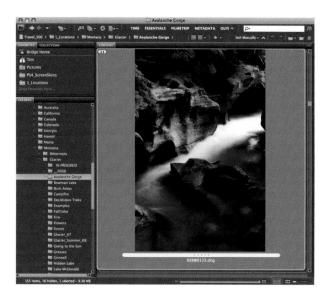

FIGURE 1.28 The Slideshow feature.

ROTATING IMAGES

When you shoot with the camera held sideways, you create images with a portrait orientation rather than the usual landscape orientation. There is no way for Bridge to know that you rotated the camera, so all the images are displayed in landscape by default. (Many cameras offer autorotation features; if you have used this feature, the images will be shown in their correct orientation, and no rotation will be needed in Bridge.) You could get a sore neck tilting your head all the time to view these images. The obvious solution is to rotate the images in Bridge, which you can do by following these steps.

- 1. Click on the thumbnail to select multiple thumbnails, then Ctrl+click on each additional image you want selected (Cmd+click for Mac).
- 2. Click on the rotation buttons on the menu bar in Bridge, as shown in Figure 1.29. The image(s) will be rotated 90 degrees.

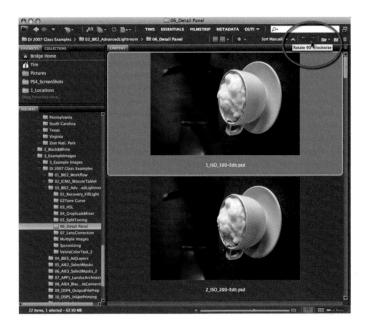

FIGURE 1.29 Rotating images.

OPENING IMAGES WITH BRIDGE

There are several ways to open images in Photoshop from Bridge. To open a file, do one of the following:

- Double-click on the thumbnail or preview.
- Choose File > Open.
- Right-click, and choose Open.

By default, Bridge stays open after you have opened an image. To open an image and minimize Bridge at the same time, hold down the Alt key (Option key for Mac) and double-click a thumbnail.

You are not limited to opening a single image at a time; a series of images can be opened at once. You can browse the thumbnails and select them by holding down the Ctrl key (Cmd key for Mac) and clicking a thumbnail. When you click the thumbnail, it is highlighted and added to the selected thumbnails. When you have finished selecting all the desired thumbnails, double-click any one of the highlighted thumbnails to open all the selected images as a series of images.

RATING AND LABELING IMAGES

It doesn't take too long to build up a large collection of images with a digital camera. In film days, there was a cost every time you pressed the shutter button. With digital, the price is your time. So how do you sort and organize all these images? Bridge has two tools to help you: rating and labeling.

Rating

Rating is a quick way to label images. You can choose from 1 to 5 stars for each image. Rank them according to the quality of the shot or relevance to your need. Select the thumbnail, and choose the star rating from the Label menu. Press the Ctrl key (Cmd key for Mac) and one of the numbers 1, 2, 3, 4, 5. Or just click inside the thumbnail and slide your cursor over the number of stars that you want to assign to the image, as shown circled in Figure 1.30.

FIGURE 1.30 Rating an image.

Labeling

Another way of tagging images is by using the labels. Labels are a little different from ratings because you select a phrase that will show as a color rather than a numerical rating. The different names of the labels are shown in Figure 1.31. To apply a colored label, right-click on the thumbnail, choose a label from the drop-down menu, and then select an item from that list. Ratings and labels can be used in conjunction with each other, as you can see in the folder shown in Figure 1.32.

	Rating	
	No Rating	₩0
	Reject	1.
	*	% 1
	**	₩2
	***	₩3
	***	₩4
	****	₩5
	Decrease Rating	₩,
	Increase Rating	₩.
	Label	
	No Label	
9	I ⊾ Select	#6
Γ	Second	₩7
	Approved	₩8
	Review	₩9
	To Do	

FIGURE 1.31 Names of the labels.

FIGURE 1.32 Images that have been labeled and rated.

The label name can be changed to whatever is most beneficial to your work-flow. While in Bridge, select the Preferences menu and choose Labels on the left side. Here you can change the words by typing in the box. If you uncheck the Require the Control/Command Key to Apply Labels and Ratings box, you can simply type the number associated with the color. You will see that 6 is red, 7 is yellow, 8 is green, and so on. This also means that you can simply type the numeral 1 for a one star rating and 2 for a two star rating, and so on.

After you go through a folder and rate and label all of your images, you can change your view so that the Content pane will only show you certain types of images. You are not deleting them; rather you are just asking Bridge to make visible only the 5-star images in this folder. Or you may want to view just the images labeled red. To view only those images, look to the Filter pane. As you add labels, ratings, and keywords to your images, those items will appear in the Filter pane. Clicking on the 5 Star or the Red label will force Bridge to show only those images that match that criterion. For example, in Figure 1.33, the Red label and the 5 Star rating have been checked. As you can see, Bridge is only showing those images that are rated 5 Star and have a Red label. To remove the filter, unclick the rating or label that you chose. A shortcut has been put on the option bar in CS4 to gain quick access to filtering by star ratings. This is helpful when you are in a view that is not showing the Filter pane. Figure 1.34 shows the icon and associated menu.

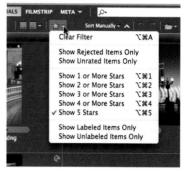

FIGURE 1.33 A folder that has been filtered.

FIGURE 1.34 The new Ratings shortcut.

There are other useful ways of filtering your images as well. All are very conveniently located right in the Filter pane. Keywords, ISO, Date Created, Orientation, and Serial Number are some of the other options.

Multiple images can be flagged all at once by first selecting them and then applying the rating or label.

ORGANIZING CONTENTS OF FOLDERS

Bridge provides a drag-and-drop environment for organizing your images. To move an image to a new folder, simply click and hold the mouse button on a thumbnail. It can then be moved to a folder by dragging to either a folder in the Folders pane or to a folder in the Content pane (see Figure 1.35). Release the mouse button to complete the move. To copy an item instead of moving it, hold down the Alt/Option key while dragging. You will see a small plus sign to indicate that you are copying an image to a new location.

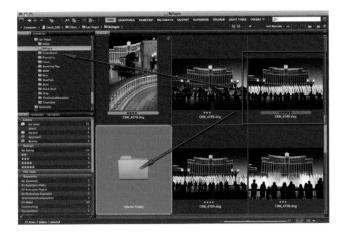

FIGURE 1.35 Moving images to new folders.

Using Favorites

Another time-saving feature in CS4 that has been borrowed from the Web browser world is the Favorites pane. This saves you from repeatedly searching for folders on your computer. Once you mark a folder as a favorite, you can quickly select it from the menu.

To mark a folder as a favorite, first navigate to the folder. Select the folder, right-click on its name in the Folders pane, and choose Add to Favorites (see Figure 1.36). The folder (Australia) will now be added to the Favorites pane, as shown in Figure 1.37. Alternatively, simply drag and drop the folder from the Content pane or the Folders pane into the Favorites pane.

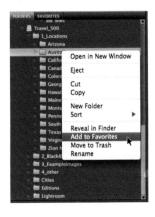

FIGURE 1.37 The folder added to the Favorites pane.

To open a folder from the Favorites pane, simply click on the folder. The thumbnails will now appear in Bridge. If you don't want your Favorites pane all cluttered with unused "favorites," a quick trip to the Bridge Preferences will take care of that. Choose Preferences > General. The Favorite items will be in the lower right. Uncheck anything that you do not use on a regular basis.

USING KEYWORDS

Keywords can easily be added to images without having to type them each time. These keywords are useful for searching for images later. You can find images from multiple locations and display them together in a single window.

Organizing Keywords

To organize the keywords, follow these steps:

- 1. Click on the Keywords pane, and you will notice that some keywords are already present, such as Events and Places. Underneath the keywords you will find sub-keywords, such as New York, Paris, and San Francisco under the Places keyword.
- 2. To start creating your own keywords, click on the down arrow in the top right of the Keywords pane, and choose New Keyword. You can also click the plus sign in the lower right of the pane (circled in red in Figure 1.38). It will appear at the top of your stack.

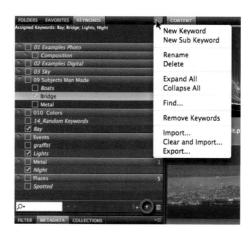

FIGURE 1.38 Keywords pane.

3. To keep help keep things organized, I like to use both keywords and sub-keywords. To start creating sub-keywords, click on the keyword you want to use as the parent and then right-click. Choose New Sub-Keyword from the resulting drop-down menu. You can also click on the parent folder and then click the plus button with the arrow (circled in Figure 1.39), and add your new keyword. Here you can see I have the keyword Subjects Man Made with the sub-keywords of Boats, Bridge, and Metal.

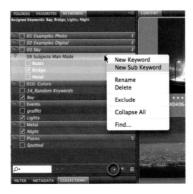

FIGURE 1.39 The Keywords pane with custom keywords added.

Assigning Keywords

To assign keywords to images, follow these steps:

- 1. Select the image and check the box next to the keywords that you want to attach to the image.
- 2. To save time, select multiple images by Ctrl+clicking (Cmd+clicking for Mac) on the thumbnails.

Searching the Keywords

You can easily locate images with keywords by performing a search:

- 1. Choose Edit > Find.
- 2. In the Look In field, choose the location to search (typically, the hard drive containing your photographs).
- 3. You can use many criteria to define your search; in Figure 1.40, we have used the keyword Historic Architecture. You could also choose File Name, All Metadata, and so on.
- 4. If you would like to narrow down the search, you can add another search field by clicking on the plus button.

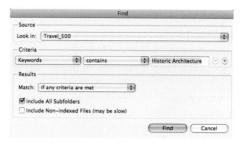

FIGURE 1.40 The Find box.

- 5. Under the Match drop-down list, choose If Any Criteria Are Met if you want to search for files that contain either of the two search fields. Choose If All Criteria Are Met if you want to see only images that contain both search fields.
- 6. Click on Find to begin the search. Figure 1.41 shows the results of the search in the Content pane.

FIGURE 1.41 The search results.

Working with Collections

A *collection* is a saved search. Once you have gone through the trouble of searching for something, save it as a collection. Next time you want to view this grouping of images, you can easily recall them without having to go through the Find dialog box again!

- 1. Once you have performed your search, the images will appear in the Content pane. Select all of the images by pressing Ctrl+A (Cmd+A for Mac) or choosing Edit > Select all.
- 2. Ensure that your Collections pane is visible. Click on the New Collection button, circled in red in Figure 1.41.
- 3. A new collection will appear in the Collections pane. Enter a name for your collection.
- 4. Reopening a collection is as simple as clicking on that collection in the Collections pane. All of your images will be visible again.
- 5. Instead of choosing the New Collection button, you can also choose the New Smart Collection button just to the right. This will create a collection that is dynamic—if an image that matches the search criteria is added, it will automatically be added to the collection. If you change an image, and it no longer fits the profile, it will automatically be removed from the collection.

A Smart Collection is a saved search that is dynamic. This means images can be added or subtracted from the collection automatically. "How does it know?" you may ask. A Smart Collection keeps track of criteria that you choose. It could be a rating, a label, or even a keyword. So, for example, let's say you want a collection of images that have the keyword HDR and also a 5-star rating. You want this collection to automatically add any new images that you create on the fly. By creating a Smart Collection, every time you tag another image with that keyword and a 5-star rating (the criteria in this case), it is added into the Smart Collection. Creating a Smart Collection is easy:

- 1. Ensure that your Collections pane is visible. Click on the Smart Collection button circled in red in Figure 1.42
- 2. You are now faced with the Smart Collection dialog box shown in Figure 1.43.

FIGURE 1.42 The Smart Collection button.

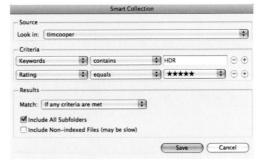

FIGURE 1.43 The Smart Collection dialog box.

- 3. In the Source section, you will find the Look In drop-down menu. Choose the folder that you want to search. If you want the collection to look through all of your images, choose the main folder in which all of your photos live. Then check the Include All Subfolders box. This command forces the search to examine every photograph on your computer. This is a good reason to keep all of your photos within one main folder.
- 4. The Criteria section determines what the search will look for. Click on the first drop-down menu to reveal the host options. In Figure 1.43, we chose to search for Keywords. The next menu to the right shows that we chose Contains. Alternatively, we could have chosen Starts With, Ends With, or a number of other options. Lastly, we typed in HDR. If we hit the Save button now, the search would look in the folder timcooper and all of its subfolders for photos that contain the keyword HDR.
- 5. By clicking the plus button on the right, you can add another set of criteria to the search. Here we decided to add in Rating Equals 5 Stars. Once you add in a second set of criteria, it becomes important to visit the Results area.
- 6. The Match drop-down menu reveals two options that will control how the search deals with the criteria:
 - a. If Any Criteria Are Met will add *all* images that have the keyword HDR in them. It will also add in *all* images that have a 5-star rating.
 - b. If All Criteria Are Met only adds in images that have the keyword HDR *and* have a 5-star rating.
- 7. Click the Save button at the bottom of the dialog box.
- 8. The search goes to work, finds your images, displays them in Bridge, and allows you to name your new Smart Collection.
- 9. If you would like to change the criteria of your Smart Collection, right-click on the Smart Collection and choose Edit. The Smart Collection dialog box reopens and allows you to make any desired changes.

METADATA

Photoshop has really boosted the amount of information that you can store with your image. This information is called *metadata*. Photoshop uses the standard of XML developed by Adobe called eXtensible Metadata Platform (XMP). This information is very important when transmitting images electronically and is becoming more important as standards are being set for professionals. This is also very useful for organizing and searching your images. Metadata includes captions, copyright information, keywords, descriptions, credits, and origin. This information will travel with the images saved in PSD, PSB, TIFF, JPEG, EPS, and PDF formats.

Exif

If you shot your image with a digital camera, all the camera information will be stored with the image. This is called the camera data or Exif. When you view this information, it will tell you all the camera settings that were used for the picture. Can you imagine how valuable this is? For example, if you have a photo that didn't come out quite right, you can look at the Exif data and see where you went wrong. This will help you learn and avoid the same problems in the future. On the reverse side of the coin, if you have a shot that is just perfect, you can take note of the settings and reproduce them in the future. Can you see how this information is going to help boost the level of photography? A scenario could involve students giving images to their teacher for review. The teacher then critiques the images based on the results and Exif data and offers suggestions for improvement.

Viewing the Data

All the metadata is displayed in the Metadata pane when you select a thumbnail. Click on the arrows next to each category to expand or collapse the sublevels and view the information. Figure 1.44 shows this information for a selected thumbnail.

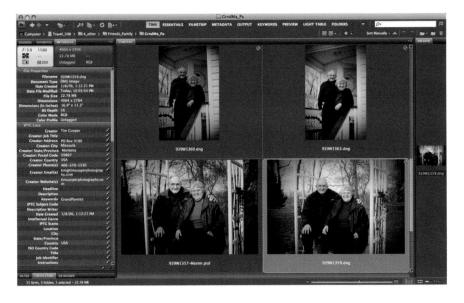

FIGURE 1.44 The metadata information can be viewed from Bridge.

There are several categories in the Metadata pane:

File Properties: The file information for the image is displayed here.

IPTC Core: This is the standard from the press folks when they started moving their notes along digitally and is used by newspapers and other publishers. They added in standardized fields for general info and also information that is specific to reporters and photographers. Most journalistic groups and online stock agencies require IPTC (International Press and Telecommunications Consortium) information for electronic image files.

Camera Data (Exif): All the settings used on the camera at the time of firing.

Adding Information to the Metadata

All this metadata would not be very useful if you couldn't edit and add to the information yourself. All the camera information is saved automatically with the image file, but the rest of the information has to be added manually.

Adding Information Directly

One way to add various information to an image is to add it directly into the Info field in the Metadata pane in Bridge:

- 1. Click on the Pencil icon to the right of any editable field. (If there is no icon, that field is not editable.)
- 2. You will see a box appear with a cursor in it. Type in your information. Press the Tab key to advance to the next field.
- 3. Click the check mark on the bottom right of the window (circled in Figure 1.45) to apply the information to the image. The information will now be saved with the image or as a sidecar file with RAW images. The sidecar is needed because you cannot write to a RAW file. Instead, an extra file is created that travels with the RAW file. Separate the RAW file from the sidecar, and this extra information will be lost.

Adding Data Using the File Info Dialog Box

You can also add or edit information using the File Info dialog box, as demonstrated earlier in this chapter. This can be accessed by choosing File > File Info from either Bridge or Photoshop itself. You can also access this dialog box by right-clicking on the thumbnail and choosing File Info.

The default category is the Description tab. Enter the desired information into these fields, as shown in Figure 1.46.

FIGURE 1.46 Using the File Info dialog box.

If you didn't apply this template to the images while downloading, you can apply it now by following these steps:

- 1. Highlight a folder in the Folders pane, and choose Edit > Select All.

 Of course, you could just click on one image at a time, but why bother?
- 2. Choose Tools > Replace Metadata, and then choose your template.

When you apply a template, it will not overwrite any Exif (camera) information. The description, categories, and origin will be replaced by the template's information. I *highly* recommend that you get into the habit of doing this every time you download a new batch of images if you haven't applied this template during download. This will save you a lot of computer time down the road!

BATCH RENAMING

You have probably noticed by now that your digital camera assigns cryptic names to the images, which doesn't help you much when trying to locate images. For example, the Canon camera assigns an incremental number prefixed by the letters CRW for the RAW images. Nikon uses NEF. The good news is that the Batch Rename feature allows you to rename an entire folder of images.

1. Choose a folder you want to rename, or just highlight a few images if you don't want to rename the whole folder. Perhaps you want to rename smaller groups at a time with meaningful names. In this example, we have chosen a

- folder of images of the Mandalay Bay Hotel. From the menu bar, choose Edit > Select All.
- 2. Choose Tools > Batch Rename. The Batch Rename dialog box will appear, as shown in Figure 1.47.

FIGURE 1.47 Batch Rename dialog box.

- 3. Begin at the top of the dialog box and work your way down. Under the Destination Folder section, you can choose to rename images in the same folder (overwriting the existing image names) or move (or copy) the images to a new folder (useful for organizing images). In this case, we have chosen to use the same folder.
- 4. Next is the New Filenames section. In the Text field, type in the desired file name. (For this example, MandalayBay was used.)
- 5. The default for the next line is Date Time. Leave this if you want to add in the date. In this example, this field has been changed to Sequence Number. Three Digits is also selected in the next field. If you have a lot of images, consider raising this number.
- 6. To remove this and other listings, click the minus sign to the right of the field; to add one, click the plus sign.
- 7. Check out the Preview section at the bottom. It shows the current file names and what they are going to be. In this case, MandalyBay001.dng, and so on.
- 8. Enter the starting serial number in the Sequence Number box and click OK to rename all the images in the folder.

EXPORTING THE IMAGES TO A CD-ROM

Why include a section on burning images to a CD-ROM, you may ask? Don't you just copy the images to a CD-ROM and burn it? Yes, you do, but the reason this section is here is to inform you of the image cache. When you make any alterations

in Bridge, all the information is saved to a small file called a *cache file*. If you copy the images without the cache to another location, all the Bridge changes will be lost, such as rotation and labels. It's best to keep the cache right in the file with the images. This way, wherever your images go, their cache files can follow. You can set Bridge to put the cache files into your folder by taking a trip to Bridge Preferences. Under the Cache tab, check the box next to Automatically Export Cache to Folders When Possible. This will do the trick!

AUTOMATION

Photoshop has an impressive array of automated tasks called *actions* and *scripts*. These features will save you hours of time and will perform difficult and repetitive tasks for you automatically. You simply choose a few parameters and let Photoshop do the rest. In this section, we will discuss a few of these tasks that pertain to photographers.

Traditionally, all the automated tasks were accessed in Photoshop by the File > Automate menu. They are still available from this menu, but they are also available directly from Bridge. These tasks can be accessed in the Tools > Photoshop menu. Others are available directly from the option bar. This is especially helpful when you want to automate tasks that include multiple images, such as making contact sheets, Web galleries, merging to HDR, or creating panoramas.

Third parties (or yourself) can create scripts for Photoshop to automate tasks. For information on how to create your own scripts, check out the Scripting Guide PDF in the Scripting Guide folder within the main Photoshop CS4 folder.

Output

Let's begin with the automated tasks that are accessed from the option bar. In an effort to streamline Bridge and simplify workflow, Adobe has created a new view called the Output pane. You will find this by clicking on the Output button in the option bar (circled in red in Figure 1.48).

PDF Creations

Portable Document Format (PDF) is really coming to the forefront of publishing technology, and Adobe has built in a lot of PDF functionality to its Creative Suite of products. A PDF is basically a universal document. It can open on Apple and

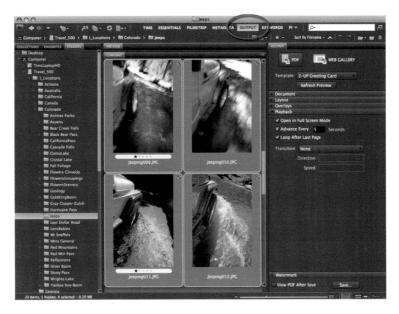

FIGURE 1.48 The Output pane.

Windows machines and can be read by anyone who has the free viewer. New computers ship with the Adobe Reader (formerly known as the Acrobat Reader). Otherwise, it can be downloaded for free at www.adobe.com.

Photoshop can natively create and open PDF files. It is beyond the scope of this book to look at all the features of PDF, but several features are invaluable to photographers. First, it is a great way to share photos with friends, family, or clients. Second, you can create a PDF image that compresses very well, can be emailed, and enables the viewer to zoom in and out of the image. It will also create contact sheets and pages with multiple images. Perhaps most important, you can set security preferences that prevent people from extracting or printing the images. You can even assign a password that will be required to view the image.

Creating a Contact Sheet

A contact sheet is a page with all the thumbnails printed out with their file names. This is very useful as an overview of your images and invaluable as a catalog tool. For example, you could create contact sheets of all your images and keep them in a binder. Then when you (or a client) need a specific type of image, you could quickly flip through the catalog of thumbnails, rather than browsing through each image. Another use for the contact sheet is to produce a liner for your CD-ROM with all the thumbnails clearly displayed. Let's create a contact sheet, and you will see how easy and useful this feature is.

- 1. Browse to the folder that contains the images you want to add to the contact sheet.
- 2. You can create a contact sheet from either an entire folder or just selected images.
- 3. If you want to use selected images, click on the first thumbnail and then hold down the Ctrl key (Cmd key for Mac). Click on each thumbnail you want added to the selection, and they will be highlighted as you select them.
- 4. If you want to use the entire folder, choose Edit > Select All.
- 5. Click on the Output button in the option bar. You will now see the Output pane shown in Figure 1.49. Click on PDF. From the Template drop-down menu, you can choose a premade template if you desire. If not, it's very simple to create your own.
- 6. To create your own, click the arrow to the left of Document. Change Page Preset to U.S. Paper and Size to Letter as seen in Figure 1.50. Although Letter is the default and is a good size for a photographic contact sheet, you can change this to anything you want, including 4.75 × 4.75 for a CD-ROM liner or 4.75 × 9.5 if you want a fold on the label. Check the desired page orientation with the Portrait and Landscape icons. Set the quality to Low for quicker generation and printing, or set it to High for a high-quality print. Choose white as the background to make it look like a traditional contact sheet.
- 7. Click the down arrow to the left of Layout to create your own custom design. In the Columns and Rows boxes, type the numbers you would like to see on your page. In Figure 1.51, I have chosen 2 across and 3 down to fit my images on one page. Check the Use Auto-Spacing box to let Bridge automatically size and fit your images on the page.

FIGURE 1.50 Creating a custom contact sheet

- 8. The Overlays section of the pane allows you to change the size, font, and color of your file name that appears under the thumbnail. Check the Filename and Extension boxes so they will print. Change the font, size, and color to suit your tastes.
- 9. Go to the top of the pane and click Refresh Preview. This will generate a new contact sheet with your chosen images and show you a preview. If there are too many thumbnails to fit on one page, Bridge will create multiple pages until all the thumbnails are arranged into contact sheets.
- 10. Click the Save button at the bottom of the pane to save your contact sheet. Bridge now performs its magic and creates the contact sheet to your specs; it is then ready to print! Figure 1.52 shows the finished contact sheet.

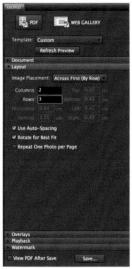

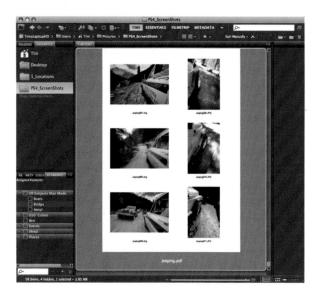

FIGURE 1.52 The finished contact sheet.

Creating contact sheets is only one of the things that you can create with Bridge's Output function. You can also create slideshows and single images that can be password protected from printing or copying. Creating a single image to send is almost identical to creating a contact sheet.

- 1. From the Template drop-down list, choose Maximum Size.
- 2. In the Document section change Page Preset to Photo as shown in Figure 1.53. Under Size, choose from either Landscape or Portrait in the sizes of 2×3, 4×6, 5×7, or 8×10. Set the quality to Low for quicker generation and online viewing, or set it to High for a high-quality print.

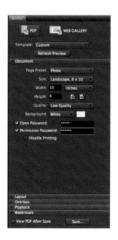

FIGURE 1.53 Setting passwords to protect your photo.

- 3. If you want to password protect this document, you'll find the options in the center of the Document section. By checking the Open Password and Permission Password boxes and typing in passwords, you can keep unauthorized folks from printing or extracting or your photo(s). Figure 1.51 shows the Document section with passwords set. Passwords are great for photographers because you could, for example, send the proofs over to a client. The client could then view the images and show them around. After you have received payment for the image, you supply a password, and then the client can print and extract the image without limitations. This is just one way you could use this feature—let your imagination be your guide.
- 4. In the Layout section, check the Rotate for Best Fit box.
- 5. In the Overlays section, check the Filename and Extension boxes if you want them to print. Change the font, size, and color to suit your tastes.
- 6. The Watermark section allows you to place your name or other text over the image. I prefer to use a password to protect my image, but some may find this to be an extra security measure. Type your name or some text in the Watermark text box. Change the font, size, and color to suit your tastes. Lower the opacity if you want some of the image to show through the text. A lower opacity gives the watermark a cleaner look.
- 7. Click the Save button at the bottom of the Output pane to save your image as a PDF.

Have your ever wanted to create a slideshow, but you knew that the people you were going to send it to didn't have the special software? Not a problem. With the PDF function, you can create a slideshow that anyone can watch. The steps are identical to creating a PDF, except that you will visit the Playback section to finish it off.

- 1. Browse to the folder that contains the images you want to put into the slideshow.
- 2. Select all of the images in the folder by choosing Edit > Select All. If you want to use only selected images, click on the first thumbnail and then hold down the Ctrl key (Cmd key for Mac). Click on each thumbnail you want added to the selection, and they will be highlighted as you select them.
- 3. From the Template drop-down list, choose Maximum Size.
- 4. In the Document section, click on the Page Preset drop-down list and choose Web. From the Size drop-down list, choose a size that will best show off your images. 1024×768 is a safe bet, as most computers these days will handle that. If you know your audience has larger resolution monitors, you can bump this number up a bit.
- 5. In the Layout section, uncheck Rotate for Best Fit. This will keep your vertical and horizontal images displaying correctly.
- 6. Check out the Overlays section to see if you have the Filename and Extension boxes checked. You may or may not want to include these in your slideshow. Checking the boxes will show the text on your slides.
- 7. The Playback section controls how your slideshow will be viewed when opened (see Figure 1.52). Check the Open in Full Screen Mode box so the slideshow will autostart when opened. Determine an appropriate viewing duration for each slide and type it into the Advance Every_Seconds box. The Loop After Last Page box will keep the slide show running until it is stopped. Uncheck this box if you would like it to end after the last slide. I keep my Transition setting at None, but experiment with the different options to determine what you like. Figure 1.54 shows the Playback section set for a slideshow.
- 8. Click the Save button at the bottom of the Output pane to save your images as a PDF slideshow.

FIGURE 1.54 The Playback section of the Output pane.

WEB GALLERY

Ever wanted to put your images up on a Web site but lacked the HTML skills? The Web Gallery feature makes it a snap. Bridge will create small thumbnails and place them on a page. When you click on the thumbnails, they will launch a larger version of the image. Photoshop resizes all the images and creates all the Web pages necessary for smooth navigation. What is more, the metadata can be used for captions, page titles, and more. You can point the gallery at a folder of images, go get a cup of coffee, and before you return, your Web page is finished and ready for uploading to the Web. Let's see how it works.

- 1. Navigate to the folder that contains the images you want to place on the Web.
- 2. Choose Edit > Select All, or choose the images you want in your Web Gallery.
- 3. Click on the Web Gallery icon in the Output pane.
- 4. You will see the Site Info section shown in Figure 1.55. Choose a layout from the Template drop-down list. You may want to start off creating a Web Gallery of just a few images to sample the different styles of Web pages available.

FIGURE 1.55 Site Info section of the Output pane.

5. The Site Info section is where you can type in your custom text to describe your gallery, name, and copyright information. Enter your email in the E-mail Address field. This will create a link that people can click on to contact you while browsing your page.

- 6. The Color Palette section does just what you think it will—allows you to alter the color scheme of your Web page. Change the colors to your taste and click Refresh Preview to see the updated Web page.
- 7. Under the Appearance section, you can alter the size of your thumbnails and main preview images. I find Fade to be a classic option under the Transition Effect.
- 8. The Create Gallery section is the last stop before creating your gallery. Here you can choose to save it to a disc if you would like to give a client or a friend a hard copy, or you could choose to load it up to your server to go online immediately! Figure 1.56 shows a preview of a what a typical Web Gallery could look like.

FIGURE 1.56 A preview of a Web Gallery.

CHAPTER 2

FROM BRIDGE TO PHOTOSHOP: THE ADOBE RAW CONVERTER

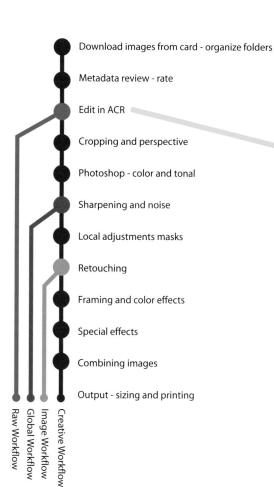

IN THIS CHAPTER:

- ISO
- File Format and Bit Depth
- White Balance
- Picture Styles and Camera Settings
- 16-Bit Images
- Using Camera Raw
- Cropping and Straightening Images
- Camera Raw to Photoshop
- Working with Multiple RAW Images
- Batch Processing in Bridge

Before jumping into Adobe's new and improved Raw Converter, we should spend a little more time looking at the files (photos) that your camera creates. Digital photographers are faced with a seemingly endless array of choices on their cameras. Many of these options are worth exploring to enhance image quality, but a great many only affect shooting convenience. Included in this chapter are several features that will affect how you work with your file in the Raw Converter. Other choices, such as exposure, metering modes, auto focus, and drive mode, are critical to the making of fine photographs, but the following represents aspects of the file that are relevant to the processing of the image. Of course, this is just a partial list of features and options, but they are the ones most photographers think about every time they pick up the camera.

ISO

ISO (International Standards Organization) is a rating that refers to how sensitive the sensor is to light. ISO 100 is considered to be slow, whereas ISO 1600 is considered to be fast. A slow ISO setting means your sensor is not really sensitive to light, so it needs a lot of light to form an image. This means you need either a slower shutter speed, such as 1/30 or 1/60, or a larger aperture such as f4 or 5.6. When your sensor is really sensitive (ISO 1600), you can use faster shutter speeds (1/250, 1/500) or smaller apertures (f16, f22) to create the image.

So why not just put it on 1600 all of the time? One word: *quality*. The higher the ISO, the more likely you are to experience noise in your photographs. *Noise* is the digital equivalent of *film grain*, just not as pretty. A sensor really only has one sensitivity. If your camera's lowest ISO is 100, then that is your real sensitivity. If 200 is the lowest, then that is your actual sensitivity. To enable a higher ISO or sensitivity to light, the camera must pass more power through the sensor. This extra power creates noise in the resulting file. At best, noise can look like small specks of grain; at worst, it takes on the appearance of an undesirable pattern. As you will see later in the chapter, the Raw Converter can help reduce noise in your photographs, but it will come at a cost.

Depending on your camera model, noise can begin to appear even at an ISO as low as 400. To see where you begin to get noise on your camera, simply take the same shot with all of the different ISOs that your camera provides and examine them in Photoshop at the view setting of Actual Pixels. You will quickly see which ISO setting causes noise. Although noise can affect your entire photograph, it first begins to rear its ugly head in the shadows.

FILE FORMAT AND BIT DEPTH

When it comes to choosing a file format for your camera, JPEG and RAW are your primary choices. Let's review the differences:

- The JPEG format will compress your file so that more images can fit onto a memory card. On most cameras, there are different degrees of compression that deliver various degrees of quality. The highest quality JPEG setting will produce exceptional images due to the fact that there is a minimal amount of compression taking place. The camera is just "saving" the file in this format. It is using the same resolution as the RAW setting, assuring maximum image quality.
- The RAW format on the other hand, applies no compression to your image. It simply takes the data off of your sensor and sends it to the card unprocessed and uncompressed (sort of . . . there is a little compression, but nothing to worry about).
- JPEGs are processed faster in the camera, so you can shoot faster. RAW images generally take longer to shoot and process.
- JPEGs are immediately ready to use in other applications. RAW images must be "post-processed" first.

My recommendation is for photographers to shoot using the RAW format. If, however, you have a camera that does not support this format, the good news is that Adobe has upgraded the Raw Converter in CS4 to accommodate JPEGs (and TIFs) as well! This means JPEGs now have access to the same streamlined image processing software that RAW images use, the Adobe Raw Converter.

WHITE BALANCE

With your digital camera, white balance is the equivalent of filtering for different light sources or choosing a designated film to match the light source. For example, if you use a daylight-balanced film (the most common type of film) under tungsten light (a typical light bulb), your image will have a heavy orange cast. This is because tungsten bulbs give off an orange/yellow light. To correct for this, you would buy tungsten film to shoot in this situation. This would produce an image with a neutral color cast. You could also put on a Tungsten Filter to correct for the orange light. This filter would be blue.

In digital cameras (and in the Raw Converter), the white balance setting can do all of this for you. You merely have to change the setting. When you are shooting under tungsten lights, you choose the tungsten setting. If you find yourself shooting under fluorescent lighting, choose the fluorescent setting. It's easy as pie. In the past, it was recommended that when shooting JPEG you

should set your white balance on your camera rather than in Photoshop. This is still a good idea. However, now that that you can open any file into the Raw Converter, you may find it easier to set the white balance in the Raw Converter rather than at the time of shooting.

Some common white balance settings found on both digital cameras and as presets in the Adobe Raw Converter are as follows:

Auto white balance will try to balance the scene for you. This works for average types of indoor photography. There are better ways of achieving a good white balance, so reserve this setting for when you are unsure of the light source, for example, when using indoor lighting. Is it tungsten, halogen, or a mix of lighting? If you are unsure, simply set your camera on Auto White Balance mode. Chances are you will end up with very good results.

Daylight will give you good results under . . . well . . . daylight conditions. It will also give proper results during sunsets, sunrises, and night scenes. In any situations where you would use daylight film, this setting will be appropriate.

Flash is designed to give you good color when you are using the on-camera flash. It adds in a little yellow/orange to combat the overly blue light of the flash. Consider using the Cloudy setting instead of this one, however, to add more warmth.

Cloudy will also add orange/yellow to your picture. Typically, the added orange cast is a little heavier than that of the Flash setting. Cloudy days usually produce a significant bluish cast.

Open Shade adds even more orange/yellow than Cloudy. The light found in open shade is very blue.

Tungsten adds a strong blue cast to overcome the heavy orange coloration of tungsten light sources.

Fluorescent will add a slight magenta color to balance the overall green cast of this light source.

Kelvin is a setting found on higher-end cameras and can drastically change the color balance of your image. The higher end of this setting (8000K) will add a lot of warmth, while the lower end (2000K) will significantly cool down your image with a lot of blue. The Daylight white balance setting on a camera is considered neutral. It usually falls within the 5200–5500K range. The Kelvin setting on the camera is mainly designed for people using a handheld color meter. Try experimenting with it to learn more about the color and temperature of light.

Custom is the most accurate of all of the settings. You can use this setting to produce a very exact neutral cast in any lighting situation. Think of the other settings as close but not quite perfect. All light sources are slightly different, and it would be impossible to create a "preset" for all of them. To use this setting, you must first take a picture of a gray or white card in the light source you want to shoot. The camera will then balance the card

back to neutral and store this setting. You then choose Custom from your white balance option, and it will revert back to the stored setting. Any time you are under a light source other than daylight, you should use this setting. Look to your camera manual for exact directions on how to set up and use the Custom setting (manufacturers will vary).

PICTURE STYLES AND CAMERA SETTINGS

Another great feature of the digital camera and the Raw Converter is that it can reproduce the look of many film types! In the Raw Converter, just moving a few sliders can change the feel of your photograph. When working with film cameras, if you wanted to take a portrait, you would choose a film with low saturation and low contrast such as Kodak Portra 160NC. This film would have a neutral or warm color cast to it. For general shooting, landscapes, or architecture, you could use a film that produced higher contrast and deep color saturation like Fujicolor Superia.

With digital cameras, instead of buying different films for each situation, you can simply set the camera to mimic the type of film you want to use. By applying a picture style, such as Portrait or Landscape, the camera will change its settings (such as saturation and contrast) to fit with the image you want to create. With most cameras, you can even adjust these picture style settings yourself. The Raw Converter also gives you control over the look of your image. Simple sliders allow you to remove or add contrast, brightness, or color saturation.

Let's take a look at the way a digital camera creates an image. The sensor will capture the image information. At this point, the image data is *raw*, meaning it has not been changed at all. It then sends this raw information to the camera's processor. In the processor, it will undergo changes, which are dictated by the way you have set your camera. These settings could include file format, JPEG compression setting, color, contrast, and saturation. If you had your camera set to shoot a picture style like Landscape or Portrait, your camera would also apply the individual settings that these styles represent.

It is at this stage that your camera keeps your file format as RAW or changes it to a JPEG. When shooting in JPEG, any settings that you have set on your camera, such as contrast or color tone, will be permanently applied to the image. The processor will apply these settings to the RAW image information, and then turn this information into a JPEG file.

If you are shooting RAW, these settings get recorded as a set of instructions, or directions, on how the image should appear when it is opened. They are not permanently applied. These directions can always be changed to suit your needs without any degradation to your file whatsoever. You can always return to the default settings as well. After these settings are applied, the processor sends the information to the memory card for storage.

The long and short of the situation is this: If you are shooting in JPEG, it is more important to adjust these settings before shooting. When shooting in RAW, these adjustments can be made in the Raw Converter afterward.

16-BIT IMAGES

So why is it more important to make adjustments in the camera for JPEGs? Bit depth. *Bit depth* describes the number of shades or tones a pixel can contain. An 8-bit image contains 256 tones per color (each image contains red, green, and blue), whereas Photoshop's 16-bit image contains approximately 32,768 tones per color. The reason it's 32,000 and not 65,000 (like a true 16-bit file) is that technically Photoshop uses only 15-bit color, but for the sake of clarity, we will call it 16-bit from here on. More shades in each channel results in smoother gradations in the images, which results in reduced *posterization* (a harsh, unnatural transition in color) in viewed and, even more noticeably, in printed images.

To take advantage of the denser 16-bit features, the images must be captured in 16-bit color. Taking an 8-bit image in Photoshop and choosing Image > Mode > 16 bits/Channel does not magically convert an 8-bit image to 16-bit. Photoshop cannot add color information that was not captured. Cameras that support the RAW format are capable of shooting images in high bit depth, such as 10-, 12-, or 14-bit. Once they arrive in Photoshop, they automatically convert to 16-bit. This conversion does not in any way degrade your image. So, again for simplicity, you can consider that your camera captures an image in high bit depth. This is important because this high bit depth is excellent for making adjustments and corrections to the images. The extra data helps the image maintain integrity while adjusting it. An 8-bit image can become posterized very quickly, whereas a 16-bit image is much more robust because of the extra image data.

As you learned earlier, all images start out as RAW images. This means they are captured in a high bit depth. If the image is destined to become a JPEG, the camera's on-board processor will apply settings, such as contrast and saturation, while the image is in this high-bit stage. This is how your camera can produce such high-quality JPEG photographs. The problem occurs when you get the wrong exposure or you need to adjust the contrast in Photoshop or the Raw Converter after it has become a JPEG. At this point, the image has already been converted down to an 8-bit file. Any drastic changes can produce posterization or rough transitions between tones or color. Figure 2.1 shows a histogram of an image that is in need of a typical adjustment to increase contrast.

Figure 2.2a shows an 8-bit histogram after the adjustment, and Figure 2.2b shows the 16-bit histogram after the adjustment. Notice the gaps in the 8-bit histogram? These gaps indicate that there is no image data available. The result would be posterization, or a very harsh transition of color gradient in the image.

Histograms and image correction are covered in more detail in Chapter 4, "Tonal Correction and Enhancement."

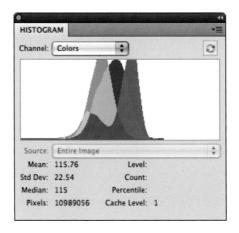

FIGURE 2.1 A typical histogram.

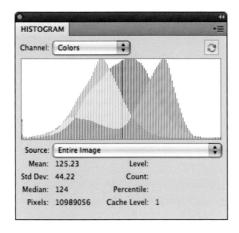

FIGURE 2.2a The adjustment with 8-bit reveals gapping.

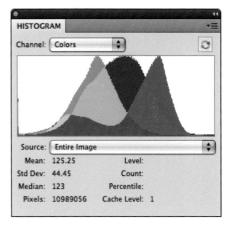

FIGURE 2.2b The adjustment with 16-bit exhibits no gapping.

The disadvantage of a 16-bit image is file size. A 16-bit image's file size is double that of an 8-bit image. After you begin to modify the image and add layers, the file size can grow very quickly. If you have a fast computer with a lot of RAM and plenty of storage, you may decide to keep the images in 16-bit. If you are working with limited computing resources, a good practice is to perform the image corrections, such as tonal adjustments and color correction, in the Raw Converter and then, when you open the image into Photoshop, convert to 8-bit. Directions for this will be covered later in this chapter.

USING CAMERA RAW

As mentioned earlier, the RAW file format is a digital equivalent of a negative, All the RAW image data from the camera's sensor is saved, but the settings are not permanently embedded in the file. When you modify and save a RAW image, you never actually alter the image; instead, an eXtensible Metadata Platform (XMP) sidecar is generated. This *sidecar* is a small file that travels along with your image and contains metadata that holds information such as white balance, exposure, sharpness, and other details. When opening a RAW image from Bridge, a dialog box appears. Here, you can set the processing options to ensure that the best possible image is opened into Photoshop. Photoshop CS4 also extends the quick and easy processing of the Raw Converter to JPEGs as well. This is an awesome upgrade for photographers who like to shoot in this format. The Raw Converter is so well designed that it drastically decreases the time it takes to perform simple adjustments to your image. One word of caution, however, is to remember that by the time a JPEG reaches Photoshop or the Raw Converter, it is in 8-bit format. This means any adjustments you make will occur to the 8-bit image. So you are still at risk of creating a file with posterization. On the other hand, 16-bit RAW images will be processed by the Raw Converter in their native high-bit depth.

It's worth noting that Adobe has introduced a new file format called *digital negative* (DNG), which is an attempt to standardize RAW file formats and thus preserve the format for the future. In 20 years, some proprietary formats may not be supported. Camera Raw allows you to convert your RAW files to the DNG format.

The DNG format includes the metadata in the files, so there is no need for an XMP sidecar file.

The latest version of Adobe Camera Raw 4.0 will truly offer some photographers the option of one-stop shopping. For many folks, a trip to Camera Raw will complete their entire editing workflow. For others, the time spent in Photoshop proper may be greatly decreased. Let's take a look at it! Camera Raw is divided into three main regions (as shown in Figure 2.3):

Preview: This is the area in which you will be able to view your image. **Processing:** This area lets you tweak the look of your image via the sliders, crop, straighten, retouch, and now with CS4, you can even work on local

parts of your image. **Output/Workflow:** The output area controls what will happen to your image when it opens in Photoshop or is saved as another type of file.

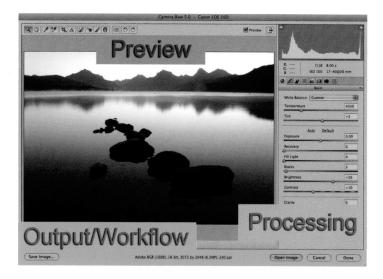

FIGURE 2.3 Camera Raw dialog box.

This new Camera Raw dialog box will seem familiar to those who have worked in Photoshop CS3. The major difference is in the addition of several new image-processing tabs and a couple of new tools in the Toolbar. All of the functionality of previous features remains intact. There are several ways that you can open your images into Camera Raw:

- From Bridge, double-click on any RAW file. This will automatically launch the Raw Converter and open your image.
- Choose File > Open from Photoshop, and navigate to your RAW file.
- Right-click on your RAW file within Bridge, and choose Open.
- If you want to open a JPEG, TIF, or PSD in the Raw Converter, right-click and choose Open in Camera Raw.

The Basic Tab

Adobe has done a great job in laying out the processing section of the Raw Converter. You'll begin your image processing with the Basic tab, as shown in Figure 2.4. The Camera Raw dialog box opens to this tab by default.

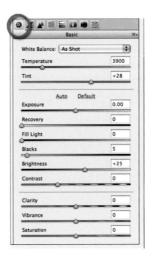

FIGURE 2.4 The Basic tab of the Camera Raw dialog box.

White Balance

The first step is to adjust the overall color of the image. Photography is the art of capturing reflected light. Each type of light has a different color temperature (measured in degrees Kelvin). If you didn't set your camera to the prevailing light source while shooting, or you chose the wrong White Balance setting, here is your chance to change it. Figure 2.5 shows an image shot with Daylight white balance set on the camera.

FIGURE 2.5 Original image.

1. Choose the White Balance option that most closely resembles the shooting conditions, such as cloudy, shade, incandescent light, and so on. If this setting looks like the color balance on your camera, it is no accident. That is exactly what you are doing. This setting adjusts the image for different lighting conditions and removes the color casts that may be present. In the example in Figure 2.6, the image was shot under some sort of unknown light source, so the Auto setting may be the best option for this particular image.

FIGURE 2.6 Choosing White Balance options.

- 2. The White Balance settings change the color temperature and tint. It's a good idea to choose the setting that looks best and then make small changes manually. Next, use the Temperature slider to fine-tune the color settings. If the slider is moved to the left, the image becomes cooler with more blue; if the slider is moved to the right, it becomes warmer with more yellow. Photographers will often use a slightly warm light for portraits because it's more flattering for skin tones.
- 3. Adjust the Tint slider if you would like to adjust the color tint of the image. Move it left for more green or right for more magenta.
- 4. In Figure 2.7, the Temperature slider was tweaked further toward blue to remove more yellow, and the Tint slider was moved toward green to take away some magenta.

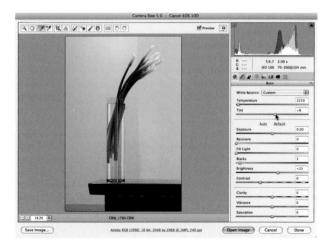

FIGURE 2.7 Fine-tuning the Temperature and Tint sliders.

TUTORIAL 2.1 WHITE BALANCE TOOL

The White Balance tool was probably my favorite addition to the Raw Converter in CS2. This makes getting the correct color balance in an image a snap!

- 1. Open an image that has some area that should be neutral white, black, or gray in the image. A gray or white card will do nicely. Whenever I am in a scene where I think the color of the light is not quite right (such as artificial lights), I throw my gray card in the scene for one exposure so I can make use of this tool.
- 2. Click on the White Balance tool (circled in Figure 2.8).

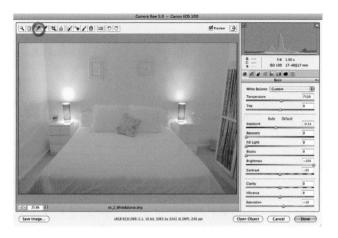

FIGURE 2.8 The White Balance tool.

3. Click on a neutral white, black, or gray in your image or your gray or white card. That's it! The Raw Converter completely balances that tone (see Figure 2.9).

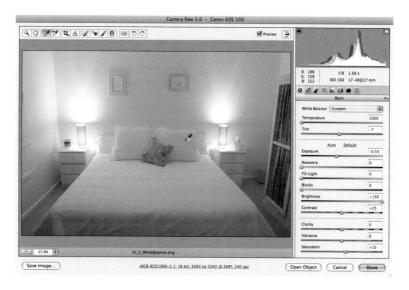

FIGURE 2.9 The corrected image.

Adjusting Image Tone

The next task to be performed in the Camera Raw dialog box is to adjust the image's tonal values. Before getting into adjusting the tonal values, however, a review of image tonalities is in order. The histogram can be broken up into segments to simplify the description of tonalities within an image (see Figure 2.10). These regions are the shadows, three-quarter tones, midtones, quarter tones, and highlights. The shadow region of the histogram represents the darkest of the tonalities. The three-quarter tones represent the values that are dark but not as dark as the shadows. The midtones are just what you think they are—the middle brightness values. The quarter tones represent lighter tones such as pastel colors. The highlight region covers the brightest pixels in the image.

When you are finished correcting the temperature and tint, the next step is to look at the overall brightness and contrast of the image. We want to brighten the image and optimize the contrast without losing any pixel data. When you lose data, it's called *clipping*. Clipping occurs when some of the highlights or shadows are lost by overcorrecting the exposure or shadows (forcing to pure white or black). Clipping can also occur during the initial exposure. If you overexpose your shot, you have clipped your highlights. You can see the image information displayed as a histogram in the top right of the Camera Raw dialog box (see Chapter 4 for more information on histograms). The goal is to remove the empty

areas to the left and right and have the histogram displayed in the window without losing any of the ends (clipping). The two settings that really concern us at this point are the exposure and shadows.

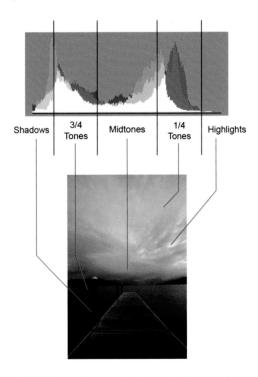

FIGURE 2.10 The tonal regions of a photograph.

The Exposure Slider

Use this slider to adjust the luminosity of the image. Moving the slider to the right makes the image appear as if it had been given more exposure at the time of capture. Moving it to the left provides less exposure. To use this slider, hold down the Alt key (Option for Mac), and slide the Exposure slider. Holding down the Alt/Option key helps you see image clipping. The entire image will turn black, and as you move the slider to the right, the first bits of color or white begin to show. These areas represent the areas that are clipping, as seen in Figure 2.11. The spots that are revealed are the very brightest points of the image. To prevent clipping, move the slider back just a bit until the white areas disappear.

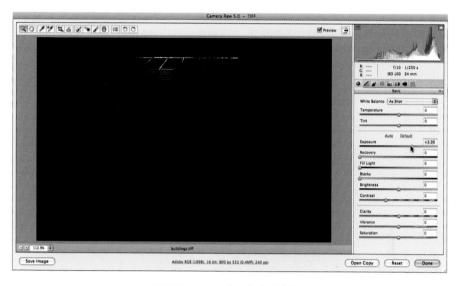

FIGURE 2.11 Setting the highlights.

The Blacks Slider

It will make the shadows darker while having less influence on the midtones and highlight values. Hold down the Alt key (Option for Mac) and move this slider to the right. You should see the darkest points of the image displayed as colored speckles, as shown in Figure 2.12.

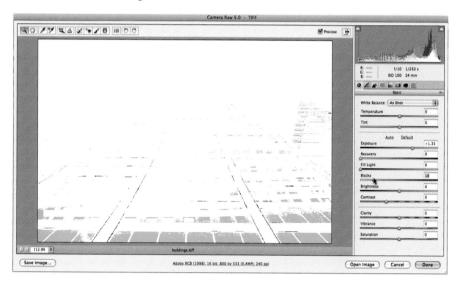

FIGURE 2.12 Setting the Blacks value.

Lift up on the Alt/Option key. You will now see your image again. If the level of blacks look good, you can leave it. If not, you can move the Blacks slider again without the Alt/Option key depressed to watch as the image changes. As you can see from the before and after in Figures 2.13a and 2.13b, the luminosity of the image is now adjusted. You can think of this as setting the overall contrast of the image. The blacks have now become darker, while the whites have become lighter. The highlights and shadows are now set, and the image has much more overall contrast.

FIGURE 2.13a Original image.

FIGURE 2.13b After adjusting the Exposure and Blacks values.

An alternative method to holding down the Alt/Option key is to click the arrows above the histogram, as shown in Figure 2.14. This will cause the clipping in the shadows to be revealed as blue and the highlights as red on the preview.

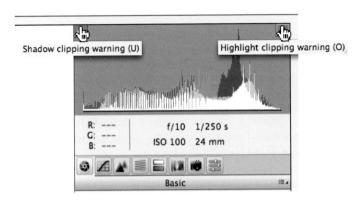

FIGURE 2.14 Setting the clipping warnings.

If you hold down the Alt key (Option key for Mac), the Open and Cancel buttons will change to Open Copy and Reset. Open Copy will open the image in Photoshop without saving the settings to the RAW files metadata, and Reset will restore all the sliders to the initial value when you first opened the image in the Camera Raw window. This is like the panic button, when you have really messed things up and need to start again.

The Exposure and Blacks sliders are typically the first place you go after adjusting the color, but what about the other sliders? The Contrast and Brightness sliders are the next two adjustments that you would make to an average image. If your image is either over- or underexposed, you many want to visit the Recovery or Fill Light sliders next.

Contrast Slider

This adjustment increases or decreases the contrast above the shadows and below the highlights. Think of it as increasing the contrast in the midtones section of the photograph. If pushed too far, the shadows and highlights of the image will begin to clip.

The Brightness Slider

This slider works mainly on the midtones of an image. Pushing the slider to the right will brighten up the midtones, while pushing it to the left will darken them. Used sparingly, the brightness adjustment will not have a heavy effect on the shadows and highlights.

The Recovery Slider

This slider was introduced back in CS3 and remains an important adjustment. The Recovery slider attempts to bring back detail in the highlight areas. It is well placed after the Exposure slider. There may be times when setting the Exposure slider to produce an overall good look will blow out the highlights in certain areas. That's where the Recovery slider comes in. Moving the slider to the right will bring detail back in the brightest areas. Do not depend on this new feature to save your images from gross overexposure. It will not reveal detail in images that are badly blown out, but you will be surprised at what this feature can accomplish! Figure 2.15 shows an image whose highlights look beyond retrieval. By raising the Recovery slider, I was able to bring back detail in the washed out fountains (see Figure 2.16).

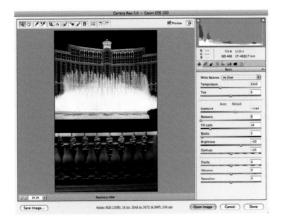

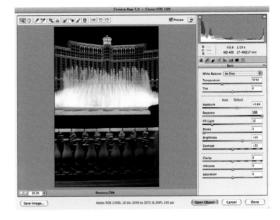

FIGURE 2.15 Original image.

FIGURE 2.16 After increasing the Recovery adjustment.

Fill Light Slider

The Fill Light slider was introduced with the Recovery slider. It will lighten the three-quarter tones while only subtly affecting the shadows and midtones. This is important because when a photo loses its darkest tone, it starts to look washed out. By moving the slider to the right, the three-quarter tones of your image will become brighter. Be careful with this adjustment, however. A heavy hand here will produce strange edges where the dark tones meet lighter tones. It's better to leave this a little below the desired value and work on further brightening with curves. It is not uncommon to increase the Blacks slider a little after doing a heavy adjustment to the Fill Light slider.

Saturation Slider

Moving this adjustment slider to the right increases the overall saturation of the image. A little goes a long way with this slider. Compared to the Vibrance slider, this tool becomes a very blunt instrument. Oversaturation is a sure sign that your image was digitally manipulated, so easy does it.

Vibrance Slider

The Vibrance slider is another welcome addition. This tool applies a nonlinear increase in saturation so pixels that are less saturated are more affected. It also has a built-in skin tone protector that makes an attempt at preventing a face from

becoming overly red, which is very cool. Care should be taken, however, with both the Vibrance slider and the Saturation slider. A much more surgical approach to color can be applied within the HSL feature (more to come on this later in the chapter).

A less glitzy feature that has been added into these sliders is the ability to reset just the sliders within an individual box. Double-clicking on the slider itself after making an adjustment will return it to its default position. This is a great alternative to resetting the whole image.

The Tone Curve Tab

The second processing tab in line is the Tone Curve tab. For those photographers who break into a nervous sweat upon hearing the word *curves*, you can thank the team at Adobe for making this box much more intuitive with their introduction of the Parametric tab. Upon entering this tab, you now have the choice of working with Parametric and/or Point curves. The Parametric tab opens by default (see Figure 2.17), but you can simply click on the Point tab to work with the traditional curve (see Figure 2.18). A full explanation of curves is supplied in Chapter 4.

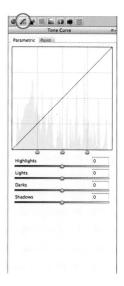

FIGURE 2.17 Parametric Tone Curve tab.

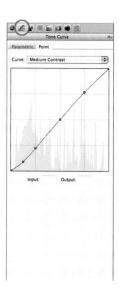

FIGURE 2.18 Point Tone Curve tab.

The first thing you will notice in the Parametric Tone Curve tab is the addition of sliders at the bottom and the middle of the box. The middle sliders are a great way to visualize where the effect of the lower sliders will occur. In Figure 2.19, the areas that will be affected by the corresponding sliders are color-coded. The Shadows slider affects the region of your image in blue, the Darks slider affects the green area, the Lights affects the red area, and the Highlights slider affects the yellow area.

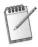

This is not how the Parametric box appears; it's just my illustration for your edification.

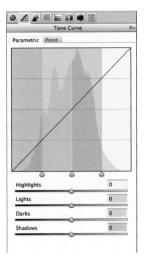

FIGURE 2.19 Parametric curve showing where the sliders will have their effect.

Another feature in the Parametric Tone Curve tab is the ability to choke down or widen the individual regions that will be affected by the sliders. In Figure 2.20, I have clicked on the region sliders and moved them out. Now my Shadows and Highlights regions are smaller, and my Lights and Darks regions have expanded. You can also move the center (Midtone) slider to alter the division of Lights and Darks. The new Parametric Tone Curve tab is worth experimenting with, even if you have been afraid of curves in the past.

The Detail Tab

The tab to the right is the Detail tab. This is where sharpening and noise reduction can be performed (see Figure 2.21).

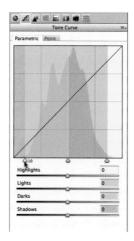

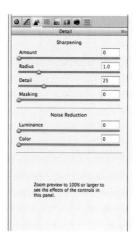

FIGURE 2.20 Moving the regions.

FIGURE 2.21 The Detail tab.

It is usually best to perform most sharpening in Photoshop after all the other corrections are complete. The amount of sharpening depends on the size of the image and should only be done *after* your image has been sized. If your image will be downsized to a JPEG file for the web, it will be very small and is likely to need no sharpening at all. If you blow up your image to 16x20, it will likely need sharpening to account for the increase in file size. For these reasons, I leave my sharpening set to the default value that Camera Raw assigns.

Use the Luminance slider to minimize noise that may have appeared from using a high ISO. Look at the darker portions of the image to spot the grain. Always zoom to 100% when working on grain and sharpening images so that you can see the true result of the adjustments. Use the Color slider under Noise Reduction to combat any colored specks that may have appeared from long exposures; the most common are blue and/or red spots in a night scene.

HSL/Grayscale Tab

Hold on to your hats—the HSL/Grayscale tab hides one of the most useful photographic innovations since the introduction of the RAW file! This tab, as shown in Figure 2.22, allows you complete control over the color in your photographs.

It is also an extremely effective method of creating grayscale images from color files. This box breaks up the three color components of hue, saturation, and luminance into individual tabs. You can then adjust the reds, oranges, yellows, greens, aquas, blues, purples, and magentas within each tab. Here is a look at what the three components actually control:

Hue: The name of the color, such as red, blue, or orange. This name describes where the color sits on the color wheel. However, there is a wide range of colors that we could call red. For example, you may have red that is similar to that of pepper. By using the Hue tab and choosing the Reds slider, you could make that red appear more blue or more orange.

Saturation: This is the intensity of the color. Reducing the saturation will bring a color closer to gray. Increasing the saturation will make the color appear more vivid.

Luminance: This is the brightness of the color. This effect is often confused with saturation. When darkening a color, it may appear to become more saturated. Lightening the same color may appear to make it less saturated. The truth is that you are really just changing the brightness. A moment or two of comparison between these two sliders will reveal their subtle differences in character.

FIGURE 2.22 The HSL/Grayscale tab.

Creating a Grayscale Image

The HSL/Grayscale tab is used to create grayscale images. As you can imagine, the HSL/Grayscale tab puts a lot of power into the photographer's hands. Nowhere is that more evident, however, than when changing a color image to grayscale. Creating great grayscale images has never been easier. A good grayscale image will have a pleasing range of tones from pure black to pure white, with good separation through the midtone gray values. There are exceptions to this rule, of

course, such as high-key or low-key images. In general, though, this is a good formula for success. The biggest issue with black-and-white photography has always been the separation of tones. This problem existed in film as it does with digital images. Our eyes have the benefit of separating tones by color. So we can note the color contrast between a red value and green value, even though they may be the exact same brightness level. When converting to black and white, the brightness value has always been the main consideration—until now.

The HSL/Grayscale tab is revolutionary in its capability to alter the brightness of individual colors within an image. This translates to brighter or darker grays in the final image. Any future grayscale image should always begin with a visit to the Basic tab to set the Exposure, Blacks, Contrast, and Brightness sliders. Very rarely will the HSL/Grayscale tab itself be enough to create great black and whites. You may also need to set the black-and-white points as well as the local contrast through the Basic tab to finish the job. You can start with the HSL/Grayscale tab and then move to the Basic tab or vice versa. I'll begin with the HSL/Grayscale tab in the following examples.

Figure 2.23 shows the color image before any changes have been made. Notice that there is sufficient color separation but very little brightness separation between the color values.

Figure 2.24 shows how the image would look if you simply checked the Convert to Grayscale box. Photoshop automatically sets the color sliders by examining the brightness of the colors in the image and trying to replicate them in a grayscale image. Sometimes you may find that this is just what the doctor ordered. In other cases, you may want to experiment and create your own values. Look closely at this image and the original color image in Figure 2.24 to note the correlation between brightness of color and the resulting gray value.

FIGURE 2.24 Auto settings.

Once you decide to manually set your own values, the sky is the limit! In the original color image, you can see that there is an abundance of red and orange metal. The small dots of blue/purple add a nice counterpoint. The goal in this image may be to separate these colors as much as possible so that they translate into different tones of gray in the final grayscale. In Figure 2.25, the Reds, Oranges, and Greens sliders have been moved to the left, which has the effect of darkening down those colors. Blues, Purples, and Magentas have been raised to lighten those colors (see Figure 2.25).

The opposite approach has been taken with Figure 2.26. The red family has been lightened and the blue family darkened. This set of values is strikingly different from the previous photo.

In Figures 2.25 and 2.26, the contrast has been increased and the black-and-white points have been set to get the final image. This is always an important consideration in creating the finished look of a fine black-and-white print. Do not solely depend on the grayscale portion of the Raw Converter to create a finished black-and-white photograph.

These sliders are very much image-dependant. Raising or lowering the values can work wonderfully on one image, while nearly destroying another. Always view your image at actual pixels (100%) to ensure that your adjustments are not creating posterization, which is a very possible result with this tool!

FIGURE 2.25 Lightened blues.

FIGURE 2.26 Lightened reds.

Split Toning Tab

Following the HSL/Grayscale tab is the Split Toning tab (see Figure 2.27). Split toning is a favorite technique among many photographers who use black-and-white darkrooms. It was a way that you could get different color tones in different

areas of your image. A typical split-toning technique was to have the shadows show a cool blue color, while the midtones and highlights were pushed toward a warmer brown or yellow tone. This combination has the advantage of adding the color contrast of cool/warm in addition to the tonal contrast of dark and light. Recreating this technique in Camera Raw is easier, faster, more efficient, and much less hazardous to your health. The really cool thing is that you can also try this technique on color images. There is no reason that the photo has to be a traditional black-and-white image to enjoy the benefits of split toning.

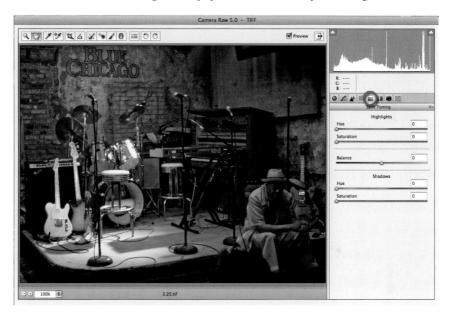

FIGURE 2.27 Split Toning tab with the original image.

The Split Toning tab is broken up into three segments: Highlights, Balance, and Shadows. The Hue sliders in the Highlights and Shadows sections allow you to choose the Hue (color) that you want applied to the region. It can be hard to choose a color without first increasing the saturation. This will intensify the hue, making it easier to visualize the final color. Move your Saturation slider up to 50, and then move your Hue slider until the desired color is produced. Return to the Saturation slider, and reduce or increase the value until the proper intensity of color is created. Do this for both the Shadows and Highlights regions.

When these steps are complete, you can adjust the Balance slider to introduce more of the highlight color into the shadows or vice versa. Moving this slider to the right will begin to push the highlight color down into the darker midtones and eventually the shadows themselves. Move the slider to the left, and the shadow color will start to replace the highlight color in the lighter midtones and eventually the highlights.

Incidentally, moving the Balance slider all the way to the left or the right is an easy way to reproduce the look of warm or cool tone black-and-white printing papers. Remember to go easy on the saturation when trying this technique. Figure 2.28 shows an image that has been split toned, while Figure 2.29 shows an image that has been warm toned.

FIGURE 2.28 Split-toned image.

FIGURE 2.29 Warm-toned image.

Lens Corrections Tab

The options in the Lens Corrections tab allow for compensation of the chromatic aberration and lens vignetting amount.

Chromatic Aberration

If you zoom into an image very closely (200–400%), you can sometimes see chromatic aberration. This effect causes a slight, colored halo around the edges. In Figure 2.30, you can see where red appears to halo the outside edges of the green leaves.

Figure 2.31 shows the same image after reducing the Fix Red/Cyan Fringe slider. When you see a red fringe, move the Fix Red/Cyan Fringe slider toward red. If you see a yellow fringe, move the Fix Blue/Yellow Fringe slider toward yellow. Moving the sliders will actually shift the color channels in Photoshop to compensate.

FIGURE 2.30 Aberration on the edge pixels.

FIGURE 2.31 Aberration corrected.

Lens Vignetting

Sometimes a lens does not distribute light evenly across the image. Because of the curvature of a lens, the edges of the image sometimes appear darker than the center, as seen in Figure 2.32a. This is called a *lens vignette*. By adjusting the Lens Vignetting Amount and Midpoint sliders, you can evenly distribute light across the image. Moving the Amount slider to the right lightens the corners, while moving it to the left darkens the corners. Moving the Midpoint slider to the left pushes the effect of the vignette toward the center from the corners. Moving it to the right pushes it more toward the corners. Figure 2.32b shows the image after lightening the corners using the Amount and Midpoint Sliders.

FIGURE 2.32a Original image with vignette.

FIGURE 2.32b Corrected image.

New to CS4 is the addition of the Post Crop Vignetting feature. This adjustment takes into account any crop you may have made and applies the vignetting to the active portion of the image. This is great for *adding* a vignette to an image for a creative effect. Once an image is cropped, the darkening of the regular lens vignette might not reach into the image. The Post Crop Vignetting adjustments are just the ticket. The Amount and Midpoint sliders work exactly the same as for the Lens Vignetting feature. Pushing the Roundness slider to the left will turn your vignette into more of a square. Moving it to the right will make it more round. The Feather slider softens the edge of the vignette to make it less noticeable. Figure 2.33a shows the original image. Figure 2.33b shows the same image with creative Post Crop Vignetting applied.

The state of the s

FIGURE 2.33a Original image.

FIGURE 2.33b Image with Post Crop Vignetting applied.

Calibrate Tab

This tab adjusts the hue and saturation of each color channel separately; apply this only if you are an advanced user. You can make adjustments to compensate for bad coloring in your camera and save the settings. This is useful when the color of the camera is inaccurate or you're using a modified camera, such as one fitted with an infrared sensor. Another option is to use the Calibrate tab for special effects, such as making green grass look more green or changing the blue in the ocean. With the introduction of the HSL/Grayscale tab, visits to the Calibrate tab will be few.

Presets Tab

The Presets tab is a place to find your saved settings. Often it will save time to create and save settings, such as Chromatic Aberration or Lens Vignetting. To save individual tab settings, follow these steps:

- 1. Open an image made with a particular focal length lens.
- 2. Fix the chromatic aberration.
- 3. From the small diagonal arrow in the top right of the tab, choose Save Settings. You will see the Save Settings dialog box shown in Figure 2.34.
- 4. Uncheck all of the settings that you don't want to save. In Figure 2.35, all are unchecked but the Chromatic Aberration setting. Click Save.
- 5. The next dialog box that appears will give you a chance to name your saved setting. Give it a name that describes what it does. In Figure 2.36, I have called my setting 14mm Chromatic Aberration. Now anytime that I shoot with a 14mm lens, I can quickly apply this saved setting. Click Save. You can see a list of my saved settings in Figure 2.37.

FIGURE 2.34 The Save Settings dialog box.

FIGURE 2.36 Naming the setting.

FIGURE 2.35 Checking only the Chromatic Aberration setting.

FIGURE 2.37 The Presets tab with saved settings.

The best thing about presets is the way in which you can apply them. Once a setting is saved, you don't even have to open the Raw Converter to apply them! Say for example I have just downloaded 50 images from a recent shoot. Of the 50, 30 of the images were made with my 14mm lens. I would highlight all 30 images made with this lens in Bridge. Next, I would right-click on any of the highlighted images, and choose Develop Settings from the resulting flyout menu. Here I will see all of my saved settings! I would choose the 14mm Chromatic Aberration setting (see Figure 2.38). That portion of the Raw conversion will automatically be applied to all of the highlighted images.

You can easily convert Adobe Lightroom presets for use in Camera Raw. Simply open an image from Lightroom with the preset applied. Choose Save Preset in Camera Raw, and you now have a Camera Raw version of the preset. The same thing works in the opposite direction, where you can save a Camera Raw preset as a Lightroom preset. (Lightroom 2 is required to do this with Photoshop CS4.)

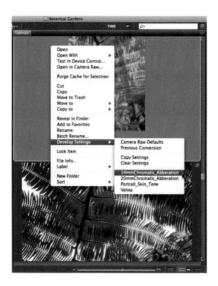

FIGURE 2.38 Applying a preset from Bridge.

CROPPING AND STRAIGHTENING IMAGES

A great addition to Photoshop CS2 was the ability to straighten and crop images inside Camera Raw. This applies nondestructive cropping and straightening, which means that the settings can be discarded at any time, even after you have restarted your computer.

TUTORIAL 2.2 STRAIGHTENING AN IMAGE

It's a simple process to straighten a crooked image. Just follow these steps:

- 1. Open the image ch_2_Straighten.tif included in the Chapter 2 folder on the CD-ROM as a reference.
- 2. Choose the Straighten tool, as shown in Figure 2.39.
- 3. Click and drag along the line that you want to become the new horizon.
- 4. Release the mouse, and a box will appear showing the new image bounds, as shown in Figure 2.40. When this image is opened in Photoshop, it will be cropped to these bounds.

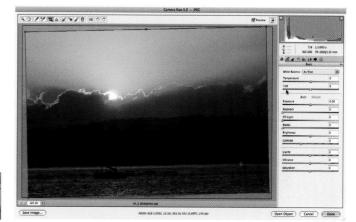

FIGURE 2.39 Applying the Straighten tool.

FIGURE 2.40 Straightened image in Camera Raw.

5. To redraw the line, grab the Straighten tool and redraw. To clear the crop box, click and hold on the Crop tool, and choose Clear Crop.

TUTORIAL 2.3 CROPPING

Cropping works similarly to straightening. Open ch_2_Crop.jpg that is included in the Chapter 2 folder on the CD-ROM as a reference. Open it from Bridge by right-clicking and choosing Open in Camera Raw.

- 1. Choose the Crop tool from the top of the Raw dialog box.
- 2. Click and drag around the area that you would like to keep in the image, as shown in Figure 2.41.

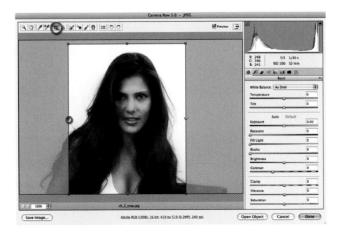

FIGURE 2.41 Cropping an image in Camera Raw.

- 3. Select the bounding boxes (circled in red) to make any adjustments.
- 4. When the image is opened in Photoshop, it will be cropped. The crop will not be permanent in the RAW image and can be removed or adjusted at any time in the future. If you do not like your crop, right-click inside the box and choose Clear Crop from the contextual menu.
- 5. Click and hold on the Crop tool to reveal a drop-down menu of crop presets (or right-click inside of the crop itself). These presets are conveniently set to common print proportions, such as 2×3 (4×6), 5×7, and 4×5 (8×10). To enable a preset crop, click on the desired proportion from the drop-down list and drag a crop on your image. Once the crop is drawn out, you can reposition it at any time by clicking inside the box and moving the crop. Drag the corner handles to resize the box while retaining the preset proportions.

TUTORIAL 2.4

CLEANING UP DUST

Back in CS3, Adobe introduced the ability to clean up your images in the Raw Converter. This addition may allow the complete processing of an image within the Camera Raw box. For some images, you may not even need to go into Photoshop! The following steps show how it works:

- 1. The image ch_2_CleanUp.crw is in the Chapter 2 folder on the CD-ROM. Open it from Bridge by right-clicking and choosing Open in Camera Raw.
- 2. From the lower-left Zoom Level box, choose 100%.
- 3. Click on the Retouch tool, as shown in Figure 2.42.

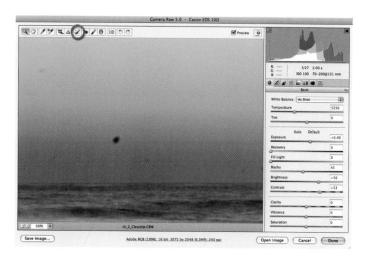

FIGURE 2.42 The Retouch tool.

4. Click in the middle of a dust spot, and draw outward until the circle is a little larger than the spot itself (see Figure 2.43). The Retouch tool will automatically find an appropriate area to sample from and heal your target area. The newly sampled area will show up as a second (green) circle as shown in Figure 2.44. If you are unhappy with the location of this sample circle, click inside, and drag it to a new location. The red spotted area will automatically update.

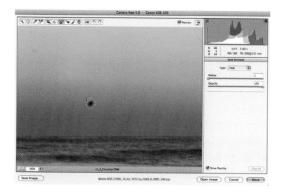

FIGURE 2.43 Drawing out the healing circle.

FIGURE 2.44 The original area and the sampled area.

5. Find another spot to clean up, and click on it. The circle will remain the same size. If you need to change it, go over to the Spot Removal panel, and raise or lower the radius to suit your needs. As you continue cleaning up spots in your image, the overlay (circles) will stay in position to let you know where you have been working (see Figure 2.45).

FIGURE 2.45 The circles show the areas that have been retouched.

- 6. To undo a spot, press Ctrl+Z (Cmd+Z for Mac). To undo multiple spots, press Ctrl+Alt+Z (Cmd+Option+Z). To undo all of the spots, click the Clear All button.
- 7. Clicking Done in the Raw Converter will save the changes to the image. When you reopen the image, however, the healing circles will not be visible. Click on the Retouch tool to make them visible again.
- 8. Lowering the Opacity in the Spot Removal panel will decrease the amount of the sample that is laid over the affected region. You might use this if you want to lessen the impact of a blemish or mole without removing it entirely.
- 9. When you need to make an exact duplicate of an area, change the Type option from Heal to Clone. &

TUTORIAL 2.5 RED EYE REMOVAL

The folks at Adobe have also added a Red Eye Removal tool in the last version of Camera Raw. Its operation is similar to that of the Retouch tool.

1. The image ch_2_RedEye.jpg is in the Chapter 2 folder on the CD-ROM. Open it from Bridge by right-clicking and choosing Open in Camera Raw.

2. Choose the Red Eye Removal tool from the toolbar at the top of the Raw Converter, as shown in Figure 2.46.

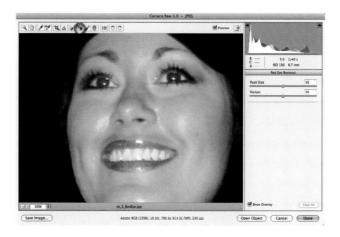

FIGURE 2.46 The Red Eye Removal tool.

3. Click outside the eye and draw a box around it, as shown in Figure 2.47. When you release the mouse, the box will automatically constrict to just around the pupil and fix the red eye (see Figure 2.48).

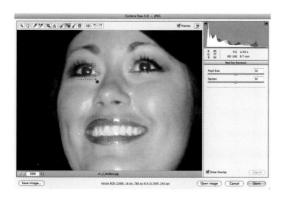

FIGURE 2.47 Drawing around the area to fix.

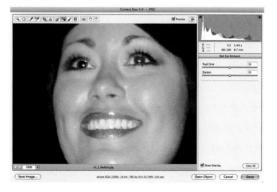

FIGURE 2.48 The red eye removed.

- 4. If the entire area of red is not fixed, you can adjust the Pupil Size slider to reduce more of the red.
- 5. If the pupil is not as dark as you would like, increase the Darken slider.
- 6. Repeat for the other eye.

New Local Adjustments

Adobe just keeps making the Raw Converter better and better. With the newest version (Adobe Camera Raw 5.0), you now have the ability to locally edit your RAW images! Imagine being able to dodge and burn without using layers, or darken a sky without even going into Photoshop. The folks at Adobe have conceived of a system that allows you to locally edit your images right in the Camera Raw dialog box. Couple this with the use of smart objects, and you have more power and control over your photographs than ever before.

Local Adjustments

Photographers have been altering their images since the dawn of photography. Changing the contrast of their printing paper, using a filter under the enlarger lens, or choosing a longer exposure time. A little lighting here, some darkening there. These methods were common darkroom practice. With the advent of digital imaging, these practices have not so much changed as just become easier.

There are two types of changes you can make to your images: those that affect the entire image (global adjustments) and those that affect only certain areas of the image (local adjustments). When you open an image in Camera Raw and begin working with the Basic tab, you are adjusting the entire image. You are applying *global adjustments*. This is, of course, the necessary first step. You may add a little exposure to your photo, increase the contrast a touch, or pump up the saturation a bit. These are familiar sliders to those who have worked in Camera Raw before. But what happens if you want to just lighten a face or darken only a sky? You now need to apply local adjustments.

There are two new tools in Camera Raw that allow you to work locally on your images, the Graduated Filter and the Adjustment Brush, shown highlighted in red in Figure 2.49. These tools allow you to target a certain area and then apply a change of Exposure, brightness, contrast, saturation, clarity, or sharpness to that area only. You can even overlay a color locally with these tools!

Using the Local Adjustment Brush

So now that you know what these tools can do, lets look at how to use them. Figure 2.50 shows the Raw Converter with a slightly underexposed image open. It would be nice to see their faces a little lighter. Clicking on the Adjustment Brush (circled in red) changes the panel on the right side to reflect the options that apply to that tool. When you mouse over your image, you can see that you have the Adjustment Brush all ready to go(see Figure 2.51).

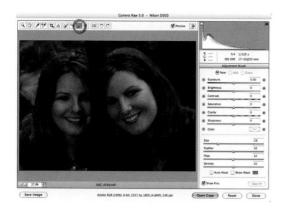

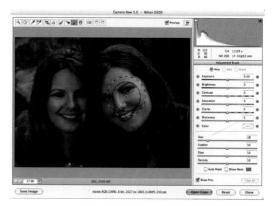

FIGURE 2.50 Underexposed image in the Raw Converter.

FIGURE 2.51 Adjustment Brush ready to paint on the image.

The goal here is to first define what you would like to do to the area—in this case, add brightness. Second, you need to define the area that you want to affect. In this image, it will be the faces.

- 1. Start with making your adjustments in the Adjustment Brush panel. Here I started by bumping up the exposure to +1.00. At first, you will not know how much to add, but you can fine-tune that later.
- 2. Simply paint over the area that you want to affect. The additional exposure is added to that area as you paint. Figure 2.52 shows the increased exposure on the face. Here the face is not quite bright enough, so in Figure 2.53, I have increased the Exposure slider and finished painting on the other face.

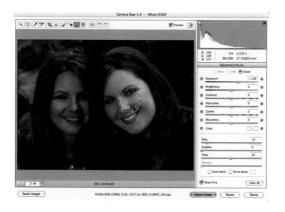

FIGURE 2.52 Some increased exposure on the face.

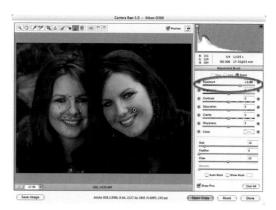

FIGURE 2.53 Both faces painted with a further increase in exposure.

As you define the area, you are actually painting a mask with the Adjustment Brush. By checking the Show Mask box, you get a visual of where you are painting, as seen in Figure 2.54. Uncheck the box to remove the mask overlay. To change the mask color, double-click on the color box next to the *Show Mask* box and choose a new color.

The overall effectiveness of your local adjustment will largely depend on how you paint your mask. Figure 2.55 shows the section of the Adjustment Brush panel that governs your paintbrush as you paint.

FIGURE 2.54 Checking the mask overlay.

FIGURE 2.55 Brush controls.

Size: Controls the overall size of the brush. For those of you who wish to use the keyboard shortcuts instead, the left bracket key shrinks the size or the right bracket key enlarges the size.

Feather: This determines how soft the brush edge will be. A higher number gives you a softer brush so that your adjustment feathers out, while a lower number gives you a harder brush. Figure 2.56 shows a low feather of 12 and the corresponding mask it creates. Figure 2.57 shows a high feather of 54 and its corresponding mask. Most of the time when painting in a local adjustment, you want your brush feathered. Rarely will you use a hard edged brush.

Flow: This slider controls the rate of application of the adjustment, or how much comes out when you're painting. A low flow rate will keep building up to the max density you have set in your Density slider. Keep this setting at 100 if you are using a mouse, and experiment with it if you are using a pressure-sensitive tablet.

FIGURE 2.56 Painting with a low feather brush.

FIGURE 2.57 Painting with a high feather brush.

Density: Controls how much total opacity there will be. Keep this setting at 100 if you are using a mouse, and experiment with it if you are using a pressure-sensitive tablet. If the Density is set to 100, then you get 100% of your adjustment coming through on your image. This is where I recommend beginning. It is easier to paint a 100% density mask and then control the amount of your adjustment through the Exposure, Brightness, Contrast, etc., sliders.

Auto Mask: When checked, this box attempts to control the brush strokes to areas of similar color.

Multiple Local Adjustments

The Raw Converter also allows you to have multiple masks, defining different areas. In Figure 2.58, the grayscale image could use some enhancement to both the door and the stairs—though separately. Each area needs slightly different adjustments. Begin by clicking the Adjustment Brush. Notice in Figure 2.58 that the New radio button is selected by default. This means you will be starting a new mask with the adjustments that are currently set. Once you begin painting, it changes to the Add radio button. This means that if you add a second paint stroke, it becomes part of this mask.

I set Exposure to +1.25 and Contrast to +100, and then painted in the door. Notice in Figure 2.58 the small green circle with a black dot in it? This is called a pin. This pin lets me know that I am working on the door mask. After painting (see Figure 2.59), the door looks much more alive. The bump in contrast and exposure has brought out more of the details.

Now to fix the stairs. In Figure 2.59 I have clicked on the New radio button. This lets me start a new mask. Notice that my settings have not changed.

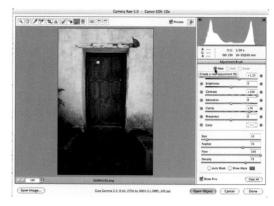

FIGURE 2.58 Starting a new mask.

FIGURE 2.59 Starting a second mask.

These settings are *sticky*, which means they always revert back to the last settings used. I will go ahead and begin painting using these settings, and then return to them later to adjust if necessary. As soon as you begin to paint, the New radio button returns to the Add radio button. So if you stop painting and begin again, you are still painting on the same mask. Figure 2.60 shows the new mask after it has been painted.

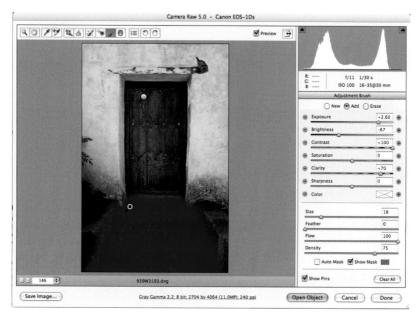

FIGURE 2.60 Making the second mask visible by clicking on the Show Mask box.

Now there is a new pin. This pin indicates the stairs mask. It now has the black dot in it. The door mask pin is solid and uncolored. This indicates that it is inactive. Whether I am painting or moving sliders in the Adjustment Brush panel, the effects will take place on the active mask—the one with the pin with the black center dot. Returning to the Adjustment Brush panel, I increased my exposure to +2.60 and lowered my brightness to -67 to lighten the mortar between the stones without significantly brightening the stones themselves.

If I wanted to return to the door mask, I would simply click on the pin for that mask. The mask temporarily shows, and the pin gets the black dot. Now the adjustments in the panel represent the door mask. Figure 2.61 shows that I moved my exposure to +1.45 to make the door a touch brighter.

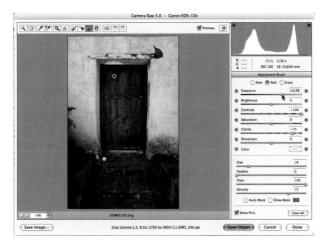

FIGURE 2.61 The finished image.

To leave the Adjustment Brush mode, simply click on any other tool. Your local adjustments are written to that image, and you are ready to proceed with global adjustments once again. When you are finished editing your image. Click Done to save your changes and close the file. Click Open Image to open the file into Photoshop for further editing.

Here are a couple of other hints:

- Checking the Show Pins box allows you to view the pins (recommended). If you turn this off, you might not know which mask you are working on!
- When you are working with the Adjustments Brush, the Preview box turns on and off the local adjustments only. All other global adjustments stay as they were when you entered this area.
- Double-clicking on any of the sliders returns them to the zero position. However, if all of your sliders are at the zero position, you cannot create a new mask. One of the values must be changed to start painting a new mask.

- Check the Erase radio button and then paint to remove the effect from that area. (You are removing the mask.)
- You can paint different densities on the same mask. Begin by painting at 100% Density. If you want to add the same adjustment to other places on the image, but not quite as strong, simply lower the density and paint them in.
- Pressing Cmd+Z (Ctrl+Z on a PC) will undo your last step in working with the Adjustment Brush. Pressing Cmd+Opt+Z (Ctrl+Alt+Z) will keep stepping you back in time through all of your edits with the Adjustment Brush.

The Graduated Filter

The other great local adjustment tool to find its way into Adobe Camera Raw 5.0 is the Graduated Filter. Figure 2.62 shows the Camera Raw dialog box open with the Graduated Filter tool selected.

The Graduated Filter tool works similarly to the old Split Neutral Density Filters—except it's much, much better. This tool gives you complete control over your filter. You can use this tool when you want to darken, lighten, or change contrast or color in a large part of the image. Figure 2.62 is a perfect candidate for this tool. Here I want to darken down the sky to give it more punch.

With the Graduated Filter selected, you can see the now-familiar sliders to the right. Here I will use the Exposure slider to darken down the sky. I'll click at the top of the image and start to draw down the center, as seen in Figure 2.63. This draws out the gradient and reveals the darkening from the lowered exposure.

Now I have the chance to readdress the sliders. In this case, I lowered the exposure and brightness and raised the contrast to get the pop I was looking for in the sky (see Figure 2.64). Looks pretty good, but I can make it better—the bottom of the gradient does not align with the hillside.

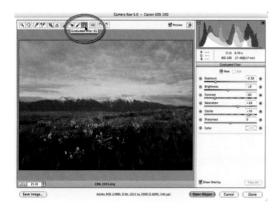

FIGURE 2.63 Drawing out the Graduated Filter.

To rotate the gradient, move your mouse over the line of the gradient (your cursor will turn into a bent arrow) and push up or down, as seen in Figure 2.65. To move the bottom line upward, click on the red circle and push up. To move the top line downward, click on the green circle and push down.

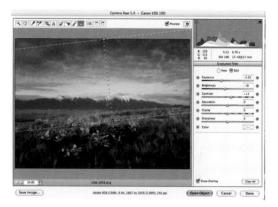

FIGURE 2.64 Graduated Filter not aligning with hillside.

FIGURE 2.65 Adjusting the angle on the Graduated Filter.

Remember that what you are actually drawing is the gradient itself. Everything above the green circle is receiving the full adjustment, and everything below the red circle is receiving no adjustment at all. The adjustment decreases in intensity from the green line down to the red line. So in Figure 2.66, you can see that I am lowering my green line to add more of the darkening adjustment lower in the sky. This has the effect of shortening the gradient. Going too far with this can make your transition zone (gradient) more obvious.

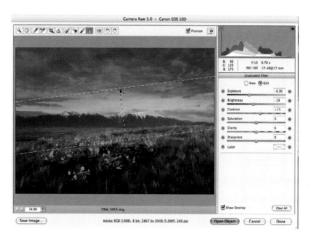

FIGURE 2.66 Adjusting the transition zone.

Much like the Adjustment Brush, you can create more than one gradient in your image. Simply click on the New radio button and draw another. In the case of Figure 2.67, I have drawn a gradient from the bottom up to saturate the foreground and increase contrast. You will notice that the first gradient has mostly disappeared and is now represented by white circles. It is no longer active. This means the effect of it is still present, but you are no longer editing it. The new (active) gradient has the red and green circles. If I made any further adjustments to the sliders, it would apply to this new gradient.

You are free to combine the effects of the Graduated Filter tool and local adjustments in one image. In Figure 2.68, I have clicked on the Adjustment Brush and lightened up the rock a little. I then lowered the density on my brush and painted the yellow flowers. This allowed a little of the lightening through but not 100%.

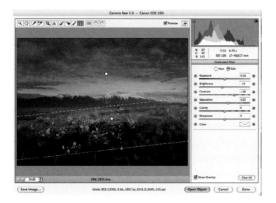

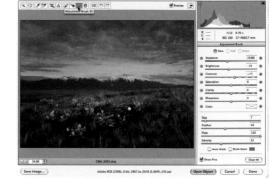

FIGURE 2.67 Adding a second Graduated Filter.

FIGURE 2.68 The rock and flowers lightened with the adjustment brush.

When you are finished editing your image, click Done to save your changes and close the file. Select Open Image to open the file into Photoshop for further editing. Figure 2.69 shows the before and after.

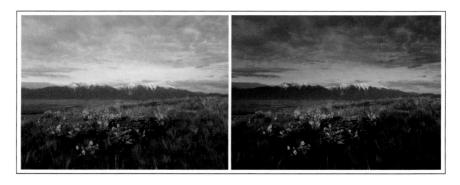

FIGURE 2.69 Before and after using the Graduated Filter.

Here are a couple of other hints:

- Holding down the Shift key while dragging the gradient keeps the gradient traveling in a straight line. It is much easier to do this first. To rotate, move your cursor over the line until it becomes the curved arrow. Now rotate. This gives you much more control.
- If you decide that you do not like a gradient, while it is active (red and green), just hit the Delete key to get rid of it.
- To activate a gradient when it is displayed by white circles, click on one of the circles.
- Click the Show Overlay box to hide and show the overlays. It is often easier to adjust the sliders when the overlays are not present.
- You can pull either the red end or green end off of the canvas to get an even smoother gradient.
- Double-clicking on the color box brings up a window where you can choose a color. This color will be overlaid in the gradient. This can be good when you want to warm up a foreground or add color into the sky. But be careful. Use the Saturation slider at the bottom of the box so that your effect is not too garish.
- You can use the Graduated Filter tool sideways as well! Same technique just drag sideways.
- The Preview box only toggles on and off the Graduated Filter when you have this tool selected. It will not turn on and off the global settings.
- The Clear All button does just what you think it will: It removes all of the gradients you have created.
- Pressing Cmd+Z (Ctrl+Z for PC) will undo your last step in working with the gradient. Pressing Cmd+Opt+Z (Ctrl+Alt+Z) will keep stepping you back in time through all of your edits to the gradient.
- The plus and minus buttons on either side of the sliders will move the slider in either .25 or .50 jumps.

CAMERA RAW TO PHOTOSHOP

Once you are finished with all your image processing in Camera Raw, it's time to decide what to do next. You have several choices. Do you want to move your image into Photoshop for further work? Or perhaps you have been able to accomplish everything needed right in the Raw Converter. All of your options for output are in the Output/Workflow section of the Camera Raw dialog box. This section is outlined in red in Figure 2.70.

To access the color space, bit depth, size, and resolution, click on the blue underlined link at the bottom center of the box. The Workflow Options dialog box in Figure 2.71 will appear.

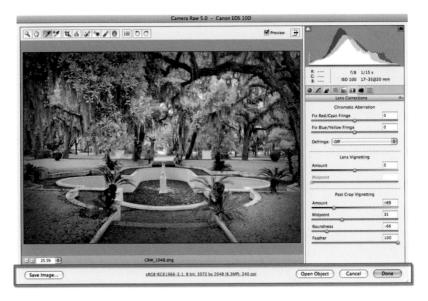

FIGURE 2.70 The Output/Workflow section of Camera Raw.

FIGURE 2.71 The Workflow Options dialog box.

Generally, it's a good idea to use Adobe RGB as the color space because this will produce predictable colors when you decide to print.

Choose either 8-bit or 16-bit channels. If further image correction will be done in Photoshop, 16-bit is a good option to use. If the corrections will be minor, 8-bit is fine.

The Size menu allows you to change the size of the image; however, I usually leave this at the default setting. Chapter 8 goes into depth on how to enlarge and shrink images.

The Resolution box is a convenience item. It has no bearing on the quality of the image. Set this to 300 ppi unless you have an Epson printer, in which case, you can change this to 360 ppi.

Check the box next to Open in Photoshop as Smart Objects if you want a Smart Object in Photoshop rather than a regular image. (See the sidebar "What Is a Smart Object?" for more information). Click OK to apply these settings.

You will be returned to the main Camera Raw Window. From the lower-right corner of the window, choose one of four options to process the image:

Save Image: Choosing this option allows you to save a duplicate of the working image in either the regular formats or create a new RAW file in the DNG format, as shown in Figure 2.72.

FIGURE 2.72 Saving a DNG file.

Open: This launches the image into Photoshop with your adjustments and settings applied.

Cancel: This option closes the Camera Raw dialog box and discards any adjustments.

Done: This closes the Camera Raw dialog box and writes the settings to the RAW file's sidecar XMP file. (These settings will remain with the image the next time it's opened.)

What Is a Smart Object?

A Smart Object is an image that stands in for the actual image. Although you are seeing the image and working with it normally, no edits (adjustment layers, and so on) are *actually* applied until you flatten it. This could be days, months, or years later. Basically, it is a reference to the file that is stored on your hard drive. While it remains a Smart Object, you are simply changing a set of directions that show you what it will look like when it prints or when it is emailed. Because you are only changing a set of directions, you retain the ability to re-edit the image in the Camera Raw Converter at any time by simply double-clicking on the layer.

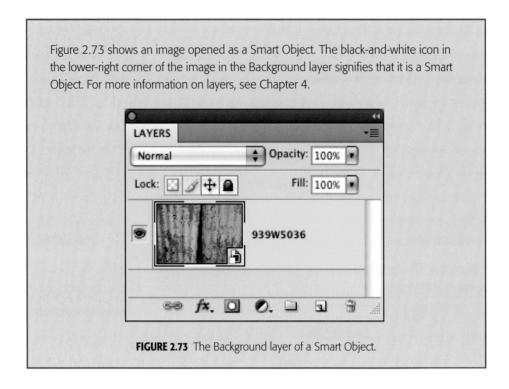

WORKING WITH MULTIPLE RAW IMAGES

A huge time saver for the photographer is the opportunity to work with multiple images simultaneously. You can now view multiple images in the Camera Raw dialog box and share various settings across images. This allows you to process multiple images very quickly.

- 1. Choose several images from Bridge. To select multiple images, hold down the Alt/Option key and click on the desired RAW thumbnails. To remove a thumbnail from the selection, click on it again while still holding down the Alt/Option key.
- 2. Either double-click on one of the selected thumbnails, or right-click and choose Open in Camera Raw.
- 3. Figure 2.74 shows the Camera Raw dialog box with a filmstrip on the left containing all the selected RAW files. To view any of the files, click on the thumbnail, and it will appear in the main Camera Raw dialog box.
- 4. Make the desired adjustments to the chosen image. When only one file is selected, the changes you make occur to that file only. Here I will choose the file with the gray card in it to adjust the color balance with the White Balance tool (see Figure 2.75).

FIGURE 2.74 Opening multiple images in Camera Raw.

FIGURE 2.75 Correcting color with the White Balance tool.

- 5. To apply your changes to all of the files, choose Select All at the top left of the Camera Raw dialog box. All the images are now selected, as shown in Figure 2.76.
- 6. Click the Synchronize button.
- 7. The Synchronize dialog box opens. Either accept the defaults to copy all the settings of the current image to all the images in the filmstrip, or choose individual parameters. You can save time and choose subsets from the dropdown menu. Figure 2.77 shows the Synchronize dialog box.
- 8. All the settings have been transferred over to the other RAW files, as shown in Figure 2.78. You can either click Done to save the settings and not open any images, or you can choose the images you want to launch in Photoshop, and then choose Open.

FIGURE 2.76 Multiple images selected in Camera Raw.

FIGURE 2.77 The Synchronize dialog box.

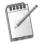

You may want to do a little fine-tuning of each image in Camera Raw before saving or opening.

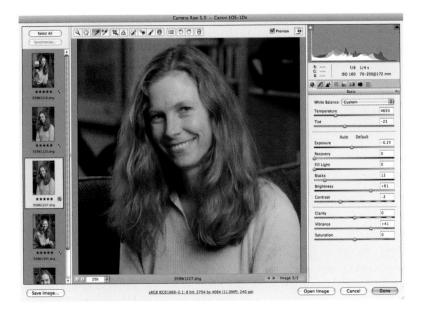

FIGURE 2.78 Sharing the settings across multiple images.

BATCH PROCESSING IN BRIDGE

You can also process multiple images without having to open them up in the Raw Converter. Someday you may have hundreds of images all from the same shoot that you need to batch process. Just follow these steps:

- 1. Open one of the images into Camera Raw.
- 2. Adjust the file to suit your needs.
- 3. Click the Done button.
- 4. When you return to Bridge, select all of the images to which you want to apply those settings.
- 5. Once they are all selected, right-click on any of the images, and choose Develop Settings > Previous Conversion. You can watch as Bridge updates all of your files to the new settings.
- 6. After your files are updated, you will notice that Bridge displays a small icon next to any modified RAW files. This icon tells you that you are not looking at the default settings but, rather, a modified file.

A great thing about this method is that it can be performed from Bridge—you don't even have to launch Photoshop. This is a good method to speed up your workflow and save time by getting a good starting point on each image. If you're doing a studio shoot, the settings will work pretty well for all the pictures under the same lighting configuration. If you change the position of the lights or model, you may have to modify the settings for the new configuration.

Remember that these settings are only applied to the sidecar XMP file by default (or database, depending on how you have set Camera Raw preferences in Bridge). At any time, you can right-click on the thumbnail and choose Clear Camera Raw Settings. This will reset the image to the settings on the camera at the time you captured the image.

The Photographers Basic Workflow

1. Download images from the memory card.

Chapter 2

- 2. Review images. Reject those for possible deletion. Rate using the rating stars. Label using colored labels if applicable.
- 3. Apply appropriate metadata, such as author name, copyright, location, and meaningful keywords.
- 4. Organize into separate folders if necessary.
- 5. From Bridge, open desired image or images into Adobe Camera Raw (ACR).
- 6. Make appropriate alterations in Camera Raw:
 - a. Crop (optional at this point), straighten
 - b. Clean up dust with Spot Removal tool if necessary.
 - c. Fix red eye if present
 - d. Basic tab
 - i. Color cast via Temperature and Tint
 - ii. Overall contrast via Exposure and Blacks
 - iii. Recovery and Fill Light for overexposed highlights and underexposed shadows
 - iv. Brightness and Contrast sliders for fine-tuning
 - v. Clarity slider for adding some presence or midtone contrast.
 - vi. Vibrance/Saturation
 - e. Tone Curve tab to increase or decrease local contrast
 - f. HSL/Grayscale tab to control color globally and locally, or change to black-and-white image
 - g. Split Toning tab if desired
 - h. Lens correction
 - i. Fix chromatic aberration if necessary
 - ii. Fix lens vignetting, or induce vignetting for effect

- 7. Local edits:
 - a. Adjustment Brush
 - b. Graduated Filter tool
- 8. If you are finished with your edits for now:
 - a. Click the Done button to save all of your changes and exit the $\mbox{\sf Raw}$ Converter.
- 9. If you want to make a copy of the image as either a digital negative (DNG), JPEG, TIF, or Photoshop file, click the Save button.
- 10. If you want to move into Photoshop for further work on your image:
 - a. Check your workflow options at center bottom of the Raw Converter box.
 - b. Decide if you want this to be a regular image or a Smart Object
- 11. Click either the Open Object or Open Image button in the lower right of the Raw Converter box to take your image into Photoshop for further editing.

Thapter 3

CROPPING AND PERSPECTIVE

IN THIS CHAPTER:

- Why Crop?
- Cropping Out Unwanted Detail
- Changing Composition and Emphasis
- Cropping for Perception
- Practical Cropping
- Straitening
- Auto Cropping
- Increasing the Canvas Size with the Crop Tool
- Removing Perspective
- The Lens Correction Filter
- Fixing Distortion
- Straightening a Horizon

his chapter will cover the Crop tool and its many uses. In addition to simply trimming your images, you'll find the Crop tool can be used to fix perspective, remove unnecessary detail, or bring attention to the main subject. We will also cover one of our favorite tools: the Lens Correction Filter. Used for both correcting and enhancing perspective, this tool will save you a lot of time when trying to correct your images. Remember, though, Photoshop is about more than just correcting. Don't forget to play and be creative!

Cropping an image is one of those steps that can be performed at any point in your workflow. While some photographers choose to crop right away, others may wait until the printing stage to crop an image. There are advantages and disadvantages to both methods. This chapter will cover when and how to use the Crop tool, in addition to teaching you how to crop your images for maximum impact. We will wrap up this chapter with a powerful tool called the Lens Correction Filter. This tool can be a photographer's best friend. You will see how easy it is to fix warped, distorted, and otherwise out-of-perspective images.

WHY CROP?

Generally, there are two reasons for cropping an image. The first reason is compositional in nature, to enhance the look of the image. This could mean cropping out unwanted sections or objects in your photograph or simply cropping in more tightly to heighten the impact of the main subject. The second reason to crop is to match the proportions of your photograph to a particular size requirement, such as printing paper or mat board.

In the case of enhancing the look of the image, try cropping right away. This not only makes your file size smaller and easier to work with, but it also allows you to make creative judgments based on the elements that remain in your image. Your eye will not be influenced by extraneous subject matter. If, however, the final print proportion is more important to you, you should consider waiting until the printing stage to crop. Take a portrait for example. You may be asked to make a 4"×6", a 5"×7", and an 8"×10" print of this image. Each one of those will need to be cropped to different proportions. In this case, cropping is better left until later to accommodate all the possibilities. In some cases, you may want to crop first in the Raw Converter; other times you may want to wait until you get into Photoshop.

CROPPING OUT UNWANTED DETAIL

Let's take a look at ways to enhance the impact of your image by using the Crop tool. When you crop an image, essentially you are using digital scissors to cut away the unwanted parts of an image until you are left with the perfect composition.

This is a great way to draw attention to a certain part of an image and create a mood. It also works well for zooming in on a photograph. It is always better to crop within Photoshop than to resort to using a camera's digital zoom. For example, the picture in Figure 3.1 shows an image taken of a bronc rider using a 200mm lens, the longest we had. A longer lens would have made the photograph seem a touch more intimate as well as cropping out some unwanted elements in the background. The cropped image in Figure 3.2 shows more of an emphasis on the tight grip the rider has on the rope. In this case, the crop has removed extraneous and distracting detail and brings the viewer right to the heart of the photo.

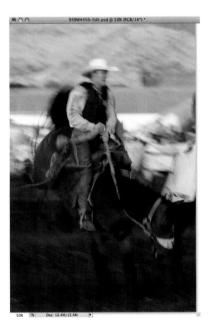

FIGURE 3.1 The uncropped image. Notice the lack of focus and an excess of distracting background.

FIGURE 3.2 The same image cropped: the emphasis is now on the rider and his grip.

To crop an image, follow these steps:

- 1. Choose the Crop tool from the toolbar.
- 2. Click, hold, and drag diagonally across the image to produce a square/rectangle shape made up of "marching ants." This box defines the part of the photo that will remain after the crop.
- 3. After you draw out your crop, you have a few options that you can set from the top menu bar, starting with the Cropped Area, Delete, or Hide options (see Figure 3.3).

FIGURE 3.3 The Crop tool options.

If you choose Delete, your image will be cropped, and all the "trimmed fat" will be tossed away. This is the most common option. If you choose Hide, the image will be cropped, but no image information will be lost. The image will still be there, and only the canvas will be reduced. You can get back the detail again by increasing the canvas size. (This is the best option if you are "comping" a layout and may want to change things later.) The Hide option is not available for images that contain only a background layer. If you want to crop a background by hiding, convert the background to a regular layer first.

- 4. The Shield options are next and also shown in Figure 3.3. By default, the Shield option is checked, the Color is black, and the Opacity is 75%. The shield darkens the part of the image that will be removed when you apply the crop. Having the shield on makes it easier to judge composition. Click once on the Color box to choose your shield color. The Opacity slider determines how transparent the shield will be. Adjust this to suit your tastes.
- 5. When you are happy with your composition and settings, apply the crop by clicking the check mark on the right side of the toolbar, by pressing the Enter key (Return key for Mac), or by double-clicking anywhere inside the cropping area. Before cropping, you may wish to tap the F key to put you into "Full Screen Mode With Menu Bar." I will often crop in this mode to better see the edges of my photo.

Pictures of people often beg to be cropped. This is especially true if you are putting your images online and want to keep them as small as possible or when you have limited space in a print piece. You may have seen many pictures where the subject is too small or the background doesn't help to emphasize the subject, as in Figure 3.4. This photo has been composed with just too much background. It is plain and vacant and simply over abundant in this composition. We want to be in close and get a good look at the expression.

Of course, there are times that call for a wider shot, such as when the background compliments or enhances the subject, but this is not one of those times. Don't be afraid to be bold and ruthless. There is no law that says that you cannot crop the subject as we did in Figure 3.5. Notice how it draws you into the picture, connects you with the eyes, and gives you a better sense of the expression. Here the viewer is more involved and not just a casual observer.

FIGURE 3.4 The image uncropped—too much background.

FIGURE 3.5 Cropped for emphasis, the picture draws the viewer into child's face.

CROPPING FOR PERCEPTION

In the old western movies, the prop builders built the doors smaller to make the men appear large and intimidating. In contrast, the doorways the women used were made larger so the women would appear daintier. This is all about perception. Another reason to crop an image is to change the perception. A classic example is the tall building. Figure 3.6 shows a typical snapshot of a tall building. By trimming out the sides and making the canvas narrower, you can put more emphasis on the vertical aspect of the image. You are adding emphasis to the fact that the building is tall and exaggerating that aspect of the picture. Notice that the building seems taller in Figure 3.7.

FIGURE 3.6 A tall building in a typical snapshot.

FIGURE 3.7 The same building with an emphasis on the vertical aspect, just by cropping the image.

PRACTICAL CROPPING

In addition to creative cropping purposes, there are also some practical reasons to crop images as well as some really useful things you can do with the Crop tool.

When you have many active layers in your image, the file size begins to get very large and can cause your computer to slow down. Even if parts of an image are off the screen, they still count toward image size. By selecting your entire image and cropping, you can sometimes greatly reduce the file size.

STRAIGHTENING

Often, a handheld photo isn't taken quite straight and is a bit tilted. This can also happen when scanning. Put a super-smooth picture onto a super-smooth glass plate and add a bit of warmth from the bulb to create a dry environment, and you have a recipe for a super-slippery surface. Trying to keep the image perfectly straight while carefully closing the lid will qualify you to perform in a circus. Remember that you will lose some of your image around the edges when cropping, so you should always be as careful as possible when shooting and scanning. Having said that, you will be well familiar with a crooked picture, such as that shown in Figure 3.8.

FIGURE 3.8 A crooked picture.

To straighten things up a bit, follow these steps:

- 1. Draw a rough marquee with the Crop tool. Grab the resizing handles, and fill most of the image area with the bounding box.
- 2. Move the mouse outside the box at a corner. You will notice that the pointer has turned into a curved arrow, which indicates that you are about to rotate the image. Begin to rotate the selection until it is at the desired angle.

Move the selection edge until it lines up with a vertical edge that can be used as a visual guide, as shown with the edge of the building in Figure 3.9.

FIGURE 3.9 Use vertical objects as guides and rotate the crop selection.

- 3. After you have everything lined up, click and drag the side handle and stretch the crop selection to the edge of the image, as shown in Figure 3.10. Make sure the selection border doesn't run off the image.
- 4. Now that everything is ready to go, apply the selection by double-clicking with the mouse anywhere within the selection area. You will now have a nicely straightened image, as shown in Figure 3.11.

FIGURE 3.10 The crop ready to be applied.

FIGURE 3.11 The straightened image.

There is another way to straighten images that is a bit quicker:

- 1. Choose the Measure tool from the Tool Palette (it's hiding under the Eyedropper).
- 2. Click and drag along one of the sides of the image. You are selecting your desired horizon in this step.
- 3. Choose Image > Rotate Canvas > Arbitrary.
- 4. The Rotate Canvas dialog box will open with the correct angle and proper rotation already revealed.
- 5. Click OK, and your image will be straightened.

AUTO CROPPING (CROP AND STRAIGHTEN PHOTOS)

To save time while scanning multiple images, several images can be placed on the scanner platen at once and then scanned together (see Figure 3.12). When you want to use these images later, you have to copy each image to a new document, straighten, and crop them individually. All this can be very time-consuming—remembering my magazine days, I say *very* time-consuming, not to mention tedious and boring!

FIGURE 3.12 Multiple images scanned at once.

If you have been a "scanner monkey," I have some exciting news for you. Since CS3, Photoshop is equipped with a one-click Crop and Straighten Photos command. The software looks at an image similar to Figure 3.12 and can detect the white space around the photos. It approximates the picture edges, straightens them, lifts them off the document, and places each picture into its own document. Sounds like science fiction? Try it; it really works. It's as simple as opening a picture and clicking File > Automate > Crop and Straighten Photos, as seen in Figure 3.13.

Now just sit back and relax, or go grab a cup of coffee. In a few moments, your images will all be processed automatically, as shown in Figure 3.14. You have to get excited about this feature because it's so easy and saves so much time! What's more, the original is left intact.

Batch...
Create Droplet...
Crop and Straighten Photos
Conditional Mode Change...
Fit Image...
Merge to HDR...
Photomerge...

FIGURE 3.13 Launching the Crop and Straighten Photos feature.

FIGURE 3.14 The images all processed automatically.

INCREASING THE CANVAS SIZE WITH THE CROP TOOL

Let's explore one of the weirdest but very useful features of the Crop tool. Have you ever heard of a Crop tool that makes the image *bigger*? The Crop tool in Photoshop will crop to whatever it has selected, and that includes off the canvas! Just follow these steps:

- 1. Open an image and apply the Crop tool to fill the entire document.
- 2. Zoom out a bit so that you can see some of the canvas area around the image.
- 3. Drag the Crop tool past the image and onto the canvas, as seen in Figure 3.15.

FIGURE 3.15 Dragging the Crop tool into the canvas.

4. Apply the crop, and the canvas is extended to fit the crop size. This is just the thing to add a bit of space and make a ticket out of your picture. I added just a bit of text to the final image to show an example of how you can use this effect in the real world (see Figure 3.16).

FIGURE 3.16 The final cropped image.

REMOVING PERSPECTIVE

Perspective is quite literally the way we see things. When an object moves away from us, it appears to shrink in size. We all know that the size does not really change—it just appears that way. For instance, look at a long fence: As it winds off into the distance, the posts appear to grow smaller and come closer together. When you look up at a tall building, you notice perspective as the top seems to get narrower.

The proper perspective is essential to making an image appear realistic. The problem is that the camera lens and the angle of the camera can exaggerate perspective, causing areas of the subject to look out of proportion. There are a couple of easy ways to fix this problem in Photoshop.

TUTORIAL 3.1

FIXING PERSPECTIVE

- 1. Open the Doorway image (ch_3_Doorway.tif) from the CD-ROM, as shown in Figure 3.17.
- 2. Notice that the image seems to be smaller at the top than on the bottom because the image was shot from a low angle, and a fairly wide-angle lens was used to compose the original shot. If speed is more important than accuracy, the following method is the right choice.
- 3. Choose the Crop tool, and check the Perspective box on the top toolbar, as shown in Figure 3.18. This option enables you to transform the corners freely.

FIGURE 3.17 An image with an exaggerated perspective.

FIGURE 3.18 The Perspective box.

4. Drag the corners toward the center to compensate for the perspective. Figure 3.19 shows the perspective crop in place. Don't overdo it; you will want to leave some perspective or the image will look like the top is larger than the bottom. Remember that a small amount of perspective is natural.

5. Apply the transformation (Crop), and the image changes to the shape of the cropped area. Notice in Figure 3.20 that the picture still looks natural, but the perspective is more realistic.

You also can straighten and creatively crop the image at the same time.

FIGURE 3.19 The Perspective Crop option in use.

FIGURE 3.20 The final corrected image.

THE LENS CORRECTION FILTER

Using the Crop tool to correct perspective is a quick way to get the job done. If you need a higher level of accuracy, however, the Lens Correction Filter is the best tool for the job. By using this tool, all manner of distortion can be removed. There are also two not-so-obvious features in this tool. In Chapter 2, you saw how you can fix color fringes and lens vignetting in Camera Raw. Perhaps you asked yourself, "What if my image isn't in the Raw Converter?" Keep in mind that with Photoshop CS4, both RAW and JPEG images can be opened in the Raw Converter. Now all of the same easy adjustments that the Raw Converter affords are available to any type of photographic file, including TIFFs and PSDs!

The Lens Correction Filter can fix the following:

Distortion: Lens distortion that appears with very wide or long lenses.

Straightening: Tilting a crooked image.

Chromatic Aberration: Colored fringe around an object in a photo.

Lens Vignette: Where the edges of an image are darker or brighter than the

center.

Perspective: Exaggerated effect of an object appearing smaller as it gets farther away (also called *keystoning* in photography).

TUTORIAL 3.2

USING THE LENS CORRECTION FILTER TO FIX VERTICAL PERSPECTIVE

Let's repair an image that suffers from perspective problems. I used a wide-angle lens (24mm) for this shot of a church. The perspective is exaggerated due to the wide-angle lens and the fact that the photographer is looking up. Notice how the top of the church seems to be leaning in. The goal is to remove some of the perspective effect. You don't want to completely remove it, or the image will look unnatural. (The image ch_3_LeaningChurch.tif, shown in Figure 3.21, is provided on the CD-ROM for your reference.)

FIGURE 3.21 The starting image.

- 1. Choose Filter > Distort > Lens Correction. You will see the Lens Correction dialog box.
- 2. Adjust the Vertical Perspective slider to compensate for the way the towers are leaning in, as shown in Figure 3.22. Look at the grid to line things up. Remember to keep a little perspective. You can show or hide the grid by checking the Show Grid box at the bottom of the page.
- 3. Adjust the Horizontal Perspective slider as shown in Figure 3.23. This helps compensate for the horizontal perspective.

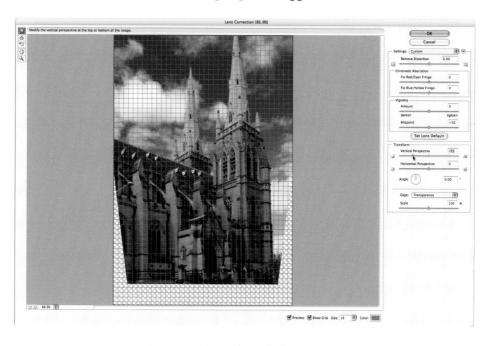

FIGURE 3.22 Fixing the vertical perspective.

The forced perspective has now been fixed but not without a cost. Notice that there is a gap in some of the corners and that the top of the tower has been cut off. For this reason, it is a good idea to give an image a little more space during the initial composition when you know you will be using this filter. To rid the image of the blank canvas (the gray and white checkerboard), apply the filter and then crop the image as you normally would.

Another way is to increase the size of the image in the filter until it fills the window. This is a good option if you are working on an image that needs to remain the original size. Drag the Scale slider, as shown in Figure 3.24.

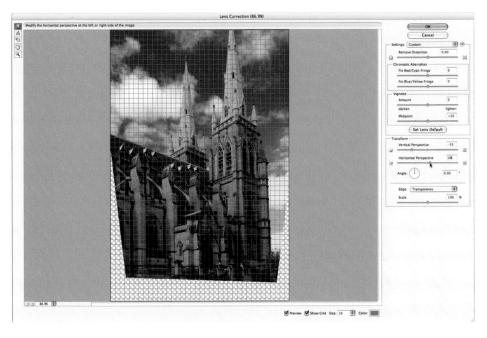

FIGURE 3.23 Fixing the horizontal perspective.

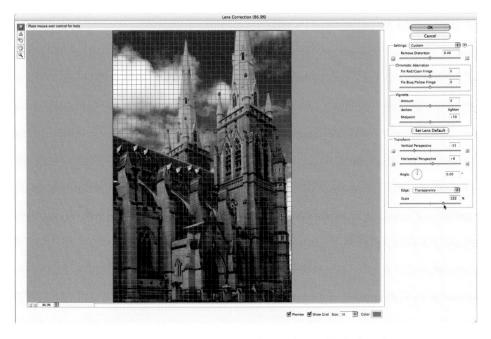

FIGURE 3.24 Scaling the image to fill the window and hide the edges.

Another way to deal with the edge is to choose Edge Extension from the Edge drop-down menu, as shown in Figure 3.25. This is only a good option when the edges are a solid color or a continuous pattern. This will stretch the edge pixels to fill the canvas. Figure 3.26 shows the final image after fixing the horizontal and vertical perspective and using the Scale slider to fill the canvas. Bear in mind the loss on the top of the image due to perspective correction.

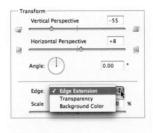

FIGURE 3.25 The Edge Extension option.

FIGURE 3.26 The final image.

FIXING DISTORTION

Two types of common image distortion are associated with wide-angle and long lenses. Barrel distortion can be seen when using super wide-angle lenses, and pincushion distortion can appear when using telephoto lenses. The Lens Correction Filter in Photoshop easily fixes both of these problems.

TUTORIAL 3.3

FIXING BARREL AND PINCUSION DISTORTION

1. Open ch_3_BarrelDistortion.tif from the CD-ROM (see Figure 3.27) or use one of your own images.

FIGURE 3.27 The original image showing barrel distortion.

- 2. Open the image in Lens Correction Filter > Distort > Lens Correction.
- 3. Adjust the distortion in one of two ways:
 - a. Move the Remove Distortion slider to the right.
 - b. Click the top left icon (shown in Figure 3.28), and then click and drag in the image. You will notice as you drag through the image that it bloats (fatter) and pinches (thinner).

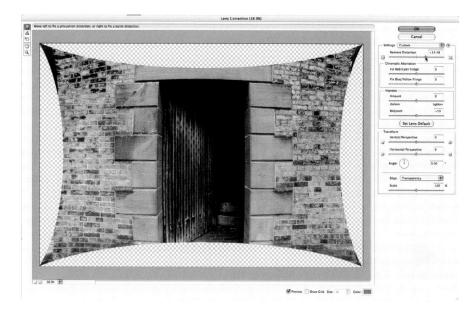

FIGURE 3.28 Fixing the barrel distortion in the image.

4. In this same manner, you can fix an image that suffers from pincushion distortion. In Figure 3.29 a church was photographed using a longer lens. The stairs at the bottom show a slight amount of bowing inward toward the center of the photograph. By moving the Remove Distortion slider to the left, you will begin to "bloat" the image, which will remove the pincushion distortion as seen in Figure 3.30.

FIGURE 3.29 An image with pincushion distortion.

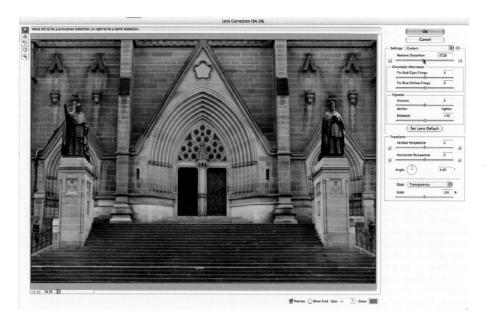

FIGURE 3.30 Fixing pincushion distortion in the image.

STRAIGHTENING A HORIZON

Fixing a crooked horizon or building in the Lens Correction Filter is quite simple. It works in the same manner as the Straightening tool in the Camera Raw Converter. Simply click on the Straighten icon in the upper-left toolbar and draw out a line along whatever element within the photograph you wish to have straight. Figure 3.31 shows a photograph taken at the beach. The horizon line of the ocean is visibly askew.

To straighten the horizon, open the Lens Correction Filter and follow these steps:

- 1. Click on the Straighten tool icon (second down from the top).
- 2. Locate an element in your image that should be straight. In this case, it is the ocean horizon.
- 3. Click on one end of the element and draw a line along it (see Figure 3.32). When you release your click, you will see the image automatically straighten out, as shown in Figure 3.33. If the image still seems a little off, simply redraw your line. You can continue drawing until you get it right. Look to the grid to assist you in your final assessment.

FIGURE 3.31 An image with a tilted horizon.

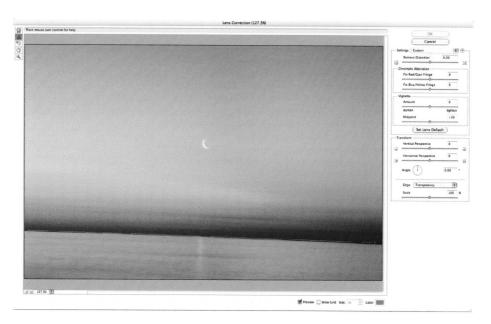

FIGURE 3.32 Drawing the line with the Straighten tool.

4. Use the Scale slider to enlarge (crop) your image and remove the blank canvas. Figure 3.33 shows the final image after straightening and scaling to crop your image.

FIGURE 3.33 The image after fixing the tilting ocean.

TUTORIAL 3.4

ADDING PERSPECTIVE

Correcting images is the main goal of the Lens Correction Filter, but that doesn't mean you can't use it to enhance the look of an image! The Lens Correction Filter is equally adept at adding or removing perspective. This is really useful when you want to add the perception of more distance, or make it appear as if the viewer has changed viewing positions. In this example, it will look like you have moved closer to the subject and used a wideangle lens. Figure 3.34 shows the original image with no perspective.

- 1. Open ch_3_AddPerspective.jpg from the CD-ROM, or use one of your own images.
- 2. Open the image in Lens Correction Filter > Distort > Lens Correction.
- 3. Adjust the barrel distortion by moving the slider to the left.
- 4. Adjust the vertical perspective by moving the slider to the left (see Figure 3.35).
- 5. When satisfied with the adjustments, click OK and crop the image. 🔏

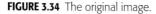

FIGURE 3.35 The image after adding in vertical perspective and barrel distortion.

When working with the Lens Correction Filter, the toolbar shown in Figure 3.36 and the options shown in Figure 3.37 can really make using this filter quite a bit easier. Following are a few hints on working with the Lens Correction Filter:

• When you hover your mouse over a tool, a description of its use and directions appear in the pane above and to the right.

Chapter 3

- Click on the Size box at the bottom of the panel to change the size of your grid.
- If you want to move the grid around so that it lines up with certain vertical or horizontal aspects of your image, click on the Move Grid tool and simply drag your grid around (shown in Figure 3.36).
- Double-click on the Color box at the bottom to choose a new color for the grid.
- When checked, the Preview box shows the image as it will appear with your current settings. Unchecking this box shows you the before version.
- Double-clicking on the Magnifying Glass icon shows you the image at its actual pixels, and double-clicking on the Hand tool fits the image to the screen.

FIGURE 3.36 The toolbar at the upper left of the Lens Correction Filter pane.

FIGURE 3.37 The options at the lower center of the Lens Correction Filter pane.

CHAPTER

4

TONAL CORRECTION AND ENHANCEMENT

IN THIS CHAPTER:

- Photoshop's New Interface
- Overview of Adjustment Layers
- Anatomy of a Color Picture
- Adjusting the Tone of Your Photographs

his chapter will give you a brief look at the newly designed interface of CS4 to help you navigate the world of Photoshop. We'll discuss Adjustment Layers and why they are so important to tonal correction and enhancement. Understanding the anatomy of a photograph is also an important step in learning to correct, so we'll spend some time here looking under the hood. Finally we'll finish up by demonstrating multiple tools to correct, brighten, and darken and enhance the contrast and image tone in your photographs.

PHOTOSHOP'S NEW INTERFACE

One of Adobe's main goals in this release of Photoshop was to make the program easier to use. Nowhere is this more evident than in the interface. Photographers used to work with their images through boxes called *palettes*. This has now changed to a system of *panels*. These panels are used for everything from adjusting your images to choosing colors. Figure 4.1 shows the new interface.

- The Tools Panel contains tools you'll use to edit your images.
- The Control Panel displays options for the currently selected tool.
- The Application Panel allows you to switch between other Adobe applications and navigate around your image.

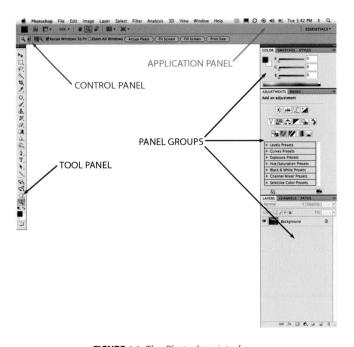

FIGURE 4.1 The Photoshop interface.

Figure 4.1 shows only some of the panels available in Photoshop. The remainder can be opened from the Windows menu, as seen in Figure 4.2. A check mark next to the name means the panel is open. Unchecked panels are closed. In earlier versions of Photoshop, it was common for photographers to customize which palettes (panels) were open and where they were located on the interface. Once you came up with an effective layout, you could save it as a workspace. During the course of editing your images, panels could be closed or moved, and it was a simple matter of choosing your workspace to return to your saved layout.

FIGURE 4.2 Opening a panel from the Window menu.

Now Adobe has included some premade and practical workspaces. Figure 4.3 shows the grouped panels as they appear in the Essentials workspace setup in Photoshop. If your screen does not look like this, simply click the list entry circled in red in Figure 4.3, and choose Essentials from the drop-down menu. At the bottom of the figure, you can see the Layers Panel, and in the middle, you see the Adjustments Panel. As photographers, we will use these two panels often. Circled in blue you will see a down arrow that provides a menu with options and commands specifically for that panel. Circled in green is the panel tab itself. When it is light gray, that panel is active. To show one of the other nested panels, simply click on the tab, and it will reveal itself.

FIGURE 4.3 The panels as they appear in the Essentials workspace.

OVERVIEW OF ADJUSTMENT LAYERS

One of the most important things about enhancing or correcting (editing) your images is the ability to undo mistakes, miscalculations, or simply bad decisions. One day you may like your image with a lot of contrast, and the next you may decide it was too much. The ability to go back and make changes without damaging your photo is paramount. Of course, as with everything in Photoshop, there are many ways to accomplish this:

- 1. When you are first adjusting your images in the Raw Converter, Adobe Camera Raw (ACR), you are practicing *nondestructive editing*. This means you can always go back to the original image, regardless of the changes you have made to the sliders. No harm, no foul.
- 2. You can continue with the previous method by opening your image as a Smart Object from the Raw Converter (see Chapter 2, "From Bridge to Photoshop: The Adobe Raw Converter"). Your image will be open in Photoshop, but double-clicking on the Background layer will return it to the Raw Converter for further adjustments. The black-and-white icon on your Background layer, which lets you know your image is a Smart Object, is circled in purple in Figure 4.3.

3. Finally, you can use Adjustment Layers to effect changes to your photos. These layers can be used with regular images, or with images that are Smart Objects.

Incidentally, the three steps above, in order, are exactly how we adjust our images:

- 1. Edit in ACR (or Lightroom)
- 2. Open as a Smart Object
- 3. Use Adjustment Layers

You may be wondering, "If I can adjust images in ACR and create Smart Objects so that I can go back into ACR, why do I need Adjustment Layers"? You are right to ask. The Adobe Camera Raw Converter is an extremely powerful tool, and even more so now that you can locally adjust images without ever going into Photoshop proper. Sometimes, however, even this is not enough. For very detailed localized adjustments (discussed in Chapter 6), compositing images together, and a host of other techniques discussed throughout this book, you will need to use layers, and the adjustments that go along with them. In addition to nondestructive editing, Adjustment Layers also produce these advantages:

- The original image is left untouched, thus preserving it. You aren't changing any pixels, just the adjustments on the Adjustment Layer.
- Adjustment Layers add nothing to the file size (unless you paint on a mask).
- You can use multiple adjustments of the same filter for precise results.
- Adjustments can be combined with Layer Blending modes.
- If you change your mind later, it's easy to make modifications. Even after you have closed and reopened the file, the adjustments remain editable.
- If you don't like the results, you can delete the Adjustment Layers, and your original image is unaffected.

Essentially, an Adjustment Layer is a like a clear piece of thin plastic. Imagine your photograph is lying on a table, and you are looking down at it. You believe that making it a little brighter will make it more appealing. So you grab a clear piece of plastic with a knob attached to it and lay it on top of your image. As you change the knob, the image below begins to get brighter. The piece of plastic and the knob together are the Adjustment Layer. At any time, you can return to the image and rotate the knob to make it brighter or darker. Or, if you want to get rid of the change altogether, you can simply throw out the plastic. Your original photograph is left unharmed.

This approach is exactly the opposite of editing directly on the image. Choosing Image > Adjustments and using, for example, Brightness/Contrast would be editing the actual pixels of your image. This would be like spray painting directly on your photograph while it sits on the table. There is no chance of altering the photo's level of brightness once the paint has dried. That's why we don't recommend this method, although for some techniques you will be forced to do this.

For most of your work, choose Layer > New Adjustment Layer to create a correction or enhancement on a layer that sits above your image. This Adjustment Layer can always be changed or discarded. This is the true power of editing your photos with Adjustment Layers.

There are several ways to create an Adjustment Layer:

- From the menu at the top of the screen, choose Layer > New Adjustment Layer and pick your desired adjustment from the resulting menu. This method provides the New Layer dialog box, which allows you to name your layer or change other characteristics.
- Click on the small black-and-white icon at the bottom of the Layers Panel (circled in red in Figure 4.4). This is quicker, bypassing the New Layer box. You can always bring up the dialog box by holding the Alt/Option key as you click
- Simply click on any of the adjustment icons in the Adjustments Panel (circled in blue in Figure 4.4). This is also faster and bypasses the New Layer box.

FIGURE 4.4 Two ways to create Adjustment Layers.

When you create a new Adjustment Layer, it will show up in the Layers Panel directly above the Background layer (see Figure 4.5). The Background layer (shown in the Layers Panel) is the layer with a small picture of your actual image, known as a *thumbnail*. Figure 4.5 shows the Layers Panel after a new Adjustment Layer has been created (now highlighted in yellow). This means it is the active layer at the moment. Figure 4.5 also shows that when your Adjustment Layer is active, the corresponding adjustment box shows up in the Adjustments Panel. In this case, it's the Levels adjustment box, ready to be manipulated.

In Photoshop you can have nearly unlimited Adjustment Layers. Figure 4.6 shows the Layers Panel after a second Adjustment Layer has been added. Notice that when you create an Adjustment Layer, it automatically becomes the active (highlighted) layer. The Adjustments Panel in Figure 4.6 has now changed to reflect the new layer. In this case, it is showing the Curves adjustment options.

Figure 4.7 shows the anatomy of an Adjustment Layer. It is made up of both an adjustment and a mask. In our previous analogy, the adjustment is the knob and the mask is the clear piece of thin plastic. Clicking the eyeball on and off will turn the Adjustment Layer on and off. If the eyeball is off when printing, the effect of that layer will not print. Clicking on the adjustment icon will reopen that particular adjustment in the Adjustments Panel for further tweaking. The mask is automatically created with the Adjustment Layer. This will be of great value when you want to apply adjustments to small areas rather than the whole image. Selections, masks, and local corrections will be covered in depth in Chapter 6, "Local Enhancements: Selections and Masks." To delete an Adjustment Layer, click on the Adjustment icon in the layer and drag it to the trash can.

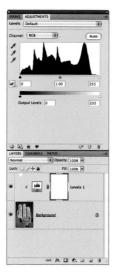

FIGURE 4.5 The Layers Panel with a Levels Adjustment Layer.

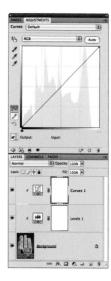

FIGURE 4.6 Two Adjustment Layers in the Layers Panel.

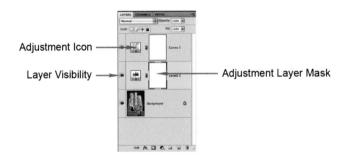

FIGURE 4.7 Anatomy of an Adjustment Laver.

Using Adjustment Layers

Working with Adjustment Layers is easy. Just follow these steps:

1. Choose Layer > New Adjustment Layer, or click on the Adjustment Layer icon (black-and-white circle) at the bottom of the Layers Panel, as shown in Figure 4.8.

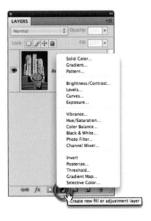

FIGURE 4.8 Creating a new Adjustment Layer.

- 2. The Adjustments Panel reflects the new adjustment.
- 3. Edit the box as needed.
- 4. When your adjustment is complete, move on to the next task. No need to click OK or apply the adjustment. It is automatically applied.

Adjustment Layers are saved with the file, so even after you close an image, you can always reopen it and make further adjustments at any time. Again, to change the settings in an Adjustment Layer, simply click on its icon in the Layers Panel (this makes it active), and the Adjustments Panel will reflect *that* layer.

THE ANATOMY OF A COLOR PICTURE

Before you start enhancing and adjusting your images with Adjustment Layers, let's get a sense of the anatomy of photographs. This will help you later when you are trying to make decisions on what to do with your images.

Originally, there was just black-and-white photography. Then a revolution called color appeared on the scene. It seems so long ago now, as we shoot high-resolution digital photos and think nothing of it. There are two basic parts to a color photograph:

- The grayscale tones (black and white), called *luminosity*
- The color information

Figure 4.9 shows a color photo broken apart. On the left, you see the color information in the picture, and in the middle, you see the luminosity image—combine the two, and you get a color image.

FIGURE 4.9 Color information and grayscale information make a color image.

It's hard to believe that the faded, flat color information refers to the colors used to create the vibrant blues in the lake seen in the photo. But it's true, and you can see for yourself by opening the layered image color-tone.psd from the Chapter 4 folder on the CD-ROM and dragging the color over the grayscale, as shown in Figure 4.10.

FIGURE 4.10 Combining the color and grayscale.

This shows the importance of the tones in the grayscale portion of the image. You can see that all the contrast and details come from the grayscale portion of the image and that the color offers none of this detail at all. We will be dealing with the color portion in Chapter 5, "Color Correction and Enhancement," but in this chapter, we will be enhancing the luminosity or grayscale information to improve the appearance of our pictures.

Histograms

Histograms are the little mountain-shaped graphs that represent the tonal properties in an image. Tonal properties are the 256 levels of grayscale that give the image its contrast and sharpness. Because 16-bit images contain over 65,000 levels of gray, we will use 8-bit photos for this section for simplicity (the theory is identical for 16-bit). Some digital cameras have histograms in their displays. Histograms are not new or unique to imaging. Scientists have used histogram charts since 1891 for various purposes.

Figure 4.11 shows the histogram you are probably most familiar with. This view is from the Levels Adjustment dialog box, which can be reached from the menu by selecting Layer > New Adjustment Layer > Levels.

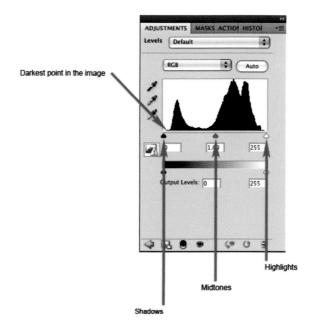

FIGURE 4.11 The histogram.

The following list describes the three regions of the histogram.

Highlights: Whites (255 or 100% brightness)

Midtones: Grays

Shadows: Blacks (0 brightness)

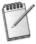

The histogram is broken into 256 levels of brightness. A setting of 0 means no light at all is present and will be reflected as black. A setting of 255 indicates that this is the highest level of light and will be shown as white. This 256-level scale is used throughout Photoshop. It stops at 255 and not 256 because the counting begins at 0, not 1.

The histogram shows a visual graph of an image. The shadows are on the left, and the highlights on the right. The horizontal measurement is in brightness from 0–255. The gray bar underneath (below Output Levels) indicates what part of the grayscale you are looking at, as seen at the bottom of Figure 4.11.

The mountain shape represents image data. The top of the mountain is the peak. The peaks show the way pixels are dispersed in the image. Where pixels are present, the peak will be higher. If there are no pixels at a particular level of gray in the image, then a gap will appear in the histogram, indicating no data in that tonal range.

Where the "mountain" part of the graph begins and ends (from right to left) indicates where the pixels lie. In Figure 4.11, you can see a gap at the left of the histogram (marked as the darkest point in the image). This means no image data is in that area. This translates to the image lacking any pure blacks.

In this histogram, the image information is all contained within the box. Sometimes the information will touch the edges or even creep up the sides, which is called *clipping*. Clipping is when some of the detail gets cut off on an image because its tones lie outside of the camera's recordable range, for example, blacker than black or whiter than white. (These are rendered as black or white without detail.) In this case, some highlight detail is being clipped off the image. An image where the flash is too bright and everyone's face is burned out with white is an example of clipping in the highlights.

Figure 4.12 shows an example of shadows, midtones, and highlights in a photograph: The shadows are number 1, the midtones are number 2, and the highlights are number 3. Figure 4.13 shows how a photograph's tones in play out on the histogram.

In a nutshell, the graph in a well-balanced image will be low on the two ends. A well-balanced histogram will be just touching the left and right edges. There is no such thing as a perfect graph in the middle of the histogram, as all images will show a different graph. A solid shape is more desirable than a broken shape, where gaps may appear. Gaps are shown by white vertical lines running through the histogram and reaching the bottom. Gapping indicates abrupt transitions in color tones, known as *posterization* or, in extreme cases, *banding*. Figures 4.14 and 4.15 show a well-balanced image and its corresponding histogram.

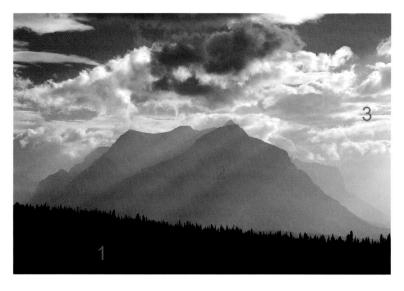

FIGURE 4.12 Shadows, midtones, and highlights.

FIGURE 4.13 The three regions of the histogram.

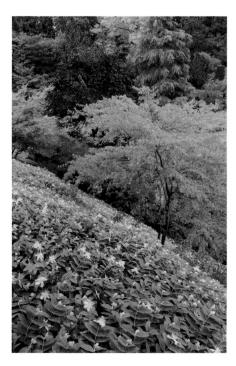

FIGURE 4.14 A well-balanced image.

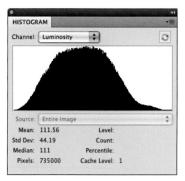

FIGURE 4.15 Image data spread throughout the histogram.

I will now explore some different histograms. Notice the images in Figures 4.16 through 4.21. These images are exaggerated for the sake of illustration. Studying these images will help you understand how a histogram maps out an image.

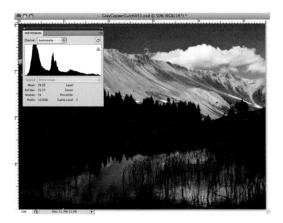

FIGURE 4.16 A well-balanced image.

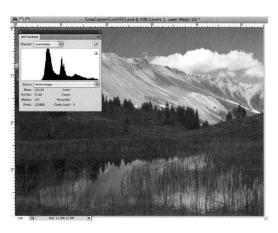

FIGURE 4.17 A washed out image, lacking shadows.

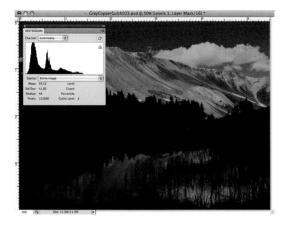

FIGURE 4.18 A dark image, lacking highlights.

FIGURE 4.19 Too much contrast (image beginning to posterize).

FIGURE 4.20 An image with the highlights blown out. Notice the clipping on the right side of the histogram.

FIGURE 4.21 An image with blocked up shadows. Notice the clipping on the left of the histogram.

The Histogram Panel

In Photoshop CS4, a feature called the Histogram Panel allows you to keep a histogram displayed on the desktop at all times so you can see what effect the adjustments are having on images. To display the Histogram Panel, select Window > Histogram.

Panel Options

You can view the Histogram Panel in several ways. To access the options, click on the down arrow at the top right of the panel, and choose your desired options from the drop-down menu. Figure 4.22 shows the Histogram drop-down menu in the Expanded view.

The Histogram Panel nests with all the other panels in Photoshop and stays out of your way while you are working. Or, as with the other panels, you can grab it by the tab and pull it out and away from the other panels.

The Expanded view is larger and offers more options than the Compact view and is ideal for most situations. The All Channels view shows you a separate histogram for each channel in the image (see Figure 4.23). If you choose Show Channels in Color, each histogram will be displayed in the host channel's color.

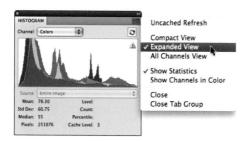

FIGURE 4.22 Expanded view with drop-down menu.

FIGURE 4.23 The Histogram Panel in All Channels view.

Reading the Histogram's Statistics

If you choose the Show Statistics option from the drop-down menu, you will see eight sets of figures in the Histogram Panel, as seen in Figure 4.24. Clicking inside of the histogram (sampling) allows you to view the statistics of that region.

FIGURE 4.24 Sampling the stats.

The four figures on the left show the overall statistics of the image. You may be familiar with some of the terms because they are math terms.

Mean: Remember that there are 256 levels of gray in an image. This shows the average brightness from 0–255 (not 256, because you begin counting from 0 and not 1). An all-black image would show as 0, and an all-white image would show as 255.

Std Dev: Standard deviation, which measures how the pixel ranges are dispersed in the image.

Median: Often defined as the vertical line that divides the histogram of a frequency distribution into two parts having equal area. It's the middle point of the image's grayscale value.

Pixels: The number of pixels present in the image.

The stats on the right-hand side are a bit easier to understand. These are the stats you get by sampling the histogram.

Level: This displays the grayscale level you are currently sampling, from 0–255. It can also show a range if you are sampling more than one level at a time.

Count: The number of actual pixels that fall into the selected range.

Percentile: The percentage of pixels in the selected range compared with the entire image.

Cache Level: How recently your histogram has been refreshed. A cache level of 1 means that your histogram is current. (More on this later in the chapter.)

To sample the histogram, click inside the window with the mouse, and you will see a line, as shown previously in Figure 4.24 This line is the brightness range you are currently sampling, from 0–255. You can also sample a range of tones by clicking and dragging with the mouse, as shown in Figure 4.25.

Photoshop will cache (pronounced *cash*) the histogram display in memory. This means that Photoshop remembers the latest settings in memory rather than displaying them in real time. The reason for this is speed. If the histogram wasn't cached, performance could be affected and slow down your computer. On a larger image, more caching will take place, whereas a small image may not be cached at all.

You will need to keep an eye on the cache level. When you see a little triangular warning icon in the histogram, this indicates that the view is cached and not current. To update, simply click on the warning icon, or the Refresh button if you are in Expanded view, as seen in Figure 4.26.

FIGURE 4.25 Viewing stats on a range of tones.

FIGURE 4.26 Refreshing the cache.

If you set the Source to Adjustment Composite and adjust your image, you will see the histogram change to reflect your adjustments. The original histogram graph will be ghosted in the background (see Figure 4.27) so you can compare the adjustments to the original before committing to an adjustment. When you apply your changes, the ghosted histogram will vanish.

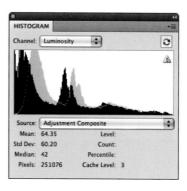

FIGURE 4.27 Original setting is ghosted.

A Word of Warning

In my band days, we were always told that musicians make the best sound people, not the actual sound engineers. Why is that? Because the sound engineers might rely on their readings and instruments too much and forget that music is about actual sound and not just readings and recorded levels. Musicians rely on their ears for the best sound possible, check the readings to make sure everything is functioning correctly, and then make a few tweaks if needed. It is the same in the area of imaging—don't be so glued to the histogram that you make all your decisions based on your readings. Use these tools to help; they are incredibly useful, but still you should trust your eyes. After all, others will be viewing the images with their eyes and not through histograms.

ADJUSTING THE TONE OF YOUR PHOTOGRAPHS

Enough of all the histogram theory—let's jump in and enhance some images now! I will be discussing four tools for adjusting the image tones in order of the simplest to the most complex and accurate: Brightness/Contrast, Shadows/Highlights, Levels, and Curves.

Brightness/Contrast

This is the simplest of the four tools that you can use to adjust the tones of images. Brightness/Contrast is really quick and easy to use. Back in CS3, this tool received a welcome makeover. The Brightness/Contrast command now allows you to brighten, darken, and increase and reduce contrast within your images in a much more intelligent way. The previous Brightness/Contrast tool simply shifted all of the pixels up or down when adjusting brightness, which often resulted in a loss of image detail. This is no longer a worry, as the new tool applies a proportionate adjustment to the image. Although this command is greatly improved, it is still not as precise as Levels or Curves.

1. Select Layer > New Adjustment Layer > Brightness/Contrast. Figure 4.28 shows the image with the dialog box.

FIGURE 4.28 Image before Brightness/Contrast adjustments.

- 2. Drag the Brightness slider to the left to darken the image or to the right to brighten it. Figure 4.29 shows the brightened image. You will notice that even though the image is brightened, it is lacking contrast. That is because the shadows have also been lightened. This loss of contrast is the reason for the Contrast setting in the dialog box.
- 3. Adjust the contrast to compensate for the brightening.

In Figure 4.30, you can see the image now has much more snap than it did in Figure 4.28. The only drawback to the Brightness/Contrast adjustment is that you cannot control specific areas to work on. The upside it is that is easy to use and a great general fix.

FIGURE 4.29 Brightening up the image.

FIGURE 4.30 Increasing the contrast.

Shadows/Highlights

This adjustment has been designed to lighten the shadows and darken the highlights. This allows you to bring back detail that has been somewhat obscured by too much or too little exposure. These are very similar in application to the Recovery and Fill Light sliders in ACR or Lightroom 2. For example, in a picture that suffers from too much exposure, there is an area that is almost all white, and most of the detail has been lost in this bright area. You can now pinpoint just that tonal area and bring back highlight detail without affecting the rest of the image. The opposite is also true for an image that is too dark and has lost all the detail in the shadows. Be aware that there must be *some* image detail captured in the photograph, or there is nothing to recover.

When you make the changes, you can adjust the range of shadows/high-lights you want to modify. For example, you can adjust all the shadows or just the very darkest shadows. Think of this tool as the graphic equalizer for image tone. (If you have a sound background, it's more like a parametric EQ.) A great thing about this tool is that you can target the shadows and brighten them without changing the rest of the image. A great example is when you have taken a picture of a person against a brighter background, and the subject ends up very dark. Using the Shadows/Highlights filter, you can lighten up the person without changing the background.

The Shadows/Highlights adjustment does not come as an Adjustment Layer. If you want the flexibility of an Adjustment Layer, open your image as a Smart Object. By doing this, the Shadows/Highlights adjustment becomes a Smart Filter. This means you can apply the filter, and any time in the future come back and alter its settings.

- 1. Open your file in Photoshop as a Smart Object by choosing File > Open as Smart Object.
- 2. Select Image > Adjustments > Shadows/Highlights.
- 3. Click on the Show More Options box, and its dialog box opens to show all the options.

You will see three regions of adjustments: Shadows, Highlights, and Adjustments. The main areas to consider right now are Shadows and Highlights. Each has three sliders, as shown in Figure 4.31.

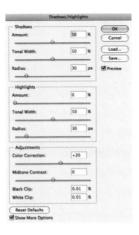

FIGURE 4.31 The Shadows/Highlights dialog box.

Amount: This determines the strength of the adjustment: 0 has no effect and 100 has full effect. Adjust this slider to suit your desired results, like the volume knob on your radio.

Tonal Width: This sets the range of tones to be adjusted. A lower setting will affect just the darkest shadows and brightest highlights. A higher setting will affect more of the image, including midtones. Experiment with this slider to encompass just the depth of shadows/highlights you want to adjust.

Radius: This tool does its magic by trying to determine individual objects in the image. By adjusting the radius, you set the distance on the image that Photoshop will affect. The filter averages adjustments based on the target tones compared with the brightness of surrounding pixels. The radius determines how many surrounding pixels will be considered for the adjustment. A lower setting will keep the adjustments more localized, and a larger setting will spread out the contrast more evenly. You really want to keep your eye on this setting to avoid unsightly halos in your image.

Halos could be described as the mixing zone where the filter is not completely on or completely off. It generally will show as a slightly lighter area surrounding a darker area. Typically, raising your radius will make the deepest blacks stay darker, which is a desired effect. You want to open up your shadows with this filter but still maintain some deep black in your image to keep it looking realistic. Changing your Black Clip point in the Adjustments section will also help you with this.

The third area, Adjustments, has four controls:

Color Correction: Adjusts the saturation of colors.

Midtone Contrast: Allows the contrast of the midtones to be reduced or increased.

Black Clip and **White Clip:** These two settings allow you to stop the filter from affecting the deepest black pixels and brightest white pixels. Adjusting these settings can help you keep the radius lower, thereby avoiding unsightly halos. By default, they are both set to .01. I usually raise the Black Clip to 1 and start raising it from there. Remember, the higher this number, the deeper the blackest black will be. The White Clip works in the same way. By raising this number, you will be forcing the filter to ignore the brightest white pixels. Raising this number will keep the brightest white pixels white. The result of setting some clipping will maintain darks and lights in the photo and avoid the washed-out look.

Figure 4.32 shows an image that is too dark in the foreground, and the detail is lost.

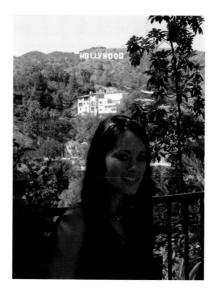

FIGURE 4.32 The image in the foreground is too dark.

- 1. Select Image > Adjustments > Shadows/Highlights. You can see that the dialog box is open in Simple mode.
- 2. Click on the Show More Options box, and the dialog box opens to show all the options.
- 3. Beginning with the shadows, adjust the Tonal Width slider by sliding until you have selected only the range of shadows you want to affect. (Slide the Amount setting up to exaggerate the adjustment so that you can see the range better.)
- 4. Adjust the Amount slider until you have brightened up the shadows sufficiently.
- 5. Do some fine-tuning with the radius until you are happy with the shadow contrast.

Repeat each step for the highlights. If the image appears oversaturated or undersaturated, make some adjustments with the Color Correction setting. If the midtones look like they need some help with contrast (turning gray because of the radius setting), adjust the Midtone Contrast setting.

You now have a corrected image (see Figure 4.33). The woman has been brightened, but the Hollywood sign has been unaffected (unlike with Brightness/Contrast). If you need to make changes in the midtones, consider using Shadows/Highlights first, and then using Levels or Curves for more control over the midtones.

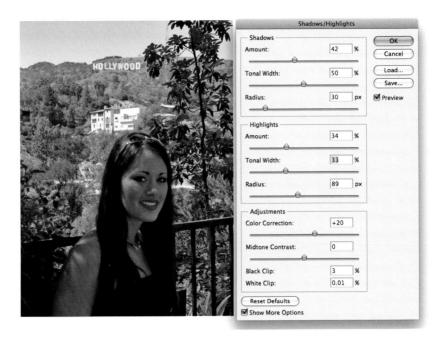

FIGURE 4.33 The adjusted image.

Levels

Now that you have learned about histograms, let's use them to make some adjustments. The most hands-on place for using histograms is the Levels Panel. The Levels Panel is really an adjustable histogram. You will notice that there are three triangles under the histogram:

Black Point Input Slider (Shadows): The left triangle is the Black Point Input slider, which sets the black point of the image. Sliding this to the right darkens the shadows. All pixels to the left of the slider will be turned black.

White Point Input Slider (Highlights): The right triangle is the White Point Input slider, which sets the white point. By moving this slider to the left, you will lighten the highlights. The pixels will be turned pure white above this slider, and no pixels will be displayed to the right of it. They will be clipped (turned pure white).

Midtones: The center slider controls the midtones. When you slide this to the left, the grays will brighten, and when you slide it to the right, they will darken.

For more on Levels, refer to Chapter 5, "Color Correction and Enhancement," where I set the white, black, and gray points.

Quick Corrections with Levels

Hang on to your hats—this section is going to move very quickly. You are going to fix the most common problems with images: underexposure and overexposure.

Fixing Underexposure

The image in Figure 4.34 looks too dark because it is underexposed. Click Layer > New Adjustment Layer > Levels. In the Levels Panel, you will notice that there is no pixel information in the highlight area.

Click and drag the White Point Input slider to the left until you just touch the pixel area, as shown in Figure 4.35. You will notice that the image brightens up. If you're working in a dialog box and see no change, click the Preview check box.

The image is now looking much better. To further control the look of your image, you can slide the middle slider to the left to brighten up the midtones or to the right to darken the midtones. Figure 4.36 shows the final image with the midtones brightened. Notice how much better the image looks after just two slides of the Levels controls.

FIGURE 4.34 Image too dark, lacking brightness.

FIGURE 4.35 Adjusting the highlights.

FIGURE 4.36 Adjusting the midtones.

Fixing an Image That Is Too Bright

In Figure 4.37, you will notice that the image seems washed out, as if we are looking through mist. Actually, I was looking through some clouds when this picture was taken. The result is a hazy-looking image. It doesn't have enough contrast. You can strengthen the image by bringing back some of the shadows.

- 1. Open a Levels Adjustment Layer.
- 2. Drag the Black Point Input slider just into the "mountain" to the right, as shown in Figure 4.38. Notice that all the haze has disappeared, and the image is much stronger.

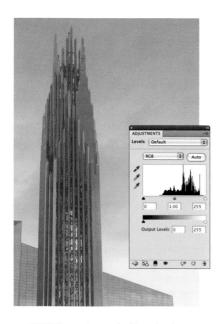

FIGURE 4.37 Image lacking shadows.

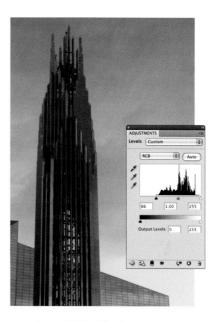

FIGURE 4.38 Adjusting shadows.

- 3. In the histogram, you can see that the image is also missing some information in the highlight. This means you have not quite reached a bright white.
- 4. Slide the White Point Input slider to the left a bit, as in Figure 4.39. The image looks much better with just a nudge to the sliders.

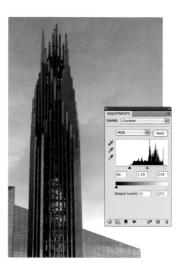

FIGURE 4.39 Adjusting the highlights.

Exposure

There is yet another way to fix the exposure on your image. It is the aptly named adjustment called Exposure. Introduced in the previous version of Photoshop, its primary purpose is to make tonal adjustments to 32-bit (HDR) images (covered in Chapter 12, "Combining Images for Creative Results"). It is also very useful in correcting 8- and 16-bit images. This adjustment works a little like the Brightness/ Contrast slider with a difference. Exposure is a great tool for brightening or darkening images while maintaining complete control over the contrast of the image. The sliders in the Exposure Panel (shown in Figure 4.40a) are somewhat cryptic, but the following explanations are simple. These three sliders really enhance your ability to make precise adjustments to your images.

Exposure: Brightens the highlights.

Offset: Darkens the midtones and shadows. **Gamma:** Adjusts the overall brightness.

Figure 4.40b shows an image (4-exposure.jpg on the CD-ROM) that is underexposed in the foreground. The sky has a nice moody look though.

Now look at Figure 4.41, and notice how the sky retains the moody look while the foreground is significantly lightened. This was achieved by an increase in exposure to lighten the foreground and an increase in gamma correction to darken down the overall brightness, as seen in the Exposure Panel.

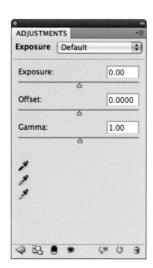

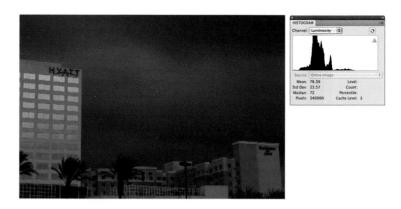

FIGURE 4.40B Image with an underexposed foreground.

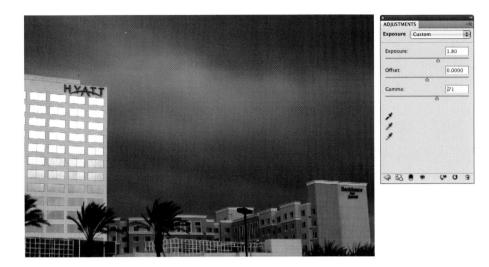

FIGURE 4.41 Adjusted with Exposure.

Auto Settings

Although most times we like to adjust our photos on an image by image basis, sometimes using Auto settings can be quick and effective. When you open the Levels Panel, you will see the Auto button (circled in red in Figure 4.42a). Clicking this button tells Photoshop to set the overall darkest point of the image as black and the overall lightest point in the image as white. If your image has a color cast, it will attempt to fix that as well. (Sometimes the Auto button works like a dream, and at other times like a nightmare.)

The Auto button can also be configured to produce several different effects. Click the down arrow circled in blue in Figure 4.42a and choose Auto Options from the list. You will see the dialog box shown in Figure 4.42b with the following options:

Enhance Monochromatic Contrast = Auto Contrast: Sets the overall darkest point as black and the overall lightest point as white.

Enhance Per Channel Contrast = Auto Levels: Similar to Auto Contrast, except this adjustment happens in each channel. This can sometimes introduce a color cast. (This is the default setting.)

Find Dark and Light Colors = Auto Color: Attempts to color correct an image by using the average of the darkest and lightest pixels.

Simply click the radio button next to the desired option to automatically preview the effect on your image. When you click OK, the Auto button will use that algorithm to adjust your photograph.

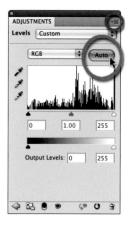

Algorithms

© Enhance Monochromatic Contrast

© Enhance Per Channel Contrast

Find Dark & Light Colors

Snap Neutral Midtones

Target Colors & Clipping
Shadows:
Clip: 0.10 %

Midtones:
Highlights:
Clip: 0.10 %

Auto Color Correction Options

FIGURE 4.42A The Auto button in the Levels Panel.

FIGURE 4.42B The algorithms that alter the behavior of the Auto button.

We started with the image from Figure 4.37, created a Levels Adjustment Layer, and then clicked the Auto button. The result is shown in Figure 4.43. The result isn't quite as good as doing it yourself, but it makes an improvement very quickly. Remember if you just click the Auto button, you get the *Auto Levels* effect, which analyzes the image and sets the darkest point in each channel as black and the lightest point as white.

FIGURE 4.43 The image after using the Auto command.

Getting Good Results from the Auto Settings

Auto settings can give very good results if you perform a little trick. Auto Levels does a great job with the contrast, but it can change the color. Sometimes this is good, and sometimes it's bad. If you like the change in contrast but not the color, there is a little trick you can apply immediately after clicking OK. Here is the technique:

- 1. Choose Image > Adjustments > Levels, and click the Auto button.
- If the contrast is good but the color has changed, immediately choose Edit > Fade.
- 3. Change the blending mode to Luminosity, as shown in Figure 4.44. Click OK. The color is now restored, and only the Luminosity of the image is affected.

The opposite is true for color adjustments. If you want to adjust the color without affecting brightness and contrast, follow these steps:

- 1. Choose Edit > Fade.
- 2. In the dialog box, change the blending mode to Color so that only the color is affected.

If your adjustments are being created with Adjustment Layers (recommended), then you can also perform this same trick by changing the blending mode to Luminosity at the top of the Layers Panel, as seen in Figure 4.45.

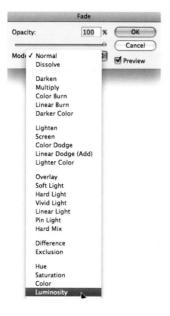

FIGURE 4.44 Changing the blending mode to Luminosity in the Fade dialog box.

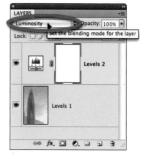

FIGURE 4.45 Changing the blending mode to Luminosity in the Layers Panel.

Curves

Of all the correction tools available, Curves gives you the most precise adjustments possible. With Curves, you can target any tone in the image and increase or reduce it. You have exact control over your entire image. Figure 4.46 shows the same image before and after using Curves. Look at the overall difference, and notice how the details in the rocks and trees show clearly in the improved image. Notice the natural skin tones and the detail in the face. Curves give you the ability to turn snapshots into photographs. By the end of this section, you will be making corrections like this using the Curves feature.

FIGURE 4. 46 Image adjusted using only Curves.

Understanding Curves

The drawback to the Curves feature is that there is a bit of a learning curve (forgive the pun). Stick with me here and don't just flip through to the next chapter. When you learn how to use Curves, it will change the way you use Photoshop and make you the master of image correction. Once you master curves, you will rarely use any of the other correction tools in Photoshop. Hard to believe? Take a walk through the world of curves and judge for yourself.

Open the Curves Panel by selecting Layer > New Adjustment Layer > Curves. Figure 4.47 shows a stripped down view of the Curves Panel, leaving only the Output and Input sections.

For now, let's focus on three things:

Input: The horizontal grayscale gradient on the bottom.

Output: The vertical grayscale gradient on the left.

Curve: The red line.

FIGURE 4. 47 Input and output tones.

The input tones are the starting values of the image and will never change. These are the tones seen in the original image.

Figure 4.48 shows the luminosity from an image. I have selected one tone of 5% brightness, one of 50% brightness, and one of 90% brightness. Follow the red lines from the image to the curve to see where the image value falls on the curve. The green lines shows you the relationship between the curve and the input horizontal gradient.

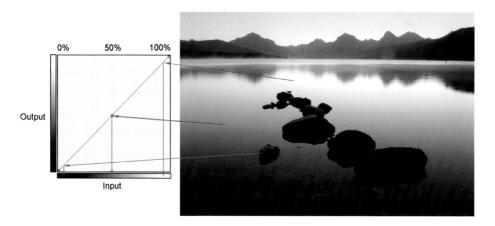

FIGURE 4.48 Luminosity and image values on the graph.

In Figure 4.49, follow the red arrows, and you will see that the tone intersects with the diagonal line. The diagonal line is the curve. Now follow the intersecting line to the left (see Figure 4.50), and you will see the vertical gradient. Notice that the shade of gray is exactly the same. The vertical gray represents the output, or what shade the tone will become. This is what that tone will look like after adjustment.

FIGURE 4. 49 The grayscale relationship to the curve.

FIGURE 4.50 Mapping the input to the output of the curve.

The relationship from the input gray to the output gray is called *mapping*. The curve will determine where the points intersect. If you adjust the curve, the mapping will change. Notice in Figure 4.42 that the shape of the curve has changed. You started with the same input gray as in Figure 4.51 but dragged the point up the graph. Now follow the red arrow. The input is still the same, but the output value (tone) has changed.

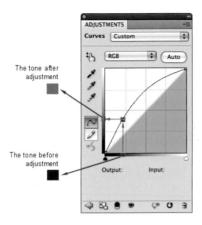

FIGURE 4.51 Adjusting the curve changes the mapping.

What has changed? The vertical intersect point is now higher. Follow it to the left, and see where it is now on the output bar. The shade of gray is lighter than it was. I have just lightened the darker tones in the image. Notice that the curve doesn't just change the point that was moved, but it also affects the other points on the curve. Follow them and see how the output tones have changed.

In a nutshell, the bar across the bottom determines what shade of gray you are working on in the image. Black is to the left, and white is to the right. If you move the curve up, it lightens the image; if you move the point down, it darkens the image. You cannot move it up from white because there is nothing brighter. You cannot move the curve down from black because there is nothing darker.

To determine the change, follow the graph up from the input level, see where it intersects with the curve, and follow it to the left to see what your output will be.

Using Curves

Now that you have an understanding of how the Curves feature works in theory, you can take a look at the Curves Panel. There have been several welcome features added to the Curves Panel over the years, which will be covered later in this chapter. First, you will see the mechanics of curves and how to use the controls; then you will adjust some images. I'll finish this section with a few tips on using the Curves Panel and a closer inspection of its new features.

Creating Curves

By default, every curve begins with the same diagonal line. This indicates that the curve is in a neutral state, no changes have been made, and the inputs and outputs are the same, as seen in Figure 4.52.

To make changes to a curve, click on the curve with your mouse, and an adjustment point will appear (see Figure 4.44). Drag the point up to brighten the tone or down to darken the tone. You can add as many as 14 points on a curve. This will bring you to 16 points in total, because black and white points are always shown. To remove any points, just drag them off of the Curves Panel. All points displayed as solid are selected, and those displayed as hollow are unselected. Only selected points can be moved on the curve. To select more than one point at a time, hold down the Shift key. To pinpoint a specific tone from the image, click the little icon that looks like a finger and two arrows (circled in red in Figure 4.53). Click and drag on the actual image to adjust the underlying tones while working in the Curves Panel.

The Pencil tool also can be used to draw a freehand curve (see Figure 4.54). This would have more uses in a special effects situation because it is not accurate enough for adjusting images precisely.

FIGURE 4. 52 The Curves Panel.

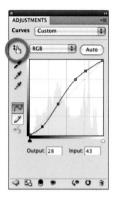

FIGURE 4.53 Curves with adjustment points.

FIGURE 4.54 Points drawn with the Pencil tool.

Different Types of Curves

An infinite number of curves can be created for images. However, there are some typical shapes that achieve certain results. These curves range from image correction to special effects. CS4 has some useful preset curves for you to work with. Spending some time experimenting with these presets will teach you a lot about how the Curves Panel works. To apply a preset curve, click the double blue arrow next to the Curves drop-down list and choose a curve, as shown in Figure 4.55. You can fine-tune your curve further after you load a preset by moving the present points or creating more of your own.

Curves will work with color images, but in this case, I'll display them in grayscale so that you can see the effect on the image tones. Figures 4.56 to 4.67 show different types of curves.

FIGURE 4.55 Choosing a preset curve.

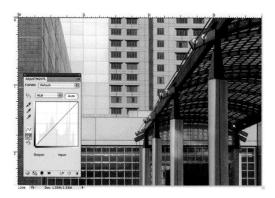

FIGURE 4.56 Original.

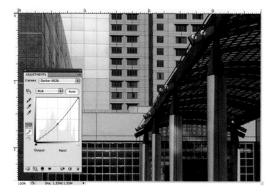

FIGURE 4.57 Darker preset darkens the midtones.

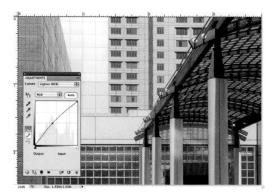

FIGURE 4. 58 Lighter preset lightens the midtones.

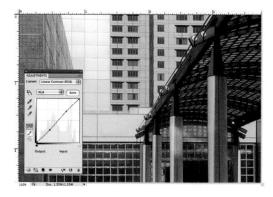

FIGURE 4. 59 Linear Contrast preset adds a slight amount of contrast to midtones.

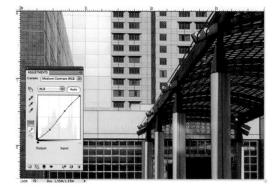

FIGURE 4. 60 Medium Contrast preset adds more contrast in midtones than the Linear Contrast preset.

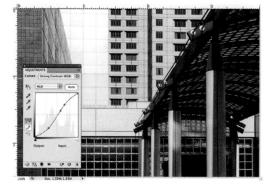

FIGURE 4. 61 Strong Contrast preset applies a heavy increase in midtones.

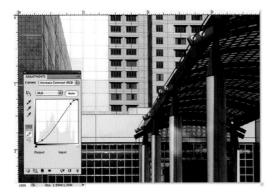

FIGURE 4. 62 Increase Contrast preset is the strongest of the Contrast presets. A significant lightening of the light tones and darkening of the dark tones results.

FIGURE 4.64 Clipping the highlights in a Custom preset. Note the relationship of the highlight point and the histogram.

FIGURE 4.66 The Negative preset inverts the image.

FIGURE 4.63 Clipping the shadows in a Custom preset. Note the relationship of the shadow point and the histogram.

FIGURE 4.65 Posterizing the image through severe contrast increase. Highlights and shadows are clipped.

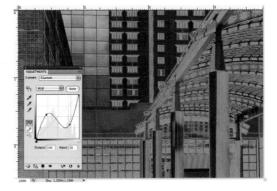

FIGURE 4.67 Solarizing the image.

Correcting Images with Curves

You are now going to correct two images with the most common tonal problems. The first image is hazy and lacks contrast. The second image is so dark that you would think it was beyond repair. It's time to unleash the magic of the Curves feature.

Adding Contrast with Curves

The image in Figure 4.68 is very faded and hazy. It was shot from the top of the Sears Tower on a hazy day with a Sony DSC-717 F. You have probably seen many pictures with this problem. This is how to fix it.

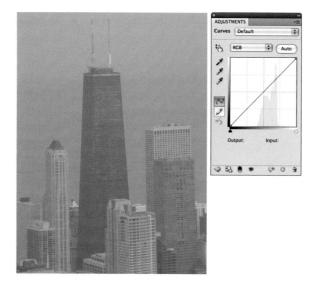

FIGURE 4.68 The image before adjusting the curves.

- 1. Open the Curves Panel by selecting Layer > New Adjustment Layer > Curves.
- 2. The image lacks contrast, so the first move is to create an S curve. At the 3/4 brightness point, drag the curve up to brighten the highlights (see Figure 4.69).
- 3. Now drag the shadows down to deepen them. Notice in Figure 4.70 that the image has more overall contrast.
- 4. Click on the finger and double arrow icon, then drag the tool over the image, and you will see a circle on the curve. This indicates which image tone you are sampling.

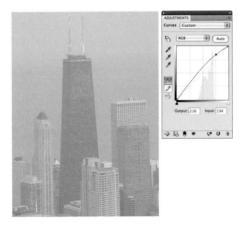

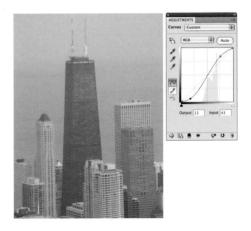

FIGURE 4.70 Darkening the shadows.

- 5. Place a point on the curve by clicking on that tone in the image. In this case, it's the John Hancock Building (see Figure 4.71).
- 6. Although the contrast has been increased, the image is now a touch too bright. Drag down on the curve at the newly selected point, as shown in Figure 4.72. This darkens the image at the chosen tone, lowering the overall brightness of the midtones.

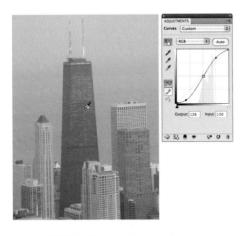

FIGURE 4.71 Sampling a midpoint.

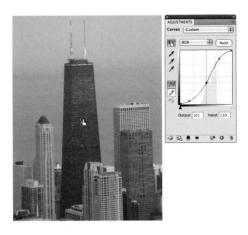

FIGURE 4.72 Adjusting the midpoint.

At this point, you could be satisfied with the adjustment; it is a lot better than it was. Just for fun though, let's brighten up the sky a bit.

1. Click on a brighter part of the sky with the Eyedropper tool to add the sky's tone to the curve (see Figure 4.73).

2. Drag the point up to brighten the sky. Notice that the curve is very steep between the two brightest points (see Figure 4.74). Be gentle with the curve. Try not to bend it too much. If a curve becomes too steep or even drops, this can cause colorizing problems, such as solarizing and inverted colors.

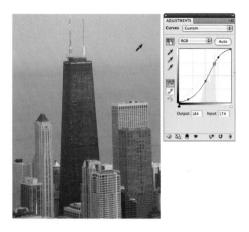

ADJUSTNICHT CONTROL [274]

Output [211] Imput [274]

FIGURE 4.73 Sampling a highlight.

FIGURE 4.74 Adjusting a highlight.

As a tweak, I smoothed off the curve in the highlights. This has caused a little clipping in the white, but it is quite acceptable in this case. Remember to be gentle with the curve. You don't want too much of a bend in it. Notice the difference between the image before and after (see Figure 4.75). It's amazing what the Curves feature can do.

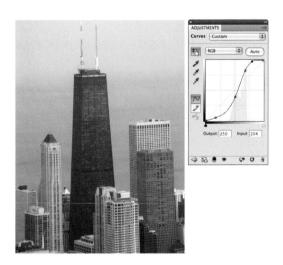

FIGURE 4.75 Final adjustments.

Brightening an Image with Curves

The camera often captures more detail than you realize. You just need to know how to bring it out. Figure 4.56 shows very little image detail. For this reason, some folks might think it is beyond saving. Not so. Half of a minute in the Curves Panel is all it will take to fix this image.

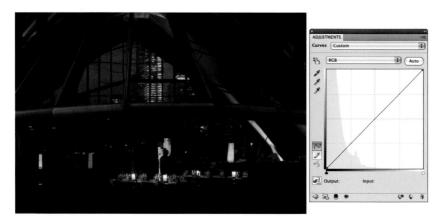

FIGURE 4.76 The beginning image.

- 1. Create a Curves Adjustment Layer.
- 2. Lighten the shadows until you can see some detail come into the image (see Figure 4.77). Moving the shadow point up from the bottom will turn your deepest blacks to mud. This is not a desired effect, but you will tweak this later. The goal right now is to see some image detail so that you can work with it.

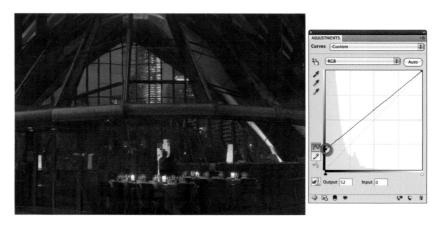

FIGURE 4.77 Adjusting the shadows.

3. Lighten the highlights until the lightest point of the image is sufficiently bright. You can do this by grabbing the upper Highlight point or the lower Highlight slider (circled in red in Figure 4.78). When dragging either of these points, a temporary vertical line becomes visible (shown in red here for the example). You can watch this line and align it with brightest end of the histogram.

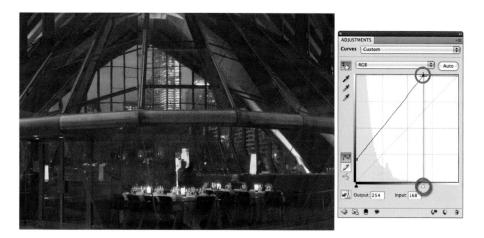

FIGURE 4. 78 Lightening the highlights.

4. Next you will sample a midtone. Click the hand icon outlined in green in Figure 4.79. This allows you to click in the image and move that point on the curve. As you move your cursor over the image, it will turn into an eyedropper.

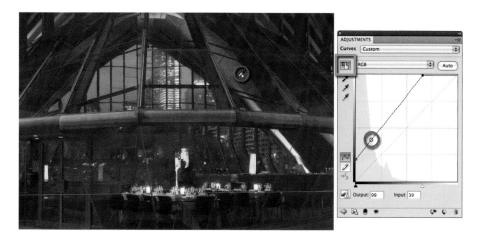

FIGURE 4.79 Sampling the midtones.

5. When you are over the tone you would like to lighten, click and move your mouse upward. The icon changes to the hand and the point in the curve moves upward, as seen in Figure 4.80. Notice how much brighter the image has become.

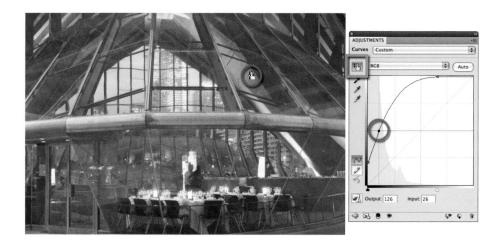

FIGURE 4.80 Adjusting the midtones.

6. In step 2, you brightened the shadows so that you could see some detail to work with. Let's darken the shadows now because they look too bright. Drag down on the darkest point just a little bit (see Figure 4.81).

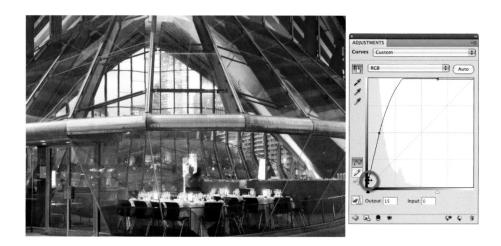

FIGURE 4.81 Darkening the shadows.

7. Finally, make a little adjustment in the higher midtones to make the highlights and midtones a bit softer (see Figure 4.82). Remember, be gentle with the curve. You want nice smooth arcs with no hard kinks in the line.

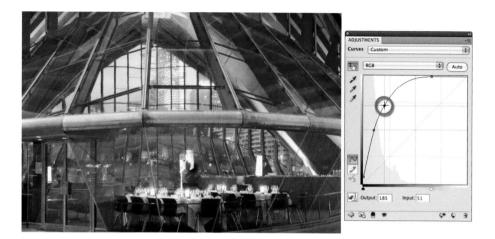

FIGURE 4.82 Final adjustments.

There you have it. You have brought out detail and color from an almost blacked-out image. Can you see the power of curves and why it is worthwhile to learn this feature?

Some New Features

As mentioned earlier in this chapter, some new features have been added to the Curves Panel that make it easier for the photographer to both visualize the tones and adjust the curve. Most of these additions were made in CS3, but they now look a little different in CS4. If you have worked in Curves before, you will have already noticed the addition of the histogram behind the curve. The second thing you may have noticed is that when you click on the down arrow in the upper right of the Curves Panel, you get the drop-down menu that includes Curves Display Options (see Figure 4.83). When clicked, this item reveals several options for modifying the way the Curves Panel will be displayed. Figure 4.84 shows the Curves Display Options dialog box.

Fortunately for us, Adobe has done a good job of designing the Curves Display default settings. When you first reveal the options, you will notice that all of the boxes are checked.

FIGURE 4.83 Display options in the Curves Panel drop-down menu.

FIGURE 4.84 Curves Display Options dialog box.

The histogram provides a great visual and makes it easier to understand the correlation between the Levels and Curves commands. It is now possible to bypass the Levels commands entirely, as all of the features are now represented in Curves! In Figure 4.85, you will see that you are starting with a flat image. You can increase the overall contrast of the image by moving the Shadows point to the right and the Highlights point to the left, as shown in Figure 4.66. Moving these points is the exact equivalent to moving the White Point and Black Point (Shadows and Highlights) sliders in the Levels Panel. Simply push them over until you reach the image information as shown by the histogram.

Figure 4.86 also highlights the new Intersection Line feature of Curves. I added a red vertical line over the intersection line to make it easier to see. Now as you move the shadow and highlight points on the curve, you can look at the intersection line—both vertical and horizontal—to help you visualize where the tones will be mapped to. You can see that I was able to precisely position the highlight point by watching the intersection line as it moved along the histogram.

When moving the Shadows or Highlights sliders (triangles), the intersection line does not appear. You must grab the points themselves to see the intersection line.

With the Baseline box checked (see Figure 4.87), you get a reference for where the curve was when you started. With the Channel Overlays box checked, you can see the individual curves that may have been altered in the color channels.

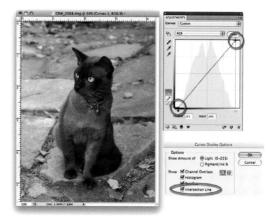

FIGURE 4.85 Opening the Curves Panel with a flat image.

FIGURE 4.86 Increasing the overall contrast by setting the shadow and highlight points by the histogram.

For changing the contrast and brightness of an image, the RGB channel is the only channel that needs adjusting; but for advanced color correction, you can individually alter each channel from within the Curves Panel. Figure 4.88 demonstrates how to access the color channels as well as shows the effect of checking the Channel Overlays box.

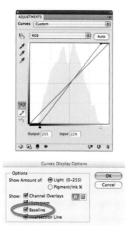

FIGURE 4.87 Baseline highlighted in red.

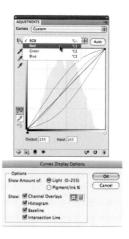

FIGURE 4.88 Seeing the changes in the color channels via the Channel Overlays.

Another option in the Curves drop-down menu is Show Clipping for Black/White Points (see Figure 4.89). When you move your Shadows and Highlights sliders while this is checked, you can easily assess any clipping that may occur in the shadows and the highlights.

Grab the Shadows slider and click. Your image turns entirely white. Now as you move your Shadows slider, color will begin to appear. When any of that color turns to black, it is an indication that these pixels are starting to clip. Back off from the adjustment until the black disappears. Figure 4.90 shows that the first pixels to clip will be around the cat's ear.

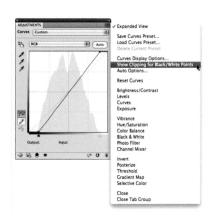

FIGURE 4.89 Choose Show Clipping for Black/White Points from the Curves menu.

FIGURE 4.90 A slight clipping of the shadows.

Begin to move the Highlights slider on the curve, and the image will turn black. The first signs of clipping will be those pixels that turn white. Figure 4.91 shows that the first highlight pixels to clip will be around the cat's collar and bell. Figure 4.92 shows the final adjustment.

Holding down the Alt/Option key does the same thing as the Show Clipping option and is usually a quicker option.

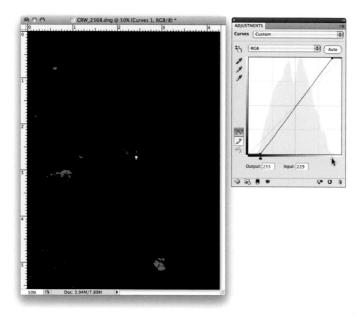

FIGURE 4.91 A slight clipping of the highlights.

FIGURE 4.92 The final adjustment.

Tips for Using Curves

Here are a few tips to make you more productive with the Curves feature:

- Press the Alt key (Option key for Mac) and click in the Curves Panel to change from a large to a small grid.
- You can have many points on the curve at one time. The black point is the active point. The hollow or white points are inactive.
- Press the arrow keys on your keyboard to move the selected points.
- Press Ctrl+Tab (Cmd+Tab for Mac) to move through adjustment points on the curve.
- Avoid falling curves, which means that tones have become inverted at that point.
- Create curves with gentle bends. Hard bends usually spell trouble in the form of posterization.
- If you are looking for posterization as a creative effect, use hard bends.

CHAPTER 5

COLOR CORRECTION AND ENHANCEMENT

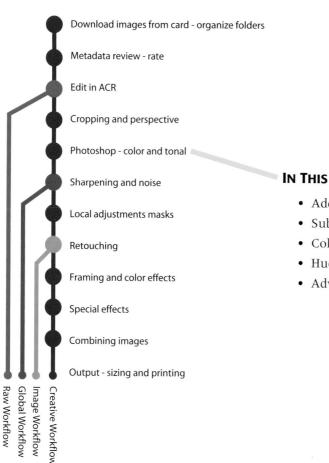

IN THIS CHAPTER:

- Additive Color
- Subtractive Color
- Color Correction Tools
- Hue/Saturation
- Advanced Color Correction

In this chapter, we'll look at various color correction techniques that will help you adjust your images to natural-looking colors. We'll begin with some very simple techniques and get more in-depth as the chapter progresses. These techniques will help you salvage a wide variety of unhealthy images and make them look great.

In the previous chapter, we mainly looked at luminosity. *Luminosity* refers to the brightness values of an image. Photographers such as Ansel Adams knew how to work with luminosity for maximum impact. The second part of a digital photograph is the color. Color is used to create moods and add a lot to an image. Think of color as the thin layer of skin-deep beauty in your color photograph. Color can be very fragile but if handled with care can produce wonderful results. Nothing is worse than when the color is off in an image, particularly with skin tones or food. In this chapter, you will learn how to correctly adjust and repair color so that you can deliver vibrant and correct images.

In the world of computers, there are two ways to understand color. One type of color is called *additive*, and the other is called *subtractive*. I won't bog you down with a lot of theory right now, but I will go through a very brief overview to help you understand how color is generated on your computer.

ADDITIVE COLOR

In additive color, all colors combine to make white. This type of color is based on light. This is the way that the natural eye perceives color. For example, when you view a lemon, you see yellow. All the colors of the spectrum are targeted at the lemon from the sun or other light source. The lemon absorbs all colors of the light spectrum except for yellow, and that color is then reflected to the viewer's eye and perceived as yellow. A rainbow displays this principle perfectly. When the light hits the raindrops at the correct angle, it splits the spectrum of light, and you can see red, orange, yellow, green, blue, indigo, and violet—all of these colors combined make white light. Because of the way this light works, you can imagine that different types of artificial light are not as pure as the sun's rays, and this produces what is called a color cast in your image. A *color cast* is when an image has an unnatural color tint. You can fix this color cast easily in Photoshop, as you will learn in this chapter.

Your computer's monitor also uses additive color. There are three different colors: red, green, and blue (RGB). The monitor mixes these three primary colors and creates all the colors that you view on the screen.

SUBTRACTIVE COLOR

Subtractive color is so named because an absence of color will produce white (or more correctly, transparency). Subtractive color is not based on light—it is based on ink and resembles mixing color as you did with your first paint set. The three main primaries used in subtractive color are cyan (light blue), magenta (pinkish purple), and yellow. Because these colors cannot produce a really dense black, black usually is added in the world of printing. This is where you get CMYK color: C = cyan, M = magenta, Y = yellow, and K = black (called K and not B so it's not confused with blue). Subtractive colors are the colors you will deal with when printing. Even though your home inkjet printer is made up of CMYK inks, you do not have to work in the CMYK colorspace unless you are printing to a commercial printing press. The inkjet printer works by receiving RGB images and changing them into CMYK.

COLOR CORRECTION TOOLS

In the previous chapter, you looked at tonal correction, and you worked on the grayscale portion of images. In this chapter, you are going to look at the color portion of the images. All photography is the art of capturing light, and different types of light affect images in different ways. For example, the sun's quality is a warm/neutral-colored light, but moonlight transmits a bluish cast and is much cooler. Shooting indoors under artificial light tends to give images a yellow cast, whereas fluorescent light adds some green to the image. Some of the best lighting conditions (for portraits especially) are outside with an overcast sky. The clouds nicely diffuse the harshness of the sun's rays without taking too much brightness away.

Digital cameras are equipped with a white balance setting that helps you compensate for different lighting conditions. You can also use different filters to help with the color, although most are not needed anymore with digital photography. Even after all that, sometimes the color is still a bit off in the photo. This is not a problem with Photoshop. There are several ways to restore natural color, and you may even want to use these techniques to alter the color for something more creative, such as to warm the skin tones of a model. If you have the option to shoot in the RAW format, most of your color correction troubles will no longer apply because you can change the setting in the Raw tools provided with Photoshop (Chapter 2, "From Bridge to Photoshop: The Adobe Raw Converter"). For images that are not in RAW (and we all have plenty of them), the following techniques will take the pain out of color correction.

Color Calibration

Before making color adjustments to your images, it's imperative to calibrate your monitor. By calibrating your monitor, you are adjusting it to industry standards. This will give you a faithful reference to go by. The goal is to get the color on your screen as close as possible to the devices you and others will use to view and output the images. You can achieve accurate results by using two things: screen calibration and color profiles.

Screen Calibration

To get accurate color on your screen, you will need some kind of measuring device. Companies like LaCie, X-Rite, Pantone, and Datacolor all provide color calibration tools that work well. Each of these solutions are bundles of software and hardware. Just about every color calibration system these days will work with both CRT and LCD screens. You place one of these measuring devices (hardware) on your screen (they either dangle in front or attach with suction cups), and then launch the included software. The devices measure the colors on your screen, and then build a color profile that is saved on your computer. This color profile ensures that your colors are accurate and that they look very similar to what someone else will see using a calibrated monitor.

It's fairly simple to calibrate and profile your display using the aforementioned tools. Some things to keep in mind are as follows:

- Make the room lighting as close as possible to your working conditions before running the calibration.
- Warm up your monitor first because the brightness and color will shift as the equipment warms up. Most manufacturers recommend at least a half hour of warm-up time.
- Recalibrate the screen on a regular basis—every two weeks should be more than sufficient.
- Be careful not to make any adjustments, such as brightness or contrast, to your screen. If you change any of these settings, you will need to recalibrate.
- Some calibrating systems will ask you to set the Gamma. The Gamma of a PC is 2.2, and the Gamma of an Apple is 1.8.
- Another option you may come across while running the software is *white point*. You can think of the white point as a very slight color cast to your monitor. Most photographers will use either 5500 or 6500 as their white point. If you use 5500, your monitor will be slightly warmer. Setting it at 6500 will give your monitor a cooler cast. If your monitor is cooler (6500), then you will generally fix your images to be a little warmer. 6500 is the setting that we choose.

Color Profile

The calibration process creates a profile for your monitor. By default, this profile will load up automatically when you start your computer. Your images should also contain a color profile, so that the settings will be translated correctly. A quick trip to the Color Settings dialog box will enable you to manage your color with success. Choose Edit > Color Settings, and set your working RGB to Adobe RGB (1998).

When you open an image and get a warning that says "Profile Mismatch," it's telling you that the image has a different color profile than the settings on your screen. You have two options: Convert the image to your working color profile or keep it as is.

If the image is coming from a calibrated system, then the color is set to that system's profile. If you will be returning the image to the source it came from (for example, another person), you should keep the embedded profile. If you plan to work on the image and print the image on your printer, then you should convert it, and then make minor color adjustments, if necessary, to match your screen settings.

If the image has no profile attached, it's a good idea to attach a profile so that you will get consistent color. To assign a color profile to an image, choose Edit > Assign Profile. The most common profile for photography is Adobe RGB (1998). You will find it under the Profile drop-down menu.

If you are shooting your images in RAW, setting the Space to Adobe RGB before converting will keep things running smoothly. You can do this by clicking on the underlined link in the center bottom of the Raw Converter. This will bring you to the Workflow Options dialog box. Space will be the first drop-down menu. You should also set the colorspace to Adobe RGB in camera if you have the option.

Check Chapter 7, "Sizing and Printing Your Images," for instructions on printing with accurate colors.

Adjusting Color in Your Images

Just as a reminder, all images should begin with a visit to the Raw Converter. This is where you will do most of your heavy lifting, such as changing brightness, contrast, or color. Once you have finished with your work in the Raw Converter, it is time to bring the file into Photoshop proper. It is in Photoshop that you will work with Adjustment Layers to further enhance or correct your images. Using Adjustment Layers gives you the ability to localize your adjustments. This means that you can apply the adjustment to a specified area of the image rather than the entire image. (This concept will be covered in more detail in Chapter 6, "Local Enhancements: Selections and Masks"). Before we get to localized adjustments, however, we need to explore the adjustments themselves.

After you have fixed the contrast and the brightness in your image, you may find that there is now an obvious color cast. There are countless ways to fix a color cast in Photoshop. To cover them all would take up this entire book. Let's focus on a couple of simple methods, and then explore some of the more accurate methods. I will end this chapter with a look at how to enhance your color rather than fix it.

Auto Color

This is a hit-or-miss filter. It's great when you are in a hurry or have only a few seconds to get an image cleaned up a bit. There are no settings for this adjustment filter, so it is very unpredictable. Auto Color will attempt to balance the color, and it does a pretty good job a lot of the time. I tend to use this on images that have a heavy color cast. If nothing else, it is a good starting point. Figure 5.1 shows an image with a green color cast caused by fluorescent lighting. To apply Auto Color, select Image > Auto Color.

FIGURE 5.1 Image with a green cast.

In this case, Auto Color did a decent job of removing the green color cast. Notice the color restored on the right wall (see Figure 5.2). There is a bit of a blue color cast on the white areas of the sign, but the image is a huge improvement over the original. A good thing to do directly after applying Auto Color is to choose Edit > Fade Auto Color and switch the blending mode to Color. This will restore the original luminosity of the image. Note that this is not an Adjustment Layer!

There are ways around that, however. Click on your Background layer to ensure that it is the active layer. Go up to Layer > Duplicate Layer to create a duplicate layer of your background and provide a place for you to perform the Auto Color command.

FIGURE 5.2 The image after using Auto Color.

Color Balance

Color Balance is a very useful tool for making color corrections. This tool allows you to target the shadows, midtones, or highlights, and then change the balance of color in the image. Although most of your color corrections can be made in the Raw Converter, this tool works well as an adjustment layer after the fact.

Six main colors (the two sets of primary colors) are used in this tool:

- Monitor primaries (additive color) are red, green, and blue.
- Print primaries (subtractive color) are cyan, magenta, and yellow.

In the Color Balance tool, these colors are arranged into three sets of opposites using the primary colors:

- Cyan and red
- · Magenta and green
- Yellow and blue

You can target a range of either shadows, highlights, or midtones, and then shift the balance of any of the colors. Pushing the slider toward Red removes a cyan cast, pushing the slider toward Magenta removes green, and moving the slider toward Yellow removes a blue cast.

TUTORIAL 5.1

ADJUSTING THE COLOR CAST

On the CD-ROM, open the file Ch 5-CB.jpg.

FIGURE 5.3 The original image with a blue color cast.

- 1. Choose the Color Balance Adjustment Layer by clicking on the white-and-black circle at the bottom of the Layers Panel and choosing Color Balance.
- 2. Keep the Preserve Luminosity box checked. This prevents the tonal qualities of the image from changing.
- 3. The Color Balance Panel will open with the Midtones option checked (see Figure 5.4a).
- 4. Slide the balance toward more Red and less Cyan. Also, move away from Blue and more toward Yellow. Be careful not to overdo it. Figure 5.4b shows the image after the midtone adjustments.
- 5. Choose the Highlights option.
- 6. Increase the Red and Yellow settings, as shown in Figure 5.5.
- 7. Repeat these steps for the shadows as well.

Figure 5.6 shows the image after the adjustments. The picture looks much more natural now. Can you see how I neutralized the blue color cast by shifting the balance of color?

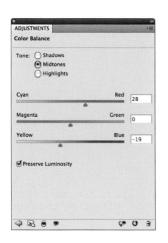

FIGURE 5.4A Adjusting the midtones.

FIGURE 5.4B The image after the midtone adjustments.

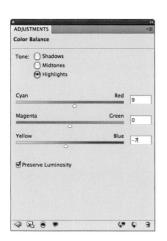

FIGURE 5.5 Adjusting the highlights.

FIGURE 5.6 The final image after shadow, highlight, and midtone adjustments.

Color Correction Using Variations

The Variations tool works just like the Color Balance tool but with a more visual interface. This tool is commonly used to fix color shifting in an image because of the great results and ease of use.

Figure 5.7 shows an image that is suffering from a pretty bad yellow color cast. There should be some yellowing of the paper to show the signs of age, but the plate should be more neutral colored.

- 1. Choose Image > Adjustments > Variations. You will see five main areas when you open the Variations dialog box (see Figure 5.8). Once again, if you wish this command was an Adjustment Layer, choose Layer > Duplicate Layer to apply the variations to a duplicate of your background image.
 - The top left shows the original image, and to the right, a preview of the image after the current adjustment.
 - The next area to the right allows you to choose a tonal range or the saturation of color.
 - Directly under the tonal range, you will see a sensitivity slider that changes the intensity of the adjustment from less (fine) to more (coarse).
 - The main area shows previews of the image with color shifting in different directions and the current pick in the center.
 - The area to the right is where you can lighten or darken the image.

FIGURE 5.7 Picture with a yellow color cast.

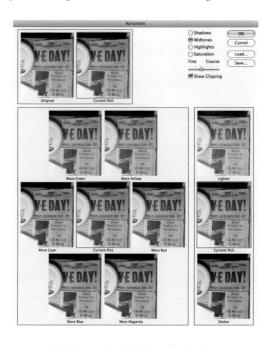

FIGURE 5.8 The Variations dialog box.

- 2. Target the midtones (default).
- 3. As you slide the intensity slider, you can see how it affects the thumbnails. As you choose the coarser settings, the color differences are more radical (see Figure 5.9).

To adjust the image, click on the thumbnail that is closest to the result you are looking for. The current pick will be updated to the colors of the thumbnail you clicked, as shown in Figure 5.10. Notice that all the thumbnails have changed to offer variations of the newly selected color.

The color is now close but not quite there, as shown in Figure 5.11.

- 1. Lower the intensity to make the adjustment more subtle.
- 2. Choose more blue.
- 3. Click on the lighter thumbnail to brighten the image.

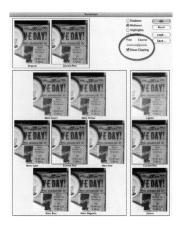

FIGURE 5.9 Changing the intensity.

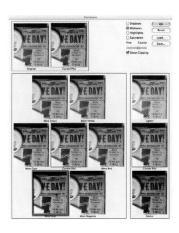

FIGURE 5.10 Making an adjustment.

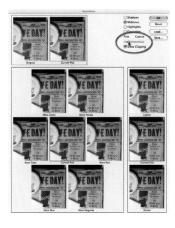

FIGURE 5.11 Making finer adjustments.

If you have Show Clipping turned on, the area will be highlighted in a bright color on some thumbnails, as shown in Figure 5.12. This indicates where the color cannot be faithfully reproduced if the highlighted variation is chosen (outside the color gamut). This is usually a good indication that you should turn down the sensitivity to a finer setting.

Figure 5.13 shows the image after the color correction has been applied with the Variations feature.

To reset the colors in Variations, click on the thumbnail at the top left labeled Original. All the settings will be reverted. It's a good thing to click the Original thumbnail whenever launching Variations because the previously used settings are always retained in memory.

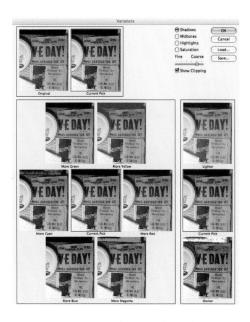

EXTRA! HARKSTALE BARK EXTRA!

WASS CONVOCATION SET

Doom
Sealed By
Surrender

THE
'SON OVA BLITZ'
IS FRITZED

DOC: 914.7K/914.7K

FIGURE 5.12 Clipping indicated.

FIGURE 5.13 The image after adjusting.

Although the Variations tool isn't available as an Adjustment Layer, you can still use it non-destructively. Right-click on the layer thumbnail and choose Convert to Smart Object. Now when you apply the variations, they will be a smart filter that can be readjusted at any time.

TUTORIAL 5.2 USING THE PHOTO FILTER

Another simple tool to correct or enhance color is the Photo Filter. This tool allows you to create a preset color cast (filter) across the entire image. Some of the choices are filters that film photographers will remember using on a regular basis. The warming and cooling filters make up the first section of the presets. In this tutorial, you will use the Photo Filter to fix an image that was shot under tungsten light (see Figure 5.14).

On the CD-ROM, open the file Ch 5-PF.jpg.

- 1. Choose the Photo Filter Adjustment Layer by clicking on the white-and-black circle at the bottom of the Layers Panel and choosing Photo Filter.
- 2. By default, the Filter radio button will be selected, which allows you to choose a filter from the drop-down menu. Choose Cooling Filter (82), as shown in Figure 5.15. The Color square will change to show you the new filter color.

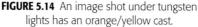

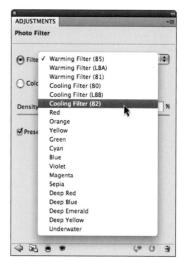

FIGURE 5.15 Choosing the Cooling Filter.

- 3. The image should look immediately better, but you can adjust the intensity of the filter to suit your taste. In this image, I increased the density to 52 to give a neutral look to the scene, as shown in Figure 5.16.
- 4. The Preserve Luminosity box should be checked by default. If it is not, check it now. This will help keep the brightness and contrast from being affected by the color changes that you are applying. Overall, the image looks pretty good. Click OK to finish your adjustment.

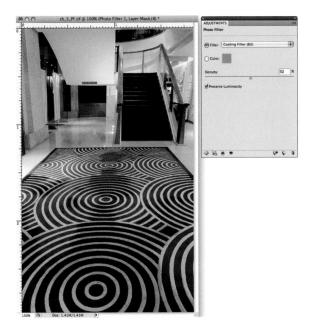

FIGURE 5.16 Adjusting the intensity of the Cooling Filter.

If you are a real stickler for precision, follow these steps to fine-tune this adjustment:

- 1. Reveal the Photo Filter Adjustment Layer by clicking its icon in the Layers Panel.
- 2. It seems that the previous adjustment left a little magenta in the white walls. Let's clean that up by customizing the color that you'll use as your filter. Start by raising the Density slider to 100%. This will initially make the color too strong, but you will fix that in the next step. Now, click the Color square to open the Select Filter Color dialog box (see Figure 5.17).
- 3. Inside of the Select Filter Color dialog box, you want to desaturate the color somewhat and slightly alter its hue. Do this by clicking on the circle within the color and moving it to the left. You can watch the number in the S box decrease as you move this circle (see Figure 5.18). You are desaturating the color as you move to the left. Choose a number between 50 and 70.
- 4. You can now move the Hue slider up and down to dial in the exact hue that will make the scene more neutral. Here, I have chosen a value of 209, as seen in the H box in Figure 5.19. Click OK in the Select Filter Color dialog box, and then click OK again in the Photo Filter Panel to complete your fine-tuning.

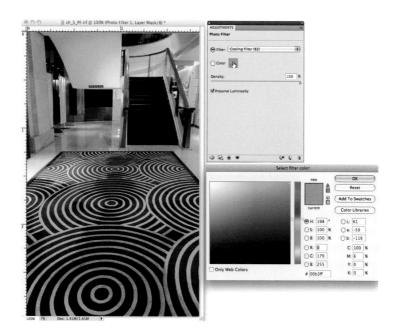

FIGURE 5.17 Clicking the Color square opens the Select Filter Color dialog box.

FIGURE 5.18 Moving the Color Picker to the left desaturates the color.

FIGURE 5.19 Moving the Hue slider to fine-tune the filter color.

HUE/SATURATION

The Hue/Saturation adjustment is a very powerful tool that you will use quite often once you are familiar with it. Although it can be used to change the color cast of an image, the roughness of the Hue slider does not have the fine-tuning abilities of the other tools that I have covered. It is, however, a great tool to enhance the color of an image. The Hue/Saturation Panel works on the three different components of color: hue, saturation, and lightness (or brightness).

Hue: The name of the color—red. Use this when you want to alter the actual color from red to blue, for example. Subtle changes can also be made.

Saturation: The intensity of the color or, more correctly, the balance of color to luminosity. At a high saturation, the color is very bright and vibrant. At a low saturation, the color turns to gray.

Lightness: Describes the brightness or darkness of the color. Use this slider to correct the brightness after hue and saturation adjustments lighten or darken your color. I would avoid using the Lightness slider in the Hue/Saturation Panel. The exposure adjustment will brighten the image but yield more accurate results.

To study the components of color, open the Color Picker dialog box by double-clicking on either the Foreground or Background color chips in the lower part of the toolbar (see Figure 5.20).

FIGURE 5.20 The Foreground/Background Color Picker.

In the Color Picker, move the arrows on either side of the Hue slider (they both move simultaneously when one is chosen) to select a hue. Notice that the number in the H box will change as you move the slider. This value is called the *hue angle*. The Hue value and the Hue slider bar are circled in red in Figure 5.21.

Click inside the color field as you did in the previous tutorial, and you can change the brightness of the chosen hue. By clicking your cursor below, you are darkening the color (see Figure 5.22). The upper center of the dialog box shows you the Current and New colors. Current is what you started with when opening the dialog box, and New is what your color will become after you click OK. Once again, look at the S and B boxes. The numbers inside will change to reflect your new Saturation and Brightness levels.

In Figure 5.23, I explore the different percentages of a solid color red. Notice how the color becomes less intense as the color is desaturated.

FIGURE 5.21 Changing the hue of a color.

FIGURE 5.22 Darkening the color.

FIGURE 5.23 Different percentages of saturation.

When first working with the Hue/Saturation Panel, it is not uncommon to overdo the saturation settings. This is always a tell-tale sign of an image being digitally manipulated. Use a soft hand here, and let subtlety be your mantra. Another mistake is to use only the Master slider in this panel. This will change the hue, saturation, or lightness of *all* colors in your image. Figure 5.24 shows a scene that can benefit from fine-tuning in the Hue/Saturation Panel. You could try to make the image more appealing by increasing the overall saturation, but this would only make all the colors more intense. By choosing individual colors within the panel, you can separate the colors from one another by applying different degrees of hue, saturation, and lightness to each color.

FIGURE 5.24 An image that will benefit from fine-tuning its color.

On the CD-ROM, open the file Ch_5_HS.jpg.

- 1. Choose the Hue/Saturation Adjustment Layer by clicking on the white-and-black circle at the bottom of the Layers Panel and choosing Hue/Saturation.
- 2. At the top center of the panel, you will find the Edit Menu (circled in red in Figure 5.25a). Click on the double blue arrows and choose Yellow from the drop-down menu, as seen in Figure 5.25b. Increase the saturation. Only the Yellows are becoming more saturated! The blues are left alone.
- 3. Choose Red from the Edit menu, and increase the saturation here as well. For this example, I chose a setting of +77. Once again, you are getting a boost to the reds without affecting the blues.
- 4. Now choose Blue from the Edit menu. Here you want to alter the color to get a better contrast between it and the yellows and reds. Start by lowering the lightness a little. Next, desaturate the color somewhat. Finally, alter the hue by moving the slider to the right. Figure 5.26 shows the settings for each edit.

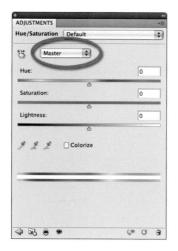

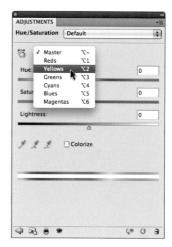

FIGURE 5.25A The Edit menu.

FIGURE 5.25B Increasing the yellow saturation.

The color blue now has much more complexity to it. There is more separation between the main colors as well as more separation within the blue itself. Figure 5.27 shows the completed image.

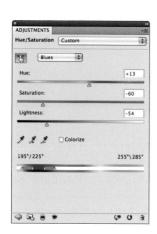

FIGURE 5.26 Changing the blue hue and decreasing its saturation.

FIGURE 5.27 After fine-tuning the hue and saturation.

ADVANCED COLOR CORRECTION

Now you are going to look at a few color adjustment techniques that go beyond the simple click-and-slide tools. These are professional-level techniques that will help you fix almost any image. You will be surprised by the power of Photoshop and also your capability to correct color by the end of this chapter.

Match Color

Another useful color correction feature in Photoshop is Match Color. With this filter, you can copy the color information from one photo to another. This is a great way to fix studio shots that are inconsistent and to remove color casts. This tool also opens up some amazing creative opportunities.

TUTORIAL 5.3

REMOVING A COLOR CAST WITH MATCH COLOR

Later in this chapter, you are going to use Match Color to take the warmth from one picture and apply it to another. For now, you are going to use the Match Color option to painlessly remove a color cast from an image.

Begin with an image that has a color cast. Figure 5.28 has an orange color cast from the artificial lighting. You must be in RGB mode for this filter to work properly. If you find that you are working with a CMYK or grayscale image (this technique is fun to try with black-and-white images), go up to Image > Mode and change the image to RGB.

- 1. Open ch_5_Match.jpg from the Chapter 5 folder on the CD-ROM, or use your own image.
- 2. From the menu, select Image > Adjustments > Match Color. (There is no Adjustment Layer available for this adjustment.)
- 3. You will see the Match Color dialog box shown in Figure 5.29. Check the Preview box to make sure it is on.
- 4. Click on the Neutralize box. The overall color temperature of the image should change.
- 5. Adjust the Fade slider until the image's color looks correct.
- 6. Adjust the Luminance setting to darken or lighten the image.
- 7. If you need to adjust the saturation of color, move the Color Intensity slider (this is unnecessary most of the time).
- 8. Click OK, and you are done.

FIGURE 5.28 Image with an orange color cast.

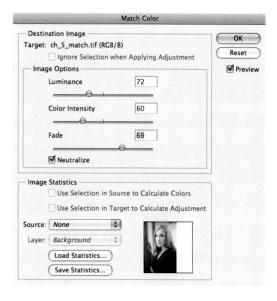

FIGURE 5.29 Adjusting the Match Color settings.

Figure 5.30 shows the image after correction. This is a pretty quick and painless way to remove a color cast, and it works well on most images. If you just want to adjust a portion of the image or a particular color, make a selection around the area first and then follow the previous steps.

FIGURE 5.30 Image after color correction.

TUTORIAL 5.4

ADDING LIFE TO AN IMAGE WITH MATCH COLOR

Match Color also enables you to take the color palette of one image and apply it to another image. In this example, you are going to use an image that was shot after the sun went down, which gave it a strong blue cast. You will then use another image that was shot at sunset and bring those warm colors over to the blue image.

You will begin with a landscape that has a strong blue hue to it (see Figure 5.31). You can use an image of your own that is on the cool side or use ch_5_match1.jpg from the Chapter 5 folder on the CD-ROM.

FIGURE 5.31 After the sun sets, the light is very blue.

- 1. Open an image that has a much warmer feel to it (or use ch_5_Match2.jpg from the CD-ROM). The image in Figure 5.32 shows a much more interesting color in the sky.
- 2. Click on the image in Figure 5.31, which is the cool landscape.
- 3. Choose Image > Adjustments > Match Color.
- 4. Choose the warmer picture under the Source drop-down menu, as seen in Figure 5.33.
- 5. Check the Preview box. At first, you may find the color change too much.
- 6. Adjust the Fade slider until you are happy with the colorizing.
- 7. Increase the Luminance setting to brighten the image and increase Color Intensity to adjust the depth of the color, as shown in Figure 5.34.
- 8. Click OK to apply the changes.

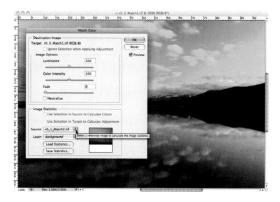

FIGURE 5.32 Better color in the clouds.

FIGURE 5.33 Initial setting adds a lot of the color.

Notice in Figure 5.35 how the Match Color tool was able to move the clouds to a pink color while keeping some of the blue in the sky and water. This is an amazing tool that can make short work of enhancing your images.

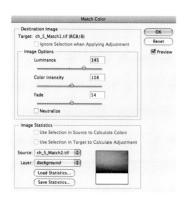

FIGURE 5.34 Adjusting the settings in the Match Color dialog box.

FIGURE 5.35 The image after color correction.

TUTORIAL 5.5

FIXING AN IMAGE WITH WASHED OUT/SHIFTED COLOR

The image shown in Figure 5.36 suffers from a reddish color shift and lacks saturation. This book is for digital photographers, but even digital photographers may, from time to time, have to scan an old image or two that has suffered the fading effects of age. In the case of this image, a lot of the film had expired and had a new date stamped on the box (a trap for naive travelers in a foreign country's photo kiosk). Needless to say, the images lack a lot of color saturation because of bad film.

1. Open Ch_5_LAB_before.tif from the CD-ROM, which is the original image in Figure 5.36, with a color cast and lacking any luster. In the real world, there will be times that you are forced to use such an image.

FIGURE 5.36 Faded image with color cast.

- 2. Choose the Hue/Saturation Adjustment Layer, or from the menu, select Image > Adjustments > Hue/Saturation.
- 3. Move the Hue slider to compensate for the color shift.
- 4. Boost the saturation to restore some color to the image, as shown in Figure 5.37.

The image in Figure 5.38 is still not perfect, but it is a lot better than it was; the trees are at least showing some green now.

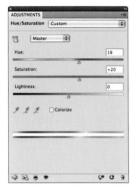

FIGURE 5.37 Hue/Saturation adjustment.

FIGURE 5.38 The image after adjustment.

Advanced Color Correction with Lab Color

You are now going to branch off into new territory by switching the color mode of your photograph. By default, photographs enter Photoshop in the RGB color mode. This means that the image is comprised of three channels: Red, Green, and Blue. For this example, you will switch to Lab color mode. Lab color will change the channels from RGB to LAB:

L (**Lightness**) **channel:** Contains all the grayscale information in the image.

A channel: Contains the magenta and green color information.

B channel: Contains the yellow and cyan color information.

TUTORIAL 5.6

SPLITTING AN IMAGE INTO CHANNELS

To split an image into channels, follow these steps:

- 1. With Ch_5_LAB_before.tif still open, go up to the Layer menu and choose Flatten Layer from the bottom of the list.
- 2. Choose Image > Mode > Lab Color.
- 3. Open the Channels Panel, as shown in Figure 5.39.
- 4. Click on the Lightness channel to activate it, as shown in Figure 5.40.

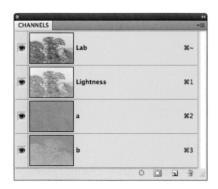

FIGURE 5.39 The Channels Panel in Lab mode.

FIGURE 5.40 The Lightness channel.

- 5. Adjust the contrast on just this channel by adjusting the levels. Select Image > Adjustments > Levels. This will affect only the luminance (grayscale information) and will not shift the colors. Figure 5.41 shows the levels being adjusted. Here I have brought the Shadows slider to the right to darken the shadows. (The Lightness channel is also the channel where all sharpening would take place.)
- 6. Click on the A channel to select it.
- 7. Turn on the Visibility icon next to the top (Lab) composite channel; the A channel should now be highlighted with all the channels visible (all eyeballs on), as shown in Figure 5.42.
- 8. Select Image > Adjustments > Levels.

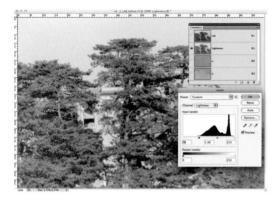

FIGURE 5.41 Adjusting the levels on the Lightness channel.

FIGURE 5.42 The A channel highlighted with all eyeballs visible.

You will now see the Levels dialog box, and you can adjust the color shift by moving the middle slider. If you slide it to the left, magenta increases, and if you slide it to the right, green increases. Move the slider to the right a little, and notice how the green in the trees begins to really pop, as shown in Figure 5.43.

- 9. Choose the B channel.
- 10. Open the Levels dialog box again.
- 11. The B channel contains yellow and cyan; move the middle slider to the left for yellow and to the right for cyan (blue).
- 12. Move the slider a little bit to the right, as shown in Figure 5.44, to bring some more blue to the sky.

FIGURE 5.43 Increasing the green in the image.

FIGURE 5.44 Adjusting the yellow/cyan.

You can see how much color has been restored in this image using the channels in Lab mode. See Figures 5.45a (the original image) and 5.45b (after the final corrections). When you are happy with the result, return to RGB mode (Image > Mode > RGB).

FIGURE 5.45A The image before adjustment.

FIGURE 5.45B The image after adjustment.

Advanced Color Correction with Levels

This technique is a contrast/tone and color correction tool all in one. Once you run through this technique, you will see how just about any image can be improved. You will use this technique many times over. For several years, this was just about the only correction technique I used.

TUTORIAL 5.7

USING LEVELS TO CORRECT COLOR

Open Ch_5_HongKong.jpg from the CD-ROM. Figure 5.46 shows an image from the amazing city of Hong Kong. As you can see, the image lacks a bit of contrast and also has a bit of a color cast to it. It's really not that bad (or is it?); it just looks a bit dirty. You will see a huge difference soon.

- 1. Choose a Levels Adjustment Layer from the Layers Panel. Next you'll correct the settings for the black and white eyedroppers. This will keep the blacks from blocking up and the whites from blowing out.
- 2. In the Levels Panel, double-click the Set Black Point tool circled in red in Figure 5.47.

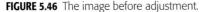

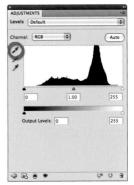

FIGURE 5.47 The black point eyedropper.

- 3. You will see the Color Picker dialog box; set everything to solid black, and then change the setting under B to 5, as shown in Figure 5.48. (This sets the black point to an *almost* pure black.)
- 4. Click OK. Click Yes when asked if you want to save the new target colors as defaults.
- 5. Double-click the Set White Point tool, which is the white eyedropper.
- 6. In the Color Picker, enter 95 into the B setting as shown in Figure 5.49. The white point is now set to 95% white.
- 7. Click OK. Click Yes when asked if you want to save the new target colors as defaults.

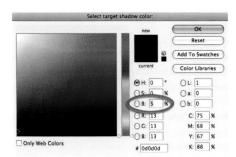

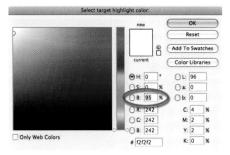

FIGURE 5.48 Black point target.

FIGURE 5.49 Setting the white point.

With your black and white eyedroppers now set, you are ready to perform the image correction by clicking the Set Black Point tool in the darkest part of the image and the Set White Point tool in the lightest part of the image.

- 1. Locate the darkest part of the image. Hold down the Alt key (Option key for Mac), and move the Shadows slider to the right. The image should turn white as you move the slider, and you will see some areas begin to show through. This is the black point threshold, as shown in Figure 5.50. The areas that start to show are the darkest areas of the image.
- 2. Take note of where the dark portion of the image is on the threshold, and return the slider to the far left.
- 3. Choose the Set Black Point tool, and click on the darkest portion of the image in the main image window, as shown in Figure 5.51. The image will be shifted, and the area you clicked on will now be set to the black that you selected in step 4 of the previous task.
- 4. Hold down the Alt key (Option key for Mac), and move the right slider to the left to reveal the whitest point of the image. The image will begin as black, and the highlight areas will show through, as shown in Figure 5.52.

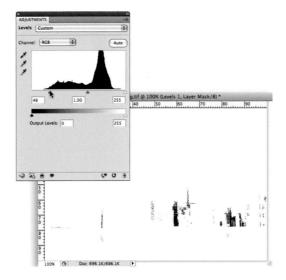

FIGURE 5.50 Finding the shadows.

FIGURE 5.51 Setting the black point.

- 5. Choose the Set White Point eyedropper tool from the Levels Panel.
- 6. Click on the whitest area of the image, as shown in Figure 5.53; the lightness of the image will be adjusted to match.
- 7. The tonal qualities of the image look much better now, and the color cast is reduced a bit. Now you can totally remove the color cast.

FIGURE 5.52 Finding the highlights.

FIGURE 5.53 Setting the white point.

- 8. Choose the Set Gray Point eyedropper from the Levels Panel. When you click on the image with this tool, it chooses the selected area as the gray point of the image and balances all the color to match.
- 9. Click on a portion of the image that should be a neutral gray, such as the small tower on the left in Figure 5.54.
- 10. The colors will shift; if you are not happy, keep experimenting by clicking the Set Gray Point tool in different parts of the image.
- 11. When you are happy with the result, click OK to apply the levels to the image.

FIGURE 5.54 Setting the gray point.

You have now learned how to use the Levels tool correctly. It may seem like a lot to do, but with some practice, you can perform this entire correction in under a minute.

Figure 5.55 shows the image before the adjustment was made; Figure 5.56 shows the final corrected image, which is a vast improvement over the original.

FIGURE 5.55 The image before adjustment.

FIGURE 5.56 The image after adjustment.

Advanced Color Correction with Curves

I covered Curves in the previous chapter as a powerful tool for making tonal corrections and effects. Curves can also be used for color correction. Curves can be considered an advanced color correction method because it is possible to really mess up your images using Curves on color if you don't know what you are doing. Some people avoid using Curves for color correction because it seems so random and difficult. Others do almost all color correction with Curves because of the control and power available. I'll discuss the benefits by showing you how to use Curves for color correction using a fairly simple method. If you have not yet read the section on Curves in the previous chapter, please do so before proceeding.

TUTORIAL 5.8

USING CURVES TO ADJUST COLOR

Figure 5.57 shows an image that has a warm color cast. Open ch_5_Color_Curves.jpg from the CD-ROM or use your own image.

FIGURE 5.57 The image before adjustment.

- 1. Choose a new Curves Adjustment Layer. You now want to sample the color in an area that is showing the excess color. (A good place to begin when dealing with images of people is to sample the skin tones. Accurate skin tones are very important for natural-looking photos.)
- 2. Click on the hand with an arrow to activate the Click and Drag tool as seen in Figure 5.58a. Hold down Ctrl+Shift (Cmd+Shift for Mac), and move your cursor over the image (it changes to an Eyedropper tool). Click on the region that you want to sample, as shown in Figure 5.58b. This adds an adjustment point to each of the color channels. There will be no point made on the initial or RGB composite layer.

FIGURE 5.58A The Click and Drag tool.

FIGURE 5.58B Sampling a region of color.

- 3. In the Channels drop-down menu, choose Red, as shown in Figure 5.59. You should now see the adjustment point near the top of the curve.
- 4. Move the point up to increase red or down to decrease it. In this case, you want to reduce red, so drag the point down and watch the image until the red cast disappears. (If you see no change in the image as you move the curve, make sure that Preview is turned on.) The movements usually need to be very subtle. Here moving the point down creates some red in the darker portions of the image. To combat this effect, put a point down on the lower end of the curve and lift it back up to the center line, as shown in Figure 5.60.
- 5. Judging by the amount of yellow remaining in the image, blue is the next channel that needs the most adjusting. Repeat the previous steps to make adjustments for the Blue channel, as shown in Figure 5.61.

FIGURE 5.59 A point on the curve in the Red channel.

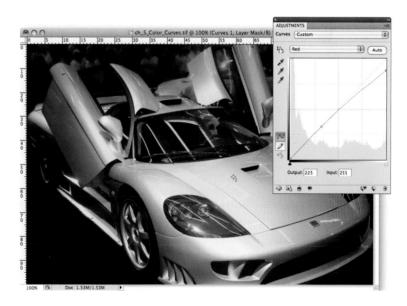

FIGURE 5.60 Adjusting the Red channel.

6. Choose the Green channel and make adjustments as shown in Figure 5.62. You may want to add an additional point on the curve to fine-tune the color correction. Here I have slightly lowered the point in the highlight region and raised the point in the shadow region to bring it back to where it started.

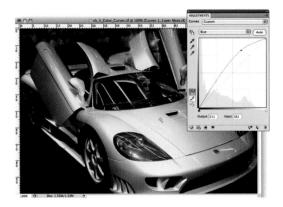

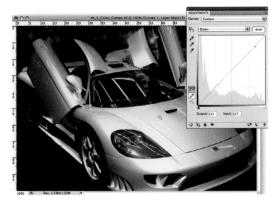

FIGURE 5.61 Adjusting blue.

FIGURE 5.62 Adjusting green.

7. The last thing to do is change the blending mode of the layer to Color. When adjusting color in Curves or Levels, there can be a noticeable increase or decrease in contrast or brightness. This is not always objectionable. If it is, however, changing the blending mode will keep the curves from affecting the luminosity (brightness/contrast). Figure 5.63 shows how to adjust the blending mode on an Adjustment Layer.

FIGURE 5.63 Adjusting the blending mode of the Curves Adjustment Layer from Normal to Color.

Figure 5.64 shows the image after the color adjustments with Curves. Notice that the color cast is neutralized, and other subtle coloring is now evident and much more pleasing. If you want to target different tones in the image, create a new Curves Adjustment Layer and repeat these steps, except for targeting a different color sample.

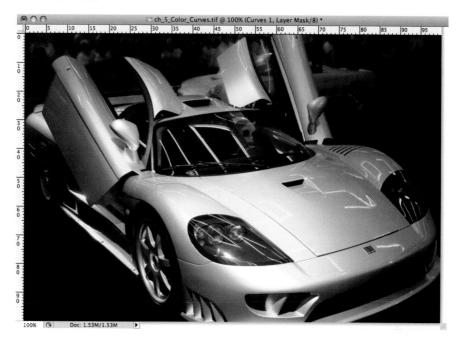

FIGURE 5.64 The image after adjustment.

Reusing Adjustments Settings

When working in the Adjustments Panel, you have the option to save the settings so that they can be reapplied to other images that were shot under similar lighting. Click on the down arrow circled in red in Figure 5.65 to reveal the drop-down menu. Although Adobe has changed the names to Save Curves Preset and Load Curves Preset, they function in the same manner as they always have. Use the Save Preset option to save a setting as a file to your computer. Here is a suggested workflow:

- 1. Open the image.
- 2. Make the adjustment, but don't close the dialog box yet.
- 3. Choose Save from the drop-down menu.
- 4. Choose a folder, and save the setting.
- 5. Click OK to apply.
- 6. Save and close the image.

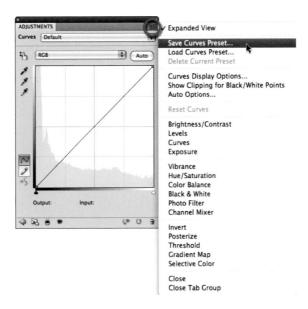

FIGURE 5.65 Saving a curve as a preset.

To load the settings, follow these steps:

- 1. Open an image.
- 2. Choose the adjustment.
- 3. Click the Load button (or Load Preset).
- 4. Locate the setting, and click OK to apply it.

The image will now have the settings applied to it. You can also use these settings with actions to batch process multiple images and save time.

CHAPTER 6

LOCAL ENHANCEMENTS: SELECTIONS AND MASKS

IN THIS CHAPTER:

- Adjustment Layer Mask
- Simple Local Adjustments
- A Photographer's Selection Tools

The ability to tweak color, contrast, and brightness within only select areas of an image is one of the greatest advantages to working in Photoshop. In the traditional darkroom, we called it *burning* and *dodging*. Burning darkens down a tone, and dodging lightens up a tone. We would use everything from complex chemical solutions to cardboard, coat hangers, and masking tape to get the job done. Photoshop, on the other hand, allows you to be far more precise without having to break a sweat.

In this chapter, you'll delve into the world of localized adjustments. The subtle (or not so subtle) changes in color, brightness, or contrast within specific areas of your photo can transform an average image into a work of art. Remember to first imagine how you want your image to look, and then decide on which tool will best accomplish that. Also bear in mind that some adjustments have enough built-in control that selections and masks are unnecessary. Other times, you'll want to be very precise and just apply the change to a specific area. Figure 6.1 shows an example of what can be easily accomplished with a little "burning and dodging." With a little practice, these techniques will become second nature!

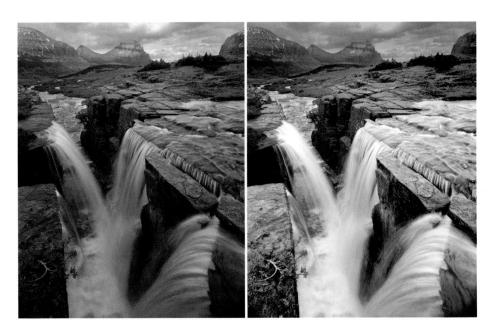

FIGURE 6.1 Before and after burning and dodging.

ADJUSTMENT LAYER MASK

In Chapter 4, we discussed the advantages of working with Adjustment Layers rather than applying the edits directly to your background image. Another advantage of an Adjustment Layer is that it comes with a layer *mask*. This enables you to apply an adjustment to an image selectively. Figure 6.2 shows that an Adjustment Layer is made up of both the adjustment and the mask. To return to our analogy, the Adjustment icon is the knob you turn to create a change. The thin clear plastic is the mask that allows the change to affect the image below (when it is white) or to have no effect on the image below (when it is black). By default, the layer mask is white. This means that the effect of the adjustment is showing through full strength.

To select the mask, click on it with the mouse. If you were to paint on the image with a black brush now, you would paint away the effect. If you were to paint with white, you would paint back the effect. Figure 6.2 shows the Layers Panel with multiple Adjustment Layers and their masks. Figure 6.2 also shows the enlarged thumbnail size. For larger and easier-to-view thumbnails, choose options from the flyout menu at the top right of the Layers Panel.

When working on Adjustment Layers, it's actually not necessary to click on the mask to make it active (unless you have clicked away from the mask). It is just a good habit to get into. Clicking on it once ensures that you are painting on the correct layer. Also when you start masking pixel bearing layers (see Chapters 11 and 12), it becomes critical that you know when you are on the mask or on the layer itself.

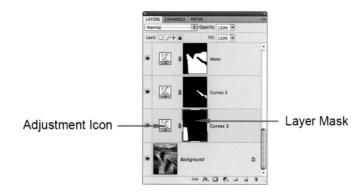

FIGURE 6.2 The Adjustment Layer box.

SIMPLE LOCAL ADJUSTMENTS

Many times, you will want to touch up just a small part of an image but leave everything else as it is. Here is a quick method for achieving those results. In this shot of a painter (see Figure 6.3), the exposure is good on the overall shot, but I should have used a fill flash to throw a little more light onto his face. No problem. We will use an adjustment layer and paint onto the mask to achieve the effect. We will use a Curves Adjustment Layer and similar technique to the one used back in Chapter 4.

FIGURE 6.3 Original image.

- 1. Create a Curves adjustment layer by clicking on the adjustment layer icon at the bottom of the Layers Panel.
- 2. Click the Click and Drag icon circled in Figure 6.4, and click inside the face.
- 3. Drag upward to brighten your curve, as shown in Figure 6.4. His face is now brightened, but the rest of the image has been brightened as well. This is because the white of the mask is allowing all of the curve to come through everywhere across the image.
- 4. Choose the Brush tool, as shown in Figure 6.5.
- 5. Set the Foreground color to black, as shown in Figure 6.6.
- 6. Set the hardness of the brush to 0. This will give the brush a nice soft edge. Circled in red in Figure 6.7 is the button that accesses the brush options. You can also make the brush larger with the Master Diameter slider. Figure 6.8 shows the size of the brush that we used.
- 7. Click on the Adjustment Layer's mask.

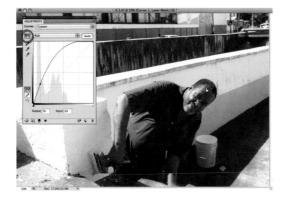

FIGURE 6.4 Brightening up the image.

FIGURE 6.5 Choosing the Brush tool.

FIGURE 6.6 The Foreground and Background color squares.

FIGURE 6.7 Setting the hardness of the brush.

- 8. Paint the parts of the image that you want excluded from the adjustment (see Figure 6.8). Notice that as you paint, the original image shows through, and you are painting away the adjustment. You can also see the black appearing on the mask.
- 9. Paint away all the unwanted adjustment with black. Here I have painted in everything but my subject. This allows the background to look as it did before the Adjustment Layer and also allows the curves to show through only on my subject! You can see the blacked out areas in Figure 6.9.
- 10. Now to fine-tune the Curves Adjustment Layer. As you can see in Figure 6.9, the whites in the bottom of the image look a little too bright. You can fix this by lowering the highlight portion of the curve, as seen in Figure 6.10. As long as you are on the Curves Adjustment Layer (highlighted in yellow), you will have access to that curve in the Adjustments Panel just above it. I have also brought my black point over a bit to darken the black somewhat and keep the shadows looking believable.

FIGURE 6.8 Painting away the adjustment from the unwanted areas.

FIGURE 6.9 Painting away the adjustment with a black brush.

In Figure 6.11a, you can see the before and after. The Adjustment Layer with the mask has only affected the foreground. The rest of the image has been painted with black, and the Curves adjustment doesn't show through. Instant fill flash!

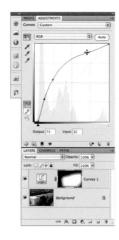

FIGURE 6.10 Fine-tuning the curve.

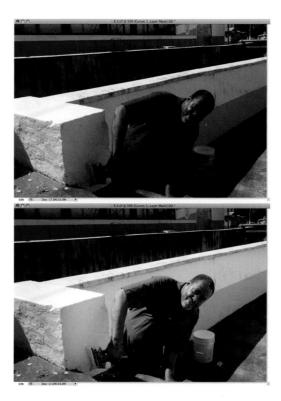

FIGURE 6.11A A selectively adjusted image.

To speed things along, if you have an image where you have to paint more black than white, you can invert your mask first by following these steps:

- 1. Follow the preceding steps 1 through 3 to create an Adjustment Layer with a mask.
- 2. Click once on the mask, and from the menu, choose Image > Adjustments > Invert. This will turn your mask from White to Black.
- 3. Choose your paintbrush, and set the foreground color to White. Now you can paint in the adjustment.

Now that you have worked with masks, it is time to take a peek at the Masks Panel. The Masks Panel is nested with the Adjustments Panel and can be accessed by clicking on the Masks tab, circled in red in Figure 6.11b. This panel will be used to control the attributes of the masks you create. In the previous example, you may have wanted to invert your mask. Instead of going through the Image > Adjustments > Invert menu, you could simply click the Invert button on the Masks Panel instead! This is much quicker.

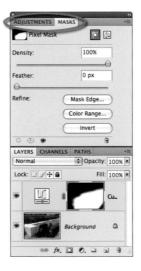

FIGURE 6.11B The Masks Panel.

The main idea here is that when you create an Adjustment Layer, the adjustment applies to the entire image. This is because the mask is white. When the mask becomes black, that adjustment does not apply. This method of working locally on your image is easy and flexible. If you paint "outside the lines," you can just flip the foreground and background colors and paint in the opposite color to cover your mistake. If you spend a fair amount of time working on masks, you may want to remember the "X" keyboard shortcut. Pressing the X key will exchange your foreground and background colors.

Selections

Creating a selection is another way to localize an adjustment. Selections tell Photoshop to "work in this area only." The cool thing about creating selections is that they automatically get turned into a mask when you create an Adjustment Layer. This can save time when painting on the mask. Start with a fast and simple selection, and most of the painting will be done for you. In this next example, we will use a selection to start the process of darkening an overly bright sky, as shown in Figure 6.12.

TUTORIAL 6.1

DARKENING A BRIGHT SKY WITH A SIMPLE SELECTION

Open ch_6_DarkenSky.jpg from the CD-ROM. Figure 6.12 shows that in this image, the sky is just too bright. Darkening it down will greatly enhance the mood of this image.

FIGURE 6.12 Original image with bright sky.

- 1. Choose the Lasso tool from the toolbar.
- 2. Drag with the Lasso tool to draw a circle inside the sky, as shown in Figure 6.13. When you return to where you started, release your mouse. Try to stay inside the area that you want to affect. Do not try to be exact with your lines by drawing right around the edge. Quick and easy is the way to go. You will fine-tune the edge later.

- 3. After you have completed your circle, you will see the marching ants. This is the selection.
- 4. Create a Curves Adjustment Layer. Notice that your selection has disappeared, and it has automatically turned into a mask. Figure 6.14 illustrates this: By creating an Adjustment Layer, the selection turns into a mask. The area you selected is white, and the rest of the image is black.

ADDITIONS
CHARGE COLUMN

COLUMN

CHARGE COLUMN

COLUMN

CHARGE COLUMN

COLU

FIGURE 6.13 Drawing a selection.

FIGURE 6.14 The selection is turned into a mask when a new Adjustment Layer is created.

- 5. Adjust the curve, as shown in Figure 6.15. Creating the selection first gives you the added bonus of being able to see what effect the curves adjustment is having in relation to the area that is not being effected.
- 6. Now simply choose the Brush tool from the toolbar. Choose a nice soft brush (0% hardness), make sure that white is your foreground color, and paint in the effect of the curve. Once again, where the mask is black, the effect of the adjustment layer does not come through. Where you paint it with white, it does show through.

Figure 6.16 shows the much improved image after the darkening down of the sky. It does, however, look a little fake. The water in the foreground is now lighter than the sky, which is an uncommon occurrence. Let's darken down the water somewhat. In this case, you can still paint on the mask you just used. Masks are great because you can always go back and repaint over them if you make any kind of mistake or if you want to fine-tune the mask.

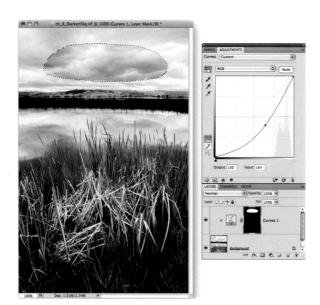

100% (G) Dec. 1.31M/1.74M

FIGURE 6.15 Adjusting the curve.

FIGURE 6.16 The image after the sky has been darkened.

- 1. Click once on the mask to ensure that it is active and not your Background layer. If you do not have the Brush tool active, click on it in the toolbar and again choose White and a Soft Edge. This time, instead of painting in all white as you did in the previous example, paint in a shade of gray. If White lets 100% of the adjustment through and Black 0%, then you can safely assume that a 50% gray will let 50% of the darkening adjustment through. In this case, if you painted with white letting all of the adjustment through, the effect would be too heavy. The water would be too dark.
- 2. To turn your foreground color gray instead of white or black, double-click on the foreground color chip. This will launch the Color Picker dialog box, as shown in Figure 6.17. Inside the Color Picker, type 50 in the B box, which is shown circled in red (B stands for brightness). This will make the new foreground color 50% gray. Notice that you get a preview of the color in the top of the box where it says New, and you can see the white circle in the left of the box indicating that you are halfway up the Color Picker box between white and black.
- 3. Paint in the water in the middle of the picture with your new gray brush. Your mask should look something like Figure 6.18.

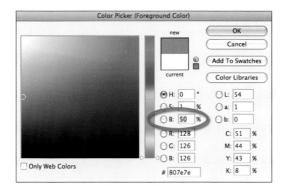

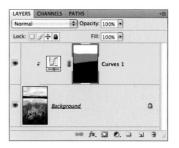

FIGURE 6.18 The mask with gray painted over the water.

Figure 6.19 shows the before and after images. It is amazing what a little localized adjustment can do for an image.

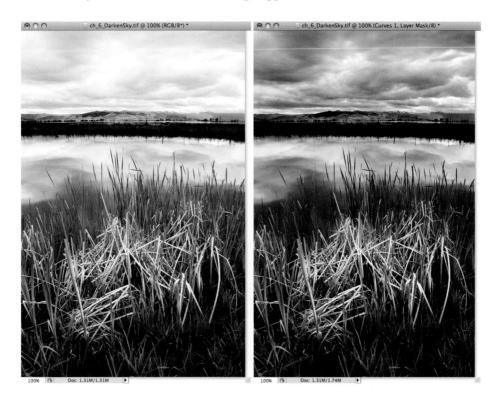

FIGURE 6.19 The image before and after the localized corrections.

A PHOTOGRAPHER'S SELECTION TOOLS

Creating a simple selection with the Lasso tool and then painting on the resulting mask will serve well in countless situations. Sometimes, however, you will be faced with images that need local adjustments within very intricate spaces. In these cases, it may be nearly impossible to paint a mask that will serve your purpose. Figure 6.20 shows an image where we need to make a mask to lighten the foreground. Painting around the trees would be tricky, so we'll use a tool called the Magic Wand to create a very precise selection.

The Magic Wand

The Magic Wand is usually the photographer's first favorite selection tool. It creates a selection by choosing tones that are the same or near to the tone that you click on. Click anywhere in the image, and the Magic Wand will choose that pixel, and then goes through the photo adding other pixels that are similar to it. Presto!

The Tolerance setting in the option bar restricts the Magic Wand's range of tone (see Figure 6.22). A higher value will choose a wider variety of tones, and a lesser value will choose only tones closer to the original. To use the Magic Wand tool, simply select it from the toolbar, and click in the area of the image that contains the color you want selected. The Wand does the rest.

The Anti-Alias box is checked by default. This setting will smooth out the jagged edge of a selection line. Keep it checked. When the Contiguous box is unchecked, the Magic Wand will search the entire image looking for similar pixels to include in the selection. Also when the Contiguous box is checked, it will only select pixels that are both similar in color and adjacent to the original pixel chosen. Both options are useful, depending on the type of selection and photograph you are working on.

TUTORIAL 6.2

USING THE MAGIC WAND

Open ch_6_MagicWand.jpg on the CD-ROM, as shown in Figure 6.20.

- 1. Click on the Magic Wand tool. (See Figure 6.21 for its location on the toolbar.)
- 2. The Tolerance will be set at 32 and the Contiguous box checked on the option bar. Uncheck the Contiguous box for this example. Your option bar should look like the one in Figure 6.22.
- 3. In this image, we want to select the whole foreground of trees, flowers, and grass. With the Magic Wand, click in the tops of the trees. Be sure that you are clicking in the tree and not the lighter background.

FIGURE 6.20 The original image.

FIGURE 6.22 The option bar when the Magic Wand is chosen.

Your selection should look something like Figure 6.23. I didn't get the whole area in one click, so I am going to have to add to the selection.

- 4. Click the Add to Selection button in the left of the option bar (see Figure 6.24). Pressing the Shift key will also cause your selection tool to use the Add To mode. Now click in the parts of the image that should be selected. The Magic Wand will automatically include these as parts of your selection.
- 5. Depending on the tones in the image, you could spend a while clicking around to include all of the pixels. The thing to remember is that the edge is the most important part of the selection. In Figure 6.25, you can see that I stopped when my edge between the trees and the background looked good. It will be easier to take care of those stray, unselected pixels later.

FIGURE 6.23 Image with most of the trees selected.

FIGURE 6.24 Choosing the Add to Selection option.

- 6. Create a Curves Adjustment Layer to brighten up the trees and foreground (see Figure 6.26). Things should look a lot better already.
- 7. I now want to take care of those extra pixels that didn't get selected. Press the Alt key (Option key for Mac) while you click once on your mask in the Layers Panel on the Adjustment Layer. This will reveal the mask in black and white on your image.
- 8. Choose the Brush tool, and pick white as your foreground color. Paint in any of the black areas that should be white in the foreground, as shown in Figure 6.27. This is a much faster way to deal with those stray pixels. When finished, press the Alt key (Option key for Mac), and click on the mask again. Your image will return.

Figure 6.28 shows the final image. If you need a fast selection of an intricate area, the Magic Wand tool can work wonders. Can you imagine trying to paint along the edges of all of those trees?

FIGURE 6.25 Some stray unselected pixels at the bottom of the image.

FIGURE 6.26 Lightening up the foreground with curves.

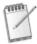

When using the Magic Wand tool, it's often wise also to use the Refine Edge tool to create more elegant and natural edges to your selection. See the section "Refining Selections" later in this chapter.

FIGURE 6.27 The mask made visible.

FIGURE 6.28 The finished image.

Quick Selection Tool

This is a great new selection tool added to CS4. The Quick Selection tool is similar to the Magic Wand in that it creates complex selections . . . kind of quickly. Like the Magic Wand, it relies on adding and subtracting to the selection to create the intricate final mask. It is found under the same tool as the Magic Wand. In this next tutorial, you will use the Quick Selection tool to select just the flower so that you can brighten it without affecting the background.

TUTORIAL 6.3

USING THE QUICK SELECTION TOOL

Open ch_6_QuickSelect.jpg on the CD-ROM, as shown in Figure 6.29.

FIGURE 6.29 The original image.

- 1. Activate the Quick Selection tool by clicking and holding on the Magic Wand tool to reveal it in the flyout menu (see Figure 6.30). In the option bar, set the size of the brush to about 45.
- 2. Starting from one end, click and drag the tool across the flower, as shown in Figure 6.31.
- 3. As you can see, the whole flower was not selected. As with the Magic Wand, however, you can add to the selection. As soon as you are finished with your first drag, the brush automatically turns into the + Quick Selection tool. There is no reason to change anything on the option bar. To add to the selection, simply paint around the inside of the flower. If your next stroke doesn't get it all, give it another paint stroke in an unselected area. If you need to get into smaller areas, you can change the size of the brush in the option bar or

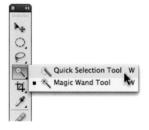

FIGURE 6.30 Activating the Quick Selection tool.

FIGURE 6.31 Painting with the Quick Selection tool.

press the bracket keys []. The left bracket key ([) makes the brush smaller, and the right bracket (]) makes it bigger. You can get this whole flower selected in just a few strokes of the Quick Selection tool (see Figure 6.32). If you over-select (and you will), use the Alt/Option key, and click in the over-selected areas to remove them from the selection, or choose the Subtract from Selection button in the option bar.

4. Now create a Curves Adjustment Layer to lighten the flower. Figure 6.33 shows the final image with the lightened flower. If you find your selection edge is not quite how you want it, keep reading. We will show you ways to fine-tune your edges in the "Refining Selections" section later in this chapter.

FIGURE 6.32 Final selection.

FIGURE 6.33 Final image after applying curves.

Selections with the Color Range Command

The Color Range command is a very powerful tool that allows ample amounts of fine-tuning. Its operation is similar to that of the Magic Wand, except that it chooses its pixels by color rather than density. It also has the ability to only half select pixels. When the Magic Wand or Quick Selection tool makes a selection, the pixels are either selected or not—on or off. The resulting mask is either black or white. The edit you apply, then, say a change in color or brightness, is either applied or it isn't.

The Color Range command can apply the edit in different doses according to the amount that each pixel has been selected. Some pixels will be 100% selected, others 0%, and others could be 20%, 30%, or 60% selected. When a pixel is only 30% selected, it will have only 30% of the edit applied to it. This part of the selection would show on the mask as a shade of gray. This is also what is happening when you apply a *feather* to a selection: The edges are not fully selected and appear as a range of gray in between the pure white and pure black of the resulting mask. Figure 6.34 shows an example image. We started by using the Magic Wand to create a selection. Figure 6.35 is the resulting mask from that selection. Notice that it is comprised of pure white and pure black areas. On or off. Next we used the Color Range tool to create a selection. Figure 6.36 shows the resulting mask from that selection. There are black and white areas, but also a range of grays. These gray areas will allow some of the adjustment through.

The color range can be chosen from the Masks Panel. This allows you to use the power of a color range to create an accurate mask without too much hand painting required.

FIGURE 6.34 Example image.

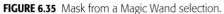

FIGURE 6.36 Mask from a Color Range selection.

TUTORIAL 6.4 USING THE COLOR RANGE SELECTION COMMAND

Open ch_6_SelectColorRange.jpg from the CD-ROM, as shown in Figure 6.37.

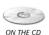

FIGURE 6.37 Original image.

In this example, we will lighten the walkway and ceiling to draw the viewer back into the photograph. Using the Color Range command will make selecting this area very easy.

- 1. Begin by choosing Select > Color Range. You will see the Color Range dialog box similar to the one in Figure 6.38.
- 2. Move your cursor over the main image window, and you will notice that it becomes the eyedropper tool. Click in the ceiling to sample the color green. Use caution when clicking in the window because you do not want to pick up the reddish-green color, just the green. After you click, the black-and-white image area in the Color Range dialog box will change to reflect your new selection, as shown in Figure 6.39. The white is showing you what is selected, and the black is showing you what is not selected.

FIGURE 6.38 The Color Range dialog box.

FIGURE 6.39 Sampling a color with the Color Range eyedropper.

- 3. You need to do some more sampling to select the entire green area of the walkway and ceiling. To add to the selection, click the + eyedropper in the Color Range dialog box and continue to sample the color green in the main image window. You can also click and drag across the image to increase the selection. If you start picking up other unwanted colors, the eyedropper will remove color from your selection.
- 4. To further refine your selection, you can use the Fuzziness slider. Moving this slider to the left will subtract similar colors from the selection. Moving it to the right will add in similar colors to the selection. This is similar to using the Tolerance setting on the Magic Wand.

- 5. You should end up with a selection preview similar to that in Figure 6.40. Click OK in the Color Range dialog box. You will be faced with the now familiar marching ants selection.
- 6. Create a Curves Adjustment Layer to lighten the selected area. If you lighten up the image enough, you will begin to see some areas of posterization where the green meets the red. Figure 6.41 shows the posterized areas circled in blue. The transition between the colors is just too abrupt because the mask is too sharp. This is a common occurrence when using selection tools. You will often need to blur the selection edge. Blurring the edge is similar to painting with a soft-edged brush, as you did earlier in this chapter. One way to accomplish this is by using the Quick Mask option under the Refine Edge command. (More on this in a moment.) Another way is to blur the Adjustment Layer mask.

FIGURE 6.40 The box after adding to the selection.

FIGURE 6.41 The image showing posterization.

- 7. Click on the mask once to ensure that it is active.
- 8. Click on the Masks tab (circled in red in Figure 6.42).
- 9. Raise the Feather slider as you watch your photograph, and watch the posterization disappear. Keep an eye on the edges where you noticed the posterization. You are looking for the point where the harsh transition between the colors disappears. Figure 6.43 shows a smoother transition between the colors after applying a 9px Feather to the mask.

CS4 adds a new feature in the Color Range dialog box that makes it easier than ever to select just what you want. It is called Localized Color Clusters. It is an added feature that allows you to contain how far out you want the Color Range to select. It works in tandem with the new Range slider. What's the difference between Clusters and Fuzziness, you may ask? Fuzziness controls the amount of near colors that get selected. Clusters control how physically close in distance to your eyedropper the color must be to get selected. In Figure 6.44, I have clicked

FIGURE 6.42 The Masks Panel.

FIGURE 6.43 The final image.

on an area of yellow in the upper right. You can see the resulting selection in the Color Range dialog box. Remember that white will be fully selected while black will be completely unselected. Gray will be partially selected.

As you raise the Fuzziness slider, more hues of that yellow get selected, as seen in Figure 6.45. It is now starting to select within the model. This is not the effect we are looking for. What we want is full selection of the background with the model not selected at all.

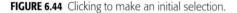

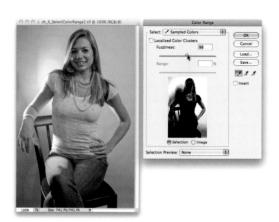

FIGURE 6.45 Raising the Fuzziness Slider.

Now let's try it with using Localized Color Clusters. This will constrain the selection to a smaller spread while still using the Fuzziness to constrain the color. In Figure 6.46, I have checked the Localized Color Clusters box, set the Range to 32, and clicked in the upper-right corner of the image. You can see that a smaller area has been selected.

Chapter 6

Figure 6.47 shows what happens when you click in the lower right. Again, notice how small of an area has been selected. Raising the range allows the selection to go farther out, as seen in Figure 6.48.

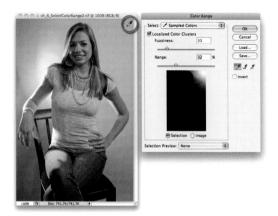

Selection Preview None (\$2000)

FIGURE 6.46 Checking Localized Color Clusters.

FIGURE 6.47 Clicking a different area with the same settings.

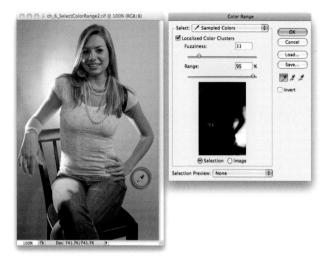

FIGURE 6.48 Raising the Range slider.

So now the trick is to use all of these controls to obtain a good selection of the background. Keeping a low fuzziness will contain the tool to only the yellow and near yellows. Checking the Localized Color Clusters box will constrain how far the selection goes outward from the selected point. I will make one click of the eyedropper tool to start the selection process. As we noted with Figure 6.47, it doesn't select the whole area. The trick now is to *add* to the selection. By clicking on the + eyedropper, you can add in other small areas of yellow. You simply click in other areas of the background to add them into the selection. Figure 6.49 shows the start of the process. Notice how clean the selection is around the arm. Using this tool will take a little practice; just remember it is always a dance between either using the + eyedropper with many add-in clicks or raising the fuzziness to select more with each click. After a few bouts with this tool, you'll be getting great selections in no time!

The Color Range tool is also great for making quick and effective density selections. Many times, you just want to select a density range, like the shadows or highlights or midtones, and be able to apply a simple adjustment to the pixels with this density. Simply click on the Sampled Colors menu to reveal your choices, as seen in Figure 6.50.

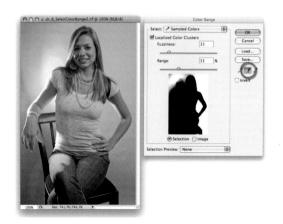

FIGURE 6.49 Using the + eyedropper to add into the selection.

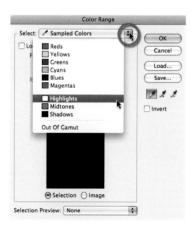

FIGURE 6.50 Choosing a density range to select.

As you can see, the Magic Wand, Quick Selection, and Color Range tools can be used to create very complex selections. These selections would take a very long time to replicate if you were hand painting on a mask. So when do you use a selection tool versus painting on a mask? Which selection tool do you choose? Here are some guidelines.

1. Determine what it is that you want to do to an area. Darken it? Lighten it? Change its color?

- 2. Decide whether or not the adjustment can be accomplished without the use of a selection or mask. For example, changing the color of something may be as simple as using the Hue/Saturation adjustments and picking that color from the drop-down menu (see Chapter 5). Lightening up the shadows could possibly be accomplished with the Shadows/Highlights tool.
- 3. If you try these tools and you find that you will need to work locally instead of globally, it is time to decide on a masking technique.
- 4. Complex selection or hand painting a mask? This will depend on your subject, the surrounding areas, and the edges in between. If the subject and its surrounding area are very different, then perhaps your adjustment will not affect the surrounding area, so painting on the mask will be fine. If your subject and surrounding area are similar, and the surrounding area will be adversely affected by the adjustment, you may need to create a more accurate selection of the area.
- 5. If you have determined that you need to create a complex selection, the next trick is decide which tool to use. Use the Magic Wand if the areas are better separated by brightness. Use the Color Range command if the areas are better separated by color, and use the Quick Selection tool if they are similar in both brightness and color.

Refining Selections

The marching ants that represent selections have been around forever. But it doesn't mean that they are the best tool for the job; it's just all we have had until recently. Adobe gave us a much better way to view selections back in CS3. It is called the Refine Edge tool. In addition to viewing, the tool gives you a chance to modify selections as well. Very rarely do you create a perfect selection on the first go around. But that's okay because this new tool gives you ample opportunities to fine-tune the selection before you turn it into a mask.

When you have any selection tool active, such as the Magic Wand or Quick Selection tool, and a selection active (the marching ants are visible on your screen), you will have access to the Refine Edge command. This command will allow you to modify or refine the edges of your selection. When you are ready to work further with selections, click on the Refine Edge button found on the toolbar. You will see the dialog box shown in Figure 6.51.

The advantage of working with your selections in this dialog box is that you are able to see their true edges. With just the marching ants, it is often difficult to tell how well you have selected an area. The Refine Edge dialog box gives you many ways to preview a selection. The row of icons in the lower section of the box describes how you can view the area of the image that is selected. By placing your cursor over the icon, you receive a description of the view at the bottom of the dialog box. The first icon is the least useful. It is the Standard view. It still

works with the marching ants, so it is hard to envision. One of the most useful is the On White view, which is the fourth from the left. This works well in general and for darker objects. You also may find the On Black view useful for lighter objects. Figures 6.52a–c show a few of the options.

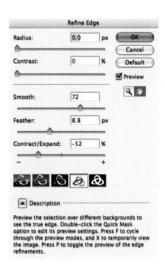

FIGURE 6.51 The Refine Edge dialog box.

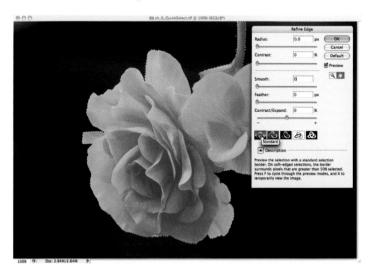

FIGURE 6.52A Standard view.

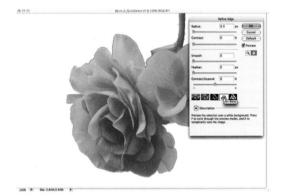

FIGURE 6.52B Preview with white background.

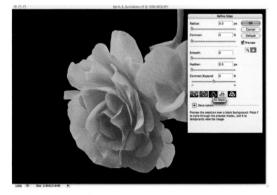

FIGURE 6.52C Preview with black background.

Let's take a look at more options in the Refine Edge dialog box. Switching on the Preview mode will help you see how the edges are being affected by the different options within the tool.

The first option is the Radius slider. By increasing this slider, you are increasing the area around the original edge that will be affected by the settings. Figures 6.53a and 6.53b show the before and after selection in Preview mode. Notice how in Figure 6.53b the increased radius allows the edge to get bigger and how it becomes softer. This will be the effect if this is the only slider that you use. If you use further refinements in the bottom of the box, this radius amount is defining the region in which the other options will operate.

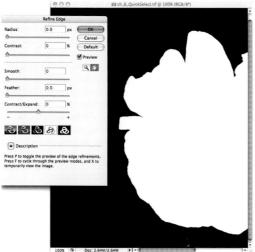

FIGURE 6.53A Original selection in Mask mode.

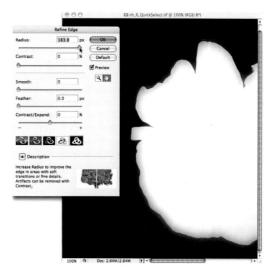

FIGURE 6.53B Selection after the radius has been increased.

The second option is the Contrast slider. This slider's main goal is to remove any fuzzy artifacts that may have become apparent when the radius was enlarged. In this example, we do not have any fuzzy artifacts to work with. Radius and contrast work together to tighten the selection or make it more detailed; but don't turn up radius too much because that's the job of the Feather slider. Another way to think of the radius is that it is used to create a soft enough edge for the contrast to have something to work with.

The Smooth slider does just what you think it may do. It smoothes out the rough edges of a selection. Figure 6.54a shows the On White view before the Smooth slider is increased. Figure 6.54b shows the edge after smoothing.

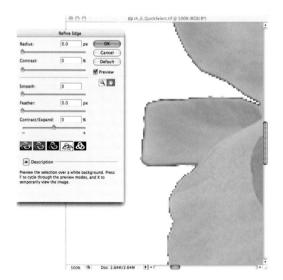

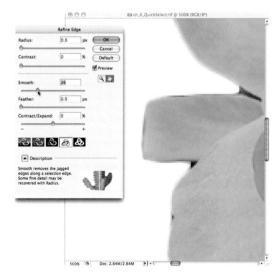

FIGURE 6.54A Original selection in the On White view.

FIGURE 6.54B Selection after the Smooth slider

The Feather slider is similar to the Radius slider in that it "blurs" the edge of the selection. It differs in that it exerts no control over the region that is being worked on by the other sliders; it is chiefly used for blurring the edge. Use the Feather slider to blend your adjustment from inside the selection to outside the selection. In this view, you are seeing the Preview mode again (see Figure 6.55a). Remember that what is white is selected and what is black is not selected. If it is a shade of gray, it is partially selected. This means that only some of the adjustment will come through. Figures 6.55a and 6.55b show the before and after.

The Contract/Expand slider will make your current selection edge grow outward (expand) or inward (contract). If your edge is hard, it will stay hard but just grow inward or outward. If it is soft, it retains its soft nature and contracts or expands. Figures 6.56a and 6.56b show before and after expansion. To get any noticeable amount of expansion, in this case, the Radius slider needed to be increased. Just increasing the Contract/Expand amount was not enough for it to be visible. Increasing the Radius slider increased the region or the area around the edge that will be affected by the Contract/Expand slider (or any of the other sliders as well). This slider comes in handy for removing halos.

Click OK inside the Refine Edge dialog box to commit to the changes that you made. You will be returned to your image with the new selection still active. Remember that you may not see any visible change to the marching ants. Don't worry, though—when you create an Adjustment Layer, the resulting mask will look just like the preview!

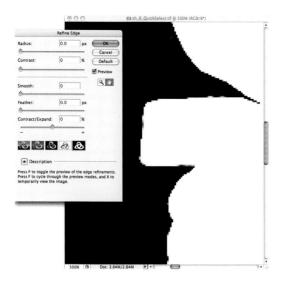

FIGURE 6.55A Original selection in Mask mode.

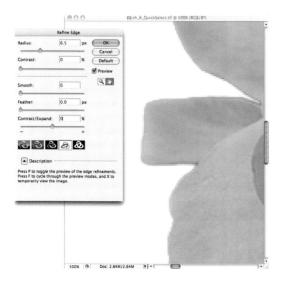

FIGURE 6.56A Original selection in the On White view.

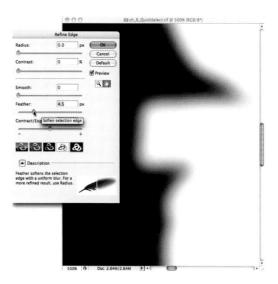

FIGURE 6.55B Selection after the Feather slider has been increased.

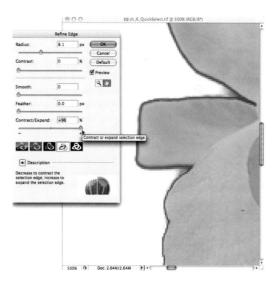

FIGURE 6.56B Selection after the Contract/Expand slider has been increased.

Refining Masks

Modifying the edges of the selection with the new Refine Edge tool is a pretty neat trick. It does have one drawback, however: visibility. The problem with working on the selection occurs when you are masking out an Adjustment Layer. The Adjustment Layer, of course, will produce a change in the image. This change may or may not be obvious at the edges of the selection. With just modifying the selection before the adjustment is made, you have no idea how each side of the selection edge will look.

If you create a good selection first, then create the Adjustment Layer and turn it into a mask, and then modify your mask, you will have a real-time visual of the effects of your edges. You will be altering your mask as it masks out (or reveals) the underlying layer or new Adjustment Layer. The ability to see the changes as you adjust is very important.

Photoshop CS4 has added a new Masks Panel that greatly reduces the time it takes to refine your mask. It even allows the Refine Edge tool to work on a mask as well as a selection! Figures 6.57a and 6.57b show an image where the sky is masked to reduce its contrast and to darken it down some. With the sky darker, it brings more attention to the foreground rocks.

FIGURE 6.57A Before any adjustments to the image.

FIGURE 6.57B After masking and darkening the sky.

When working with a mask, it is always a good idea to click on it once (the mask itself, not the Adjustment Layer) to ensure that you are actually on the right layer and on the mask itself. This will get you into a good habit that will be beneficial to you when you begin to work with multiple Adjustment Layers and multiple images in one document. Figure 6.58 demonstrates how to ensure that the mask is active by clicking on it once. Of course when you click on the mask, it activates the Adjustments Panel as well. Here you can see the corresponding Curves adjustment for the layer. To reveal the Masks Panel, click on the Masks tab.

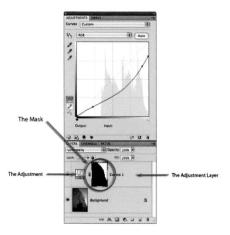

FIGURE 6.58 Clicking on the mask itself.

If you accidentally double-click on the mask rather than single click, it will bring up the Layer Mask Display options box. Just click OK for now. No harm done. The function of this box will be explained later in this chapter.

Once you click on your mask, you are able to modify it in any way that you would a grayscale image. This means you can lighten, darken, increase contrast, use the Clone Stamp tool, blur, sharpen, or apply any other number of filters to it. At the moment, however, you can't really see the mask. This doesn't mean you can't affect it; you just can't see what you are doing. There will be many times when you want to affect the mask without looking at it. One example would be when you have created an Adjustment Layer with a mask, and the new adjustment is adversely affecting the surrounding areas. By working on the mask but looking at your image, you can watch how your edits are affecting the mask. Of course, there are those times that you will want to look at the mask directly. There are two ways you can view a mask:

1. Press the Alt key (Option for Mac), and click on the mask itself. This will overlay the mask in black and white on your image. Figure 6.59 shows the Normal view of the image. Figure 6.60 shows the Mask view. To return to Normal view, just press the Alt key (Option for Mac), and click on the mask again.

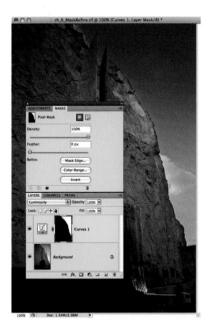

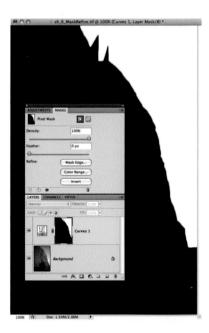

FIGURE 6.59 The image in Normal view.

FIGURE 6.60 The image with the mask visible.

2. Press the backslash key on your keyboard. The backslash key is just to the right of the bracket [] keys. This will show the mask as a semitransparent red overlay on your image, as shown in Figure 6.61. The color and the opacity of this overlay can be changed to suit your needs. Double-click on the mask to bring up the Layer Mask Display Options dialog box (see Figure 6.62). Click OK in this box when you have made the desired changes. The mask overlay will display these new settings until you return to this box to change them. Pressing the backslash key again will return your image to Normal view.

It is beneficial to know both of these options, as neither will work 100% of the time. Sometimes, you may need to see through to your image, while other times it will be easier to work in the black-and-white mode. These are the manual techniques for viewing your mask. When you begin working in the Masks Panel, these overlay modes are also available. Click on the Masks tab to reveal the Masks Panel. When adjusting the sliders in the Masks Panel, you should be looking directly at your image rather than at the small icon of the mask in the Adjustment Layer. This allows you to see in real time the changes you are making to the mask.

The first slider you will see is the Density slider. It is set to 100% by default. This means the mask is at full density. Blacks are black, whites are white (see Figure 6.63a). If you reduce this slider, you will be lightening the blacks and grays on

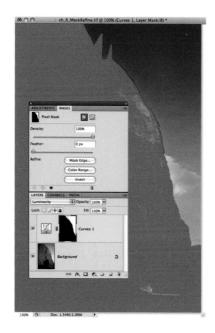

FIGURE 6.61 The image with the mask overlay visible.

FIGURE 6.62 The Layer Mask Display Options dialog box.

the mask (see Figure 6.63b). Remember, the blacks of the mask are blocking the change occurring from that Adjustment Layer. The grays are somewhat blocking the change. The whites allow it through fully. If you lower the density of the mask, the blacks and grays are getting lighter, thus allowing more of that change through to your image.

FIGURE 6.63A Full density mask.

FIGURE 6.63B Mask with reduced density.

The next slider down is the Feather slider. It works just like the Feather slider in the Refine Edge tool for selections. The Feather slider "blurs" the edge of the mask. This creates a transition zone (from black to gray to white), from the adjustment being fully on to fully off (see Figures 6.64a and 6.64b). The Feather slider will affect smaller resolution images more drastically than larger resolution images.

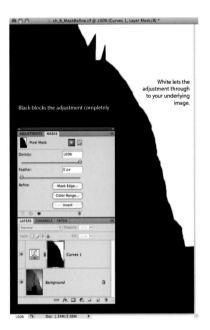

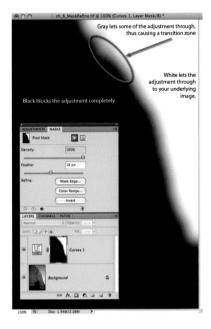

FIGURE 6.64A Unfeathered mask.

FIGURE 6.64B Mask with an 18 pixel feather.

The next section of the Masks Panel is the Refine area. Here you will see the buttons for Mask Edge, Color Range, and Invert. The Mask Edge button brings up the very same control panel that you get with the Refine Edge tool for selections. Here it works on the mask rather than a selection. As mentioned earlier, we find that it is often easier to refine the mask after the fact instead of trying to refine the selection before hand. The reason is that you are refining the mask with the current adjustment applied, allowing you see your image while you work. In Figure 6.65, we have an image where the initial selection/adjustment combination has a caused a halo. Follow along as we fix this using the Refine Edge command in the Masks Panel.

TUTORIAL 6.5

USING THE NEW MASKS PANEL

Open ch_6_MaskRefine.tif from the CD-ROM, as shown in Figure 6.65.

FIGURE 6.65 The original image.

- 1. Click once on the mask you want to affect.
- 2. Choose the Masks tab to reveal the Masks Panel.
- 3. Click on the Mask Edge button.
- 4. Choose the Standard view, as shown in Figure 6.66. Notice that marching ants are obscuring the view.
- 5. On your keyboard, press Ctrl+H (Cmd+H for Mac) to hide the selection. This keyboard shortcut is a toggle, so you can turn the marching ants on and off by repeating this keystroke.
- 6. The problem with this mask is that it is just a bit too small. The curves adjustment is darkening down the sky, but the mask does not go all the way out to the edge of the mountain. You need to enlarge the mask. In Adobe parlance this is called expand.
- 7. Raise the Contract/Expand slider until the halo disappears. We have raised ours to +81, as seen in Figure 6.67.
- 8. Click OK to apply your changes.

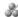

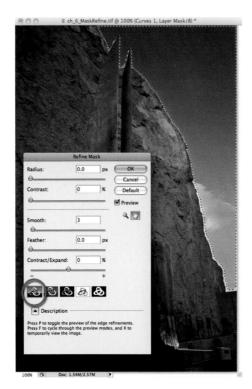

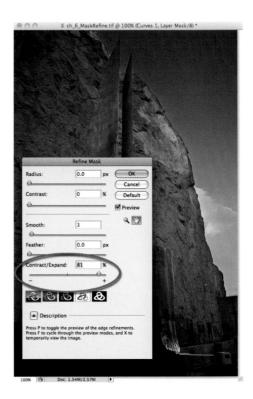

FIGURE 6.66 The Standard view.

FIGURE 6.67 Raising the Contract/Expand slider.

You would follow the same steps to apply any of the other commands such as Smooth, Contrast, or Radius within this dialog box. For the most part, the edge now looks pretty good. And in most cases this is all you would need. Sometimes you may find that the whole edge, however, does not benefit from the same amount of Contract/Expand adjustment. In this case, the area where the wings meet the mountain still shows some halo. This could be fixed manually by going in and painting on the mask. Grab the Brush tool, choose white, and paint where the sky is a little lighter. In Chapter 12, we will show you a technique for fixing a trickier edge in the "Adding a New Sky" tutorial.

On occasion, you can create a mask that has shades of gray as well as white and black (see Figure 6.68). This is not uncommon when using Select > Color Range. In cases like these, you may want to subtly alter the tones in the mask. You can adjust a mask with any adjustment (Curves, Levels, and so on) that work on brightness or contrast. Color adjustments will be grayed out when you are on a mask. To alter the contrast of a mask (remember to click once on your mask first), choose Image > Adjustments > Curves. You could also use Levels.

The adjustment will be reflected on your mask, as shown in Figure 6.69. Remember, white allows your adjustment to be visible, and black restricts it. So as you increase the contrast of a mask like this, you are simultaneously letting more and less of the adjustment through in different areas of the image.

You can also combine the selections with masks. Let's say that on the previous image (see Figure 6.68), you wanted to blur a section of the mask rather than the entire thing. With your mask active, draw a selection of the area that you want to affect. In this example, we will blur the edges of the sky and top of the canyon.

FIGURE 6.68 A view of a complex mask with shades of gray as well as white and black.

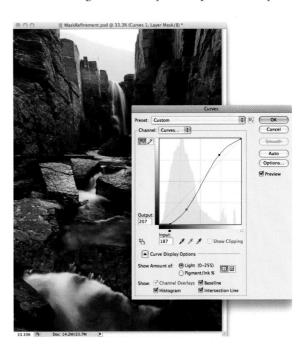

FIGURE 6.69 Using Curves to adjust the contrast of a mask.

Draw a rough selection with the Lasso tool, as shown in Figure 6.70. Next, click the Refine Edge button in the Masks Panel. You need to blur the selection to ensure a good blur on the mask, as shown in Figure 6.71.

To blur the mask, you would think you could just use the Feather slider in the Masks Panel. Not so. For some reason, the panel ignores the selection. So we will use a trusted old technique. With the selection active (and your desired mask active), select Filter > Blur > Gaussian Blur, and adjust the radius to suit your needs. Remember to go to Select > Deselect when you are finished! Figure 6.72 shows the result of selectively blurring a mask.

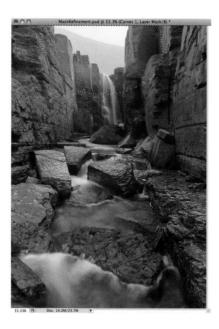

FIGURE 6.70 Creating a selection on a mask.

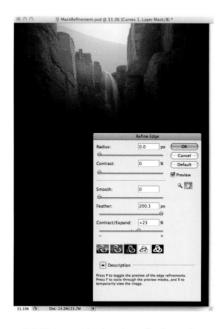

FIGURE 6.71 Blurring the selection using the Refine Edge command.

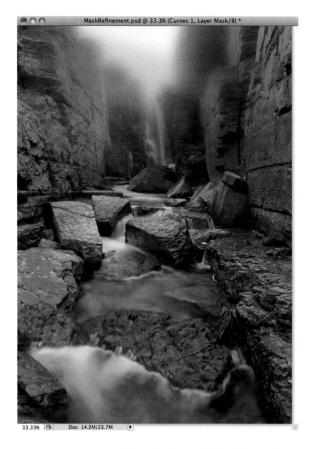

FIGURE 6.72 A mask that has been selectively blurred.

Download Workflow

- 1. Download images
- 2. Review, reject, rate, and label
- 3. Apply metadata
- 4. Organize into separate folders if necessary
- 5. From Bridge, open desired image or images into Adobe Camera Raw (ACR)
- 6. Global adjustments in Camera Raw
- 7. Local edits in Camera Raw
- 8. Open image(s) into Photoshop

Local Editing Workflow

- 1. Bridge or Lightroom are used for the first steps of our workflow: organizing, cataloging, cropping, and various global adjustments. The next step is to move into Photoshop.
 - a. If you have come from Bridge and ACR, the image on the screen has not been saved yet. It is a copy of your RAW or JPEG image with changes made in ACR. Before going any further, save your image! Give it a meaningful name, and pay attention to which folder you have saved to! I typically type an "M" at the end of the original file name to designate that it is the master file.
 - b. If you have come from Lightroom, your image has already been saved as a copy of your original RAW or JPEG. It will typically have the word "edit" added to the file name to differentiate it from the original.
 - c. Whether you are coming from Bridge or Lightroom, it is always important to save your image as you are working on it in Photoshop. The old adage is *save early, save often*.
- 2. In Photoshop, perform any edits that are not possible in the Raw Converter.
 - a. More specific cropping or rotating with Photoshop's Crop tool.
 - b. Fix distortion and/or perspective and straighten your image with the Lens Correction Filter.
- 3. Use Photoshop to perform advanced tonal edits:
 - a. Shadows/Highlights
 - b. Curves
- 4. Use Photoshop to perform advanced color correction and enhancement:
 - a. Variations
 - b. Match Color
 - c. Lab Color
 - d. Levels
 - e. Curves
- 5. Touch up your image using advanced tools, such as the Patch tool and Healing Brush (see Chapter 9). Combined with layers and masks, these tools provide more precision and flexibility than their cousins in ACR or Lightroom.
- 6. Perform local edits using the power and precision of Adjustment Layers, selections, and masks.
 - a. Curves
 - b. Brightness and Contrast
 - c. Levels
 - d. Photo Filter
 - e. Hue/Saturation
- 7. The next step is to show off your images. Printing and emailing is covered in the next chapter.

CHAPTER 7

SIZING AND PRINTING YOUR IMAGES

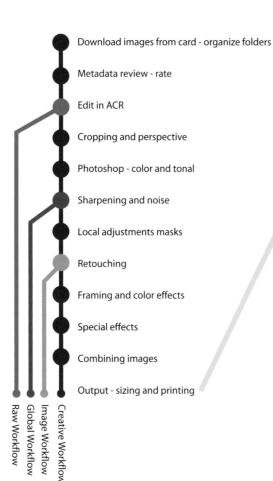

IN THIS CHAPTER:

- Resizing Things
- Printing Proportions
- Printing Your Photographs

In this chapter, we'll show you how to take the images you have worked so hard on and turn them into beautiful photographic prints. Making great prints is more than a click of a button, however. So we'll start the chapter off with an explanation of resolution and how it influences the size of your photographs and the size of the final print. Next we cover the topic of image resizing, an important step in the creation of well-crafted print files, as well as high-quality images for email or the Web. We'll conclude with the important topic of color management and show you how to ensure that your prints match what you see on your monitor.

RESIZING THINGS

After all of your hard work on your images, it is finally time to share them! Before you do that, though, it is important that you resize the images correctly for either the print or the screen. So, let's jump into a little theory before you begin printing your images. If you are not comfortable with resolution and resizing algorithms, this section will help you. If you are already familiar with the concept, you should still skim through this material in case you missed some of the recent upgrades.

Resolution

Whatever the reason for resizing your images, there are a few things that you should know. The first thing you should understand is *resolution*. Resolution is how many pixels there are in an image. We measure resolution in pixels per inch (ppi), which is the measure of the number of pixels displayed in an image within a given inch. A digital image is composed of samples that your screen displays in pixels. Adobe Photoshop uses ppi for image resolution, but you may hear it called dots per inch (dpi) as well. Dpi, however, is the measure of the resolution of a printer. It properly refers to the dots of ink or toner used by an image setter, laser printer, or other printing device to print your text and graphics. In general, the more dots, the better and sharper the image. Dpi is printer resolution. When we refer to resolution, we will be referring to ppi.

There are three main target resolutions for Photoshop files:

Offset printing: The best resolution for the professional offset press printing world is generally 300 ppi (half the target linescreen).

Inkjet printers: Use 360 ppi for Epson printers and 300 ppi for Canon, HP, and Lightjet printers. Lightjet (or similar technology) printers are the machines primarily used by photo labs and online photofinishers.

Online: The standard resolution for Web and multimedia use is 72 ppi; this is also known as *screen resolution*. Do not confuse this with sending your prints over the Web to be printed. The resolution for these types of printers should be posted by your online photofinisher, but is typically 240 or 300 ppi.

If you try to use an image with insufficient resolution, there are not enough pixels to provide a sharp display and, as a consequence, *pixelization* occurs, also known as "the jaggies." Figure 7.1a shows an image at the correct resolution, and Figure 7.1b shows an image suffering from the jaggies.

FIGURE 7.1A Photo has sufficient resolution.

FIGURE 7.1B Having insufficient pixels causes jaggies.

For the technically minded, you can estimate how large an image will print by using the following formula:

Image size in pixels × Target resolution × Output size in inches

For example, if an image is 500 pixels wide, and you want to output at 300 ppi, then $500 \times 300 \times 1.667$. So the maximum size you can output this image at 300 ppi will be 1.667 inches. The same image would be 6.9 inches at 72 ppi $(500 \times 72 \times 6.9)$. Both sizes contain exactly the same number of pixels because the image itself has not been altered. No pixels have been added in or taken out. Only the target size of the existing pixels has been changed. When you change only the target resolution, the process is called *resizing*. When you change the dimensions and the resolution, you will be resampling (interpolating).

Any time you change the number of pixels in an image, you will lose some quality. Sometimes it is noticeable, and sometimes not. This is called *resampling*. Resampling is when you alter all the pixels in an image. When you change the physical size of a document, pixels have to be added or discarded and the image re-rendered. If you increase the size of an image without adding in more pixels, the photo doesn't have the pixels to fill the new size, so pixelization may occur. To solve this problem, you add in more pixels (upsampling). When you are reducing the size of an image, all the pixels are mashed together, and Photoshop has to throw away some pixels (downsampling).

A 6-megapixel camera will (roughly) yield a 7×10 print at 300 ppi. If you want to make a bigger print, you will need to upsample (add in pixels). If you want to make a smaller print, you will downsample (throw out pixels).

Image Interpolation

By now, you may be thinking what is the point in resizing an image if you are going to lose quality? Well, the loss of quality when printing is nothing new. Photographers have been experiencing this since the first enlarger was invented. Every time we enlarged a negative to make a print, we experienced a loss of quality. The loss of quality was there; we just didn't notice it. It is the same situation with digital files and resizing. Think of your digital file as a negative from your old film camera. When you made 3.5×5 or 4×6 prints, they looked perfect. If you made an 8×12, it still looked great. Now take that same negative and try to enlarge it to a 32×48 print. There would be an obvious loss of quality.

Digital images behave in the same way. Almost any current digital camera will produce great 8×10 prints, even though to get there, the image must be resized. Most can even produce fine 11×14 prints. It is usually above this size that the point-and-shoot style cameras will start to reveal artifacts or a loss of quality from the upsizing process. This of course is a general statement, and some cameras in this class can and do produce fine prints at this size and larger. At this point, it becomes more a matter of the viewers' tastes and their ability to recognize quality loss. Beginning photographers are less likely to be able to spot imperfections in their final prints, while a 20-year veteran will be more finicky about the results. Suffice it to say that if you are making 8×10 to 11×14 prints from your digital camera, you need not have any fear of upsampling your image!

The studious team of engineers at Adobe realized that you may want to change the size of your images at some point, so they incorporated a technology into Photoshop called *image interpolation*. Interpolation is a popular term in the scanning world. Chances are that your digital camera also has a form of interpolation—definitely if it uses digital zoom (a feature that should be avoided most of the time). Digital zoom analyzes a picture and, based on the pixel information, interpolates, or calculates, what pixels should be created to fill in all the gaps. The camera's interpolation engine will then kick in and draw the missing pixels just like magic. In theory, this works well, but you are better off not using the digital zoom. Instead, shoot using only the optical zoom (the zoom provided by your lens), and then crop and upsize using the tools provided by Photoshop.

The advantage to resampling in Photoshop is that you have a choice of interpolation methods. (Adobe calls these *resizing algorithms*.) The interpolation method you choose will depend on the size and type of image you are resizing. There used to be only three methods, but two new methods were introduced in Photoshop CS (Bicubic Smoother and Bicubic Sharper). In Photoshop CS and CS2, these algorithms were a bit of a mystery. To figure out which method was best for what kind of image, I developed a test chart that you can print out with your image. This chart shows both text and line art. You can find this image (ch_7_Interpolation-chart.tif) on the CD-ROM. Include this with a photo and try out the different interpolations. Figure 7.2 shows an image with the chart overlayed.

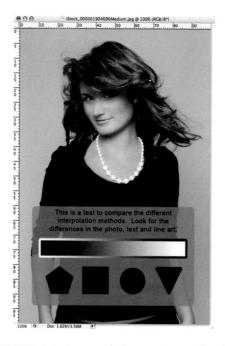

FIGURE 7.2 An image with the test chart overlayed.

Figure 7.3 shows the interpolation drop-down menu that was provided in older versions of Photoshop, but it's not much help. The folks at Adobe have helped us out with the new drop-down menu introduced back in CS3. Figure 7.4 shows that we are now assisted in our decision making.

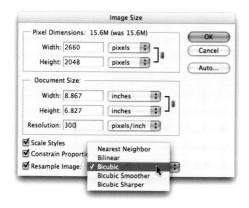

FIGURE 7.3 The old interpolation drop-down menu.

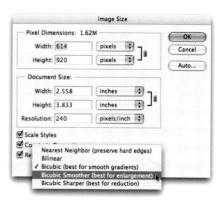

FIGURE 7.4 The new (more helpful) drop-down menu.

Here is a breakdown of the interpolation methods and their uses:

Nearest Neighbor: This method bases decisions on the adjacent pixels and is the lowest quality setting. It is best for line art type images.

Bilinear: This is a medium quality setting, good for solid color and text. It looks at the four pixels on the two sides, the top, and the bottom of each existing pixel.

Bicubic: This is high quality; it uses the eight surrounding pixels and is the default setting for most images. It's a good "Jack of all trades" setting.

Bicubic Smoother: This is the best setting for upsampling images.

Bicubic Sharper: This is the best setting for downsampling images, according to the Adobe engineers. Be careful, though, because it can sometimes add unwanted sharpening. Try it first to see if it is appropriate for your image.

At first appearances, the only time you have access to different interpolation modes is when you open the Image Size dialog box. However, whenever you use the Free Transform tool, interpolation is applied to the transformation. The Transform tool uses the settings in Preferences. You can set the method in the Preferences dialog box, shown in Figure 7.5. The default is Bicubic, which is a good general-purpose setting. This preference will be applied to all transformations and scaling.

When you change the resampling method setting in Preferences, the new setting is applied right away, and you don't have to restart Photoshop as with some of the other settings.

FIGURE 7.5 Setting default interpolation in Preferences.

- So as you see, resizing your photos is not a problem. However, you do not
 want to make a photo smaller (downsize), and then turn around and make it
 bigger (upsize). Upsizing an already downsized image will degrade its quality.
 For this reason, you should always start with your master file (the one with all
 of the local edits, not your original RAW or JPEG) and make copies of that for
 printing.
- 2. So let's say I have an original file named 1234.dng. This image gets turned into a Photoshop file once I begin working on it in Photoshop. I will give it a name like 1234_M.psd to let me know that it is the master. Or if Lightroom names it for you, it will read something like 1234-edit.psd. If I want to make a 5×7 print, I will open 1234_M.psd and immediately do a File > Save As. This creates a copy. I would name it 1234_5x7.psd. Now that I have a copy of the master file, I am free to resize and sharpen my image. If I then I want to make an 8×10 print, I reopen 1234_M.psd and do another File > Save As. This time I name my file 1234_8x10.psd. Now in my folder I have four images:

1234.dng: Original RAW file.

1234_M.psd: Photoshop file with all of my layers and adjustments. 1234_5x7.psd: This is a copy of my master file sized to a 5x7 print. 1234_8x10.psd: Another copy of my master file sized to a 8x10 print.

So the mini workflow for this section would look like this:

- 1. Edit your original in ACR or Lightroom, then move to Photoshop.
- 2. If you are coming from ACR, immediately do a File > Save As and put _M (for Master) in the file name to differentiate it from the original.
- 3. If you are coming from Lightroom, just begin working. Lightroom has just made a master file for you and named it with –Edit.
- 4. Complete your corrections or enhancements in Photoshop.
- 5. Save.
- When the time comes to make a print, open up the master file.
 Do a File > Save As and save your file with the print size in the name (for example, 1234_5x7.psd).
- 7. Resize the file.
- 8. Sharpen if necessary.
- 9. Print.

Sizing an Image for Print

You have taken the plunge; now you are going to resize an image to make a print. We will first explore the easiest and most direct way of doing this. Then we will explore the subtleties of the process.

- 1. From the menu bar, select Image > Image Size.
- 2. You will now see the dialog box shown in Figure 7.6, which displays the current image size and resolution of your picture (circled in red).
- 3. The photograph that this dialog box reflects is 6.8×10.24 inches high at a resolution of 300 ppi.
- 4. If you wanted to make a print that was 8×12, you would simply click inside the Width box and type in 12. The Height box would automatically change to read 8, as shown in Figure 7.7.
- 5. Click in the Resolution box, and type in a resolution of 300.
- 6. Click OK. That's it. You have just resampled your image! Wasn't that easy?

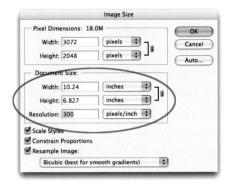

FIGURE 7.6 The Image Size dialog box.

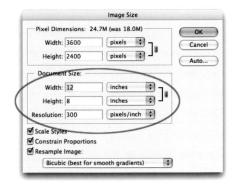

FIGURE 7.7 Setting the Width automatically changes the Height setting.

Okay, so that is the fast and easy way to size your image so that it will print out at the correct size and resolution. Let's explore what else is going on inside the Image Size dialog box (see Figure 7.8).

When you first opened the Image Size dialog box, some boxes were checked by default.

Scale Styles: Keeping this box checked ensures that any styles you have applied to layers will stay the same size as the corresponding layer. Without this button, any layer styles will look like a child wearing his parent's clothes, or an adult wearing a kid's clothes. We will use some layer styles in Chapter 11, "Special Effects." Usually, you just keep this checked.

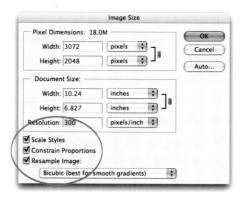

FIGURE 7.8 Options inside the Image Size dialog box.

Constrain Proportions: This is the box that allowed you to just type in 12. Because the proportions are constrained, the other dimension has to be 8. When this box is checked, it keeps you from stretching and morphing your image out of shape. This should be checked most of the time, unless you have a specific creative interest in turning your image into taffy.

Resample Image: Keeping this box checked gives Photoshop permission to add in or take out pixels. This is typically what you want to do when you enter into this box, so keep this checked. There may be times, however, when you want to change the resolution of the image without adding in or taking out pixels. In this case, uncheck the Resample Image box.

Now for the resolution. As mentioned earlier, if you are printing to an Epson printer, type in a resolution of 360 ppi. If you are printing to any other home printer or you are taking your file to a lab, type in a resolution of 300 ppi.

Another place to look for information is at the top of the box. Here you will find the Pixel Dimensions area (see Figure 7.9). Think of this as your overall file size. It reflects all three channels of your image. Like film, digital files have three layers (channels) consisting of Red, Green, and Blue. The combination of these layers creates all the colors that are visible in your image. This image comes from a 6-megapixel camera, so if you were looking down on the file, you would see a rectangle made up of roughly 6 million pixels. But if you were to look at the cross section, you would see three layers of 6 million pixels each. Three layers of 6 million equals 18 million pixels (roughly). So the pixel dimensions can be thought of as the total depth of your file. In this case, we have an 18MB (megabyte) file. So when you resample an image, the pixel dimensions change to show how big the file will become. In this example (see Figure 7.10), when we upsample our image to 8×12 at 300 ppi, Photoshop tells us that the image was 18MB but will be 24.7MB after the upsample.

Widtn: 3072	pixels	Cance
Height: 2048	pixels 🗘 🕽	Auto
Document Size:		
Width: 10.24	inches	
Height: 6.827	inches 🗘 🕽 🕯	
esolution: 300	pixels/inch 💠	
Scale Styles		
Constrain Proportion	5	

Pixel Dimensions: 24.7M (was 18.0M) OK Wint 2600 Cancel Height: 2400 pixels Auto Document Size: Width: 12 inches . 8 Height: 8 inches pixels/inch Resolution: 300 Scale Styles Constrain Proportions Resample Image: Bicubic (best for smooth gradients)

FIGURE 7.9 The Pixel Dimensions area.

FIGURE 7.10 The pixel dimensions change when you resample.

The Pixel Dimensions area (circled in Figure 7.10) helps you see whether Photoshop is going to upsample or downsample an image when you type in a new resolution and dimensions. Sometimes when you first open the Image Size dialog box, your resolution may show 72 ppi. The image could look like the one in Figure 7.11, which is 42.6×28.4 at 72 ppi. Is this image larger or smaller than the previous image of 10.24×6.8 at 300 ppi (see Figure 7.12)? They are the same size. A quick look up to the Pixel Dimensions area shows that they are both 18MB files.

The last thing you need to focus on in this dialog box is the interpolation method. Earlier in the chapter, we discussed the different methods and their uses. For photographers, our choices are pretty easy. When you upsample, you use Bicubic Smoother, and when you downsample, you use Bicubic Sharper.

FIGURE 7.11 Image with a resolution of 72 ppi.

FIGURE 7.12 Same size image with a resolution of 300 ppi.

There are some exceptions to this rule that we will discuss shortly. So after typing in your Width, Height, and Resolution values, look up to the Pixel Dimensions area. If your image is getting bigger, choose Bicubic Smoother. If the image is getting smaller, use Bicubic Sharper.

Sizing Your Print for the Web or Email

Have you ever received a photograph via email that appears to be 10 times bigger than your monitor? You have to scroll around just to see the entire image! If you learn how to size your image properly, you can teach your friends how to do it and save some aggravation. Sizing your image for use over the Web, whether it will land on your Web site or a friend's inbox is a snap. The first thing to realize is that the target for this type of sizing is someone's computer screen. Computer screens have a resolution just like printers. Some common resolutions are 800×600 , 1024×768 , or 1280×960 . The newer LCD monitors are even bigger. These resolutions are the height and width measured in pixels. So if someone sends you an image that is 3072 pixels long by 2048 pixels wide, and you try to view it on your 1024×768 monitor, you will only be able to see a small section of it. The problem is that they didn't shrink their image to fit on your screen! Figure 7.13 demonstrates the theory.

FIGURE 7.13 Email image too big to fit on your screen.

Most monitors these days are about 1024×768 or larger. This means that if you resize an image to be no taller than 600 or wider than 600, anyone will be able to view it. Sizing for email is similar to sizing for print.

- 1. From the menu bar, select Image > Image Size.
- 2. This time around, we are only concerned with the top of the Image Size dialog box (see Figure 7.14).
- 3. Find the longest dimension, in this case, the height, and type in 600. Figure 7.15 shows the resulting size of your image, 600 pixels wide by 400 pixels high small enough to fit on screen but large enough for the viewer to enjoy it. You can also see that the overall size of the file has dropped from 18MB to 703KB. This is rather small, but it will become even smaller in the next step!

FIGURE 7.14 The Image Size dialog box.

FIGURE 7.15 The resulting size of the file.

- 4. Choose File > Save As.
- 5. When you get to the Save As dialog box, choose to save your file as a JPEG. Give it a name, and save it to a folder that you will remember. Click Save.
- 6. Next the JPEG Options dialog box appears, as shown in Figure 7.16. For the highest quality image, choose Quality 12, or move the slider all the way to Large File. Even at this setting, your image is now only 190KB! You could email 10 images of this size with an email program that has a 2MB attachment limit.
- 7. If you really need to get the size down, move the slider to the left to decrease the file size. You can watch your image and look for the first signs of image degradation. You can also check the Preview box on and off to monitor the amount of degradation. (We chose Save As rather than Save for Web because Save for Web in CS4 defaults to the sRGB colorspace, which is best for Web. But if you are emailing the picture, Adobe RGB is better because it will maintain your color settings.)
- 8. Click OK.

FIGURE 7.16 The JPEG Options dialog box.

That's it, and it couldn't be easier. But you may be thinking, "That's fine for one image, but I have 30 images that I want to email. Is there a way I can do it faster?" Sure.

Batch Sizing Images for Email

If you have a lot of images that need to be resized to the same dimensions, take a visit to File > Scripts or Bridge and check out the Image Processor. This tool will allow you to create multiple files and file types from a folder full of images.

- 1. Working within Bridge, put all of the images that you want to size in one folder. Navigate Bridge to this folder.
- 2. After your images are in the content pane of Bridge, choose Edit > Select All from the menu.
- 3. Go up to the menu again and choose Tools > Photoshop > Image Processor. You will see the Image Processor dialog box, as shown in Figure 7.17.

Step 1 of the dialog box is for RAW files. It allows you to open the first image and apply RAW settings, and then the processor will apply those RAW settings to the rest of the batch. You should adjust your images individually first, and then leave the Open First Image to Apply Settings box unchecked.

By default, step 2 of the dialog box will have the Save in Same Location option selected. This is as good a place as any to save your files. It will create a new folder within this existing folder. But if you want them to be easily accessible, you can click the Select Folder button and select any folder that you want to store them in.

In step 3 of the dialog box, all the magic happens. Check the Save as JPEG box, and type in a Quality of 12. Next check the Resize to Fit box, and type in 600 in both the W and H boxes. Doing this will fit all of your images into a 600-pixel square box. No need to worry about whether the image is horizontal or vertical.

Check the Convert Profile to sRGB box. (This will keep your colors looking good if you're going to the Web.) Uncheck the Save as PSD and Save as TIFF boxes (unless you want to make extra copies of these images).

Click Run. Photoshop will take over and open up each one of your files, resize them, and save them as JPEGs while you go and get a cup of coffee!

Do some experimenting with the sizing of your images to determine what size works best for you and those who receive them. For some, 600 pixels in the longest dimension might be too small, and for others too big. To try out some different sizes, following the earlier sizing directions for a single image. Create some at 400 pixels, 600 pixels, and 800 pixels. Open them in Photoshop, and view them at Actual Pixels setting (from the menu, choose View > Actual Pixels). You could do the same thing by double-clicking on the magnifying glass. This will show you the approximate size of the image as it will appear on the Web or on your friend's monitor. Because all monitors are different, you can never be sure, but this definitely gets you in the ball park.

Increasing the Image Size Beyond 200%

Earlier in the chapter, we mentioned some guidelines for upsampling your images. Theory once said that if you go beyond double the original file size, your image will lose too much quality. There are ways, however, to break this rule.

As a rule of thumb, Photoshop does a good job of downsizing your image. With upsampling, you need to be more careful. There are a couple of ways of doing this. The first is simply to use the Bicubic Smoother interpolation method. The earlier theoretical limits were based on the old Bicubic Interpolation method. We have made some large prints (24×30) using Bicubic Smoother and found the results to be very agreeable.

The second is called *Stair Step interpolation*. This technique is credited to photographer Fred Miranda. The idea is that when enlarging to more than twice the original file size (say an 18MB file to a 40MB file), it's best to help Photoshop by choosing a size that is easy to calculate. If you size in increments of one-tenth (10%), you will find that the overall quality is better. This makes it possible for Photoshop to add or remove pixels in an even way.

It can take a while to keep enlarging an image many times, so this is a great time to create an action. We have included a simple action on the CD-ROM, under the file name PSDP_Colin_Smith.atn. There are two actions in this set. The first is a 110% enlargement in a single step. The second is the same enlargement five times, which will save a bit of time.

To load an action, follow these steps:

- 1. Open the Actions Palette (choose Window > Actions).
- 2. Choose the drop-down menu at the top right of the palette.
- 3. Choose Load Actions.
- 4. Navigate to the action on the CD-ROM.
- 5. Click OK.

You are now ready to run the action. Click on the action itself (upsample by 10%), not the action set labeled PSDP. To run the action, click the right-facing arrow in the bottom of the Actions Palette. When you are running an action, you will no longer be viewing the Image Size dialog box. How will you know when you have reached your target size? Click on the arrow on the bottom left of the Document window (the status bar). Choose Document Dimensions for the preferences.

Third-party products are also available for resizing images, including the following:

- Alienskin Blow up at http://alienskin.com/blowup/index.html.
- Genuine Fractals at www.ononesoftware.com.
- Fred Miranda's Stair Interpolation Action at www.fredmiranda.com/ software/.

PRINTING PROPORTIONS

Have you ever noticed that images never seem to quite match up with standard print sizes? You want an 8×10 print, but the lab tells you that they will either need to crop the image or make it smaller. This can be frustrating, especially in very carefully composed images. This mismatch has its roots in early photography when cameras had proportions of either 8×10 or 5×7. Photographic paper companies would manufacture paper to match these negative sizes. This is where we get the common paper sizes of 5×7, 8×10, and 11×14—none of which match up with our current negative or digital file proportions (called *aspect ratio*) of 1×1.5.

Figure 7.18 shows a typical 35mm proportion. Figure 7.19 shows the image as it would be cropped to fit on 5×7 paper. Figure 7.20 shows how it would appear on 8×10 paper. As you can see, the forced cropping really affects the impact of the image. To keep the visual balance in this image, you would only want it to appear as a 1×1.5 proportion. The other crops just don't work as well.

FIGURE 7.18 The original size file.

FIGURE 7.19 The image cropped to a 5×7.

FIGURE 7.20 The image cropped to an 8×10.

If you try to print one of your 35mm files to a print size of 5×7 , it won't work because the proportions are wrong. It could either be 5×7.5 or 4.6×7 . The only proportions that will work without cropping are 2×3 , 4×6 , 8×12 , and so on. Any other proportion, such as 8×10 , 8.5×11 , 11×14 , and so on, requires cropping. Return to the Crop tool, and type your desired dimensions into the option bar. See Chapter 3, "Cropping and Perspective," for more information on cropping.

PRINTING YOUR PHOTOGRAPHS

Photoshop has a few interesting features when it comes to printing. The most important thing to note, as mentioned earlier in this chapter, is the printing resolution.

As a reminder, 360 ppi is the native resolution of an Epson printer. You can also choose 240 ppi or 180 ppi if you want a smaller file size that will print faster. You may experience a slight drop in quality. For a Canon or HP printer, choose 300 ppi. Likewise, 150 ppi will work for smaller file sizes or contact sheets. Please also note that these printers will interpolate the images to match their native resolution. There is no advantage in trying to print at a higher resolution because the prints will still be downsized. Don't be fooled into thinking that because the printer has a higher dpi rating, a higher pixel resolution will produce a higher quality print.

Color Management

When you are printing your photos, the most frustrating thing is when the colors don't match what you see onscreen; but it is possible to get very accurate prints for your system.

The first thing you need to do is calibrate and profile your monitor. You need a sensor to read the colors on your screen. LaCie, X-Rite, Pantone, and Datacolor all market affordable solutions. These devices are placed on the screen and read the colors as the included software calibrates your screen. When you use these devices, make sure that your room's lighting is set to your typical working conditions. You then install the included software and follow the onscreen instructions. This is very easy to do. (For more information on color and color management, see Chapter 5, "Color Correction and Enhancement.")

After your monitor is calibrated, recalibrate every week or so to ensure that it's accurate. Warm up the monitor before running a calibration because the colors will change as the tube warms up. This is not so much an issue with LCDs, which are good enough for accurate color work. In the past, LCD technology lagged a little, and photographers didn't trust those monitors for high-end color work. Just be sure that you are using a display that is as high quality as your budget allows.

When working on an image, be sure to use the color profiles in Photoshop. We recommend the setting Adobe RGB (1998); this is the most popular setting in the industry. If you are working with an image that is unprofiled, assign Adobe RGB from the Edit > Assign Profile menu. If you are shooting RAW images, choose the Adobe RGB option before opening the image into Photoshop. These color profiles will ensure that the colors are consistent between different systems and devices. You can choose Adobe RGB (1998) as the default from the Edit > Color Settings menu.

Printing Colors as Accurate as You See Onscreen

Photoshop CS4 allows for a very accurate preview of what your image will look like when it prints. This "preview" is called *soft proofing*. This technique will change the appearance of your file on the monitor to match the results you will see on paper.

Soft proofing is done with profiles. The better or more accurate the profile, the closer your monitor will look to your final print. Profiles are individual. One profile matches one type of printer with certain ink and one type of paper. During the initial loading of your printer driver (when you first install your printer), you are actually loading up profiles as well. The profile for a matte paper is a separate profile from glossy, which is a separate profile from semigloss. If you print on 10 different kinds of papers, you will need 10 different profiles.

Some printers from Epson actually take you to the Epson Web site to load up the latest profiles directly from them! Make sure you have an active Internet connection when installing this software. After installing the Epson printer driver, click on Color Management Solutions, and then click on Premium ICC Color Profiles. This will take you to the Epson Web site to download the latest profiles. Three different sets are currently available on the Web site: Glossy Papers, Matte Papers, and Fine Art Papers Matte. We recommend downloading all three (each one is a separate download). Click on either Mac (Apple) or Win (Windows) to start the download.

If you are using a PC, the downloading will start an automatic install. If you are using an Apple, the download will place an icon on your desktop, which you then need to double-click to start the installation of your profiles. The profiles are stored in the following places:

- On a Windows XP or Vista machine, the profiles are stored in the Color folder inside your C drive. Find it by opening C:\Windows\System 32\ Spool\Drivers\Color.
- On an Apple machine, the profiles are stored in a Profile folder. Find it by opening up your hard drive, and choosing Library\ColorSync\Profiles.

Setting Up the Soft Proof

Start by creating the image you want. Adjust contrast, color, and anything else that needs taking care of. Now, in theory, the print that comes out of the printer should look like your screen, right? Well, sometimes. You can ensure a more accurate print by using a soft proof. This will actually change the image on the screen to look more like the print coming out of the printer. To do this with your image open, follow these steps:

1. Go up to View > Proof Setup > Custom. You will see the dialog box shown in Figure 7.21.

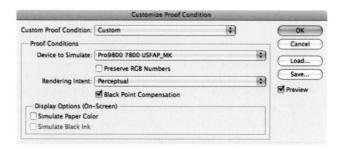

FIGURE 7.21 The Customize Proof Condition dialog box.

- 2. In the Device to Simulate drop-down list, choose the printer *and* paper that you want to print with. Both of these items create one profile. In this example, we have chosen to print with the Epson 7800 with UltraSmooth Fine Art Paper.
- 3. Under Rendering Intent, choose the option that looks the closest to your original. Perceptual, Saturation, Relative Colorimetric, and Absolute Colorimetric are your choices. Go through the options, and click on and off the Preview check box to ascertain the closest match. Remember the setting you choose here because *you will need this later*. All other boxes should be set as they appear here.
- 4. Click OK, and your image will now be a better match to your print! Depending on the printer, paper, and profile, you may or may not see any change to your print.
- 5. Press Ctrl+Y (Cmd+Y for Mac) to toggle the proof on and off. If you see no change, you are in the money. If you do see a change, now is your chance to fix the problem before it goes to print. Adjust as necessary.
- 6. When you are happy with the way your print looks onscreen, it is time to navigate to Photoshop's new Print dialog box (see Figure 7.22).

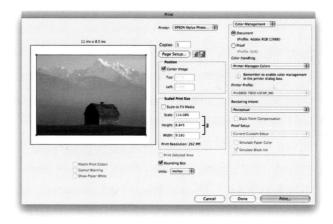

FIGURE 7.22 The new Print dialog box.

CS4 has upgraded the old Print with Preview dialog box and consolidated a lot of options. It is now much more user friendly to open the Print dialog box (choose File > Print). It is a good idea to get in the habit of checking each option in this box. Following is a list of the options and some suggested uses.

- 1. Start at the top and work your way down. From the Printer drop-down list, choose the printer you will be using.
- 2. Click on the Page Setup button to set your paper size and orientation.
- 3. If you uncheck the Center Image box, you can move the print around on the page.

- 4. You should probably ignore the Scaled Print Size area. We hope you have already sized your image to fit on the page using techniques discussed earlier in this chapter, which provide more controllable results.
- 5. Clicking the Bounding Box check box will also allow you to resize your image. Drag the corner handles to change its size.
- 6. Moving to the upper-right of the dialog box, you see the Color Management menu. You can click here to change the lower display to Output options, although most of these are for graphic designers. Return this to Color Management to proceed.
- 7. In the Color Management area, leave the Document option selected rather than the Proof option. This will take the document that is on your screen to the next step.
- 8. By default, Color Handling reads Printer Manages Colors. Because we are working with profiles, we want Photoshop to Manage Colors. Choose this option, as shown in Figure 7.23.

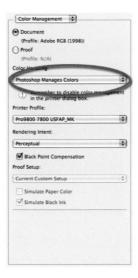

FIGURE 7.23 Setting the Color Handling option.

- 9. Choose the printer profile that you used to soft proof your image. Here we are printing to an Epson 7800 printer using UltraSmooth Fine Art Paper with matte black ink. That is what USFAP_MK stands for in this profile.
- 10. The last step before clicking Print is to choose the Rendering Intent. Use the one that you thought looked most like your original image back in the soft proof stage. Perceptual is a good choice if you forgot to soft proof.
- 11. Click Print.

The next step is the printer's own Print dialog box. Every printer manufacturer will have different options. You may even see differences from one model to the next within a certain line of printers! Following is a list of the things that should be checked to ensure high print quality:

- Choose the type of paper or type of media you will use.
- Set the highest print quality for best results. If you are working on an Epson, only choose the highest (2880) option when you have a lot of very smooth gradients in the image. For the most part, 1440 is fine.
- Uncheck High Speed Printing if that is an option. This setting allows the print head to lay down ink when it travels both back and forth, which can lower the print quality.
- Turn off the printer's color management so that the image is not twice color managed, or you will get some weird results.

On a Mac, click on the Layout drop-down menu and choose Printer Settings, as seen in Figure 7.24a. This will reveal all of the settings you need to check, as seen in Figure 7.24b.

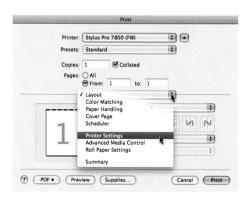

FIGURE 7.24A Choosing Printer Settings from the drop-down menu.

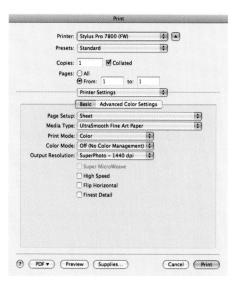

FIGURE 7.24B The Printer Settings area of the printer's dialog box.

In Windows, choose high-quality printing and avoid all the color enhancement features. Choose the ICM option button in the Color Management area, and then select No Color Adjustment. Figures 7.25a/b show screen shots from a PC printing with an Epson Stylus 2400.

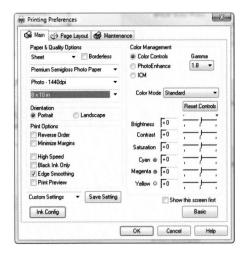

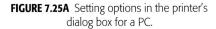

FIGURE 7.25B Choosing ICM reveals the No Color Adjustment option.

If you followed these directions, your print should now be very close to what you see onscreen. If not, make sure you have the correct paper and ink installed. If you still have trouble, consult your printer manufacturer.

Creating a Test Print

It's a good idea to print a small portion of the image to see how it will look before committing the time, ink, and the expensive sheet of paper that it takes to print a full page.

To do this, take a smaller portion of the image, print it, and then check it for color and tone accuracy. You could also take a few sheets of photo paper and cut them into smaller pieces to print on, thus reducing waste. Here is a strategy for creating a test print:

- 1. Open the image you want to print.
- 2. Choose the Rectangular Marquee tool, and make a selection around the portion of the image you want to print.
- 3. Choose Edit > Print with Preview.
- 4. Check the Print Selected Area box. The selected area will be printed in the center of the page.

Choosing Paper

When you want the best quality print from your printer, you will need to use the best paper. The two main manufacturers of quality photo printers are Epson and Canon, and both manufacturers make their own paper. These papers are specially formulated to produce the best results from the chemical composition of the specialty inks used. Therefore, if you are using a Canon printer, Canon photo paper will yield the best results, whereas Epson paper will produce the best images from an Epson printer.

Download Workflow

- 1. Download images
- 2. Review, reject, rate, and label
- 3. Apply metadata
- 4. Organize into separate folders if necessary
- 5. From Bridge, open desired image or images into Adobe Camera Raw (ACR)
- 6. Global adjustments in Camera Raw
- 7. Local edits in Camera Raw
- 8. Open image(s) into Photoshop

Local Editing Workflow

- 1. If you are coming from ACR, immediately do a file save as and put _M in the file name to differentiate it from the original.
- 2. If you are coming from Lightroom, just begin working. Lightroom has made a master file for you and named it with –edit.
- 3. In Photoshop, perform any edits that are not possible in the Raw Converter.
- 4. Use Photoshop to perform advanced tonal edits.
- 5. Use Photoshop to perform advanced color correction and enhancement.
- 6. Touch up your image using advanced tools, such as the Patch tool and Healing Brush (see Chapter 9). Combined with layers and masks, these tools provide more precision and flexibility than their cousins in ACR or Lightroom.
- 7. Perform local edits using the power and precision of Adjustment Layers, selections, and masks.
- 8. Save.
- When the time comes to make a print, open up the master file.
 Do a File > Save As and save your file with the print size in the name (for example, 1234_5x7.psd).
- 10. Resize the file.
- 11. Sharpen if necessary (see Chapter 8).
- 12. Print.

CHAPTER 8

SHARPENING AND NOISE REDUCTION

In this chapter, you will learn about sharpening and noise reduction. These two techniques can seem to fight against one another, but in a correct balance, they can happily coexist in the same image. Bear in mind that these techniques will assist in enhancing your images, but they are not substitutes for good photography. For instance, correctly focusing the camera, holding it steady, and using adequate lighting and correct exposure will minimize the need for sharpening and noise reduction. Mistakes made in the field are among the hardest things to fix in Photoshop. Often, the outcome is worse than the original. So be careful and apply the following techniques with subtlety. Over-sharpening is a sure fire way to alert your viewers to your technique (or lack thereof) rather than image content.

Even the newest digital cameras don't produce perfectly sharp images right from the camera. That being said, prints that are smaller than the original files, such as photos for email, 4×6s, or 5×7s, typically will not need sharpening. However, when you are creating a print that is larger than the original file, some amount of sharpening is usually needed. This of course is not set in stone. Some people prefer a sharper "look" than others. A portrait may need less sharpening than an image with lots of detail, like a landscape or an architectural photograph.

An important point to remember is that you generally *do not* want to sharpen the original RAW file or the master file that contains all of your edits. Sharpening should always be done to a copy after it has been resampled—either upsized or downsized. So a review of the workflow would look like this:

- 1. When the time comes to make a print, open up the master file. Save your file (using File > Save As) with the print size in the name, for example, 1234_5x7.psd.
- 2. Resize the file.
- 3. Sharpen if necessary.
- 4. Print.

SHARPENING YOUR IMAGES

There are many ways to make your images appear sharper. Whether you are going to email a small JPEG or print an 11×14, you will need to consider the overall image sharpness. Following are four different options for getting the job done.

Unsharp Mask

The most common method for sharpening images goes by the most unusual name: Unsharp Mask. What this oddly named filter does is detect the sharp changes in tone in the image, and then it says, "This must be an edge." The Unsharp Mask

then brightens one side of the edge and darkens the other side to make it look more pronounced, and the result is a sharper image with more edge definition. The way this is done is by Photoshop creating a blurred copy of the image and then masking it. The difference between the original and blurred mask adds contrast. You have control over three attributes of the filter:

Amount: This is how pronounced the effect will be by adjusting the amount of the mask applied to the original image. The result is a change in contrast. The lighter pixels on one side of the edge will be brightened, and the darker pixels on the other side of the edge will be darkened as you increase the amount.

Radius: This is the amount of blurring applied to the mask. The brightening and darkening effect will increase outward from the original edge as you increase the radius. If you turn this all the way up, you will see a "halo" around the edges.

Threshold: This determines what Unsharp Mask interprets as edges by adjusting the sensitivity of edge detection. This is useful for protecting textures while sharpening edges. Portraits are a popular way of using these controls.

TUTORIAL 8.1

SHARPENING AN IMAGE USING UNSHARP MASK

Open ch_8_OperaHouse.jpg from the CD-ROM. Figure 8.1 shows the image, which could use a little bit of sharpening.

FIGURE 8.1 Image in need of sharpening.

- 1. Choose Filter > Sharpen > Unsharp Mask. You will see the Unsharp Mask dialog box, as shown in Figure 8.2.
- 2. Click anywhere in the image to sample that region. This new region will appear in the preview area of the dialog box.
- 3. Use the + and buttons to zoom in or out of the image. The default view is 100%. The preview is best viewed at either 100% for 8×12 images or smaller. A 50% view provides better results for images larger than 8×12.
- 4. Make sure the Preview box is checked so that you can see the result on the image.
- 5. First, adjust Amount according to the image and how much sharpening you want to apply. Usually 100 is a pretty good starting place.
- 6. Adjust Radius to get a good result without making the effect look artificial and filtered. Between 0.5 and 2.0 usually works well.
- 7. You may need to go back and forth between Amount and Radius a few times to get a good balance. Remember that you should sharpen a bit higher for buildings than you would for people; sharpening people is not flattering because it can bring out flaws in their skin.
- 8. Finally, set Threshold. In this case, keep it at 0, which tells Photoshop that everything is an edge and to sharpen all edges. If you were sharpening a person's face, you might use Threshold to ignore certain things such as the face's texture. The higher the threshold, the more contrast must be present to be affected.
- 9. When you are happy with your settings, such as in Figure 8.3, click OK to apply the effect.

FIGURE 8.2 The Unsharp Mask dialog box.

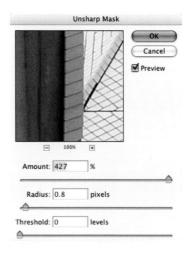

FIGURE 8.3 Setting the options in the Unsharp Mask dialog box.

Fading the Sharpness (Optional)

Immediately after applying a filter, you can use the Fade option to adjust the intensity of the effect. This option is available only when the previous command was a filter. It is not available after you have done anything else to the image, even changing the visibility of a layer or channel.

To apply this effect, follow these steps:

- 1. Choose Edit > Fade *name of last filter*.
- 2. Adjust the Opacity if needed; keeping it at 100% retains all sharpness, and moving it toward 0% reduces the sharpening effect. Next set the blending mode to Luminosity (see Figure 8.4). This will ensure that the sharpening effect does not introduce any color artifacts. The completed image is shown in Figure 8.5.

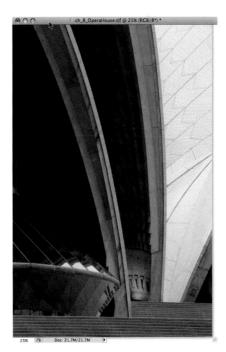

FIGURE 8.4 Changing the blending mode to Luminosity.

FIGURE 8.5 The sharpened image.

It's best to avoid overdoing sharpening because it can make an image look too harsh and artificial. All corrections should be done with subtlety.

Here is a method for setting the sliders that we have found to be fairly foolproof with almost all types of images. Begin by prepping the box before actually starting to sharpen:

- 1. Open the Unsharp Mask dialog box (Filter > Sharpen > Unsharp Mask), and set the Amount to 500, the Radius all the way to the left at 0.1, and the Threshold to 3.
- 2. Move the Radius slider up one click at a time (one-tenth) until the image starts to look over-sharpened. You will notice it first in the sharpest edges. It's easiest to highlight the number in the Radius box and press the up arrow key to move this in small increments.
- 3. Move the Amount slider to below 100%.
- 4. Your box is now prepped. Give your eyes a break by looking around the room for a minute or so to readjust them to what real sharpness looks like.
- 5. Now to sharpen the image, slowly increase the Amount slider until the image looks properly sharp. Remember that at 500, it was too sharp, so it will be somewhere less than that.

Sharpening Using Lab Mode

In previous chapters, we moved into the realms of Lab mode as a way of correcting images. Lab mode is also great for sharpening images because you can apply the sharpening to just the Grayscale channel. This has two advantages:

- It prevents any color shifting because the color information is untouched.
- It minimizes the introduction of noise to the image. Sometimes there is a lot of noise or grain in the color of a photo, particularly in the blue regions. If you were to sharpen the blue, it would also accentuate the grain and noise.

Open the image ch_8_Brugge.jpg from the CD-ROM or use one of your own images. Figure 8.6 shows the image before sharpening.

- 1. Convert to Lab mode by choosing Image > Mode > Lab Color.
- 2. Choose the Channels Panel, and click on the Lightness channel, as shown in Figure 8.7.
- 3. Apply the Unsharp Mask in the usual way by selecting Filter > Sharpen > Unsharp Mask.
- 4. Choose the best settings for your image, as shown in Figure 8.8.
- 5. Click OK to apply the sharpening effect.
- 6. Click on the top channel to display all the channels and preview the image in color again.

Figure 8.9 shows the image after sharpening through the Lightness channel. This is a great way to apply sharpening. When you are finished, you can convert the image back to RGB mode.

FIGURE 8.6 Image before sharpening.

FIGURE 8.7 Choosing the Lightness channel in Lab mode.

FIGURE 8.8 Applying the Unsharp Mask.

FIGURE 8.9 The sharpened image.

Smart Sharpen

One of the biggest complaints concerning sharpening is that it introduces noise. When you sharpen an image, you also sharpen the grain. With the Smart Sharpen filter, however, you can now mostly sharpen an image without sharpening the grain.

If you examine a digital photograph, you will notice that most of the noise is introduced in the shadows and halos in the highlights. This new filter allows you to sharpen the midtones only and isolate the highlights and shadows. By isolating the midtones, you can avoid sharpening the noise.

Figure 8.10 demonstrates an Unsharp Mask on the image. Notice how much noise has been introduced as the image is sharpened. (Note that Unsharp Mask will not add noise to all images, only those that already contain excessive grain, such as high ISO images or low-light conditions.)

FIGURE 8.10 Unsharp Mask introduces noise.

TUTORIAL 8.2

USING SMART SHARPEN

Let's use Smart Sharpen to work on this image. Open ch_8_Smart.tif from the CD-ROM.

- 1. Choose Filter > Sharpen > Smart Sharpen.
- 2. Make your sharpening adjustments without worrying about noise at this point (see Figure 8.11). Amount controls the strength of the effect, and Radius controls the width of the effect. Use either the Gaussian or Lens type of sharpening. Motion is useful for an image that has a streaky blur.
- 3. Click on the Advanced option button and click the Shadow tab (see Figure 8.12).
- 4. Only two sliders really concern you:

Fade Amount: This is the strength of sharpening in the shadows. Slide to the right to lesson the sharpening in the shadows.

Tonal Width: This determines how dark the shadows are. Slide to the right to include some midtones.

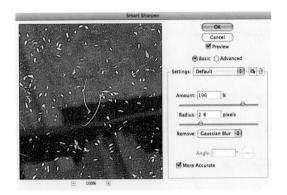

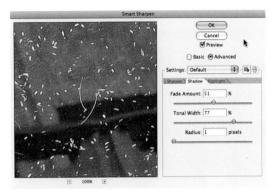

FIGURE 8.11 Smart Sharpen settings.

FIGURE 8.12 Fading the shadows.

- 5. Continue adjusting the Fade and Tonal Width sliders until you have the maximum sharpening and minimum noise in the shadows.
- 6. Click on the Highlight tab (see Figure 8.13).

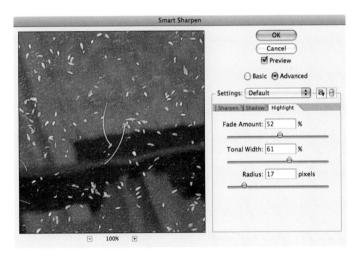

FIGURE 8.13 Fading the highlights.

- 7. These sliders work the same way as they do in the Shadow tab. Make adjustments to the Radius if needed; you can usually leave it alone. (This filter is based on the same technology as Shadows/Highlights.)
- 8. Return to the Sharpen tab, and make some tweaks if you desire. Click OK to apply the filter.

Figures 8.14 and 8.15 show the comparison between Unsharp Mask and Smart Sharpen. Notice in Figure 8.15 that the image has been sharpened but almost no noise has been introduced. This is a good sharpening effect because it's not obvious that the image has been sharpened.

FIGURE 8.14 Sharpened with Unsharp Mask.

FIGURE 8.15 Sharpened with Smart Sharpen.

TUTORIAL 8.3 NONDESTRUCTIVE SHARPENING USING HIGH PASS FILTER

This technique, sometimes called High Pass Sharpening, sharpens the image very well and is not destructive. It is called nondestructive because it does not affect the original image. Instead, it works through a layer that we will call a *sharpening layer*. We use High Pass Sharpening to keep the sharpening effect to a minimum in smooth areas, such as skin tones or blue skies.

Open ch_8_HighPass.jpg from the CD-ROM. Figure 8.16 shows the image before sharpening.

- 1. Duplicate the Background layer by dragging the layer thumbnail to the New Layer icon in the Layers Panel.
- 2. Change the blending mode of the new layer to Overlay, as shown in Figure 8.17a (this will be the sharpening layer). Don't be alarmed when your image changes a bit because that will be remedied shortly.
- 3. Choose Filter > Other > High Pass (see Figure 8.17b).
- 4. Turn on Preview, if it isn't on already.

FIGURE 8.16 Image before sharpening.

FIGURE 8.17A The sharpening layer with its blending mode set to Overlay.

FIGURE 8.17B Adjusting the High Pass Filter.

- 5. Lower the Radius setting to 0.1. Your preview should turn gray. Raise the Radius until you start to see the lines in the image begin to appear. This setting, or a little higher, should be just what you want. A lower setting will give you less sharpening, and a higher setting will give you more. The lines you are seeing in the Preview box are the ones that will be sharpened.
- 6. Click OK to apply the effect to the image. 🔏

Your image is now sharpened, as shown in Figure 8.18. If you ever want to reduce the sharpening effect, just lower the opacity of the layer. If you want to remove the sharpening effect altogether, just delete the sharpening layer.

FIGURE 8.18 The final sharpened image.

NOISE REDUCTION

With film, we had to deal with grain, and with digital cameras, we have to deal with noise. There are two types of noise:

Luminosity Noise: Monochromatic noise—there are no colored speckles, just grain.

Color Noise: Colored speckles, usually blue or red dots.

Usually noise is introduced when the lighting is low, or the ISO is turned up on the camera. Whenever you can, use a lower ISO, shoot with a slower shutter speed, and open up the aperture. The techniques you are about to learn are the same for reducing both noise and film grain.

TUTORIAL 8.4

USING CHANNELS FOR NOISE REDUCTION

On older SLRs or point-and-shoot cameras, it was common to see most of the noise in one or two channels—usually the blue and green. The following techniques work wonders for reducing noise in files from these cameras. The first technique corrects the offending channel(s) rather than trying to correct the entire image. The second involves the use of a blur on the image. The last uses a type of blur in Lab mode to reduce the noise in the Lightness channel. For folks with newer cameras, jump ahead to Tutorial 8.5, "Noise Reduction Filter."

Open an image that contains noise, such as the one shown in Figure 8.19. This file titled ch_8_Chan_noise.jpg can be found on the CD-ROM in the Chapter 8 folder.

FIGURE 8.19 The beginning image.

- 1. Enlarge your image to actual pixels (100% magnification). Choose the Channel Panel. Open it from Window > Channels if it is not already open.
- 2. Click on the Blue channel thumbnail to view the Blue channel by itself, as shown in Figure 8.20a. Notice that all of the eyeballs are off and the Blue channel is highlighted. This means that only the Blue channel is visible, and it is the only active channel. When all of the eyeballs are on, all channels are visible. The highlighting shows which channel is active (meaning if you do something like blur, it will happen to the active channel). The Blue channel shows clumpy noise in the darker areas of the image.

- 3. Also check out the Green and the Red channels by clicking on their thumbnails. You will notice that most of the noise is in the Green and Blue channels. These are the channels that we'll blur.
- 4. To help fine-tune the results, you want to look at all of the channels, but only have the Blue channel active. Do this by clicking on the Blue channel thumbnail so its eyeball is on and it is the only channel active (highlighted).
- 5. Click the eyeball in the composite RGB channel to make all channels visible, as shown in Figure 8.20b.

FIGURE 8.20A Viewing the Blue channel.

FIGURE 8.20B Highlighting the Blue channel but viewing all channels.

- 6. Choose Filter > Blur > Smart Blur, and adjust the settings to smooth out the shadow areas of the image. You will be looking at the black-and-white preview inside the Smart Blur dialog box (not your main image), as shown in Figure 8.21.
- 7. Raise your Threshold to the max of 100. Beginning at 0.1, slowly slide the Radius slider to the right until the noise is smoothed out. You might now find that the edges are soft (where black meets white is too blurry). To fix that, lower your Threshold until you achieve a balance between good noise removal without too much edge blurring. Clicking on the image inside the box toggles the preview on and off. Click OK when satisfied.
- 8. Smart Blur will render and be applied to your main image window. If you find that it blurred the edges too much, immediately choose Edit > Fade Smart Blur. This gives you a chance to lower the intensity of what you have just done.
- 9. Click on the Green channel thumbnail, and then click the eyeball of the composite in the RGB channel.

Chapter 8

FIGURE 8.21 Running the Smart Blur Filter on the noisy channel.

- 10. Repeat the same blur process to this channel as well.
- 11. Choose the RGB thumbnail from the Channels Panel to return to the normal color view.

Figure 8.22 shows before and after channel blurring. This is not a perfect solution for all images, but it works wonders on those older camera files you may dig up! &

FIGURE 8.22 Before and after blurring the channels.

Reducing Luminosity Noise with Smart Blur

Open an image that has some noise or grain, as shown in Figure 8.23. (ch8_Noise.jpg on the CD-ROM.)

FIGURE 8.23 The image with some noise present.

- 1. Choose Filter > Blur > Smart Blur. (You can also use the Median Filter if you prefer to use this to soften the detail.)
- 2. Choose High Quality.
- 3. Adjust Radius and Threshold until the noise is gone but as much detail as possible remains in the image, as shown in Figure 8.24.
- 4. Click OK to apply. Your image will have all the noise removed, as shown in Figure 8.25. The only problem is that, depending on the severity of the noise problem, the image could be too blurred, appearing as if it is hand painted or lacking in detail. You can rectify this using the next three steps.
- 5. Choose Edit > Fade Smart Blur. If this command is not available, undo the blur, reapply it, and then choose Fade.
- 6. Change to Luminosity mode.
- 7. Adjust the Opacity until you reach a good balance of blur and detail, as shown in Figure 8.26.

Notice that there is still some color noise present in this image. The grain has been reduced, but colored specs are still noticeable. We will use Lab mode to reduce this type of colored noise.

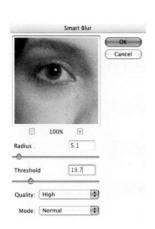

FIGURE 8.24 Using Smart Blur.

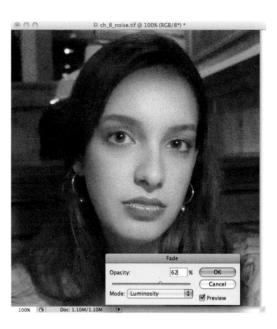

FIGURE 8.25 Blurred image.

FIGURE 8.26 The corrected image.

Color Noise Reduction Using Lab Mode

Once again, we come to Lab mode. This is the best method of color noise reduction that preserves as much of the original detail as possible.

With the image still open (ch_8_Noise.jpg), follow these steps:

- 1. Choose Image > Mode, and then select Lab Color. This will separate the color channels from the luminosity (grayscale).
- 2. Choose the *a* channel from the Channels Panel.
- 3. You can see in Figure 8.27 that a lot of noise is present in this channel. The good thing about Lab mode is that the color channels are separate from the grayscale, and you can blur the color channels without affecting the sharpness of the image too much.
- 4. Choose Filter > Noise > Median. Raise the Radius until the image looks smooth, as seen in Figure 8.28.
- 5. Select the *b* channel, as shown in Figure 8.29.
- 6. Choose Filter > Noise > Median. Raise the Radius until the image looks smooth, as seen in Figure 8.30.
- 7. Choose the Lab composite channel at the top of the Channels Panel to return to the regular color view.

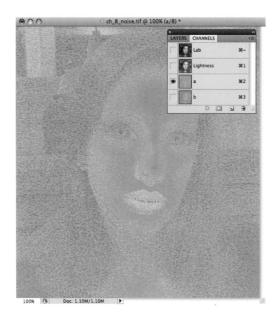

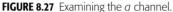

FIGURE 8.28 Blurring the *a* channel.

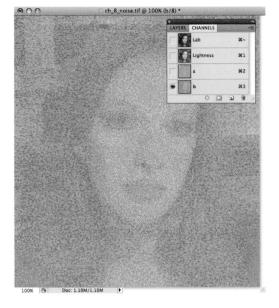

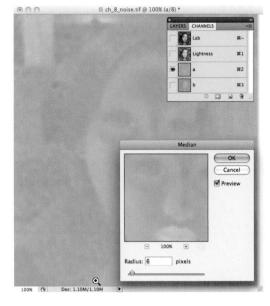

FIGURE 8.29 Examining the *b* channel.

FIGURE 8.30 Blurring the *b* channel.

Examining the image shown in Figure 8.31, the color noise has been removed, and the image has retained its sharpness and detail. To use the image, convert it back to RGB. Note that this example is exaggerated for educational purposes. In a real-world situation, we would try to begin with a better image. Compare the finished result with the starting image.

FIGURE 8.31 Image with noise reduced.

TUTORIAL 8.5

NOISE REDUCTION FILTER

Now that you understand all that is going on with noise reduction, we can tell you that there is an easier way to do all this thanks to a cool built-in filter. Why learn all this then? Why not start with the filter? Because now you will truly understand what is happening, and you have the ability to work on the channels manually for complete control. You should choose the best method depending on the type of noise in the photo. Noise is one of the most difficult things to work with in image correction, and the larger the arsenal of tools you have in your belt, the more success you will have in your imaging career.

Open ch_8_Reduce_noise.jpg from the CD-ROM, as shown in Figure 8.32.

FIGURE 8.32 Image with noise.

- 1. Choose Filter > Noise > Reduce Noise.
- 2. Make adjustments to the image, as shown in Figure 8.33.

Strength: The amount of blurring applied to the image to reduce Luminosity noise.

Preserve Details: A threshold slider.

Reduce Color Noise: Removes color noise; also known as chromatic noise.

Sharpen Details: Sharpens the image.

Remove JPEG Artifact: Repairs the blocky damage of image compression in the JPEG format.

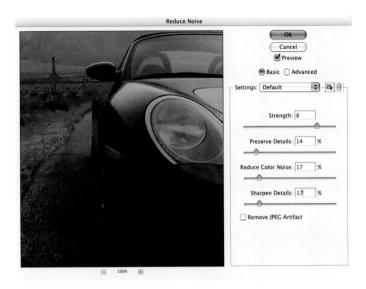

FIGURE 8.33 Reduce Noise dialog box.

- 3. Click on the Advanced option button.
- 4. Under the Per Channel tab, choose the Blue channel from the Channel drop-down list. You are now blurring each channel as you did in the previous tutorial (see Figure 8.34).

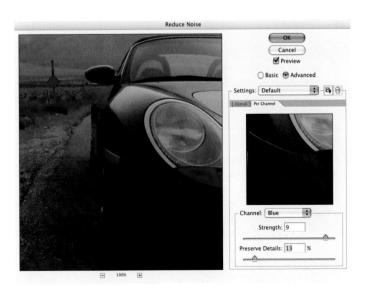

FIGURE 8.34 Reducing noise in each channel.

- 5. Adjust the Strength setting to set the amount of blur.
- 6. Now slide out the secret weapon, the Preserve Details slider. This sets the threshold, and you will keep it all the way to the left to blur everything or move to the right to preserve the areas of detail and just blur areas of flat color. As with most filters, this is a balancing act.
- 7. Repeat for each channel, reducing as much noise as possible and yet retaining the detail.
- 8. Click on the Overall tab and see if you need to fine-tune any of the settings.
- 9. Click OK to apply.
- 10. Now the noise in the image is significantly reduced. This is perhaps one of our favorite (practical) features introduced in the previous version of Photoshop (see Figure 8.35).

FIGURE 8.35 Image with noise reduced.

CHAPTER 9

IMAGE RETOUCHING

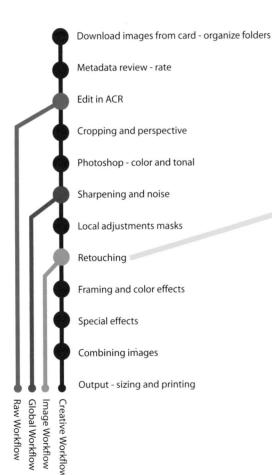

IN THIS CHAPTER:

- Spot Healing Brush
- Wrinkle Reduction
- Enhancing the Eyes and Teeth
- Soft Focus Filter
- Removing Red Eye
- Removing Tattoos and Birthmarks
- Reducing Noses
- Eyes Wide Open
- Fixing White Wedding Dresses and Black Tuxedos
- Color Balancing Skin

In this chapter, you will follow the workflow that many professional retouchers use to make photos of people look better. After the images are captured and long after the models have retired to their cozy dwellings, it's time to do a little work. This is where you will make people look younger, more alive, and glamorous, as well as remove blemishes. If only this were possible in the real world, we would make a fortune!

There is the ethical question, of course: How much is too much? The answer is up to you and your client. Even supermodels are retouched for the covers of magazines, and all imperfections are smoothed out. You can use these techniques to fix minor problems or turn someone into a completely different person. Figure 9.1 shows an image that was retouched using the techniques we will show in this chapter. The techniques are subtle and do not change the character of the model. The secret to a good retouching job is to ensure the photo does not look retouched!

FIGURE 9.1 Original and retouched photo. (Image from iStockphoto.com.)

Most of the techniques in this chapter will involve the Healing Brush family, which includes the Healing Brush, Spot Healing Brush, Patch tool, and the Red Eye tool. These tools are all nested with the Spot Healing Brush shown circled in Figure 9.2. To choose the Healing Brush or Patch tool, simply click and hold on the Spot Healing Brush icon as shown in Figure 9.3. From the resulting flyout menu choose the desired tool.

FIGURE 9.2 The Spot Healing brush.

FIGURE 9.3 Choosing the Healing brush.

The healing tools are almost magical. When you "clone" using these tools, they match the texture, color, and shading of the part of the image that you pick up (sample) and attempt to blend that with the surface in and around the blemish (destination).

Many photographers will chose to create a duplicate Background layer (highlight the Background layer and choose Layer > Duplicate Layer) on which to work. This leaves the original untouched if irreversible mistakes are made. Name the duplicate Background layer with a meaningful name, such as Retouch, or Healing Layer to help keep things organized.

TUTORIAL 9.1

REMOVING MOLES AND OBVIOUS BLEMISHES

This technique will quickly and painlessly remove any type of blemish. This is the first step in retouching. Fix the obvious first, and then move on to the subtle.

Open ch_9_Mole.jpg from the CD-ROM, or use your own image. In Figure 9.4, we have a picture of a pretty face with a mole. Always check with your client before removing moles because these can be desired distinguishing marks in some cases, such as with Cindy Crawford.

- 1. Choose the Healing Brush from the Tools Palette.
- 2. Choose a portion of the skin similar to the portion with the mole. Press the Alt key (Option key for Mac), and click over this area to capture a sample.
- 3. Release the click, and move your mouse over the blemish, as shown in Figure 9.5. Notice the tool gives a preview of what the affected area will look like. The Healing Brush "carries" the sample with it and shows it to you as an *overlay*.
- 4. Click and release the mouse, and the sample will blend into the existing image.

Just like magic, the mole is gone. Figure 9.6 shows the same image after just a few seconds of work. Use this technique to remove any obvious blemishes from the image.

FIGURE 9.4 The original image. (Image from iStockphoto.com.)

FIGURE 9.5 Removing the mole.

The overlay (preview of the sample) of the Healing Brush is new to CS4. Most folks will find this new feature beneficial. If you are accustomed to the old Healing Brush, click on the Clone Source Panel icon circled in red in Figure 9.7. When the panel opens, you will see the Show Overlay option (circled in blue). Uncheck this box.

FIGURE 9.6 The repaired image.

FIGURE 9.7 Show Overlay option in the Clone Source Panel.

SPOT HEALING BRUSH

Sometimes you may have many tiny blemishes, such as acne and stray freckles (in this case, more moles), to clean up. The quickest method is to use the Spot Healing Brush. No need to take a sample first. Just make the brush size a bit larger than the mark you want to replace and simply click on top of the blemish. Figure 9.8 shows some minor spots that we will remove.

FIGURE 9.8 Some small blemishes.

Open ch_9_SpotHealing.jpg from the CD-ROM, or use your own image.

- 1. Click and hold on the Healing Brush icon. From the resulting flyout menu, choose the Spot Healing Brush tool.
- 2. Choose a small brush size somewhat larger than the blemish itself.
- 3. Click once on the affected area. The blemish will disappear. This technique is called *dabbing*. Dabbing away the blemishes is a good way to fix tiny spots without disturbing the surrounding skin.
- 4. This brush works best when it is a little larger than the blemish itself. To quickly change the size of the brush, press and hold the Ctrl+Option (Ctrl+Alt for PC) keys while you drag your cursor to the right to make it bigger or to the left to make it smaller. Release the key combination when you are finished and return to healing.

Figure 9.9 shows the same image after a few seconds with the Spot Healing Brush. The same technique will also work with larger and more widespread spots.

The Healing tools have come a long way since their first appearance in Photoshop 7, and their behavior and options have evolved into a very usable set of tools. At the core of these tools is their ability to pick up or use a sample area to blend with the destination area, while still removing the blemish or undesired spot. This all hinges on where you sample. In the case of the Healing Brush, choosing an area that is similar in texture and color will help the tool do a better job. With the Spot Healing Brush, using a brush larger than the spot itself lets the tool know what to keep and what to remove.

A retouch job may contain many different layers as well as Adjustment Layers, and the Healing tools have the ability to sample some or all of these layers. The option bar in Figure 9.10 shows the different choices for the Spot Healing Brush.

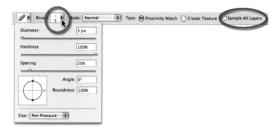

FIGURE 9.9 Retouched.

FIGURE 9.10 Option bar for the Spot Healing Brush.

- 1. The Brush box (circled in red) controls the size of the brush and the way it will lay down its sample. Diameter and spacing work very well at their default settings. The diameter (of this and any brush) can be changed here as well. A faster way may be to use the left bracket key ([) to make it smaller and the right bracket key ([) to make it bigger.
- 2. Under the Size drop-down list, if you are using a Wacom tablet, set this box to Pen Pressure to change the size based on how hard you press. Or use Stylus Wheel if you're using the optional Airbrush tool. Otherwise, set it to None to use a mouse and maintain a set brush size.
- 3. Sample all Layers (circled in blue) does just what you think it will. When it takes a sample, it will use the information from all layers. This is really useful for painting onto a new blank layer, which we recommend. If you are working

on the Background or Background Copy and you have multiple Adjustment Layers above, you may find that checking this box produces odd results. Experiment with and without.

The option bar in Figure 9.11 shows the different choices for the Healing Brush.

4. The Brush box is the same as the one for the Spot Healing Brush.

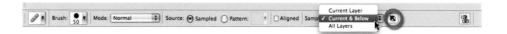

FIGURE 9.11 Option bar for the Healing Brush.

5. Under the Sample drop-down menu, you have three choices:

Current Layer: A good choice if you don't want to sample information from any other layer.

Current & Below: This is good when you want to use all of the information except what is in the layers above your current layer.

All Layers: Just as it sounds, it samples all active layers in the document.

6. Circled in red is the No Adjustment Layer icon. When this is depressed (it becomes darker in color), your Healing Brush will not pick up the effects of any Adjustment Layers. This is a good option to try when you have Adjustment Layers and multiple pixel-bearing layers in one document, but you only want to sample from the pixel-bearing layers.

WRINKLE REDUCTION

While we wait for the invention of the miracle wrinkle cream, Photoshop can quickly remove a few years off our faces. In this tutorial, you will once again be using the Healing Brush. This time you will use it to reduce the signs of aging by reducing wrinkles. You don't want to completely remove *all* wrinkles or the face can tend to look like it's made out of plastic, which is hardly a convincing retouch.

TUTORIAL 9.2

REDUCING WRINKLES

Open the image ch_9_wrinkles.jpg from the CD-ROM, or begin with one of your own. The woman in this image (see Figure 9.12) is about to drop several years from her appearance.

FIGURE 9.12 The beginning image. (*Image from iStockphoto.com.*)

FIGURE 9.13 A new layer.

A good practice to get into is creating a new layer and naming it Retouched (see Figure 9.13). Do this by going up the menu item Layer and choosing New > Layer. This will leave the original layer intact. You can also adjust the opacity of this layer later to lessen the effect of the digital plastic surgery and produce a much more realistic result.

- 1. Select the Healing Brush tool.
- 2. Choose the Current & Below option from the Sample drop-down list in the option bar (see Figure 9.14). This enables you to work on a blank layer. If you do not turn on this option, nothing will happen when you work on the blank Retouched layer.
- 3. Press Alt+click (Option+click for Mac) to sample.
- 4. Click to paint over the target area of the image. Rather than dragging the mouse with the Healing Brush, it's better to "dab" the effect. Click, move the mouse a little, and click again, slowly building up your effect. This technique produces a more subtle effect and blends much better. Sometimes, such as when you are working on a larger, more contrasted area, you may need to drag a little, but this is the exception rather than the norm.
- 5. Release your mouse button, and Photoshop does the blending.

FIGURE 9.14 Choosing Current & Below from the Sample drop-down list.

Adjust the brush size for the area you are working on. Make frequent samples for a more accurate match.

- 6. Take a sample from below the eye, as shown in Figure 9.15.
- 7. Dab away the wrinkles around the eyes, as shown in Figure 9.16. Figure 9.17 shows the area of the eye being smoothed out with all wrinkles removed.

FIGURE 9.15 Sampling.

FIGURE 9.16 Dabbing with the Healing Brush.

FIGURE 9.17 The wrinkles are smoothed away.

- 8. Keep working on the image until all the wrinkles are removed from around the eyes; you can also remove the smile lines.
- 9. Repeat the same process around the mouth to remove the wrinkle marks.

You may find dark marks appearing on the working areas. This is because either the brush is too soft or the sample is wandering into shadowed areas of the image. To fix this, reduce the size of the brush and make the edge hard rather than soft. You can do this from the Brush box on the option bar.

- 10. Finish retouching all the wrinkles on the image (see Figure 9.18). Don't worry if it looks a bit plastic and unnatural, you will fix that next.
- 11. Reduce the opacity on the Retouched layer, as shown in Figure 9.19. This fades the retouch and lets a hint of the wrinkles show through. By doing this, you retain the character of the person, without all the adverse effects of the wrinkles. This produces a younger-looking natural face.

Figures 9.20 and 9.21 show the image before and after the retouch.

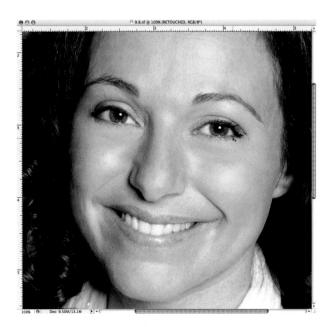

FIGURE 9.19 Reducing the Retouched layer's opacity.

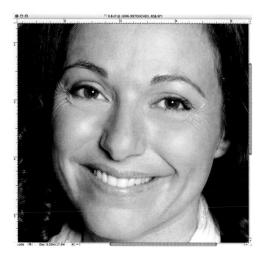

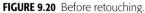

FIGURE 9.21 After a realistic looking retouch.

ENHANCING THE EYES AND TEETH

One of the most important parts of facial retouching is the eyes, and they deserve extra consideration. The eyes will always capture the viewer's attention. When you look at any photo of a face, the first thing you see is the eyes. It's in our nature to look at eyes; it's how we communicate and read people. We will walk through a few techniques to add some extra zing and life to the eyes.

For this section of the chapter, open ch_9_Eyes.jpg from the CD-ROM (see Figure 9.22), or choose an image that you have taken showing some eyes. You probably have plenty in your collection.

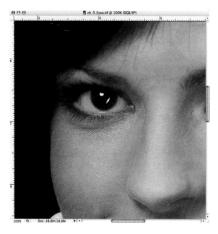

FIGURE 9.22 The beginning eye. (*Image from iStockphoto.com.*)

Removing the Red from the Whites

To remove the red, follow these steps:

1. Using the Magnetic Lasso tool or the Ouick Select tool, carefully draw around the whites of the eyes, as shown in Figure 9.23. (Actually, you can use any tool you prefer, including the Magic Wand.) Figure 9.24 shows the eve with the white selected. We will need to soften the edges of the selection so that the effect looks natural. Hard lines are a sure giveaway because they rarely exist in nature.

FIGURE 9.23 Making a selection.

FIGURE 9.24 The white of the eye selected.

- 2. Choose the Refine Edge command from the option bar. Click the Overlay Mode, and then set the Radius to 1.0, set the Feather to 4.6, and set the Expand to +12 (see Figure 9.25).
- 3. With the selection active, choose a Hue/Saturation Adjustment Layer. Click the Adjustment Layer icon at the bottom of the Layers Panel, and select Hue/Saturation.

Remember that a mask is automatically created from the selected area. This mask ensures that only the eye will be affected, and the rest of the image is protected from the correction. See Chapter 6, "Local Enhancements: Selections and Masks," for more on selections and masks.

4. Lower the saturation until just about all the yellow is gone, as shown in Figure 9.26. You can also raise the Lightness if you want to brighten up the whites as well. Use caution here, however, because a little goes a long way. (You will use this same technique for instant dentistry later in this chapter: yellow to white teeth in a few clicks.)

FIGURE 9.25 Softening the edges of the selection.

FIGURE 9.26 Removing some of the natural red and yellow from the eye.

Enhancing the Iris

To enhance the iris, follow these steps:

1. Choose the elliptical Marquee tool and make a selection of the iris, as shown in Figure 9.27. It can be tricky to get the selection in the correct position.

FIGURE 9.27 Selecting the iris.

Hold down the spacebar as you are making the selection. When the spacebar is depressed, you can reposition the selection.

- 2. With this selection active, create a Curves Adjustment Layer. Click the Direct Selector Control (circled in blue in Figure 9.28) and click in the iris where you want to lighten the color. Use either your up and left arrow keys on your keyboard or the mouse to raise this point up and to the left. Increase the brightness until the iris looks good. An added benefit of this method is that it increases the eye color as well as brightening it.
- 3. This technique will usually leave the pupil looking a little too light, so click on the shadow point in the curve and move it to the right until your pupil becomes an agreeable depth of black (see Figure 9.29).

FIGURE 9.28 Lightening the iris with Curves.

FIGURE 9.29 Darkening down the pupil with curves.

- 4. The effect of the curve has spilled out over the iris, due to the initial selection, so let's take care of that. Grab the Brush tool, and choose black as your foreground color. On the Adjustment Layer mask, paint away areas that should not be affected (see Figure 9.30). Press the X key to flip your foreground color to white, and paint in the adjustment on the other eye.
- 5. Once both eyes are painted in, you will have a much better idea of how the Curves adjustment looks. You may want to reduce the size of your image onscreen so that you can see the eyes in relation to more of the face. This will help in judging whether the effect was too heavy handed or not enough. If the effect is too much, you can simply reduce the opacity of this Adjustment Layer, as shown in Figure 9.31.
- 6. If the effect is not enough, double-click on the Curves icon to reopen the Curves dialog box. Click on the middle point, and raise it further up and to the left, until you reach the desired effect.

FIGURE 9.30 Painting out the overspill.

FIGURE 9.31 Reducing the opacity of the Adjustment Layer.

Figures 9.32 and 9.33 show the before and after shots of the eye enhancement. You can now see how crisp the eye is looking without being too obvious. The reason the eyes appear much more alive is because the iris is lighter and more colorful, and the whites of the eye have become less yellow and lighter. Again, be careful not to overdo these techniques; retouching should not really be noticeable until you compare it to the original.

FIGURE 9.32 Before . . .

FIGURE 9.33 ... and after.

TUTORIAL 9.3

WHITENING TEETH

After you have worked on the skin and eyes, the next step is to make sure that those pearly whites are indeed white. It's amazing what a difference these Photoshop "whitening strips" can make. In Figure 9.34, we have a picture of a nice smile that can be made even nicer. Open ch_9_Whiten-Teeth.jpg from the CD-ROM.

1. Create a selection of the teeth using the Magic Wand, as shown in Figure 9.35. Keep the Tolerance to around 25. If you don't get it all on the first click, choose the Add to Selection button, or press the Shift key and continue to click inside of the unselected teeth.

FIGURE 9.34 The untouched image with a little yellow on the teeth. (Image from iStockphoto.com.)

FIGURE 9.35 Creating a selection with the Magic Wand.

- 2. Choose a Hue/Saturation Adjustment Layer by clicking on the Adjustment Layer icon in the Layers Panel and choosing Hue/Saturation.
- 3. When the dialog box pops up, move the Saturation slider to the left until the yellow in the teeth has disappeared. If the teeth are also too dark, you can lighten them up with the Lighten slider in the Hue/Saturation box. A word of caution—brightening them too much can look quite unnatural, so use a soft hand here (see Figure 9.36).
- 4. In some cases, you may find at this stage that your selection is not perfect. An easy way to be sure of this is to overdo your desaturation or lightness adjustment to reveal any spill over. Take the time to go in with a paintbrush and fine-tune the mask. Remember that the rule of retouching is to make things look natural, not to make it perfect. Figures 9.37 and 9.38 show the before and after.

FIGURE 9.36 Desaturating the teeth.

FIGURE 9.37 Before . . .

FIGURE 9.38 ... and after.

So far, we have dealt with retouching subtle things in the image. You will take these steps with just about every image. From this point, we will look at some of the more extreme and specialty type fixes, starting with skin softening.

SOFT FOCUS FILTER

It is not uncommon for folks to want their skin smoothed out somewhat. Harsh sun and studio lights have a way of bringing out the imperfections in imperfect skin. In the days of film, photographers would use a soft focus filter. Today we can shoot without the filter and apply the same technique in a much more controlled and accurate manner. In keeping with the idea that retouching should be subtle, we will work on a separate layer to provide more control over the final result of this effect. Figure 9.35 shows the original image.

Method 1

1. Open the image ch_9_SoftFocus.jpg from the CD-ROM (see Figure 9.39).

FIGURE 9.39 The original image. (Image from iStockphoto.com.)

- 2. Duplicate the Background layer by choosing Layer > Duplicate Layer.
- 3. From the menu, choose Filter > Blur > Gaussian Blur.
- 4. Choose a Radius that makes your subject glow without throwing them too out of focus, as shown in Figure 9.40. Don't worry about losing some of their finer detail; you will get that back later. Click OK.
- 5. Now create a mask so that you can control where and how much of this blur will be visible on the final image. From the menu, choose Layer > Layer Mask > Reveal All (see Figure 9.41).
- 6. At this point, you may want to lower your Opacity somewhat to get a better feel for the image, as shown in Figure 9.42.

FIGURE 9.41 Adding a layer mask.

FIGURE 9.42 Lowering the Opacity.

7. Now you need to paint away some of the blur. Paint at a lower opacity with a black paintbrush to make the effect look more believable. Completely removing the blur by painting at 100% sometimes looks unnatural. Choose the Brush tool, and make black your foreground color. In the option bar, type 30% into the Opacity box (or press the numeral 3 key).

- 8. Paint over the eyes to reveal some of the sharper image beneath.
- 9. Lower your brush opacity to around 20% (or press the numeral 2 key), and paint over the nostrils and mouth. Painting at a lower opacity lets even less of the sharpness through.
- 10. At this point, you may want to tweak your Layer Opacity for the blurred layer. It is always easier to make the final call after the mask has been made. Figure 9.43 shows the final image.

FIGURE 9.43 The final image.

Voilà! Instant soft focus filter with that added advantage that you can blur more of the image while still keeping the eyes, mouth, and nose somewhat sharp! Also try experimenting with the other filters in the Blur menu. Both Box Blur and Surface Blur can create some nice results.

Method 2

Here is a similar but quicker method to get a nice soft focus filter effect. Open up ch_9_SoftFocus2.tif (see Figure 9.44) and follow along.

- 1. Go to the Channels Panel and Ctrl+click (Cmd+click for Mac) on the Red channel, as shown in Figure 9.45. This loads the channel as a selection, as seen in Figure 9.46.
- 2. Press Ctrl+J (Cmd+J for Mac). This makes a copy of the selected area in the background and puts it on its own layer, as shown in Figure 9.47.

FIGURE 9.44 Before Soft Glow.

FIGURE 9.46 The selection on the image. FIGURE 9.45 Loading the Red

FIGURE 9.47 A new pixel-bearing layer from the selection.

3. Choose Filter > Blur > Gaussian Blur. Raise the Radius until you achieve the desired effect. We chose a radius of 2.2 for this example. You will need a higher Radius for full size images. Figure 9.48 shows the before and after.

channel as a selection.

FIGURE 9.48 Before and after Soft Glow technique.

This method is quick and effective due to the nature of the Red channel. At their core, channels are just grayscale images. By Ctrl+clicking (Cmd+clicking for Mac) on a channel, you load up those values as a selection. Areas that are white in the channel are very selected, areas that are darker are less selected, and blacks are not selected at all. Channels can produce some very quick and effective selections. As you look at the channel, just imagine it as a mask. That will give you an idea of what your resulting selection will look like. The Red channel is typically very light in the skin tone area (will be very selected) and darker in the other areas of the image (these will be less selected). The Ctrl+J (Cmd+J for Mac) command copies whatever is selected and places it on its own layer. In this case you are copying mostly the skin. So when you run the Gaussian Blur, you are mostly affecting the skin.

This method still gives you all of the control of the previous method. If you want more blur, duplicate the blurred layer. Too much? Lower its opacity a bit. The blurred layer can also be masked and painted on, as in the previous example.

REMOVING RED EYE

Red eye is a common problem caused by using a flash that is too close to the lens. We are all familiar with it and can reduce this effect by shooting without flash, defusing the flash, or using an off-camera flash. Many digital cameras have a red-eye reduction mode. This prefires the flash, causing the iris to contract, and then fires another flash to take the image. This option works in some cases but not others.

The good news is that red eye can be fixed easier than ever by using the Red Eye tool. To remove red eye, follow these steps:

- 1. Open ch_9_redeye.jpg from the CD-ROM (see Figure 9.49), or choose an image of your own that suffers from this common problem.
- 2. Choose the Red Eye tool, which resides in the flyout menu with the Healing Brush tool and Patch tool (see Figure 9.50).

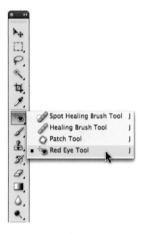

FIGURE 9.49 A little too much red eye.

FIGURE 9.50 The Red Eye tool.

- 3. This tool is very intuitive and easy to use. Simply click once, centering over the pupil to remove the red-eye effect.
- 4. Repeat for the other eye.

The red eye has been eliminated just like that! Figure 9.51 shows the corrected image.

FIGURE 9.51 The corrected image.

REMOVING TATTOOS AND BIRTHMARKS

This tutorial will show you how to retouch larger portions of an image. You are going to use the Patch tool. This is similar to the Healing Brush but can quickly affect much larger areas.

TUTORIAL 9.4

USING THE PATCH TOOL

Begin with the image ch_9_Tatoo.jpg from the CD-ROM (see Figure 9.52), or use your own.

FIGURE 9.52 An image showing a tattoo. (*Image from iStockphoto.com.*)

- 1. Choose the Patch tool; click and hold your mouse on the Healing Brush, and the Patch tool will appear from the flyout menu, as shown in Figure 9.53.
- 2. Choose Source from the option bar, as shown in Figure 9.54.
- 3. Make a selection around the area that you want to replace using the Patch tool (see Figure 9.55). Click and drag as you would if using the Lasso tool.
- 4. Click anywhere inside the selection, and drag with the Patch tool. You will see the destination area previewed in the selected area as you move your mouse (see Figure 9.56).
- 5. Move the mouse until you have a smooth-looking match.
- 6. Release your mouse, and the Patch tool will smooth the edges of the selection. Choose Select > Deselect from the menu or press Ctrl+D (Cmd+D for Mac) to deselect the patch area.

As you can see in Figure 9.57, the area looks pretty good. Sometimes, however, you may have some small areas of color around the replaced area that need to be touched up. If so, choose the Healing Brush, and clean up the edges.

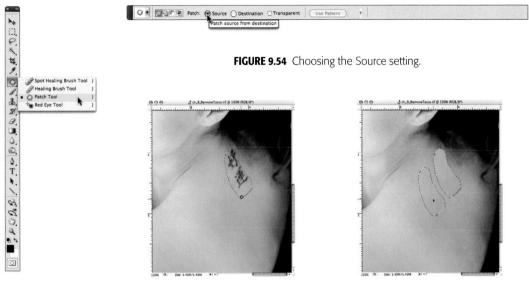

FIGURE 9.53 The Patch tool.

FIGURE 9.55 Making a selection.

FIGURE 9.56 Choosing the replacement area.

After a little fine-tuning with the Healing Brush, you would never know that a tattoo used to sit right there on her back. This technique is also great for birthmarks and other areas that require larger fixes.

FIGURE 9.57 The Tattoo is painlessly removed.

REDUCING NOSES

The guy in Figure 9.58 doesn't really have an oversized sniffer. He just got a bit too close to a wide-angle lens and suffers from a case of lens distortion. By now, I'm sure you have discovered that some interesting perspectives can appear when you shoot really close. Never fear—you can reduce that nose in a jiffy.

FIGURE 9.58 He got a bit close to the lens. (Image from iStockphoto.com.)

TUTORIAL 9.5

SHRINKING NOSES

To shrink the nose, follow these steps:

2. Choose Filter > Liquefy to launch the Liquefy tool.

3. Choose the Freeze Mask tool, as shown in Figure 9.59. Freeze Mask protects portions of the image from the results of liquefying.

4. Paint around the nose to protect the eyes, lips, and cheeks. The mask will not hurt your image (see Figure 9.60).

5. Grab the Pucker tool from the list of tools on the left of the interface. Figure 9.61 shows the Pucker tool selected.

- 6. Carefully click with the Pucker tool to reduce the nose a little (see Figure 9.62). This trick is very easy to perform but be delicate with it. There is a menu in the upper right where you can change the density of the brush (how much it will liquefy). The preview here might be somewhat deceiving. It usually looks a little sharper in the final image. Click OK to commit to the liquefy.
- 7. Immediately after clicking OK, go up to the menu and choose Edit > Fade. This will give you the chance to reduce your liquefy effect if you so desire.

Figure 9.63 shows the original image, and Figure 9.64 shows the image after a little nose surgery. Notice that it looks natural because we didn't overdo it.

FIGURE 9.59 Choosing the Freeze Mask tool.

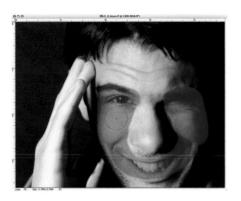

FIGURE 9.60 Protecting the image.

FIGURE 9.61 Choosing the Pucker tool.

FIGURE 9.62 Shrinking the nose.

FIGURE 9.63 Before . . .

FIGURE 9.64 ... and after.

EYES WIDE OPEN

Many things cause a person to squint, such as bright lights, smog, smiling, and even age (see Figure 9.65). Even when the eyes are perfectly fine, they are enlarged by many professionals for cover shots and such uses because doing so causes the eyes to attract more attention, and slightly enlarging them will make a big difference in the image. We will examine two methods to open and enlarge the eyes. The first method is the traditional way. The second is done with the Liquefy tool. Be very wary of the second method because it's easy to change the shape of the eyes, unless that is the result you are looking for.

FIGURE 9.65 The original image with squinting eyes.

Method 1

To use the traditional method, follow these steps:

- 1. Choose the Lasso tool.
- 2. Make a selection around the eye area as shown in Figure 9.66. Try to keep a little distance between the selection and the eyes and eyebrows.
- 3. Click the Refine Edge button to soften the selection (or choose Select > Modify > Feather). Set the Feather slider to about 6 and Contract/Expand to around 40 (see Figure 9.68). These figures will change according to the resolution of the image. The higher the resolution, the higher the settings. If you think about 10 pixels in a 72-ppi image, that can cover a reasonably large area. In a 600-ppi image, 10 pixels would be a much smaller area. Experiment with this setting if you are not getting the desired result.

Refre Edge

Refre

FIGURE 9.66 Making a selection.

FIGURE 9.67 Softening the selection.

- 4. Select Layer > New > Layer via Copy or press Ctrl+J (Cmd+J for Mac) to copy the eye to a new layer.
- 5. Repeat this process for the other eye. (Make sure you choose the background with the pixels on it again before trying to copy to a new layer. It's easy to forget.) Your Layers Panel should now look like Figure 9.68, with the original image and each eye on its own layer.
- 6. Choose Edit > Free Transform, or press Ctrl+T (Cmd+T for Mac).
- 7. Click and drag on the resizing handles to open and enlarge the eye. Be careful not to overdo it (see Figure 9.69). You could also type into the Height box in the option bar. In this case, we typed 107% in the Height box.

FIGURE 9.68 Copying the eyes to new layers.

FIGURE 9.69 Transforming.

8. You may have to reposition the eyes after transforming, as the center may have shifted slightly.

The image now has the eyes opened and enlarged (see Figure 9.70). See how much more eye-catching it is? This is a very flattering technique for the subject if it's performed with care. Repeat this for the other eye.

FIGURE 9.70 Opened eyes.

Method 2

You can really get carried away with this technique if you are not careful. You can also have a lot of fun with this tool.

- 1. Choose Filter > Liquefy. You will see the Liquefy tool open.
- 2. Choose the Forward Warp tool, as shown in Figure 9.71.
- 3. Make the brush larger than the eye, and position the crosshairs outside the actual eye, as shown in Figure 9.72. This is so that you don't warp the iris and make "cats eyes" by accident.
- 4. Click and drag carefully. Pull the edge of the eye to open it up. Be careful to be subtle with this technique, or it will look bad. Repeat the same technique to open the tops of the eyes as well.

Figure 9.73 shows the eyes after liquefying. This technique is more useful if you are working with an anonymous model rather than with a portrait for someone because when you change the shape of the eyes, you can really transform the appearance of a person.

FIGURE 9.71 The Forward Warp tool.

FIGURE 9.72 Liquefying the eyes.

FIGURE 9.73 The finished image.

FIXING WHITE WEDDING DRESSES AND BLACK TUXEDOS

Getting nice skin tones in a portrait sometimes means that you will overexpose your highlights or underexpose your shadows. On some occasions you may lose detail in both places! This is not uncommon when photographing a bride and groom together, as seen in Figure 9.74. When a large area of blank white or black without detail is present in a photo, they tend to overwhelm the rest of the image. Not to mention, in many cases, the bride's dress is full of delicate detail that should not be missing from the final photograph. In this case, the bride's veil is completely blown out.

A great place to start recovering detail is in the Raw Converter or Lightroom. When you decide that you want to begin working on an image, checking for highlight and shadow detail will be one of your first tasks.

FIGURE 9.74 The original image.

TUTORIAL 9.6

RECOVERING SHADOW AND HIGHLIGHT DETAIL

Open ch_9_ShadHigh.CR2 into ACR and follow along.

- 1. The first stop is the Raw Converter. To recover highlight detail in the veil, simply slide the Recovery slider to the right. In this case, you can push the slider all of the way, and although it helps, it doesn't bring back all of the detail, as seen in Figure 9.75. We'll try to fix this later in Photoshop.
- 2. Next, look at the Tuxedo. It is not pure black, but it seems to be lacking detail. This is because it is all very dark without much variation. Raise the Fill Light slider until the tux is a little lighter. We raised our Fill Light slider to 29. This, however, tends to make all of the darks a little washed out. This is because the photo has no pure blacks left. The trick then, is to raise the Blacks slider to get the deepest grays black again, as seen in Figure 9.76.
- 3. When trying to recover detail, it is important to do as much as you can to the RAW image. By opening the RAW image as a Smart Object, you retain the ability to return to the Raw Converter at any time. To open an image as a Smart Object, click the blue hyperlink at the bottom of the ACR window (circled in red in Figure 9.77). Check the Open in Photoshop as Smart Objects box. Click OK.

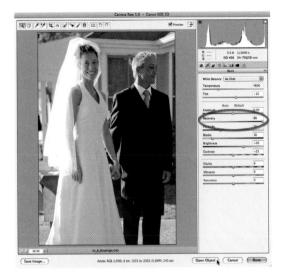

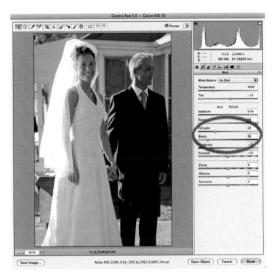

FIGURE 9.75 The Recovery slider pushed to maximum.

FIGURE 9.76 The Fill Light and Blacks sliders adjustments.

- 4. Click Open Object at the bottom of the page to open the object into Photoshop.
- 5. Now it's time to see if we can recover more detail in the veil. Choose Image > Adjustments > Shadows/Highlights.
- 6. When you first open the Shadows/Highlights dialog box (see Figure 9.78), it assumes you want to fix shadow detail. Lower the Amount slider under Shadows to 0%. Because this is a severe case, we want to raise the Amount slider under Highlights to 100%. This will bring back as much detail as possible. The Amount slider darkens the bright tones.

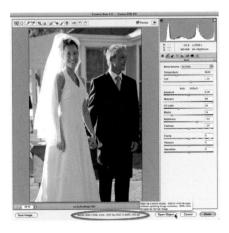

Highlights
Amount: 100 K
Tonal Width: 6 K
Radius: 50 px

Radius: 50 px

Midtone Contrast: 0

Black Clip: 0.01 K
White Clip: 0.01 K
Save At Defaults

Fill Show More Options

FIGURE 9.77 Setting the photo to open as a Smart Object.

FIGURE 9.78 The final Shadows/Highlights settings.

- 7. The Tonal Width slider controls how far down from pure white the Amount slider will affect. As you can see, at the default setting of 50, the Amount slider has begun to darken even the dress a lighter tone but not bright white. As you lower this slider, you are essentially keeping the darkening to just the brightest whites.
- 8. The Radius slider controls how the effect of the Amount slider will look next to the unaffected portions of the image. Think of it as a mask that you can blur. When your mask is perfectly sharp, sometimes your adjustment becomes obvious, so you have to blur to make it look natural (see Chapter 6). As you increase the radius, you are blurring the edges near the effect to make it look more natural. (Our final Shadows/Highlights settings are seen in Figure 9.78.)
- 9. Figure 9.79 shows the unadjusted image and the image after the Camera Raw and Shadows/Highlights adjustments.

FIGURE 9.79 Before and after.

You may have noticed that when you apply a filter to a Smart Object, you get what looks like an Adjustment Layer. This is called a Smart Filter. This means you can reopen the filter and readjust your settings! Do this by double-clicking the words Shadows/Highlights circled in red in Figure 9.80. Just above this is the mask. If you want to remove the effect of this filter from areas in the photo, click on the mask and paint with black in those areas. You can also turn the filter off and on by clicking on the eyeball next to the mask.

FIGURE 9.80 Reopening a Smart Filter.

COLOR BALANCING SKIN

Getting just the right skin tones has always been a bit of a dark art. Perhaps you are working with some older film, or the image was made under bad light. Whatever the case, using Match Color can help you get great skin colors.

TUTORIAL 9.7

REMOVING RED FROM SKIN

Too much red in the skin is rarely flattering for your subject. Simply desaturating the red can turn the skin an unsettling shade of gray, and the Color Balance adjustment can be a bit daunting. Let's use Match Color and a blank white document to remove the red in this photo of a cold ice fisherman, seen here in Figure 9.81. Open the image ch_9_Remove Red from the CD-ROM. A duplicate layer and mask has been included in this file for your convenience.

- 1. Create a new document by choosing File > New. Size doesn't matter here, so just make it 100 pixels by 100 pixels. Mode should be RGB and the Contents White. Click OK.
- 2. Return to the ice fisherman image.
 - a. If you are not using the example image, duplicate the Background layer (Layer > Duplicate Layer). This Match Color effect will alter most of the image in an undesirable way, so you will need to mask out the skin tone.
 - b. Choose Select > Color Range to isolate the skin tone. When the selection is made, click Add Layer Mask to turn the selection into a mask on the duplicate layer.

- 3. Click on the duplicate layer thumbnail to ensure that the layer is active and not the mask. Change the Layer blending mode to Color.
- 4. Choose Image > Adjustments > Match Color. From the Source options, choose Untitled-1 (the blank white document).
- 5. Check the Neutralize box and lower the Color Intensity to 1.
- 6. Adjust the Fade slider to achieve the desired skin tone. Every image will need a different level of Fade. Click OK to apply the adjustment. Figure 9.82 shows the settings we used for this image. Figure 9.83 shows the image before and after the Match Color treatment.

FIGURE 9.81 Too much red in the face.

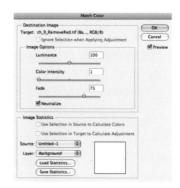

FIGURE 9.82 Match Color settings.

FIGURE 9.83 Before and after Match Color.

A similar approach can be taken for simply shifting the color of skin tones. Often the entire image will look fine, but the skin tones are just a bit off. Or in the case of Figure 9.84, the color cast is so severe that you cannot color balance the image so that all tones look good. In this next technique, we use a square of color lifted from a portrait with good skin tone rather than using a blank white square. On the CD-ROM, we have provided 12 different skin tone samples that range in color and brightness for your future use. Figure 9.85 shows an example of the different tones.

FIGURE 9.84 Image with severe color cast.

FIGURE 9.85 Sample skin tones provided on the CD.

- 1. Open the document that has an undesirable skin tone. Open a Tone Sample square that looks like a good match.
- 2. Duplicate the Background layer (Layer > Duplicate Layer).
- 3. Depending on the image, you may want to create a mask of the skin tone.
- 4. Click on the duplicate layer thumbnail to ensure that the layer is active and not the mask. Change the Layer blending mode to Color.
- 5. Choose Image > Adjustments > Match Color. From the Source options, choose the tone sample.
- 6. Adjust the Fade slider to achieve the desired skin tone. Every image will need a different level of Fade. Click OK to apply the adjustment. Figure 9.86 shows the image after the Match Color treatment.

FIGURE 9.86 After Match Color.

CHAPTER 10

FRAME AND COLOR EFFECTS

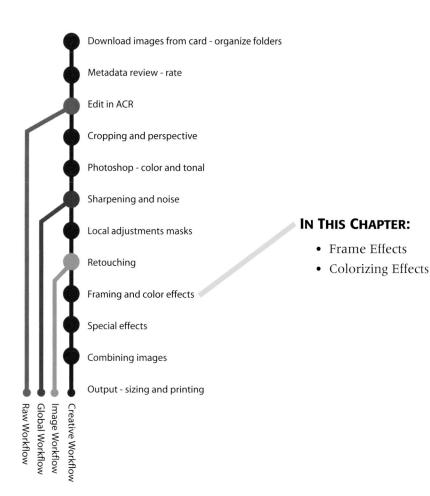

In this chapter, you'll learn how to create different frame effects and transform the appearance of your images. These frames and borders can help contain your photographs as well as heighten their impact. You'll also discover how to add some interesting color effects. These effects can totally change the feel of an image and add some excellent visual interest. Freely experiment with these techniques and try combining them or doing something different with these effects. They are meant to be a springboard, propelling you to new heights of creativity.

FRAME EFFECTS

Frame effects are a lot of fun and can help present your images in a new way. The mood of the photo can really be enhanced or altered by choosing different types of frames. The correct presentation can strengthen the feel you were looking for while taking the picture. Beware, however, that overuse of these effects or choosing the wrong type of frame for your image can make it look cheap.

TUTORIAL 10.1

CREATING A CLASSIC VIGNETTE

One of the simplest and most classic edge effects is the vignette. This is when you soften and fade a picture's edges. There are several types of vignettes that you can employ to increase the attention on your subject. The first type we'll cover is a darkening vignette. This draws the viewer's eye into the subject area of the photo. There are several methods for creating this effect. The following method will not damage the original image, and it will allow flexibility later on.

Open the image ch_10_Dark_Vignette.tiff from the CD-ROM (see Figure 10.1), and begin with the image open in Photoshop.

- 1. Choose the Elliptical Marquee tool from the toolbar.
- 2. Make a selection around the portion of the image that you want to keep light (see Figure 10.2).

If you hold down the spacebar while drawing the selection, it will enable you to reposition the selection while drawing. Holding down the Alt key (Option key for Mac) will draw the selection out from the center. The Shift key will constrain it to a perfect circle (same keys as for the Rectangular Marquee tool).

3. From the Select menu choose Invert. This inverts the selection so the active area is the opposite of what you just chose.

337

FIGURE 10.1 The original image.

FIGURE 10.2 Making a selection.

- 4. Create a Curves Adjustment Layer. This will turn your selection into a mask that can be modified to suit your needs. Grab the upper right point of the curve and lower it straight down, as seen in Figure 10.3. This method has the advantage of lowering contrast and darkening down the highlights.
- 5. The selection by default was hard edged. Click on the Masks Panel tab and increase the Feather slider, as shown in Figure 10.4. This will soften the edge of the mask to allow the vignette to be smoother.

FIGURE 10.3 Lowering the highlight values with a Curves Adjustment Layer.

FIGURE 10.4 Feathering the hard edge of the mask.

6. If you feel like the unaffected area (his face in this case) should be larger, click on Mask Edge in the Masks Panel. Here you can manipulate your mask to get just the right look—and you can do it while watching how it affects your image! Click on the icon circled in red shown in Figure 10.5. This will display your image with the marching ants. Press Ctrl+H (Cmd+H for Mac) to hide the selection. Now you can see in real time how your image is being affected.

FIGURE 10.5 Contracting the mask.

- 7. From the Refine Mask dialog box, set your Radius to 250. Lower the Contract/ Expand slider as seen in Figure 10.5. Contracting the mask shrinks the white and enlarges the black area of the mask. The black is blocking the darkening Adjustment Layer, so by enlarging it we are removing the darkening from the face.
- 8. If you want to change the level of darkening, simply click on the Adjustment Layer, and choose the Adjustments Panel. You can now readjust your curves to your liking. Figures 10.6a and 10.6b show the before and after vignette.

FIGURE 10.6A Before vignette.

FIGURE 10.6B After vignette.

With practice, your initial selections will be better, which will require less time in the Masks Panel. Spend some time experimenting with different sized selections. Some images will benefit from just having the edges darkened, while others may look better when the vignette comes in closer to the center, as demonstrated in this last example.

TUTORIAL 10.2

CREATING A WHITE VIGNETTE

Another way to vignette the image is to fade out to white rather than black. Open ch_10_WhiteVignette.tif from the CD-ROM, as seen in Figure 10.7. Almost all of the steps will be the same as in the previous example.

FIGURE 10.7 The original image.

- 1. Choose the Elliptical Marquee tool from the toolbar.
- Make a selection around the portion of the image that you want to keep unaffected.
- 3. From the Select menu choose Inverse. This inverts the selection so the active area is the opposite of what you just chose.
- 4. Create a new layer by choosing Layer > New > Layer.
- 5. Click on the Add layer mask button from the bottom of the Layers Panel. This turns your selection into a mask, as seen in Figure 10.8.
- 6. Activate this layer by clicking on the blank thumbnail. This will be indicated by a thin black border around the thumbnail. Fill with white via Edit > Fill. Choose White in the Use box. Figure 10.9 shows an example of what your image and Layers Panel should look like at this point.

FIGURE 10.8 Turning the selection into a mask.

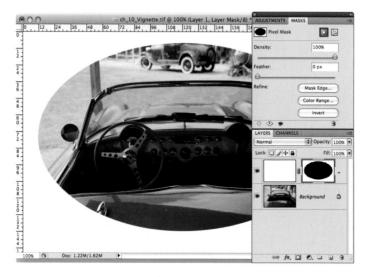

FIGURE 10.9 Blank layer filled with white.

- 7. Raise the Feather slider in the Masks Panel to soften the mask edge. This in turn creates a nice transition in the white fill layer. Use the Mask Edge button in the Masks Panel to further refine your edge for desired effect.
- 8. Figure 10.10 shows the final image with the white vignette.

FIGURE 10.10 Image after white vignette effect.

TUTORIAL 10.3

CREATING A VIGNETTE USING CAMERA RAW

The fastest way to vignette an image is to use the vignette option in Camera Raw. If you are working with Smart Objects, you can doubleclick your Background layer to bring you back to the Raw dialog box.

- 1. Open an image into Camera Raw. If your image is already open as a Smart Object, double-click the Background layer to reopen it in Camera Raw.
- 2. Click on the Lens Corrections tab to find the Vignette controls (circled in red in Figures 10.11 and 10.12).
- 3. Lower the Amount setting in the Lens Vignetting area for a dark vignette or raise it for a light or white vignette.
- 4. In the Post Crop Vignetting area, again lower or raise your Amount slider. I go to the maximum so that I can better decide on my shapes in the next step.
- 5. Skip ahead to the Feather slider and place it at zero. This allows you to see the hard edge and shape of your vignette, as seen in Figure 10.11.
- 6. Next move to the Roundness slider to determine how round you want your vignette.
- 7. Slide the midpoint to move your vignette in and out from center and return to the Feather slider to smooth out the vignette line.
- 8. Fine tune the Amount Slider to your taste.
- 9. Figures 10.12 and 10.13 show a white vignette and a black vignette with their associated settings.

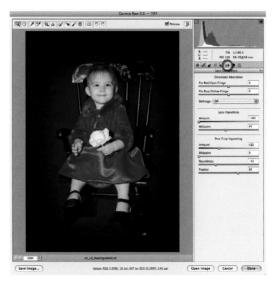

FIGURE 10.11 A dark vignette showing the hard edge.

FIGURE 10.12 Dark vignette effect in Camera Raw.

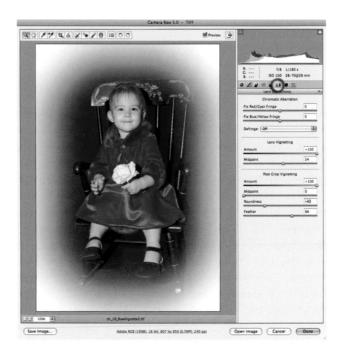

FIGURE 10.13 White vignette effect in Camera Raw.

TUTORIAL 10.4

CREATING A SIMPLE BORDER

At some point, you'll probably want to create a simple border around your images. Whether you have a white vignette, or parts of your image are blank white, as seen in Figure 10.14, a border can help contain your image. Open ch_10_SimpleBorder.tif from the CD-ROM and follow along as we use the Stroke Command to create a border.

FIGURE 10.14 An image in need of a border.

- 1. With your image open, create a new layer (Layer > New > Layer).
- 2. Choose Select > All (Ctrl+A for Windows, Cmd+A for Mac).
- 3. Choose Edit > Stroke. From the Stroke dialog box, set a Width of 4 pixels and set the Location to Inside, as seen in Figure 10.15. This will keep the outside corners of your border square.
- 4. Click inside the color box to open the Color Picker. Choose a color from the Color Picker dialog box. Instead of choosing a color within the box, you can also move your mouse outside the Color Picker box and it becomes an eyedropper. Click on any tone or color within your photo to choose that as your stroke color. Click OK.
- 5. Hit Ctrl+D (Cmd+D for Mac) to deselect. Voilà. If you find that your stroke is too fat or too thin, simply walk back in history until your stroke disappears (Ctrl+Alt+Z for Windows, or Cmd+Opt+Z for Mac) and do it again with a different pixel setting.
- 6. Figure 10.16 shows the image with a 4-pixel, light gray stroke.

FIGURE 10.15 The Stroke dialog box.

FIGURE 10.16 The image with a 4-pixel light gray stroke.

With the stroke on different layer, it is easy to customize it. From the Image menu, choose Adjustments and Curves to lighten or darken it. Choose Color Balance or Hue Saturation to change its color.

TUTORIAL 10.5 USING A FILM BORDER

A favorite border for darkroom enthusiasts entailed filing out your negative carrier so that the dark edge of the film would show up on your final print. In the digital darkroom, we can recreate that border without the file! For those of you with old negatives lying about, you can scan them and reuse them as borders. If you have no old negatives, no worries; we've supplied you with a couple of film borders that are ready to use.

- 1. Open MedFromFrame.psd and ch_10_FramePortrait from the Chapter 10 folder on your CD-ROM. For this example, the frame and portrait both happen to be horizontal. If the frame is the wrong orientation for your image, choose Image > Image Rotation. Here you can rotate your image either clockwise or counterclockwise.
- 2. Activate the Frame image by clicking on its tab. Choose Select > All or press Ctrl+A (Cmd+A for Mac).
- 3. Press Ctrl+C (Cmd+C for Mac) to copy this image or choose Edit > Copy.
- 4. Click the tab of the Portrait image. Press Ctrl+V (Cmd+V for Mac) or choose Edit > Paste to paste the portrait into this image.

5. The frame is now a separate layer in the portrait, as shown in Figure 10.17. As you can see, though, it is a little bigger than the portrait image. Let's fix that.

FIGURE 10.17 The frame as a separate layer.

- 6. Tap the F key to move into Full Screen with Menu Bar. Press Ctrl + (minus key) (Cmd + for Mac) to decrease the size of your image on screen. This will make it easier to see layers outside of your image.
- 7. To resize an individual layer, you use the Transform command. With Layer 1 (the frame layer) active, choose Edit > Transform > Scale. Notice the bounding box around the frame. This box allows you to resize and reposition the frame. Grab a corner or side box and drag them until the frame sits nicely over the image.
- 8. Click the check mark at the top of the screen or hit Enter to commit to the transformation. Figure 10.18 shows the final image with the new film border.

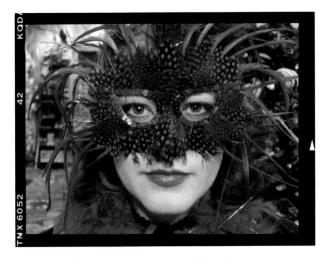

FIGURE 10.18 The final image.

You'll notice that this type of border hides some of your original image. If you want to see the whole image, expand your canvas before you copy the frame into the portrait. A fast way to expand your canvas is with the Crop tool.

- 1. Press D to change the foreground and background colors to default (black for the foreground, white for the background).
- 2. With the Crop tool, drag out a crop that encompasses your entire image.
- 3. Grab one of the corners and press the Shift+Alt keys (Shift+Option keys for Mac). Drag outward, as seen in Figure 10.19. This will take your crop outside of your image. When you feel you've given yourself enough room, press Enter or click the check mark in the option bar at the top of the screen.
- 4. When you commit to your crop, it automatically adds white canvas to your image, as seen in Figure 10.20.
- 5. You can now copy the frame into this file and position it without losing any of the image.

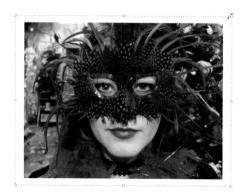

FIGURE 10.19 Expanding the canvas.

FIGURE 10.20 The expanded canvas.

Using Quick Mask to Create an Edge Effect

This next method allows complete creative freedom. You have likely seen different types of effects like this on brochures, posters, and commercials. They are the rough-cut type of frames.

TUTORIAL 10.6

CREATING AN EDGE EFFECT

1. Open ch_10_edge.jpg from the CD-ROM (see Figure 10.21), or use one of your own images.

FIGURE 10.21 The original image.

2. Begin by making a selection. You could use the Rectangular Marquee tool, but in this case, we will use the Lasso tool because it allows a more organic/random type of selection (see Figure 10.22). We are not looking for perfectly straight edges for this effect; we want something a bit more daring.

FIGURE 10.22 Making a selection.

- 3. Press the Q key on the keyboard to invoke Quick Mask. You will see a reddish color replacing the unselected portion of the image. The Quick Mask will replace a selection with a workable mask. (Actually, it creates a temporary alpha channel.) The advantage of Quick Mask is that you can apply filters to the mask that would be impossible to apply to the selection on its own (see Figure 10.23).
- 4. Let's apply some filters to the masked selection. Choose Filter > Artistic > Rough Pastels.
- 5. You will now see a large dialog box. Many of the filters are grouped into what is known as the Filter Gallery. The Filter Gallery allows you to combine a number of filters and change their settings, while previewing the result on the image without applying the filters. Make the adjustments to the Rough Pastels, as shown in Figure 10.24.

FIGURE 10.23 Quick Mask is on.

FIGURE 10.24 The Filter Gallery and Rough Pastels settings.

- 6. To continue creating adjustments to the mask with different filter effects, click on the New Effect Layer icon at the bottom of the Filter Gallery, as shown in Figure 10.24 This automatically sets this filter on the top of the stack. You sometimes may find it easier when building on effects to move this effect layer to the bottom of the stack, as shown in Figure 10.25.
- 7. Click on any other filter now, and this layer will change to reflect that filter. Here Rough Pastels is selected again, but you can click any filter in the pane to change it to something else. Here we have changed the second filter to Smudge Stick. Make your adjustments as shown in Figure 10.26.
- 8. When you are satisfied with the result, you can apply them all at once. The result is an image that holds more of its integrity because it hasn't been filtered many times.

FIGURE 10.25 Moving the filter stack.

FIGURE 10.26 Adjusting the Smudge Stick filter.

- 9. Click OK to apply the filter. Notice that the filter has been applied to the Quick Mask.
- 10. Press the Q key to convert the Quick Mask to a selection again. This time the selection reflects our filters.
- 11. Invert the selection by choosing Select > Inverse. Remember that it's good to preserve the original image as much as possible. The same thing applies here, so create a new layer.
- 12. Fill the selection with your desired color. In Figure 10.27, it is filled with black. Finish by deselecting.

FIGURE 10.27 The final effect.

There are infinite effects you can create using the Quick Mask method. Experiment with different filters to see what kind of effects you can come up with on your own.

Creating a Double Matte Effect

When framing and mounting a photo, it's common to use a matte or even a double matte for nicer presentation. Here is a way to fake the matte effect. This technique can be used for printing your image in a catalog, displaying on a Web page, emailing, or printing just for fun.

TUTORIAL 10.7

CREATING A DOUBLE MATTE EFFECT

Begin by opening ch_10_matte.jpg from the CD-ROM, or use your own image. The first step is to enlarge the page size—you don't want to lose any of your image, so resist the temptation to just matte inside the existing image.

- 1. Duplicate the Background layer. This will leave you a full size image to work with.
- 2. Choose Image > Canvas Size. This is where you will resize the page "canvas."
- 3. Check the Relative box; you don't have to do any math now. The setting you enter will be added to the overall size.
- 4. Let's make the matte 20% wider than the width. Click on the Inches drop-down list and change this to read Pixels. This shows that the image is 1,000 pixels wide. So enter 200 for both Height and Width, as shown in Figure 10.28. Use a relative size for the size of the image you are working on.
- 5. Make sure the background color is set to white, and click OK.
- 6. Let's add a texture to the matte. Choose the background. (We have copied a layer of the image, so we can just texturize the whole background.)
- 7. Choose Filters > Texture > Texturizer.
- 8. Select Canvas as the texture. Use the settings shown in Figure 10.29, or lower the Relief slider for a more subtle effect. Click OK to apply the texture.
- 9. Let's make a selection the same size as the original image. With the background still selected, press the Ctrl key (Cmd for Mac), and click on the Background copy thumbnail in the Layers Panel. You will now see the marching ants, as shown in Figure 10.30.
- 10. Right now, just the image size is selected, so select the outside and ignore the center. Choose Select > Inverse.
- 11. Press Ctrl+J (Cmd+J for Mac) to make a new layer from the selected portion of the background.

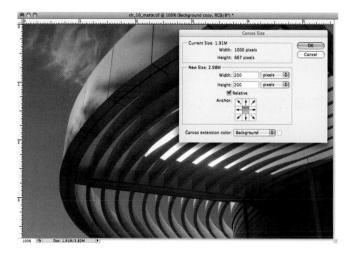

FIGURE 10.28 Extending the canvas size.

FIGURE 10.29 Texturing the matte.

FIGURE 10.30 Making a selection.

- 12. Name the new layer Matte, as shown in Figure 10.31.
- 13. Drag the Matte layer to the top layer of the Layers Panel; you can now see a textured matte around the image. It's very flat looking but not for long.
- 14. Click on the Layer Style icon in the Layers Panel (circled in Figure 10.31) and choose Drop Shadow in the resulting Layer Style dialog box.
- 15. Use similar settings to those shown in Figure 10.32. If you are using a higher resolution image, you will need to increase the settings until you have a natural result.

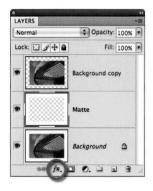

FIGURE 10.31 Creating the new matte layer.

FIGURE 10.32 Drop Shadow.

- 16. We are now going to solve two problems in one move. We will add the depth of the matte and change the lighting angle, which will also affect the drop shadow.
- 17. Check the Bevel and Emboss box. Click on the words Bevel and Emboss to access the options for that style.
- 18. Choose Chisel Hard from the Technique drop-down menu. Choose a small bevel, as shown in Figure 10.33 to determine the thickness of the matte.
- 19. Change the angle as indicated in Figure 10.33. Changing this angle will affect all the styles. Position the light more on top of the matte; this will produce a more pleasing result.
- 20. Click OK to apply the style. You should now see a realistic looking matte on your image (see Figure 10.34).

FIGURE 10.34 The matte applied.

Two is always better than one, so we will now make a double matte. The good news is that you don't have to do all the steps again.

- 1. Duplicate the Matte layer, and click on the lower Matte layer in the Layers Panel.
- 2. Press Ctrl+T (Cmd+T for Mac) to access the Free Transform tool.
- 3. Click on one of the side handles, and drag it toward the center of the page. By holding down the Alt/Option key, you can move both sides in at the same time. If you click on a corner handle, you can control the top and bottom as well as side-to-side transformation all in one go, as shown in Figure 10.35.
- 4. You have now completed your matte effect, as shown in Figure 10.36.

FIGURE 10.35 Resizing the inside matte.

FIGURE 10.36 Final image with the double matte.

COLORIZING EFFECTS

Black-and-white images have always had a timeless effect. With most digital cameras shooting in color, we need some techniques that can retrieve that black-and-white look. Some digital cameras can shoot in a black-and-white mode; however, I recommend keeping the image in color and doing your conversion in Photoshop. This provides two advantages. First, you have more control over how the final image will look. Second, you preserve the color values in case you decide to print it differently. A lot of mood or drama can also be added to an image by adding or tweaking the color. The following collection of effects are all related to color.

Color to Grayscale

Converting a color image to *grayscale* (the technical name for black and white) can be quite simple. You can use several methods to achieve this result. The quickest (not necessarily the best) way is to convert the image to Grayscale mode. All the color information will be discarded, and you will be left with only the gray tones. Another method is to desaturate an image. Although this removes all of the color from the image, it does not always create a pleasing black-and-white image. The problem with these methods is that you have no control over the conversion, and a lot of contrast will be lost when the tones are merged. Using a Channel Mixer Adjustment Layer or the new Black and White Adjustment Layer is a much more refined method of changing a color image to black and white. These processes will improve control over the conversion and allow you to create a pleasing tonal contrast. Figure 10.37 shows an image that has been converted using the methods of Desaturate, changing it to grayscale, and using the Black and White adjustment.

TUTORIAL 10.8

TURNING COLOR TO GRAYSCALE

- 1. Open ch_10_ChannelMix.jpg from the CD-ROM (see Figure 10.38).
 - 2. Click into the Channels Panel. Note when you enter the Channels Panel that all of the eyeballs are on. This means all channels are visible. Examine each channel one at time by clicking in the channel, as shown in Figure 10.39. The image looks best in the Red and Green channels, and the Blue channel doesn't contribute too much. So, you need the Red channel with a bit of the green. Start by putting all of the eyeballs back on and then clicking on the top RGB composite layer.

FIGURE 10.37 Multiple conversions to black and white.

FIGURE 10.38 The original image.

FIGURE 10.39 Viewing the channels.

- 3. Return to the Layers Panel. Click on the New Adjustment Layer icon and choose Channel Mixer. This adjustment allows you to create a composite based on the amount of each channel you choose.
- 4. Click Monochrome, which will convert the preview to grayscale.
- 5. By default, the Channel Mixer will turn to 40 Red, 40 Green, and 20 Blue, as shown in Figure 10.40. (This is the same setting you would get if you changed your image to grayscale via the Image > Mode > Grayscale option.)

FIGURE 10.40 Channel Mixer Panel.

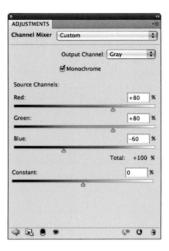

FIGURE 10.41 Adjusting the Channel Mixer.

6. Remember that you saw more detail and contrast in the Red and Green channels? Here is your chance to tweak the mix of channels. Increase the red and green and lower the blue until you are satisfied with the result, as shown in Figure 10.41. Depending on the image, different settings would be used. This method is fairly simple and produces much better results than simply converting to grayscale.

Figure 10.42 is the result of a conversion using the Channel Mixer. Another advantage of this method is that, because you used an Adjustment Layer, the original layer is still intact. You can make changes whenever you want simply by double-clicking on the Channel Mixer Adjustment Layer icon.

The Total indicator, shown in Figure 10.43, represents the total amount of the channels being mixed together. To stay on the safe side, this number should read 100%. If you are below 100%, you run the risk of losing shadow detail. More than 100% and you can lose highlight detail, as shown in Figure 10.43. When your total is more than 100%, the Channel Mixer Panel displays a Caution symbol. The Constant slider can be used to lower or raise the overall brightness if your desired mix of channels goes above or below 100%.

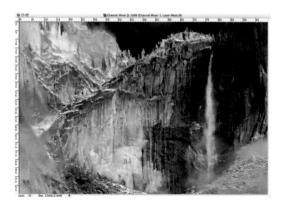

FIGURE 10.43 The Total warning feature.

Converting to Sepia Tone

You have probably seen sepia tone images before. They are very popular in today's image culture because the retro look has made a big comeback. The effect is a single-colored tint over the entire image.

We will now describe the process of producing this result. We will add a cool twist at the end that will really make your image leap out at the viewer.

1. Open ch_10_Sepia.jpg from the CD-ROM (see Figure 10.44). Convert the image to grayscale using the Channel Mixer as demonstrated in the previous tutorial. If you already have a grayscale image, then continue with the following steps.

FIGURE 10.44 Original image.

- 2. Choose the Hue/Saturation Adjustment Layer from the bottom of the Layers Panel.
- 3. Check the Colorize box in the bottom right of the panel. By default, the panel will show a Hue of 0 and a Saturation of 25, as shown in Figure 10.45. You can change both of these settings to suit your tastes.
- 4. Choose your desired tint from the Hue slider, as shown in Figure 10.46.

FIGURE 10.45 Hue/Saturation Adjustment Layer.

FIGURE 10.46 Changing Hue and Saturation.

- 5. Lower the Saturation so there is just a hint of color.
- 6. Click OK to apply the adjustment.
- 7. To only affect the color and leave the luminosity alone, change the layer blending mode to Color, as shown in Figure 10.47.

Figure 10.48 shows the final sepia tone image.

FIGURE 10.47 Changing the blending mode.

FIGURE 10.48 The image after sepia toning.

Using the Black and White Adjustment

The Black and White adjustment is a great alternative to the Channel Mixer. This tool creates a black-and-white image by changing the brightness of several different colors within the image. When a color is brightened, it becomes a lighter shade of gray in the final image. Decreasing the brightness of a color will create a darker shade of gray. In the following example, we will take an image that looks fairly flat with the default black-and-white settings and create a more interesting final image.

- 1. Open ch_10_BW.jpg from the CD-ROM (see Figure 10.49).
- 2. Choose the Black and White Adjustment Layer from the bottom of the Layers Panel. The adjustment will appear with default settings, as shown in Figure 10.50.
- 3. Adjust the color sliders to lighten or darken tones within the image. Here we will decrease the Green, Cyan, and Blue sliders to darken the grass, as shown in Figure 10.51.
- 4. Next increase the Red and Yellow sliders, as shown in Figure 10.52. In this example, the magenta has also been decreased to darken the background.
- 5. When finished adjusting the sliders, click OK to apply the adjustment.

FIGURE 10.49 The original image.

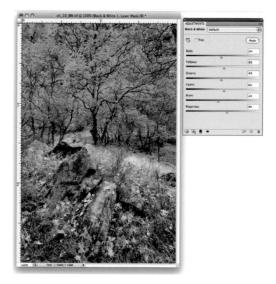

FIGURE 10.50 The default Black and White settings.

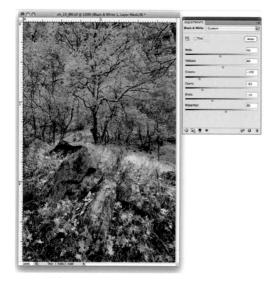

FIGURE 10.51 Decreasing the green, cyan, and blue.

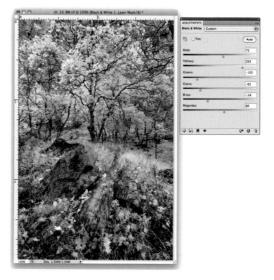

FIGURE 10.52 Increasing the red and yellow.

As you can see from the previous examples, the Black and White adjustment has the ability to separate many different colors within an image. This tool gives you more possibilities and a new level of control over converting your color images to black and white. Caution should be exercised, however, when pushing the sliders too far in any one direction. Increasing or decreasing the sliders too much can result in a choppy or unrealistic look to the image. Keep an eye on the image as you push the sliders back and forth. Viewing the image at Actual Pixels (100% magnification) will help you spot these irregularities. To view your image at 100% while the Black and White adjustment is open, click your mouse while pressing the Ctrl+spacebar keys (Cmd+spacebar for Mac) simultaneously. Look to your title bar to see your current magnification. You can also adjust any of the tones by clicking on the image and dragging to the left or right. Notice that the targeted tones adjust without you moving the sliders. Photoshop knows which slider to move!

Altering Color Locally

There will be many times when you wish to either enhance or correct color in a small area rather than affect the whole image. The Hue/Saturation adjustment allows you to do just that. It is a powerful tool that allows precise control over individual hue, saturation, and lightness (brightness).

TUTORIAL 10.9

CHANGING THE COLOR OF AN OBJECT PAINLESSLY

Perhaps you want to change the color of someone's shirt in an image. Instead of retaking the picture, use this method to change the color of an object in an image without affecting the rest of the image. Most clients will not be able to tell that you changed the color.

- 1. Open ch_10_ChangeColor.jpg from the CD-ROM, or use your own image. Figure 10.53 shows the original. We are going to do the unthinkable—we will change the color of this New York cab from its familiar yellow to a shade of red.
- 2. Choose Hue/Saturation from the Adjustment Layers icon at the bottom of the Layers Palette.
- 3. Change the Edit drop-down menu to Yellows. (The color doesn't really matter; this just moves you into sampling mode.)
- 4. When you move the pointer over the image, you will see an Eyedropper tool. Click on the color that you want to change, in this case, the yellow cab (see Figure 10.54).
- 5. Move the Hue slider until you see your image change color. Notice that your sampled color now changes to a different color, as shown in Figure 10.55.

FIGURE 10.53 Original image.

FIGURE 10.54 Sampling a color.

FIGURE 10.55 Shifting the color.

- 6. Frequently, this is all that's required, but sometimes, you may need to do a little fine-tuning. Perhaps all the color wasn't picked up or, alternatively, more colors than you wanted have been affected.
- 7. When you took the color sample, sliders were added to the gradient ramp at the bottom of the Hue/Saturation Panel, as indicated in Figure 10.56. Move the outside sliders inward to keep those near colors from being affected by the hue change. Try to keep them from touching the inner sliders. If they become too close or they touch, your colors can end up posterizing.

- 8. Most of the fine-tuning should have been accomplished by adjusting the gradient sliders; however, other objects in the image with a similar color have also been changed. Click OK to apply the adjustment.
- 9. All Adjustment Layers come with a layer mask. Click on the mask to activate it.
- 10. Choose black as the foreground color and a soft brush.
- 11. Paint in the image window, concentrating only on those areas where you want to restore the color. Figure 10.57 shows painting out the mask to allow the original yellow to show through on the head light's reflection on the pavement.

FIGURE 10.56 Fine-tuning.

FIGURE 10.57 Touching up.

Figure 10.58 shows the image with the color changed only on the cab. This is a convincing effect, and the whole process only takes a couple of minutes to accomplish. Don't tell your clients or coworkers how easy this was!

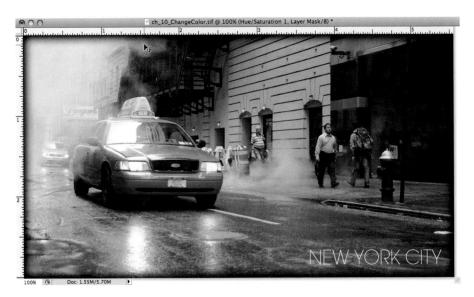

FIGURE 10.58 Final image.

TUTORIAL 10.9

USING SPOT COLOR

Mixing color and black and white in the same image is a technique that has been around as long as photography itself. It began with painting color oils over black-and-white prints. The brightness of the colors were determined by the underlying tone in the photograph. Darker tones would produce less saturated colors while the grays allowed more color. Hand tinting (as it was called) produced a pleasingly soft and desaturated color palette. Fast forward to Photoshop. You now have the ability to produce any type of color and black-white mix that you can imagine. Here are a couple ways to reproduce old effects and create brand new ones. The first involves adding just a spot of color to your black-and-white image. This is not to be confused with PMS spot color printing, which is a designer's technique rarely used by photographers and thus not covered in this book.

1. Open ch_10_SpotColor (as seen in Figure 10.59) from the CD-ROM.

FIGURE 10.59 Original Image.

- 2. Create a Hue/Saturation Adjustment Layer and reduce the Saturation completely to –100%.
- 3. Grab the Brush tool and choose black as your foreground color. Paint on the image where you want the color to return. Because you are on the Adjustment Layer, you are painting black on the mask, thus punching a hole through to the Background layer. Figure 10.60 shows the effect.

FIGURE 10.60 Painting through black on the mask.

FIGURE 10.61 The final spot color affect.

4. Finish painting the desired area, changing the brush size and feathering to achieve smooth edges on the flowers. Figure 10.61 shows the final result. Mission accomplished!

Some images may look too bold with such a stark difference between color and black and white. You can soften this look by reducing the *density* of the mask.

1. Click on the Masks Panel and lower the Density slider until the image looks a little softer, as seen in Figure 10.62.

FIGURE 10.62 The image after sepia toning.

FIGURE 10.63 Lowering the opacity of the Hue/Saturation layer in the Layers Panel.

- 2. Taking the technique a little further, you can recapture the romance of a hand-tinted photo by allowing some of the color back. Lower the opacity of the Hue/Saturation layer in the Layers Panel, as seen in Figure 10.63.
- 3. Figure 10.64 shows the subtle hand-tinted spot color look.

Keep in mind that it may be easier to make a selection rather than paint with the Brush tool. You may also want to change the brightness of the area that you have kept the color in (see Figure 10.65).

- 1. Ctrl+click (Cmd+click on Mac) on the mask to load it as a selection.
- 2. Choose Select > Inverse.
- 3. Create a new Adjustment Layer with this selection active.
- 4. Darken or lighten to suit your tastes. 🔏

FIGURE 10.64 Hand-tinted look.

FIGURE 10.65 The flowers lightened with a selection and Curves layer.

CHAPTER T

SPECIAL EFFECTS

In this chapter, we'll delve into the world of special effects. We'll begin by showing you how to use Smart Filters to greatly expand your creative license. You'll use these filters to turn your photos into sketches and watercolor paintings. Next you'll create a sense of depth in your photographs by using the Lens Blur Filter. The last part of the chapter demonstrates some creative techniques achieved through the use of both filters and layer effects.

SMART FILTERS

Before we go into the next tutorial let's take a look at Smart Filters, a great option for nondestructive editing. A Smart Filter is any filter that is applied to a Smart Object. For a photographer's purpose, a Smart Object is an image that stands in for the actual image. Although you are seeing the image and working with it normally, no edits (Adjustment Layers and so on) are applied until you flatten it. Additionally, when you open a RAW image as a Smart Object, you retain the ability to re-edit the image in the Camera Raw Converter at any time by simply double-clicking on the layer.

When you apply a filter to a Smart Object, it becomes a Smart Filter. The advantage of a Smart Filter is that you can adjust, hide, mask, or remove the Smart Filter at any time before flattening. This is a huge advantage over applying a filter in the past.

Most of the filters in the Filter menu can operate as a Smart Filter, including the Shadows/Highlights and Variations Adjustments under the Image > Adjustments menu. Filters that cannot be applied as Smart Filters are Extract, Liquify, Pattern Maker, and Vanishing Point.

Many of the techniques in this chapter can benefit from the use of Smart Objects and Smart Filters. To create a Smart Filter, first you must be working with a Smart Object:

- To change your background layer into a Smart Object, right-click on the layer and choose Convert to Smart Object.
- To change duplicate Background layers into Smart Objects, click on the down arrow in the upper right of the Layers Panel and choose Convert to Smart Object from the resulting menu. You will now see a little black-and-white square in the bottom right of the layers to indicate that it is a Smart Object.

To work with Smart Filters, follow these steps:

- 1. Select the Smart Object layer in your Layers Panel.
- 2. Choose the desired filter, and set the options. You will see the filter appear in the Layers Panel below the Smart Object (see Figure 11.1).

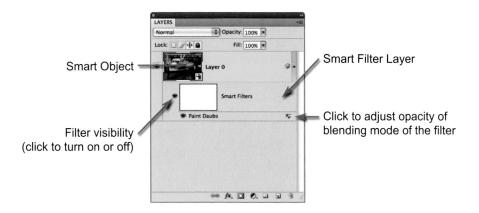

FIGURE 11.1 A Smart Filter applied to a Smart Object.

- 3. Toggle the effect of the filter on and off by clicking on the upper Visibility eyeball next to the mask.
- 4. Double-click the name of the Smart Filter in the Layers Panel to readjust the filter.
- 5. Double-click the Edit Filter icon on the Smart Filter to change the blending mode or adjust the opacity of the Filter layer, as shown in Figure 11.2.
- 6. Add other filter effects by clicking on the Smart Object and choosing another filter. The new filter layer will appear below the current Smart Filter, as shown in Figure 11.3.

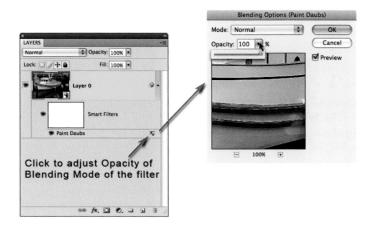

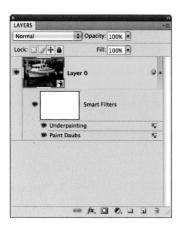

FIGURE 11.3 Multiple Smart Filters.

7. Paint on the Smart Filter mask if you want to remove the filter from part of the image. Figure 11.4 shows gray painted on the mask to partially block the effects of the filter. This works exactly like a regular layer mask, which is covered in Chapter 6, "Local Enhancements: Selections and Masks."

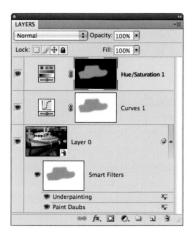

FIGURE 11.4 Multiple Smart Filters and Adjustment Layers.

8. Figure 11.4 also shows the Layers Panel with multiple Smart Filters applied in addition to Adjustment Layers applied in the normal fashion. When multiple filters are applied, use the individual eyeballs to toggle on or off the effect of that filter. The eyeball next to the Smart Filter mask will turn off all the filters at once.

NATURAL MEDIA

This section discusses the techniques used to turn photographs into images that mimic fine art. After you have finished this section, feel free to experiment, using what you have learned as a springboard into your own discovery.

TUTORIAL 11.1

TURNING A PHOTO INTO A WATERCOLOR PAINTING

This effect will show you how to turn a photo into a watercolor-type painting. Open ch_11_WaterColor.tif from the CD-ROM (see Figure 11.5), or begin with an image of your own. Go to Image > Mode, and ensure that your image is in 8-bit depth by checking 8-bits/channel.

FIGURE 11.5 The original image.

- 1. Duplicate the background image twice. You should now have three identical layers.
- 2. Choose the top layer.
- 3. Select Filter > Stylize > Find Edges. The image will take on the appearance of an outline.
- 4. The midtones need to be reduced so that mainly the outline is showing. Choose Image > Adjustments > Levels. Slide the midtone slider to the left, as shown in Figure 11.6. This will clean up the stray detail.
- 5. Hide the top layer by clicking on the eyeball to the left of the layer (see Figure 11.7), and click on the middle layer thumbnail to activate it. From the Layers Panel menu circled in red, choose Convert to Smart Object.

FIGURE 11.6 Adjusting the filtered layer.

FIGURE 11.7 The Layers Panel.

- 6. The Filter Gallery will be used to create the effect of a painting.
- 7. Choose Filters > Artistic > Paint Daubs.
- 8. Apply a setting that produces an effect where the image appears painted but not so much that all definition is lost. Figure 11.8 shows the settings that we used. Click OK.
- 9. Now to add a second filter to mimic the surface of watercolor paper. Choose Filters > Artistic > Underpainting.
- 10. Choose settings similar to those shown in Figure 11.9. Click OK.

FIGURE 11.8 The Paint Daubs filter.

FIGURE 11.9 Adding the Underpainting filter for some texture.

- 11. So far, the image should resemble Figure 11.10. The image reminds us of a watercolor, but it lacks the fine brush detail. The top layer will provide this detail. Turn the top layer's visibility on, as shown in Figure 11.11. Change to Multiply mode, and experiment with the opacity.
- 12. Fine-tune your image by adjusting the opacity of the second layer. In this example, the opacity is 90%. Further fine-tuning by double-clicking on the name of the filter will allow you to go back and readjust the filter settings. Doubleclick on the Edit Filter icon to reduce opacity or change the blending mode.

As you can see in Figure 11.12, the final image resembles a hand painting.

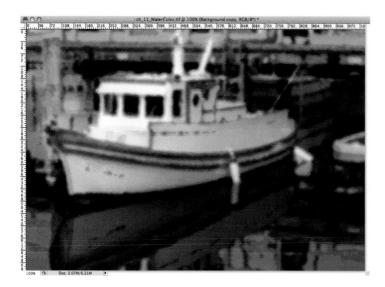

FIGURE 11.11 Turning on the top layer, changing the blending mode, and adjusting opacity.

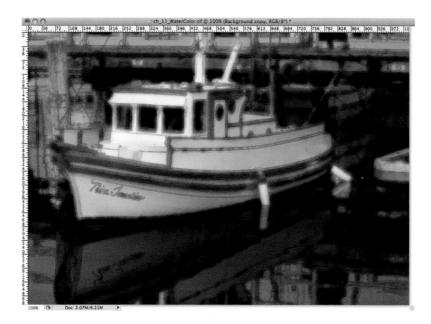

FIGURE 11.12 The final image.

TUTORIAL 11.2

TURNING A PHOTO INTO A SKETCH

This technique will show you how to turn a photo into something that resembles a pencil sketch. Open ch_11_sketch.tif from the CD-ROM (see Figure 11.13), or open your own image.

- 1. To preserve your original image, duplicate the original layer; we will work on the duplicate.
- 2. Choose Image > Adjustments > Desaturate to remove the color, as shown in Figure 11.14. The image should now appear in grayscale.

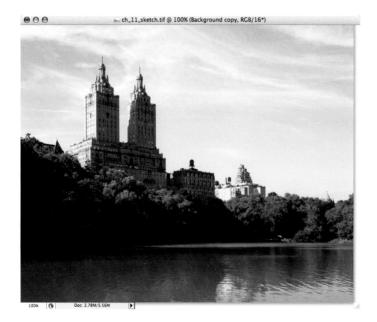

FIGURE 11.13 The original image.

FIGURE 11.14 Duplicated, desaturated layer.

- 3. Duplicate the grayscale layer.
- 4. Invert the duplicated layer, as shown in Figure 11.15. Press Ctrl+I (Cmd+I for Mac) to invert.
- 5. Switch the layer blending mode to Color Dodge, as shown circled in Figure 11.16. The image should now appear almost white.
- 6. Now set the outline of the sketch. Choose Filter > Blur > Gaussian Blur, as shown in Figure 11.17. Be careful not to overdo the blur, or the result will resemble a photocopy more than a sketch (unless that is the effect you want).

FIGURE 11.15 The inverted layer.

FIGURE 11.16 Changing the blending mode to Color Dodge.

FIGURE 11.17 Setting the blur.

You will now see something that resembles a pencil sketch (see Figure 11.18). Creating two layers, one inverted over the other, and choosing the blending mode causes the layers to cancel each other out. When the blur is added, it will cause the blurred area to be visible because those portions have changes from the cancelled portions. A variation would be to change the blending mode to Hard Mix. This will produce an etched effect, as shown in Figure 11.19.

FIGURE 11.18 A pencil sketch.

FIGURE 11.19 An etched effect.

DEPTH OF FIELD EFFECTS

You can use two methods to simulate a depth-of-field effect that will keep the foreground objects sharp while blurring the objects in the distance. Both methods use a feature in Photoshop called Lens Blur. The first method is very quick and easy and produces a good result. The second method is more in-depth and will be indispensable for producing detailed results that will even fool the experts.

Depth of Field with a Layer Mask

This method produces pretty good results and works best on images that have smooth flat surfaces.

TUTORIAL 11.3

REMOVING DEPTH OF FIELD WITH LENS BLUR

Open the image ch_11_LensBlur1.tif from the CD-ROM in Photoshop. Figure 11.20 shows a candy store shot with a wide-angle lens. It can be difficult to achieve a shallow depth of field with today's wide angle lenses, so let's create some focus fall off with the Lens Blur Filter.

The Lens Blur Filter works off of a gradient map that you create in an alpha channel. The tones will control where the blurring will occur. The next tutorial describes Lens Blur in more depth. For now, let's just get started.

FIGURE 11.20 The original image.

- 1. Open the Channels Panel. If the Channels Panel is not visible, choose Window > Channel.
- 2. Create a new channel by clicking the New Channel icon in the Channels Panel. Click the eyeball in the RGB composite layer. The image will now look as if it is covered with a red film.
- 3. Press the D key to reset the foreground and background colors.
- 4. Choose the Gradient tool, and set it for Foreground to Background, Linear (see Figure 11.21).
- 5. Drag the gradient from the far right to the far left side of the window. You should now see something like the image shown in Figure 11.22.

FIGURE 11.21 Choosing the Gradient tool.

FIGURE 11.22 Adding the gradient onto the alpha channel.

- 6. Click on the RGB thumbnail to highlight all of the channels. Click on the eye in Alpha 1 to remove it.
- 7. Click on the Layers Panel, and choose Filter > Blur > Lens Blur.
- 8. For the source, choose Alpha1 from the drop-down menu.
- 9. You can see that the sharp area is where you started the gradient on the right. The blurred area is on the left. Raise or lower the Radius slider to change the amount of blur and see how the depth of field falls off, as shown in Figure 11.23.
- 10. To change the portion of the image that is in focus, slide the Blur Focal Distance slider; this is just like focusing a lens. Figure 11.24 shows the focus in the center right of the image (a more likely place to focus the camera).
- 11. Click OK to apply the effect. 💸

FIGURE 11.23 Lens Blur, showing the left side of the image blurred.

FIGURE 11.24 Focus moved to the center right of the image with the Blur Focal Distance slider.

You can have a lot of fun with this filter. Experiment with different types of gradients; circular ones work really well too. Now let's move on and create a complex effect with the same filter.

Depth of Field Using Lens Blur and Depth Map

The Lens Blur Filter simulates the effect of an aperture and focal length on a camera lens. To really get the best out of this filter, you need to create a depth map. The filter uses a map to blur the image selectively. You can assign areas with different levels of grayscale, and then have the filter focus on the tones and apply a varying blur according to how dark or light the map is in the chosen areas.

TUTORIAL 11.4

REMOVING DEPTH OF FIELD USING LENS BLUR AND DEPTH MAP

Open ch_11_Fishing_blur.tif from the CD-ROM (see Figure 11.25).

FIGURE 11.25 The original image. (Royalty Free Image from Hemera™.)

- 1. Duplicate the background to preserve the original image in case you change your mind later.
- 2. Create a new layer, and name it "Mask" (see Figure 11.26). This is where you'll begin creating the depth map. A map has been created on the sample image if you don't want to create one yourself. If this is the case, skip ahead to step 15.

FIGURE 11.26 Creating the Mask layer.

- 3. Choose a white brush and paint the area of the image that should appear in focus. Usually this will be the highest point of the image. Use the Marquee tools to help with the painting if desired, as shown in Figure 11.27. (Remember to deselect when finished!)
- 4. Create a new layer and move it beneath the Mask layer. Name the new layer "Mid Mask" (see Figure 11.28). This is where you will define the areas that should be half in focus.
- 5. Use a soft brush set to 50% gray and paint over the portions of the image that are higher than the background but not as high as the main focused portion of the image, as shown in Figure 11.29.
- 6. Add a Gaussian blur to the midtones. The blur is added to soften the edges of the mask. If the blurs drop off softly, they will appear more natural. Choose Filter > Blur > Gaussian Blur, as shown in Figure 11.30.

FIGURE 11.27 Assigning the highest points, which will be the sharpest.

FIGURE 11.29 Paint the middle ground in 50% gray.

FIGURE 11.28 Creating a layer for the middle levels.

FIGURE 11.30 Blur the map to soften the edges.

- 7. Create one more layer and name it "Low Mask," as shown in Figure 11.31.
- 8. Choose a dark gray—about 75% will work. Define the low points of the image, but leave the very lowest portions alone. These portions will be mostly blurred but will retain a slight amount of sharpness (see Figure 11.32).

⊕ ⊕ □ ch_11_fishing_blur.tif ⊕ 100% (Low Mask, RG8/16*)

100x □ Doc: 1.834/8.03M □

FIGURE 11.31 Create another layer for the lows.

FIGURE 11.32 Paint the low points with a dark gray.

- 9. Hide the background layers so that only the masks are visible. Now that you can see the mask more clearly, clean it up a bit with the Brush tools and fill in any spots that may have been missed, as shown in Figure 11.33.
- 10. Merge the three mask layers. Choose Merge Visible from the flyout menu on the top right of the Layers Panel. Make your Background and Background Copy layers visible again. Your Layers Panel should now look like that shown in Figure 11.34.

FIGURE 11.33 The map on its own.

FIGURE 11.34 Merging the mask layers.

- 11. You have created the depth map. Now you will transfer it to a channel and prepare to filter the image.
- 12. Select the entire mask layer by pressing Ctrl+A (Cmd+A for Mac) on the Mask layer.
- 13. Choose Edit > Copy.
- 14. Open the Channels Panel.
- 15. Add a new alpha channel by clicking the Create New Channel icon at the bottom of the panel.
- 16. Choose Edit > Paste, and then deselect. The alpha channel should now look like Figure 11.35. (You will notice that the sample image already has a map created for your use if you have had trouble creating one yourself: the Alpha channel Blur-Map.)
- 17. Click on RGB in the Channels Panel. Choose the Layers Panel, show the image layer, and hide the mask layer, as shown in Figure 11.36.

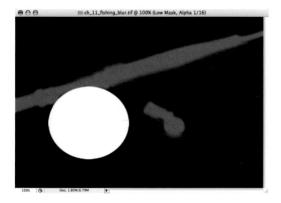

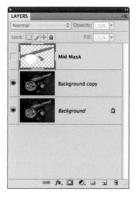

FIGURE 11.36 Choose the top layer and hide the mask.

- 18. Everything is now set up; it's time to apply the filter.
- 19. Choose Filter > Blur > Lens Blur (see Figure 11.37).
- 20. Choose Alpha 1 for the source (or Channel Blur Mask if you used the included map).
- 21. When you slide Blur Focal Distance, you will see the focus change in the preview as it interacts with the depth map. Move it to 255 (this represents the 256 shades of gray in an alpha channel).
- 22. Adjust Radius to change the amount of blur. You can play with the other iris settings if you wish. The shape, curvature, and rotation all simulate the blades of a camera's iris.
- 23. Adjust the Specular Highlights options to cause bright parts of the image to become specular highlights. The Brightness slider can be adjusted; Threshold determines the cutoff point at which tones will be turned into highlights.

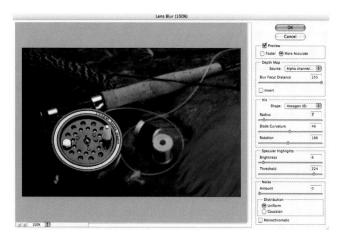

FIGURE 11.37 Applying Lens Blur.

- 24. The Noise options are available for images with grain. As you know, when a blur is applied to an image, the grain is lost. These settings allow you to simulate the grain back into the blurred portions of the image and make the effect more realistic. No grain is present in the example image, so leave the setting at 0. If you were applying grain, you would choose between Gaussian and Uniform under the Distribution section. The Gaussian setting is more random, but you would make the choice that best matches the existing grain of the image.
- 25. Click OK to apply the effect.

Figure 11.38 shows the image with the shallow depth of field applied to it. Notice how portions of the image appear more in focus than others. This is a great filter that produces stunning results.

FIGURE 11.38 The result with a realistic depth of field.

USING PATTERNS TO CREATE SCAN LINES

The next effect will teach you how to use repeating patterns in an image to create texture, add a background, or apply any number of other effects. Once you learn how to use patterns, you may find all types of uses for them! The scan-line effect reproduces the interlacing effect seen on a TV screen. To accomplish this, a custom pattern will be created.

TUTORIAL 11.5

CREATING SCAN LINES

Begin with any image open in Photoshop, such as Figure 11.39, titled ch_11_ScanLines.tif on the CD-ROM.

FIGURE 11.39 The original image. (Royalty-free image from Hemera.)

- 1. We will now create the pattern that will be used for the effect.
- 2. Create a new document (File > New), and make it 4 pixels by 4 pixels in RGB mode with a white background and 72 ppi. At the end of this tutorial, you will see why we chose a white background rather than a black one (it has to do with flexibility).
- 3. Zoom in to 1600% so that you can see what you are doing.
- 4. Use the Pencil tool, which is nested with the Brush tool. Make the settings a single pixel and black in color. Fill in half the image with black, as shown in Figure 11.40.

- 5. We will now turn this image into a reusable, repeating pattern.
- 6. Press Ctrl+A (Cmd+A for Mac) to select the entire document.
- 7. Choose Edit > Define Pattern to add the selection to the Pattern Library.
- 8. The Pattern Name dialog box (see Figure 11.41) will open with a preview, offering the opportunity to assign a name to the pattern. Enter "scanline," and click OK. The pattern is now added to the Pattern Library. The document that the pattern was created on is no longer needed and can be discarded.

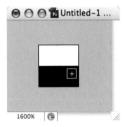

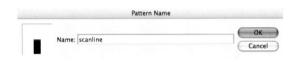

FIGURE 11.40 Creating the pattern.

FIGURE 11.41 Defining a pattern to the library.

- 9. Choose the image that will have the scan-line effect applied to it.
- 10. Create a new blank layer.
- 11. Choose Edit > Fill from the menu. The Fill dialog box like that shown in Figure 11.42 will open.
- 12. Select Use > Pattern. Click on the thumbnail, and select the Scanline pattern from the library.
- 13. Click OK to apply the pattern to the top layer. The pattern will now fill the entire screen, hiding the image underneath, as shown in Figure 11.43.

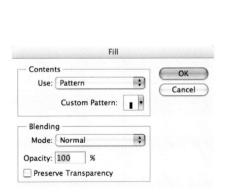

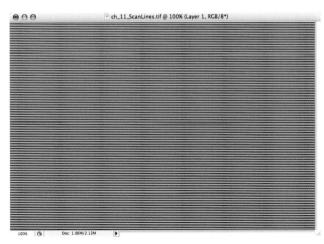

FIGURE 11.42 Using a pattern as a fill.

FIGURE 11.43 The Scanline pattern.

14. Change the layer blending mode to Screen, and lower the Opacity to about 30% to blend the scan line into the image. Figure 11.44 shows the result of the scan line. Tweak the opacity to produce the desired result.

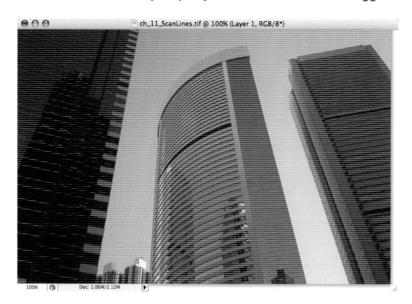

FIGURE 11.44 The final image with scan lines.

Another alternative is to use Multiply mode to produce darker scan lines. This is the reason we created a black-and-white pattern and not a transparent pattern for the scan line. You can make the pattern darker or lighter than the base image.

ADDING COLOR

Another trendy effect is to add color to images to make them more dramatic. This simple technique offers lots of room for experimentation.

- 1. Begin with any image open in Photoshop, such as Figure 11.45 (ch_11_Color Overlays.tif on the CD-Rom)
- 2. Create a new layer.
- 3. Choose Edit > Fill from the menu. From the Use drop-down list, choose Color.
- 4. The Color box opens to allow you to choose a color. This example uses a deep blue, as shown in Figure 11.46. At this point, your image will be the solid color you have chosen.

FIGURE 11.45 The original image.

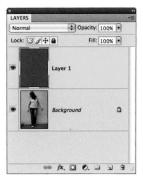

FIGURE 11.46 A new layer added and filled with blue.

5. Now for the fun. Experiment with changing the blending mode of this layer. Each blending mode will provide a unique effect. Not all will look good, and some will only look good when you lower the opacity of the layer. Try each blending mode, and vary the opacity each time to create different effects. Experiment with changing the contrast after you have decided upon a blending mode and layer opacity (see Figures 11.47, 11.48, and 11.49). Once you have decided on a blending mode that shows promise, create a Curves or Brightness/ Contrast layer and experiment with lightening, darkening, and changing contrast. Figure 11.47 is included on the CD-ROM (ColorOverlays.tif) with the different treatments shown below.

FIGURE 11.47 Blending mode of Soft Light with a layer Opacity of 45%. Curves were applied to lighten up the midtones.

FIGURE 11.48 Blending mode of Color Burn on a layer filled with brown. Opacity of 50%. Curves were applied to lighten up the midtones.

FIGURE 11.49 Blending mode of Color on a layer filled with yellow. Layer Opacity of 50%. Brightness and contrast increased.

TUTORIAL 11.6

CREATING AN IMAGE WITH HIGH COLOR AND TONAL CONTRAST

This technique can be applied to all types of images, but it seems to work well with portraits that are somewhat flat in color and contrast. The principles behind it will be useful in many situations.

- 1. Open ch_11_ColorContrast.tif from the CD-ROM, or use your own image (see Figure 11.50).
- 2. Create a Levels Adjustment Layer, and ensure that the image is producing a deep black by moving the Shadows slider to the right.
- 3. To brighten up the midtones and highlights, create another Curves layer (see Figure 11.51).
- 4. Create a second Curves Adjustment Layer.
- 5. Change its blending mode to Color.
- 6. Choose a color from the Channels drop-down menu. In this case, I have chosen the blue channel to work with. Through the color channels in Curves, you can add both blue into the shadows and yellow into the highlights or vice versa. The same could be accomplished with the green/magenta in the Green channel or red/cyan in the Red channel.
- 7. Put a point in the center of the curve to lock it down. Pulling down the upper part of the curve will push the highlights toward yellow. Lifting up the lower part of the curve will add blue into the darker areas of the image, as shown in Figure 11.52.

FIGURE 11.50 The original portrait.

FIGURE 11.51 Curves to brighten the highlights and midtones.

FIGURE 11.52 Adding yellow to the highlights and blues to the shadows via the Blue channel in Curves. Your curve may not look the same as this one. Experiment to see what looks best for your photo.

Figure 11.53 shows the final image after adding tonal contrast via Curves and Levels and color contrast via the Blue channel in Curves. This technique is one way to accomplish split toning. Simply add a Black and White Adjustment Layer before you begin to adjust the colors in Curves. See the next example for more on split toning.

FIGURE 11.53 The final image.

TUTORIAL 11.7

SPLIT TONING A PHOTOGRAPH

Split toning is another technique borrowed from the darkroom. It was a way to tone a black-and-white image with two different colors. The highlights picked up one color as the shadows displayed the other. As with many traditional techniques, Photoshop proves more controllable and far easier than the darkroom. Here is one of many techniques.

Choose an image that you want to split tone. We are using ch_11_SplitTone.tif from the CD-ROM, as seen in Figure 11.54.

- For color images, create a new Black and White Adjustment Layer to turn the image to black and white.
- For black-and-white images, check to ensure that your image is in RGB mode. From the menu choose Image > Mode, and the flyout menu will show you whether the image is Grayscale or RGB Color. If it is Grayscale, click on RGB Color.
- 1. With your image open, create a Black and White Adjustment Layer to remove the color and adjust the tones (covered in depth in Chapter 10).
- 2. Press the Ctrl + Alt + ~ (Cmd + Opt + ~ for Mac) keys. This will create a Luminance selection.
- 3. Create a Hue/Saturation Adjustment Layer. Change its blending mode to Color. Click the Colorize box, as shown in Figure 11.55. Adjust the Hue slider to choose a color for the highlights. We used yellow for this example.
- 4. Ctrl+click (Cmd+click for Mac) on the mask in the Hue/Saturation layer to load this mask as a selection.

FIGURE 11.54 The original image.

FIGURE 11.55 Checking the Colorize box.

- 5. Press Ctrl+Shift+I (Cmd+Shift+I for Mac) to invert the selection. Now we will be working on the shadows.
- 6. Create a new Hue/Saturation Adjustment Layer. Change its blending mode to Color. Check the Colorize box.
- 7. Adjust the Hue slider to choose a color for the shadows. We used blue for this example. Blue shadows with yellow highlights is a traditional toning scheme, but experiment to suit your tastes.

Figure 11.56 shows the final image. If you find that the default Saturation settings in the Hue/Saturation Panel are a bit much, click on each of the Hue/Saturation layers and revisit the Adjustments Panel to lower or raise the Saturation sliders to your taste.

FIGURE 11.56 The final image.

A few points to ponder:

- If the colors seem to be posterizing, click on each mask and raise the Feather value in the Masks Panel to blur the masks.
- It is common to be seduced by the color. If you are looking for a true toning look, keep your saturation levels a little lower.
- Try this same technique without changing the image to black and white (see Figure 11.57). The possibilities are endless.

FIGURE 11.57 The same image with the Black and White Adjustment Layer removed.

TUTORIAL 11.8 SLIDE SANDWICH TECHNIQUE

ON THE CD

Here's a very easy but cool technique that creates a heightened sense of saturation and contrast similar to sandwiching two slides together. This works well with images that lack some contrast, but try it with all types of images. Follow along with image ch_11_SlideSandwich.tif from the CD-ROM, as seen in Figure 11.58.

- 1. Duplicate the Background layer.
- 2. Change the blending mode to Overlay, as seen in Figure 11.59.
- 3. If the effect is too heavy, lower the opacity on the duplicate layer.
- 4. Figure 11.60 shows the resulting image.
- 5. Take this technique a step further. Click on the duplicate layer.
- 6. Choose Filter > Blur > Gaussian Blur. Experiment with the Radius setting to produce the final image, as seen in Figure 11.61. We used a Radius of 4.4 to achieve this effect.

FIGURE 11.58 The original image.

FIGURE 11.59 Change the blending mode to Overlay.

FIGURE 11.60 The final image.

FIGURE 11.61 Slide sandwich with Gaussian Blur.

TUTORIAL 11.9

DOUBLE EXPOSURE BLUR

A favorite technique among photographers shooting film was the double exposure blur. Setting the camera to shoot two exposures on one frame of film, we would shoot the first exposure sharp and the second one out of focus. This would have the final effect of a sharp image with a blurry romantic feel.

1. Open ch_11_DblExpBlur.tif from the CD-ROM, as shown in Figure 11.62.

FIGURE 11.62 The original image.

- 2. Duplicate the Background layer.
- 3. Press Ctrl+T (Cmd+T for Mac) to transform this layer. Type 101% in the Height and Width boxes in the option bar (see Figure 11.63). This will make the top layer slightly bigger than the lower layer, emulating the enlargement that occurs when you defocus a lens. Click the check mark in the option bar to commit to the transformation.

FIGURE 11.63 Adjusting the Transform settings.

- 4. Choose Filter > Blur > Gaussian Blur.
- 5. Set the Radius to an amount that you feel may be a bit too much. You can lower the Opacity layer to suit your tastes. Click OK.
- 6. Lower the opacity of the top layer to achieve the desired effect. Figure 11.64 shows the final image.

FIGURE 11.64 The final image.

TUTORIAL 11.10

MAKING A GRITTY LOOKING PHOTO

This is a great technique for adding a hip style to your photographs. Figure 11.65 shows the original image ch_11_grain on the CD-ROM. The following steps will show you how to create grain in any type of photograph.

- 1. Open the image ch_11_grain.tif. Create a new blank layer. Choose Edit > Fill. Choose 50% Gray from Contents.
- 2. Change the blending mode to Overlay, as shown in Figure 11.66.
- 3. Add some noise to the image by choosing Filter > Noise > Add Noise. Click Gaussian and Monochromatic. As you watch your image, move the Amount slider until the desired amount of grain is introduced (see Figure 11.67).
- 4. Create a new Hue/Saturation Adjustment Layer, and then lower the saturation. For this example, the saturation is –40. The opacity of the Grain layer is also lowered to 75%. The final effect is shown in Figure 11.68.

FIGURE 11.65 The original image.

FIGURE 11.66 Changing the blending mode.

FIGURE 11.67 Adding noise.

FIGURE 11.68 The final image.

Looking for something with an edge? To expand on this technique, try the following steps:

- 1. Duplicate the Background layer. Desaturate this layer by pressing Ctrl+Shift+U (Cmd+Shift+U for Mac). The Layers Panel is shown in Figure 11.69.
- 2. Now duplicate this layer, and invert the duplicate (Image > Adjustments > Invert). Your image and Layers Panel should now look like Figure 11.70.

FIGURE 11.69 Duplicate the layer and desaturate.

FIGURE 11.70 Inverting the duplicate layer.

- 3. Change the blending mode of this layer to Color Dodge. Your image will appear totally white. Choose Filter > Blur > Gaussian Blur. Increase the radius to obtain the effect shown in Figure 11.71. This is an interesting look in itself and could be the final image. To add the color back into the image, continue with the tutorial.
- 4. With the upper (blurred) image layer active, choose Merge Down from the Layers menu, as shown in Figure 11.72. This will merge the duplicate layers together without affecting the other layers in the image.

FIGURE 11.71 Blurring the layer.

FIGURE 11.72 Merging the duplicate layers.

5. Change the blending mode to Overlay. Figure 11.73 shows the final image. This technique offers a lot of room for experimentation and can be applied to many types of images.

FIGURE 11.73 The final image.

TUTORIAL 11.11

CREATING DRAMATIC SKIES WITH SPLIT NEUTRAL DENSITY EFFECT

This effect is most useful for landscape photographers. Usually, the sky is brighter than the objects on the landscape. Because a camera doesn't have the dynamic range of the human eye, you cannot properly expose for both the sky and the ground. You can either expose for the sky and the ground will become very dark, as we have done in Figure 11.74, or expose for the ground and the dramatic clouds in the sky get lost. To combat this problem, photographers have for many years used a split neutral density filter. This graduated filter sits in front of the lens and darkens the sky. This allows a correct exposure for the entire scene. The effect you are about to use will simulate this effect but with more control. To use this effect, you must have an image that has a properly exposed sky and darker foreground. Once the highlights are overexposed, you cannot bring them back!

- 1. Open ch_11_Split.tif (see Figure 11.74) from the CD-ROM, or use your own image.
- 2. This next step can be done a few ways. The best way is to begin by shooting two images, the first exposed for the sky and the second for the landscape (bracketed). Alternatively, if you are using RAW, you can open two copies, each adjusted for the sky and landscape. Place each of these images on its own layer within the same document, and then skip to step 5.
- 3. If you only have a single image (as in the images from the CD-ROM), you will be all right—just follow along.
- 4. Choose a Curves Adjustment Layer, and adjust the foreground, as shown in Figure 11.75. Don't worry about the loss in the sky yet.

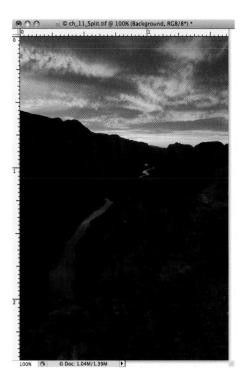

FIGURE 11.74 The original photo.

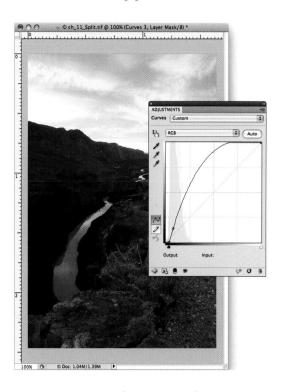

FIGURE 11.75 Making a Curves adjustment.

- 5. Select the mask on the Adjustment Layer. (Create a mask on the top layer if you are using two images instead of an adjustment.)
- 6. Select the Gradient tool. Choose a linear black to white gradient.
- 7. Drag the gradient through the horizon. Try about an inch above and drag to an inch below. If the effect is too abrupt, increase the distance of the gradient. Figure 11.76 shows the Layers Panel with the gradient mask.

This final image (see Figure 11.77) shows the picture with the foreground brightened up without losing any of the drama in the sky.

FIGURE 11.76 Creating a gradient mask.

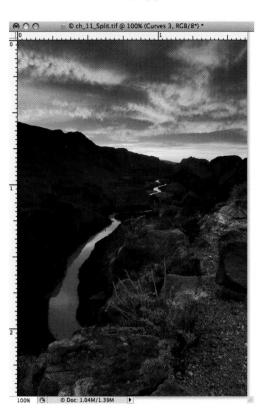

FIGURE 11.77 The final image.

TUTORIAL 11.12

CREATING A VANISHING POINT

Vanishing Point is an astonishing tool that allows you to define a plane in a surface. After the plane has been defined, you can then clone, paint, select, copy, and paste—all in 3D space. That's right, all the tools in Vanishing Point respect the perspective of the image. The tools even work around corners on different planes. Let's take a tour of Vanishing Point.

- 1. Open ch_11_Vanishing.tif from the CD-ROM.
- 2. Choose Filter > Vanishing Point. You will now see the interface, as shown in Figure 11.78.

3. The first task is to define a plane.

Do not press the Escape key while using this tool or the Vanishing Point window will close and all your work will be lost.

4. Choose the Create Plane tool, as indicated in Figure 11.79.

FIGURE 11.78 Vanishing Point.

FIGURE 11.79 Defining a plane.

5. Click on the first corner, then click on the next corner, and you will notice a line. When you click on the third corner, the indicator will change to a box. Position your pointer over the fourth corner and click. You will now see a grid, and the tool will automatically revert to the Edit Plane tool, as shown in Figure 11.79.

Press Z to temporarily zoom in while working in Vanishing Point.

- 6. Now create another plane on the side of the box. You don't have to create an entirely new plane. Choose the Create Plane tool, and click on the middle handle of the previous plane. Click and drag. Notice that you are now creating a new plane that is perpendicular to the previous one, as shown in Figure 11.80.
- 7. Make sure the Edit Plane tool (the top one) is selected, and use it to drag a corner to fine-tune the plane, as shown in Figure 11.81. This will take a bit of practice.
- 8. Continue to drag perpendicular planes until you have covered four surfaces, as shown in Figure 11.82.
- 9. After the planes have been defined, you can begin working on the image.
- 10. Choose the Stamp tool. Its operation is very similar to that of the Clone Stamp in Photoshop, but this one works in perspective!

FIGURE 11.80 Creating an adjacent plane.

FIGURE 11.81 Adjusting the corner.

11. Clean up the crack in the front of the box. Press the Alt/Option key and click. This will pick up a sample of that area (and keep it visible). Hover your mouse over the area that you want to cover and click. You can also drag and paint with the tool. To reposition the sample, press Alt/Option and click again. Turn on Healing from the Vanishing Point option bar for some spectacular results. Figure 11.83 shows this tool in action. As you can see from Figure 11.84, this tool does a great job of cloning in perspective as you drag!

FIGURE 11.82 The image mapped with perpendicular planes.

FIGURE 11.83 Using the Stamp tool.

- 12. Now for the grand finale of the Stamp tool, press the Alt/Option key and click to make a sample of the front pattern. Click on the side of the box. The tool can actually work around a corner!
- 13. Another way to clone is to use the Rectangular Marquee tool. Choose the Marquee tool, and make a selection around an object on the wall (see Figure 11.85). You will notice that this tool also works in perspective.
- 14. Switch on the Heal option for this tool from the Vanishing Point option bar.

FIGURE 11.84 After a little cloning, the cracks are gone.

FIGURE 11.85 Selecting an object.

- 15. Hold down the Alt key (Option key for Mac), and click inside the selection. Then drag a copy of the selection to the front of the box (sarcophagus). Release your mouse button, and the object will blend into its environment (see Figure 11.86).
- 16. Without deselecting, hold down the Alt/Option key, but this time add the Shift key. The Shift key will constrain your movements to the perspective of the plane. Begin to copy multiple instances of the shape, as shown in Figure 11.87.

FIGURE 11.86 Copying the object to another surface.

FIGURE 11.87 Making multiple copies.

- 17. Experiment a little to see what else Vanishing Point can do. Make a selection on the front of the box. Copy the selection to the back wall, as shown in Figure 11.88. Notice what a nice job the Heal option does to the color and texture.
- 18. When you are satisfied, click OK to apply. Figure 11.89 shows the results of your work.

Following are some useful tips when working with Vanishing Point:

- Create a new blank layer before working with Vanishing Point. This tool works very well on a layer, and this will give you more control later.
- To add your own texture or logo, copy the image to your Clipboard. Once you are in Vanishing Point, you can paste your Clipboard's contents.

FIGURE 11.88 Moving surfaces onto the wall.

FIGURE 11.89 Compare the final image with the original in Figure 11.78.

USING THE IMAGE WARP TOOL

The Image Warp tool was introduced in Photoshop CS2. This tool allows you to mold and shape your images to fit any surface. It is different from Liquify because it's easier to work with, is reversible, and comes with preset warps. In fact, this tool works the same as the Text Warp tool except that you are now working with images. We will use two images that I snapped to give you an idea of what this tool is capable of.

- 1. Open ch_11_ImageWarp.tif from the CD-ROM.
- 2. You will see the image with two layers; select the top layer. You are going to make the gauges follow the contours of the car.
- 3. Choose Edit > Transform > Warp, as shown in Figure 11.90. A quicker way is to apply this shortcut: Press Ctrl+T (Cmd+T for Mac), right-click (Crtl+click for Mac), and choose Warp.
- 4. Drag each of the corners into position so that they follow the edges of the object, as shown in Figure 11.91. This is a good "anchor" start.
- 5. Click and drag the handles (lines with dots on the ends that are sticking out from the corners). Use the handles to make the curves the same shape as the front of the car.
- 6. Click and drag the edges of the grid to mold the shape of the layer to fit the curves on the car. This may take a little practice, but it will come quickly. Figure 11.92 shows the layer shaped to fit the car.

FIGURE 11.90 Choosing the Warp tool on the starting image.

FIGURE 11.91 Positioning the corners.

Finally, to finish things off a bit, I changed the Layer mode to Screen and reduced the opacity. Then I used a layer mask to hide the edges of the layer. The final image is shown in Figure 11.93. Masks and modes are covered in Chapter 6.

The great thing about these techniques is that everything is nondestructive. You can go back to the original shape any time by choosing None from the drop-down menu in the option bar that currently says Custom.

FIGURE 11.92 Warping the top layer to match the contours of the car.

FIGURE 11.93 The final image using the Image Warp tool.

12

COMBINING IMAGES FOR CREATIVE RESULTS

IN THIS CHAPTER:

- Removing an Object from Its Background
- Rules for Compositing Two Images
- Combining Images to Create an Advertisement
- Creating a Panoramic Image
- Merge to HDR (High Dynamic Range)
- Collaging Techniques and Blending Modes
- Advanced Blending
- Summary and Conclusion

In this chapter, you will work with multiple images. We will begin with extracting an image from its background and the technicalities involved in achieving a believable placement into a new environment. The next part of this chapter will deal with some of the more creative expressions of collaging and compositing images.

REMOVING AN OBJECT FROM ITS BACKGROUND

At the very core of compositing is the challenge of removing an object from its background. The long method is to use the Pen tool or the Lasso tool. These tools are covered in some depth in the user's manual and online help. We will look at two quicker approaches in this section.

Using Color Range

The first method works best for an image that is on a somewhat uniform background color. Most people reach for the Magic Wand tool. Although this is a viable method, Color Range provides extra control over fine-tuning of the selection. A fine-tuned selection will have cleaner edges.

USING COLOR RANGE TO REMOVE AN OBJECT FROM ITS BACKGROUND

1. Open ch_12_Motocross.tif from the CD-ROM. You can see the image in Figure 12.1.

- 2. Choose Select > Color Range. You will see the Color Range dialog box, as shown in Figure 12.2.
- 3. From the Select drop-down list (circled in red in Figure 12.2), choose Sampled Colors. Choose the Selection radio button at the bottom of the dialog box (circled in blue) to see a grayscale preview of the selected area. From the Selection Preview drop-down list, choose Grayscale. In this example, we will not be checking the Localized Color Clusters box, but see Chapter 6, "Local Enhancements: Selections and Masks," for more on this new option.
- 4. It will be much easier to select all the blue areas instead of the intricacies of the subject itself. Move the cursor into the image area, and you will notice that the it turns into an eyedropper. Click an area of the blue sky, as shown in Figure 12.3. Notice that the selected color turns white in the preview.

FIGURE 12.1 The original image. (Royalty-free image from Hemera.)

Select. Sample Color Survey

| Select. Sample Color Curren
| Incomited Color Curren
| Fuzziness | 175 |
| Incomited Color Curren
| Fuzziness | 175 |
| Incomited Color Curren
| Incomited Color Curr

FIGURE 12.2 Color Range dialog box.

FIGURE 12.3 Clicking in the sky.

- 5. Select the Eyedropper tool with the plus sign (+) next to it in the Color Range dialog box (circled in red in Figure 12.4). The tool will now add any selected colors to the existing selection.
- 6. Click on the darker part of the sky to add it to the selection. Keep clicking on the different areas until the background becomes a solid white, as shown in Figure 12.4.

7. Move the Fuzziness slider to fine-tune the selection. You want the background to remain white while the object turns black, as shown in Figure 12.5. This is defining the selection area. You cannot perform this fine-tuning step with the Magic Wand, which is why we used this method.

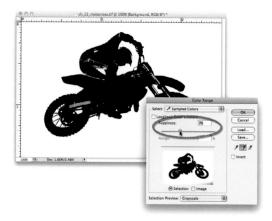

FIGURE 12.4 Adding areas to the sample.

FIGURE 12.5 Adjust fuzziness.

- 8. To temporarily toggle between the Selection view and the image, press and hold the Ctrl key (Cmd key for Mac), as shown in Figure 12.6. This can help to refine the selection.
- 9. Click OK to apply Color Range. A selection will now appear around the areas that were white in the Preview window, as shown in Figure 12.7. The blue areas are all selected now.

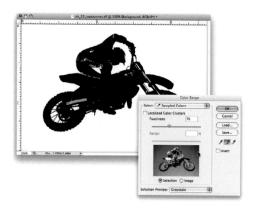

FIGURE 12.6 Pressing Ctrl/Cmd for a temporary preview of the image.

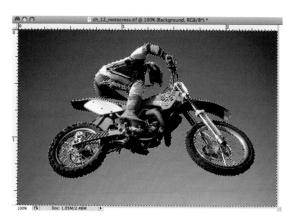

FIGURE 12.7 The blue areas are selected.

- 10. Because some of the object itself is blue, the selection has also included unwanted portions of the cycle and biker. Let's clean these up the easiest way possible. Press the Q key on the keyboard, or click the Quick Mask button at the bottom of the Layers Panel to enter Quick Mask mode, as shown in Figure 12.8. The selection will now be painted in a mask. Another method is to extract the image and use the History brush to paint back the missing areas. The Quick Mask method enables you to get a clean selection right away. This is useful if you want to save the selection as an alpha channel.
- 11. Choose a hard-edged brush and black for the foreground.
- 12. Paint over the unmasked areas of the image until the entire object is painted in red, as shown in Figure 12.9. Press the X key to toggle between painting black and white (which would appear as red or erasing in this quick mask mode). Press the tilde (~) key if you want to see the mask in black and white instead. Press it again to return to the red overlay.

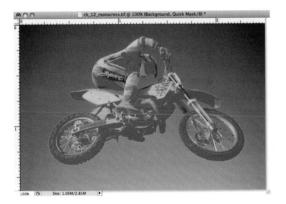

FIGURE 12.8 Choosing Quick Mask.

FIGURE 12.9 All the gaps are filled.

- 13. Press the Q key again, or select Standard mode from the bottom of the Layers Panel to turn the mask into a selection again. The selection will now be visible, as shown in Figure 12.10. Now to fine-tune the edge. Whenever a selection tool is active, you'll see a tool on the option bar called Refine Edge. This tool will allow you to make the edges nice and crisp. This feature is covered in depth in Chapter 6. The Refine Edge tool will get a nice crisp edge before cutting out the object from its background.
- 14. Choose Select > Inverse to change the selection from the background to the object.
- 15. Press Ctrl+J (Cmd+J for Mac) to copy the selected object to a new layer and hide the background to reveal the extracted image, as shown in Figure 12.11. You could have just deleted the background instead for step 14, but it's a good practice to preserve the original image whenever possible.

FIGURE 12.10 Fine-tuned selection.

FIGURE 12.11 The image has been removed from the background.

Figure 12.12 shows the extracted object placed onto another picture. To do this, simply open another image and drag and drop the extracted layer to the new document. The object will become a new floating layer. The color has been warmed up and the contrast increased on the motorcycle and rider to have them match the color and contrast of the of the background image.

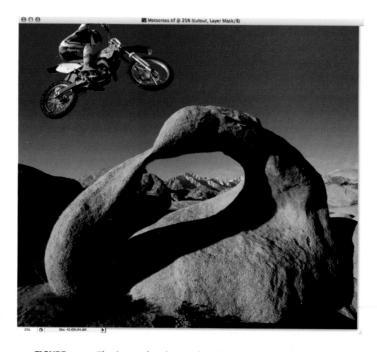

FIGURE 12.12 The image has been placed on a different background.

Extracting Images Using the Extract Tool

The Extract tool is great for removing objects that are on multicolored and complex backgrounds. It also works well for complex soft edges, such as hair and fur, by defining an edge. Unfortunately, Adobe did not include the Extract Filter in this version of Photoshop. Their thinking may be that with the Quick Select tool and advances in the Masks Panel, the Extract tool is obsolete. This may be true, but you may find that you prefer the old extraction method better. To follow along with the next tutorial, download the Filter from the Adobe Web Site.

- For Windows go to www.adobe.com/support/downloads/ detail.jsp?ftpID=4048.
- For Mac go to www.adobe.com/support/downloads/detail.jsp?ftpID=4047.

Here is how it works: You tell Photoshop what you want to keep by filling a defined area. Everything inside the area is preserved, and everything outside the area is discarded. Where the magic happens is on the line that is drawn around the edges. The Extract tool will separate what should be kept and what should be discarded based on the color on either side of the edge. There are also a couple of touch-up tools available to further refine the edges of extracted images.

TUTORIAL 12.2

EXTRACTING IMAGES WITH THE EXTRACT TOOL

1. Open ch_12_couple-sailing.jpg from the CD-ROM. The task is to cut out the people and the wheel from the background. Figure 12.13 shows the original image.

Make a duplicate layer and work from the duplicate, hiding the background. This is done purely for preserving the original image. The reason to do this rather than just saving a copy is that by duplicating the layer and hiding it, it will always be there and travel with the image. For instance, if you want to work on this image a year from now, the original will be embedded in the PSD file, and you won't have to hunt for another document. This workflow is preferred and recommended but not necessary; you should use a workflow you are comfortable with.

2. Using the Edge Highlighter tool, draw along the hard edges of the object. It is important for the pen to be in the middle of the desired edge, with half the stroke in the foreground and half covering the background. This is how the Keep and Discard colors are flagged. Check the Smart Highlighting box for the hard edges. This will attempt to detect the edges and snap the tool to the recognized edges, thus making it easier to draw around the perimeter of the object, as shown in Figure 12.14.

FIGURE 12.13 The original image. (Royalty-free image from Hemera.)

3. Switch off Smart Highlighting, and choose a larger brush size for soft areas, such as hair. Cover all the hairs that you want to keep, as shown in Figure 12.15.

FIGURE 12.15 Defining the edges.

- 4. Be sure to define areas where holes are present, as shown in Figure 12.16.
- 5. Make sure that there are no gaps present in the defined edge. The edge of the screen is included in the edge, so there is no need to draw around the edges of the screen.

6. When the edges are defined, choose the Fill tool and fill the area that you want to keep by clicking inside it, as shown in Figure 12.17. This tells Photoshop what area should be discarded.

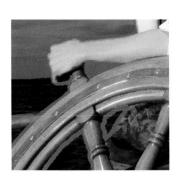

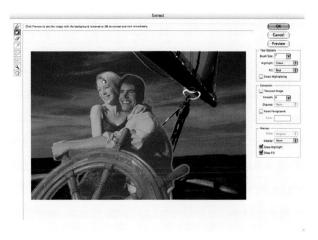

FIGURE 12.16 Filling in the gaps.

FIGURE 12.17 Filling the area to keep.

- 7. Choose the Preview button (see Figure 12.18). Extract will now remove all the areas outside the filled selection and calculate what should be kept and what should be discarded from the edges.
- 8. To see what is going on better, choose a solid color from the Display drop-down list. The white matte chosen in Figure 12.19 is for display purposes only and will not affect the image. You can see there are some areas that need to be cleaned up.

FIGURE 12.18 Preview.

FIGURE 12.19 Choosing a white matte.

- 9. Use the Edge Touch Up tool to clean up any stray pixels on the edges, as shown in Figure 12.20. Use the 0–9 keys to adjust the pressure.
- 10. Finally, use the Clean Up tool to fix areas manually. As you paint with the Clean Up tool, it will erase pixels. To paint pixels back in that were erased accidentally, hold down the Alt/Option key and paint. In Figure 12.21, we are painting back in a portion of the shoulder that was removed by an overzealous extraction.

FIGURE 12.20 Cleaning up the edges.

FIGURE 12.21 Fixing the selection.

- 11. When you are satisfied with the preview, click OK to apply the extraction to the image. It should now look like Figure 12.22a.
- 12. You can now drop this image onto another background for a fantasy effect, as shown in Figure 12.22b.
- 13. Open the image ch_12_Stars.jpg from the CD-ROM (a royalty-free image from Hemera). Both images should now be open.
- 14. Return to the sailing couple image. The bottom layer should not be visible. Click off the eyeball on this layer. You will now see your extracted image surrounded by gray and white squares. Click on the top (extracted) layer and drag it onto the other image. It is always better to drag from one image to the other. If you copy and paste, you use the clipboard and use up more RAM. This results in a longer copy and paste time and a greater chance of a computer crash.
- 15. Click on the Move tool to move them into the desired position.
- 16. The color scheme of the two different images may not be an exact match, so you'll need to bring them a little closer together. Create a new blank layer above the sailors.

FIGURE 12.22A The image separated from its background.

FIGURE 12.22B The extracted image on a new background.

- 17. Choose the Eyedropper tool, and click in the red color of the image, as shown in Figure 12.23a to change your foreground color to this red. You will apply this color to the sailors. With your blank layer active, choose Edit > Fill, and use Foreground Color from the Use box. Your image will be completely filled with this color.
- 18. Set the blending mode to Color Burn and reduce the opacity of the layer. The opacity is 22% in this example. This blending mode will take the color of the layer and influence the brighter tones of the image. Figure 12.23b shows how the shadows in the shirt remain blue, but their faces and lighter portions of the face begin to pick up the red color.

FIGURE 12.23A Choosing a new foreground color.

FIGURE 12.23B The new image with a closer color match.

RULES FOR COMPOSITING TWO IMAGES

When taking a selected portion of one photo and dropping it into another photo, there are a few things to watch out for. If these rules are ignored, the image will appear fake. Figure 12.24a shows a correct composition. We will look at some bad compositions and discuss what rules are being ignored.

Color/Hue Match: In Figure 12.24b, the girl has a redder tint than the background, making it obvious that she was added after the fact. The solution is to color correct the girl using one of the methods discussed in Chapter 5, "Color Correction and Enhancement."

FIGURE 12.24A A correctly composited image. (Royalty-free image from Hemera.)

FIGURE 12.24B Color mismatch

Brightness: In Figure 12.24c, the girl is brighter than the rest of the image. This is a real giveaway and sometimes can be seen in green screen situations in movies when poor correction techniques are applied. The solution is to use the techniques in Chapter 4, "Tonal Correction and Enhancement," to either darken the girl or brighten the rest of the image so that they match.

Saturation: Saturation is the amount of color. In Figure 12.24d, the girl is more saturated than the rest of the image. In this case, it is exaggerated. Saturation is easy to miss and will cause the image to appear mismatched. The solution is to use the Hue/Saturation or Curves tool discussed in Chapter 5 to reduce the saturation of the color in the girl.

Film Grain: Different ISO settings and lighting conditions can cause inconsistent grain in the images. In Figure 12.24e, the girl is grainier than the rest of the image. The solution is to either reduce the grain in the girl using techniques discussed in Chapter 8, "Sharpening and Noise Reduction," or add grain to the rest of the image using Filter > Noise > Add Noise or Filter > Artistic > Film Grain.

FIGURE 12.24C Brightness mismatch.

FIGURE 12.24D Saturation mismatch.

FIGURE 12.24E Grain mismatch.

There are some other things to watch for, too:

Proportion: Make sure that objects are scaled to the correct size to fit in with the perspective of the target image.

Shadows/Light Source: Make sure that the light source matches the images. If they are lit from opposite sides, it will look very artificial. Using the Dodge and Burn tools can help with this, but it's best to choose your images carefully before compositing.

Wind: This problem is rare, but it's good to keep an eye on. If wind is present in the image, be sure it is blowing in the same direction.

COMBINING IMAGES TO CREATE AN ADVERTISEMENT

Using what you have learned so far, you will create an advertisement for a fictitious timetable Web site of someone who has missed his train.

TUTORIAL 12.3

COMBINING IMAGES

1. Open ch_12_Trainstation.jpg and ch_12_TeenagerPose.jpg from the CD-ROM, or choose a couple of your own images. Figure 12.25 shows the original train station image.

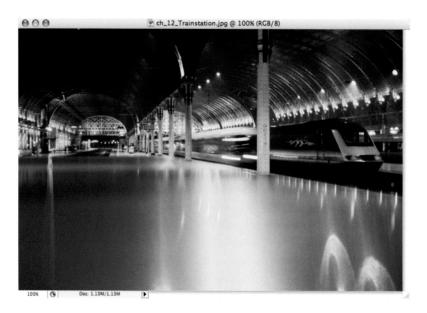

FIGURE 12.25 The original train station image. (Royalty-free image from Hemera.)

2. The image of the teenager is part of the Hemera Photo-objects series and comes with an alpha channel already included. To remove it from the background, click on the Channels Panel and then Ctrl+click (Cmd+click for Mac) on the alpha channel thumbnail (named Cutout) to load the selection. Return to the Layers Panel, and then choose the Move tool. Drag the object into another image, as shown in Figure 12.26. If you are using another image, use the techniques demonstrated at the beginning of the chapter to remove the object from its background.

3. Sometimes there can be a tiny fringe visible around the object. This can be removed by choosing Layer > Matting > Defringe and choosing a small setting, as shown in Figure 12.27.

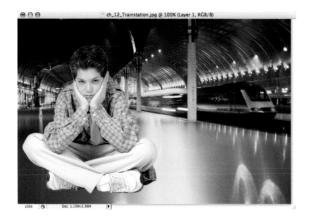

FIGURE 12.26 Drop the object onto the background.

FIGURE 12.27 Defringing.

- 4. Notice in Figure 12.28 how the image looks much cleaner around the head now.
- 5. The boy looks a little large in comparison to the rest of the picture, so let's downsize him a bit.
- 6. Choose Edit > Transform > Scale. Grab one of the corner handles of the transform box and drag it inward while pressing the Alt/Option key to keep the proportion the same, as shown in Figure 12.29. Click the check mark in the option bar to commit to the transform.

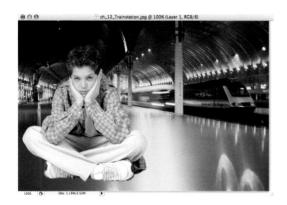

FIGURE 12.28 Cleaning up the halo on the head.

FIGURE 12.29 Scaling the boy down.

- 7. It also looks like the boy is floating in the air. You need to make him interact with the background. The floor is very reflective, so adding a reflection to the floor will cause the image to interact with the environment.
- 8. Duplicate the Teenager layer.
- 9. Choose Edit > Transform > Flip Vertical.
- 10. Move the transformed layer beneath the Teenager layer.
- 11. Reposition the flipped layer, as shown in Figure 12.30.
- 12. Notice that other reflections in the floor appear streaky. You will need to do the same with the flipped layer to make the image believable.
- 13. Choose Filter > Blur > Motion Blur.
- 14. Choose an angle of 90° and a distance of 8 pixels, as shown in Figure 12.31.

FIGURE 12.30 Dragging into position for a reflection.

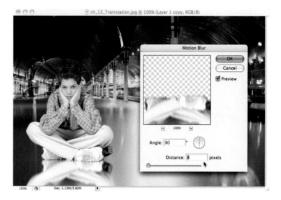

FIGURE 12.31 Adding motion blur.

- 15. To complete the effect, reduce the opacity of the layer to 68%. It now appears that the teenage boy is sitting firmly on the floor while his train is speeding away. Figure 12.32 shows the finished reflection.
- 16. Again you may want to draw this image (and its reflection) closer in color to the background. Start by clicking on the uppermost layer and choosing Merge Down from the Layers menu. This will merge the upper layer with the lower layer.
- 17. Grab the Eyedropper tool, and click in a section of blue.
- 18. Choose Layer > New Adjustment Layer > Photo Filter or use the Adjustment icon. You will see that the Adjustment Layer has a down arrow (circled in red in Figure 12.33). This arrow indicates that the adjustment is clipped to the layer below it, meaning it will only affect the layer below it, but not affect the Background layer at all. You can turn the clipping off by clicking the icon circled in blue in the Adjustments Panel.

FIGURE 12.32 The finished reflection.

FIGURE 12.33 Creating a clipping mask.

- 19. Click on the color square in the Photo Filter area, and then click on the foreground color in your toolbar. This will load up the previously picked blue color into the Color square. Click OK in the Select Filter Color dialog box. Raise or lower the Density slider to add or subtract the blue color from the boy. Figure 12.34 shows the final image. In the final image, we've added a Curves layer to the image to darken the boy. Create the Curves layer in the same way you did the Photo Filter by using the clipping mask.
- 20. To wrap up the advertisement, add some text, as shown in Figure 12.35.

FIGURE 12.34 The final image.

FIGURE 12.35 Adding text for an ad.

Adding a Cast Shadow

Another way to add realism is to reproduce the effects of light hitting an object at an angle and producing a cast shadow. This is a fairly easy effect to reproduce.

TUTORIAL 12.4

CREATING A CAST SHADOW

1. Open ch_12_phone_man.psd from the CD-ROM. Figure 12.36 shows the image.

FIGURE 12.36 The original image. (Royalty-free image from Hemera.)

- 2. Duplicate the layer with the man on it.
- 3. Click on Layer 1 Copy to activate that layer, as shown in Figure 12.37.
- 4. Ctrl+click (Cmd+click for Mac) on this layer thumbnail to create a selection of the man. Fill with black.
- 5. Choose Free Transform by pressing Ctrl+T (Cmd+T for Mac).
- 6. Right-click (Ctrl+click for Mac), and choose Skew.
- 7. Drag the top-center handle to the right, as shown in Figure 12.38. The light is hitting the man on the left of the forehead, so the shadow should fall in the opposite direction. Commit to the transformation, and deselect.
- 8. To soften the shadow, choose Filter > Blur > Gaussian Blur. Enter a Radius setting of 2.5 (see Figure 12.39).
- 9. As a shadow gets further away from the object, it tends to soften. You will create the softer shadow and then blend the two shadows together to create a gradual falling-away effect.
- 10. Duplicate the shadow layer. Hide the top shadow, and select the bottom one, as shown in Figure 12.40.

FIGURE 12.37 Duplicate the layer, and select it.

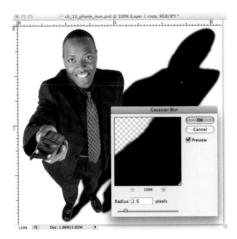

FIGURE 12.39 Softening the shadow.

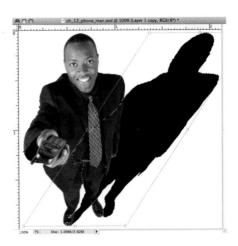

FIGURE 12.38 Creating the cast shadow.

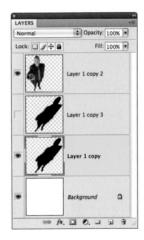

FIGURE 12.40 Duplicating the shadow.

- 11. Make this one softer with a 9.5-pixel Gaussian Blur, as shown in Figure 12.41.
- 12. Drop the opacity of this layer to 36% (see Figure 12.42).
- 13. Show the top shadow layer, and make this opacity 38%. Figure 12.43 shows both shadows.
- 14. You will now blend the shadows together.
- 15. Create a layer mask on the top shadow.
- 16. Choose the Linear Gradient tool, as shown in Figure 12.44a. With white as the background, black as the foreground, and the Gradient option set to Foreground to Background, drag the gradient from top to bottom in the layer mask, as shown in Figure 12.44b. The shadow should soften at the top.

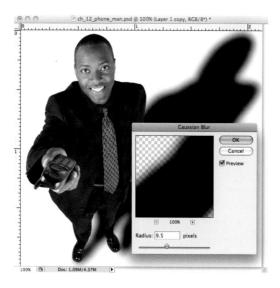

FIGURE 12.41 Softening the shadow.

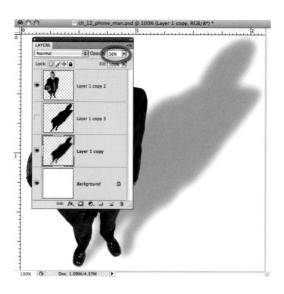

FIGURE 12.42 Lowering the opacity.

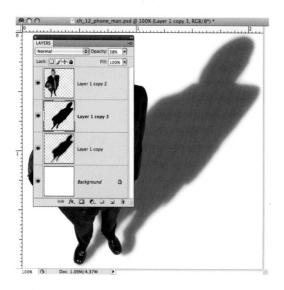

FIGURE 12.43 Showing both shadows.

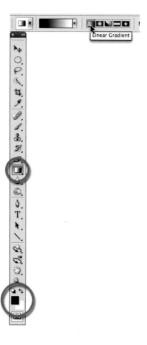

FIGURE 12.44A Choosing and setting the Gradient tool.

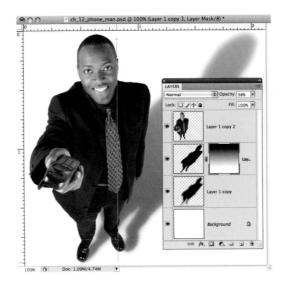

FIGURE 12.44B Running the Gradient tool from top to bottom.

17. The image can be easily added to another background for an interesting effect. Shadows are key to making an image fit within a new background and look like it was shot that way. Figure 12.45 shows the final image.

FIGURE 12.45 The final composite.

CREATING A PANORAMIC IMAGE

When it comes to landscape and scenic photos, there is seldom anything as breathtaking as a sweeping panoramic image. With Photoshop CS4, this is within the grasp of any photographer. All you need is a camera, some scenery to shoot, and Photoshop. Of course, a tripod will help a lot.

Take three (or more) images of the scenery. Take a picture to the left, one in the middle, and another to the right of the scene.

- While taking the shot, be sure that the camera is held level, and slightly overlap each image by about 30%. Try to avoid too much overlap as well as not overlapping enough.
- Avoid shooting with auto exposure because it's better if each image has
 the same exposure settings, which will maintain uniform brightness. Set
 your camera on Manual Exposure mode, find the medium exposure for
 the three images, dial that into the camera, and use it for all three shots.
- Avoid using a polarizer. This can create an uneven sky.
- It also helps to use normal lenses rather than wide-angle lenses. Wide-angle lenses tend to distort images at the edges, making it harder for Photoshop to do its job. (Although Photoshop CS4 has some really good lens correction built in).

After you have taken your pictures, it's time to work on this tutorial, which will show you how to splice them together using one of the features in Photoshop called Photomerge.

If you don't have your own images ready, use the three images provided on the CD-ROM called ch_12_Pano_1.tif, ch_12_Pano_2.tif, and ch_12_Pano_3.tif (see Figure 12.46).

FIGURE 12.46 The three images selected in Bridge.

TUTORIAL 12.5

CREATING A SEAMLESS PANORAMA

- 1. Open Bridge and navigate to the folder that contains your images. Select all of the images that you want to be part of the panorama. If they are RAW or JPEG images, you can open them all into the Raw Converter to make any changes.
- 2. Once opened into the Raw Converter, be sure to click Select All. This will ensure that all of the images receive the same treatment. When finished, click Done, and return to Bridge.
- 3. All of your images should still be selected; if not, reselect them. Choose Tools > Photoshop > Photomerge. You will see the Photomerge dialog box with the open images displayed in a list. In this dialog box, you have several Layout options, as shown in Figure 12.47. Look to the end of this tutorial for examples of the different Layout options.
- 4. Check the Vignette Removal box to make the images blend more naturally. This removes darker gradients around the seams. To keep the perspective looking the way you saw it, choose Reposition and click OK. Photoshop combines the images and blends them together for you! Figure 12.48 shows the merged images.
- 5. The Photomerge command is very powerful, but even so, it is a good idea to enlarge your image to Actual Pixels and scan the entire image for areas that do not match. Photoshop does not always blend the image perfectly!
- 6. If your image has spots where the blend isn't quite right, it's time to switch to manual! We will have Photoshop merge the images together for us, but we will do the blending.

Make a copy of your original images and then downsize them. Use these as your test subjects. If you like the results, repeat the process with your full-sized images.

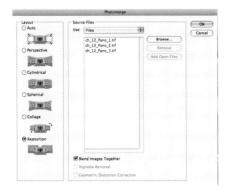

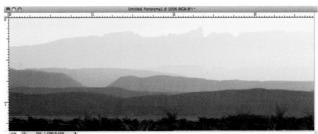

FIGURE 12.47 The Photomerge dialog box.

FIGURE 12.48 The three images blended together.

7. Close out your image and begin again. When you arrive at the Photomerge dialog box, uncheck the Blend Images Together box (see Figure 12.49). This will leave your images as layers in the final composite, as shown in Figure 12.50.

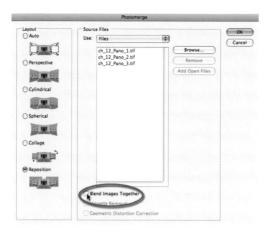

FIGURE 12.49 Uncheck the Blend Images Together box.

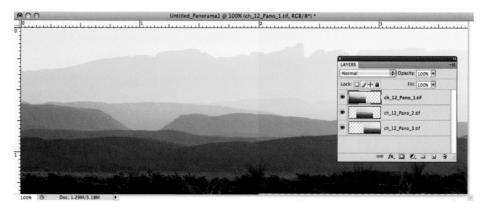

FIGURE 12.50 The final merge with the overlapping lines visible.

- 8. Click on each layer, and apply a layer mask, as shown in Figure 12.51.
- 9. The next step is to paint on the mask over the edge of the image line. Click on and off the eyeballs to target the mask you want to paint on. Use a soft brush and paint with black to manually blend the images together, as shown in Figure 12.52.

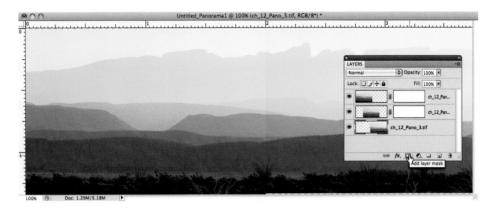

FIGURE 12.51 Adding Layer Masks to the layers.

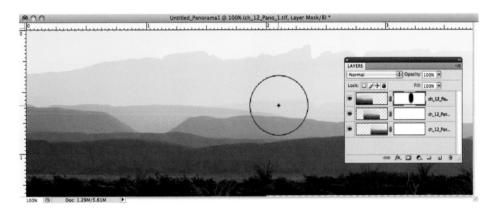

FIGURE 12.52 Painting over the edges.

10. Finally, crop the image to remove any background transparency that may be present (the gray and white squares). Figure 12.53 shows the final merged, blended, and cropped image.

In the beginning of this tutorial, you saw the several Layout options from which to choose. Figures 12.54a through 12.54f show the results of using the different Layout options to create your panoramic image. Figures 12.54a and 12.54f most closely match what I saw through my lens. All layouts except Reposition will transform (reposition, stretch, or skew) the images. I use Reposition for results that seem the most realistic to me.

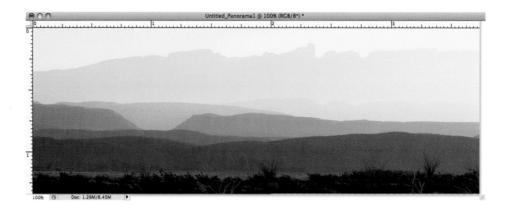

FIGURE 12.53 The final image.

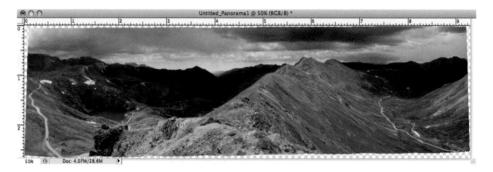

FIGURE 12.54A Auto.

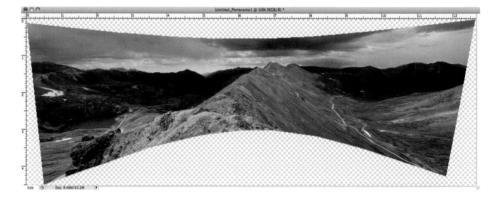

FIGURE 12.54B Perspective.

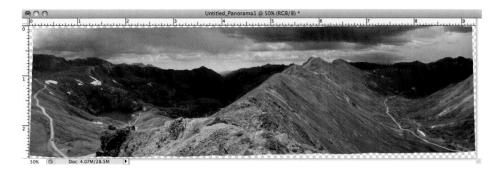

FIGURE 12.54C Cylindrical.

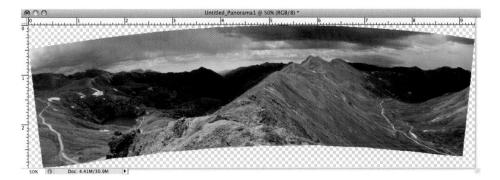

FIGURE 12.54D Spherical.

FIGURE 12.54E Collage

FIGURE 12.54F Reposition.

MERGE TO HDR (HIGH DYNAMIC RANGE)

HDR stands for *high dynamic range*, so called because you are extending the normal dynamic range of the photograph. The dynamic range is the difference between the darkest and lightest point in a photograph. Our eyes are capable of seeing a much wider range of tones than digital sensors can handle in a single shot. For example, imagine you're sitting in a room. (You probably are right now). Look at the brightest thing in the room. Perhaps it's a white windowsill. You can probably make out little details, such as the wood grain or the ornamentation in it.

If you were to photograph this object and expose the shot to show the detail, many other elements in the room would be underexposed and become black without detail. Turn your attention to the darkest thing in the room. Perhaps it's a black leather briefcase. Look carefully, and you can make out the leather grain. Snap a shot, exposing for the detail in the leather. The briefcase looks great, but now the windowsill (and probably everything outside the window) is blown out to white. See how the camera can't capture a very wide dynamic range? HDR changes all that. You can now capture several photographs, changing the exposure setting on each until you capture all the tonal detail in the scene. Now merge them together to make a single photograph showing all the detail. That's what you are about to do in this tutorial! (There is a lot to HDR. For more detailed information, check out the 2½ hour DVD at PhotoshopCAFE.com/video.)

By shooting multiple exposures of the same scene, you can bring them into Photoshop and let Merge to HDR blend them together. This will create a single 32-bit image with ample tonal detail.

There are three steps to creating an HDR image:

- 1. Capturing the photographs.
- 2. Merging them together.

3. Tone Mapping: This is where you reduce all the tones to those that can be displayed on screen and printed. This third step is where you choose how you want the photo to look. You can choose a very natural look with extra detail in shadows and highlights, or you can choose a more extreme and illustrative effect. The final result is up to your individual tastes.

Shooting

The key to blending images together is shooting the scene correctly. You need images that contain both highlight detail and shadow detail; this can only be achieved by shooting multiple exposures. Shoot one for the average exposure, another photo to capture all the details in the highlights, and yet another to capture all the detail in the shadows. Use the following tips to capture the best candidates for HDR:

- You will be bracketing enough shots to cover the full dynamic range of the scene. Usually you can cover it with three shots at 2-stop intervals: normal, highlight, and a shadow exposure. Sometimes you will need more exposures for more contrasty scenes, such as indoors with detail through the windows outside.
- If supported on your camera, use the AEB (Auto Exposure Bracketing) feature. Set the shooting mode to Continuous. (See the camera's user manual for instructions on this.)
- Whenever possible, use a tripod. If you can't for some reason, make sure
 you can hand-hold the camera at the slowest shutter speed used in the
 bracket shots. Use a wall or some solid object for extra support in the absence of a tripod.
- Bracket in Manual or Aperture Priority to avoid shape and depth of field changes in your images that you would get by changing the aperture setting.
- Avoid moving subjects, as these will give you "ghosting." Ghosting is when portions of a moving image appear on each exposure.

TUTORIAL 12.6 USING MERGE TO HDR

Once you have captured the photos, it's time to bring them into Photoshop for processing. Fig 12.55 shows the three photographs captured for this exercise (ch_12_HDR1.jpg, ch_12_HDR2.jpg, and ch_12_HDR3.jpg on the CD-ROM). For this example, we are providing JPEGS, but when creating your own HDRs, RAW files will work best because of the extended dynamic range.

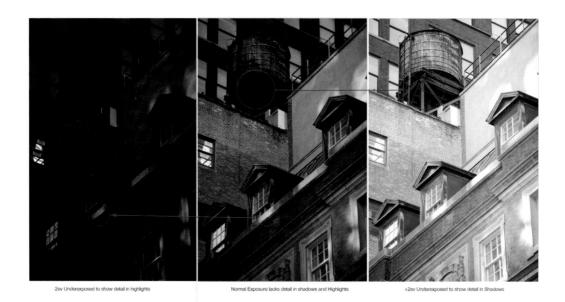

FIGURE 12.55 A range of exposures.

- 1. In Photoshop, choose File > Automate > Merge to HDR.
- 2. Click Browse and find the bracketed photos on your hard drive.
- 3. The Merge to HDR dialog box will appear. If the photo looks blurry, try turning off one of the photos on the thumbnails at the left by unchecking its box. You can change the white point at this time, but we don't recommend that yet.
- 4. Click OK.
- 5. You will now see a single image in Photoshop. At the bottom left, you will see a slider that can be adjusted to change the exposure of the photo. This is a dead giveaway that you are now dealing with a 32-bit image. It probably looks awful right now, even worse than the original. That's because it's only merged. You still need to tone map the photo. Right now the screen isn't capable of displaying all the tones in this photo at once. When you tone map it, you will choose what's to be displayed on screen.
- 6. To tone map, you first need to change the photo to 16 or 8 bit. Choose Image > Mode 16 bits/Channel (or 8 bits/Channel).
- 7. You will see the HDR Conversion dialog box. Choose Local Adaptation (the only option that lets you move the curve). Adjust the threshold to get the desired amount of sharpness. You may want your photo to look sharp and chiseled, or you may prefer it softer and more natural. Adjust the radius until you don't see any halos around the areas of contrast. (Halos appear as a glow around areas of contrast, a tell-tale sign of a badly tone mapped HDR.)

FIGURE 12.56 Merge to HDR dialog box.

FIGURE 12.57 The merged 32-bit photo in Photoshop.

- 8. Click on the arrow next to Toning Curve and Histogram to reveal the Curves box. Move the shadow point on the curve to the right until your image shows a deep black but doesn't clip any of the detail. An image without a pure black may look fake. Remember to release your mouse to see the effect as you set this point. Adjust the white point to brighten up the lighter parts of the photo without losing any detail in the highlights. You may also need to tweak the midtones to get a better look. Figure 12.58 shows the adjusted curve.
- 9. Now you're ready; click OK and the conversion will be complete. Figure 12.59 shows the final tone mapped image after a little adjustment for color.

FIGURE 12.58 Adjusting the curve in the Local Adaptation dialog box.

FIGURE 12.59 The final tone mapped photograph showing detail in both shadows and highlights.

Other Tone-Mapping Options

There is a growing trend with HDR photography. Due to this, photographers have been searching out better tone mapping tools than Photoshop currently offers. By far the most popular and most powerful tone mapping tool commonly used is the Photomatix plug-in (or Photomatix Pro, a standalone HDR tool). Figure 12.60 shows the same HDR image being tone mapped in the Photomatix plug-in. This plug-in is applied right after the Photoshop Merge to HDR step. After applying Photomatix, the photo is converted to 8 or 16 bits, just as explained in the previous steps. Photomatix is available from www.hdrsoft.com. We have arranged a 15% discount for readers of this book. When you purchase, enter the code PhotoshopCAFE to receive your discount.

FIGURE 12.60 Tone mapping with the Photomatix tone mapping plug-in.

TUTORIAL 12.7

AUTO-ALIGN

The Auto-Blend and Auto-Align commands make up a fascinating technology that is used within the Photomerge and HDR processing functions. They can, however, be used to create much more than just panoramas or high dynamic range images. Although I recommend using a tripod to create images that will be blended together, these new commands can align images that were taken hand-held. The possibilities are endless with this

technology. In the following example, I have taken three photographs of the same subject at different times of the day. Each image highlights a desired part of the scene. The HDR feature wouldn't allow for the full effect of each section, but the Auto-Blend and Auto-Align features are perfect for the job. Figures 12.61 through 12.63 show the three images.

FIGURE 12.61 Warm light on the mountain.

FIGURE 12.62 Detail in the shadows of the building.

If you don't have your own images, use the three images provided on the CD-ROM called ch_12_AutoAlign1.tif, ch_12_AutoAlign2.tif, and ch_12_AutoAlign3.tif. The goal is to have the final image show the orange glow of sunset on the mountain, the glow of the pool and indoor lights, and the detail in the shadows of the building. Begin by selecting the three images in Bridge.

1. From the Tools menu choose Photoshop > Load Files into Photoshop Layers.

FIGURE 12.63 Lights on in the pool and building.

FIGURE 12.64 Loading files into layers.

- 2. Select all of the layers at once by highlighting the bottom layer and then Shift+clicking on the top layer. Choose Edit > Auto-Align Layers. Choose Auto, and click OK. Your image will look like Figure 12.65. Be sure to check your edges for bits of transparency showing up. Crop if necessary.
- 3. At this point the layers are aligned and ready for the next step. You could either mask out individual layers and paint, or you could try Edit > Auto-Blend Layers. Figures 12.66 and 12.67 show the results of using Auto-Blend Layers and using Merge to HDR. As you can see, the Auto-Blend Layers image looks more natural, but still not great. This is because there is a color as well as tonal difference between the photographs. Sometimes you just have to blend things manually. In this case, Auto-Align Layers has at least loaded all of the images into one file, and then ensured that they were aligned properly. Not a bad start.

FIGURE 12.65 Choose Auto-Align Layers to align the layers.

- 4. Undo the last Auto-Blend step. Add layer masks to the upper two layers.
- 5. Click on the mask of the topmost layer. Go to Select > Color Range. Click inside the pool. Notice that it automatically applies to the mask! Refine the selection so that the pool looks good. You could also simply paint the pool with white. Figure 12.68 shows the top layer painted so the lighter pool underneath shows through.
- 6. Now to get some of those room lights showing through. Paint white on the lower part of the building on the upper mask, as seen in Figure 12.69.

FIGURE 12.66 Image created with Auto-Blend Layers.

FIGURE 12.67 Image created with Merge to HDR.

FIGURE 12.68 Painting to reveal the lower layer.

FIGURE 12.69 Painting to reveal the window lights.

- 7. This looks pretty good already, but we could fix it up a bit. Let's get some detail in the building and the patio in front of the pool. Click on the mask of the middle layer. As you paint on this layer with black, you will reveal the lighter layer below. This, however, will allow the full brightness to come through and might look a bit odd.
- 8. Click on the foreground square to bring up the Color Picker. Choose a middle gray. This will allow some of the lower layer to show through. Paint in the building and the pool, as seen in Figure 12.70.
- 9. At this point you could call it good or continue to fine-tune the image. The building still looks somewhat dark. To fix this, you could go back in and paint it with a lighter gray to let more of the lower layer through, but that would take too long. Instead, adjust the mask via a selection.

10. Alt+Click (Opt+Click for Mac) on the mask. This shows the mask in the image window. With the Lasso tool, make a loose selection around the building part of the mask, as seen in Figure 12.71.

FIGURE 12.70 Painting gray on the building and patio.

FIGURE 12.71 Creating a simple selection.

- 11. Alt+Click (Opt+Click for Mac) on the mask again to return to normal view.
- 12. From the Image menu choose Image > Adjustments > Curves. You are not creating an Adjustment Layer, simply a Curves adjustment to the mask within the selected area. As you move the bottom point of the curve up, you will be lightening the gray to allow less of the lower layer through. Dragging the bottom point of the curve to the right will darken the gray. This is a very fast and accurate technique for altering the tones in a mask without repainting.
- 13. Click OK to the curves box when you have reached the desired tone. Figure 12.72 shows the final image.

FIGURE 12.72 The final image.

To continue painting on the mask with this new shade of gray, Alt+click (Opt+click for Mac) on the mask to show it in the image window. With the Brush tool, Alt+click (Opt+click for Mac) on the area of gray that you want to paint. The Alt/Opt key temporarily changes the paintbrush into the eyedropper. When you click, it picks up the color and puts it into the foreground color. Now as you paint, you will be painting with the exact color as the surrounding image.

TUTORIAL 12.8

AUTO-ALIGN AND STACKS BLENDING MODE

In this example, I was trying to take a picture of a local courthouse through constant traffic without a tripod. Each image is slightly crooked due to me hand-holding my camera. Through the use of the Auto-Align command and the Stacks blending modes, you can align the three images together and create an image free of cars! Figures 12.73, 12.74, and 12.75 show the three initial images.

FIGURE 12.73, 12.74, 12.75 The three images showing different car placement within the frame.

1. On the CD-ROM, open the image called ch_12_AutoStacks.psd. The image has the three layers already stacked into one document. If you are following along with your own images, drag the other open documents all into one image. Pressing the Shift key while dragging will center the new layer over the other layers. Figure 12.76 shows the image with three stacked layers.

FIGURE 12.76 The starting image with three stacked layers.

2. Select the three layers by clicking one and then Ctrl+clicking (Cmd+clicking for Mac) on the others as shown in Figure 12.77.

FIGURE 12.77 Selecting the three layers.

- 3. Choose Edit > Auto-Align Layers. The progress bar will appear, indicating that the layers are being aligned. The larger the images, the longer this process will take.
- 4. When the layers are aligned, choose Convert to Smart Object from the Layers menu, as shown in Figure 12.78. Your three layers will turn into one Smart Object.
- 5. Choose Layer > Smart Objects > Stack Mode > Median, as shown in Figure 12.79. This Stack mode will replace anything that does not appear at least 50% of the time. Figure 12.80 shows the final image after cropping.

FIGURE 12.78 Converting layers to a Smart Object.

FIGURE 12.79 Apply a Stack mode.

FIGURE 12.80 The final image.

6. This technique will work wonders with CS4 Extended version. (It is a great noise reduction technique!) If you have the standard version of CS4, the same results can be achieved with the manual application of masks to the individual layers, and then painting out the objects on the appropriate layers. Follow steps 1 to 4 in this tutorial, and then create masks and paint as you did in the previous example of the pool.

TUTORIAL 12.9

AUTO-ALIGN AND BLEND TO ACHIEVE MAXIMUM DEPTH OF FIELD

Sometimes it is just impossible to get everything completely sharp within a photo, even if you stop down to the smallest aperture (such as f22 or f32). This is often due to using a longer focal length lens, focusing on a subject that is very close, or a combination of both. In this example of Aspen trees, I was using a 200mm lens to visually compress the trunks and remove unwanted background. This resulted in a composition where it was physically impossible to get all of the trees sharp. When faced with this type of situation, the solution is to shoot several images, with each focused on a different area of the frame, and then use Photoshop to blend them together. Figure 12.81 shows the three separate images. In the first image, I focused on the front tree. For the next exposure, I focused on the second tree back. The last shot was focused so that the far tree was sharp. Each image was made at an aperture of f16 to spread out the depth of field.

FIGURE 12.81 Three separate images with different focus points.

- 1. On the CD-ROM, open the image called ch_12_Auto_DOF.psd. The image has the three layers already stacked into one document. If you are following along with your own images, drag the other open documents all into one image. Pressing the Shift key while dragging will center the new layer over the other layers. Figure 12.82 shows the image with three stacked layers.
- 2. Select the three layers by clicking one and then Ctrl+clicking (Cmd+clicking for Mac) on the others, as shown in Figure 12.82.
- 3. Choose Edit > Auto-Align Layers. Choose Auto for projection, and check the Vignette Removal and Geometric Distortion boxes. Click OK.
- 4. Now that your layers are all aligned, Choose Edit >Auto-Blend Layers. Choose the Stack Images option and check the Seamless Tones and Colors box, as seen in Figure 12.83.
- 5. Voilà! Photoshop has blended your layers together and created a final photo that is sharp throughout. Figure 12.84 shows the resulting image with the Layers Panel. Notice that Auto-Blend has masked out the necessary areas to create the final image.

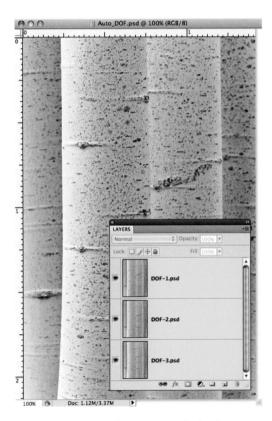

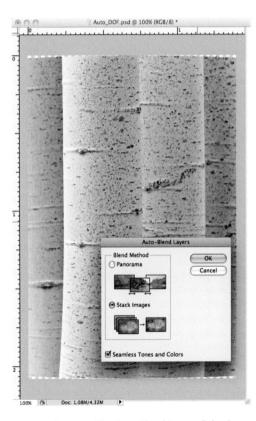

FIGURE 12.83 The Auto-Blend Layers dialog box.

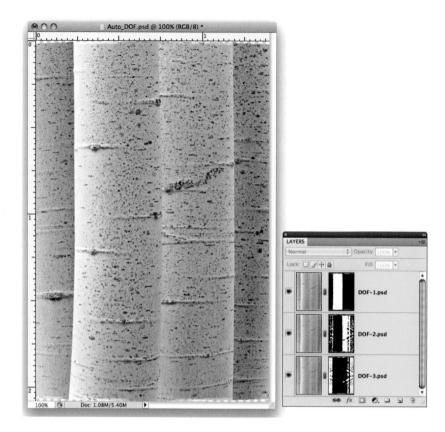

FIGURE 12.84 The final blended image.

TUTORIAL 12.10

ADDING A NEW SKY

How often do you have a good composition, but the sky is either too bright or lacks any interest at all? No problem. Just use a better sky from a different image! The technique is surprisingly simple. Once again, the trick is to use the right images. If your composition was created with a wide-angle lens, then the sky that you drop in should be a wide-angle shot as well. Putting a sunset sky into an image that was shot in the middle of the day will not look very convincing. If your foreground was created on an overcast day, you will have more luck using a sky that is very light rather than a dark blue. In this example, we will use two wide-angle photographs.

1. Open the images ch_12_whitesky.tif and ch_12_clouds.tif provided on the CD-ROM (see Figures 12.85 and 12.86).

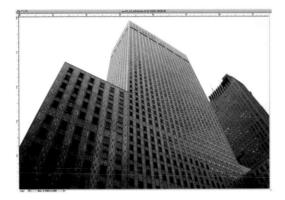

FIGURE 12.85 In need of an interesting sky.

FIGURE 12.86 An interesting sky.

2. Activate the White Sky image and, using the Magic Wand, select the sky. Check the Contiguous option for the Magic Wand to keep it from wandering outside the sky and into the buildings. If the first click does not select the whole sky, add to the selection by pressing the Shift key and clicking again. Figure 12.87 shows the sky selected. When working on images of your own, you may find that the Color Range tool creates good selections of the sky.

FIGURE 12.87 The sky selected.

- 3. Choose the Clouds image, and choose Edit > Select All. Then choose Edit > Copy.
- 4. Return to the White Sky image, and choose Edit > Paste Into. You now have a new and interesting sky, as shown in Figure 12.88. The Paste Into command is convenient because it automatically unlinks the mask from the layer, as shown in Figure 12.89. This means you can use the Move tool to move the sky around in the background. Go ahead and try it.
- 5. This is a dramatic improvement, but you are not finished yet. A sky should look believable when placed into another image. This one seems dark compared to the buildings. Create a new Curves Adjustment Layer. Click the Clip Layer icon (circled in red in Figure 12.90) in the Adjustments Panel. This will clip the Adjustment Layer to only the layer below it (the sky layer). Notice the down arrow circled in blue. This indicates that only the layer below is being effected. Adjust the curve to lighten the sky, as shown in Figure 12.90.

FIGURE 12.88 The final image.

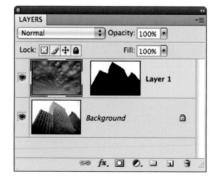

FIGURE 12.89 The unlinked mask.

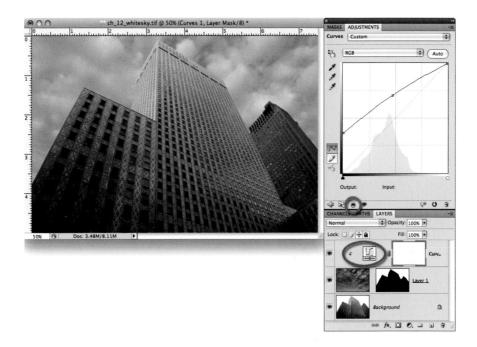

FIGURE 12.90 Lightening the sky with Curves.

- 6. Sometimes, the sky is too large or too small to fit properly within the scene. This can be changed with the Transform tool. First, downsize the view so that you can see the Transform handles. Then while holding down the Alt/Option+ spacebar keys (to turn your cursor into the minus magnifying glass), click a couple of times within your image. This shrinks the screen view for the next step.
- 7. Activate the clouds layer by clicking on it. Choose Edit > Transform > Scale. You will see a bounding box surrounding your clouds layer, as shown in Figure 12.91. Adjust the size of your image by pulling in or out on the corner handles. Pressing the Alt/Option and Shift keys simultaneously will constrain the proportions as you resize the image. Click inside the box to move the cloud layer into the desired position. Click the check mark in the option bar to commit to your transformation.
- 8. Now to refine your mask. The building to the right suffers from a mask with an edge problem. In this case, the mask is not quite large enough. This permits some of the edge of the building and some white sky to show through. The trick is to enlarge the mask. You should only do it in this area, however, because the rest of the mask looks good. Start by selecting the area of the mask that needs enlarging. In Figure 12.92, I used the Lasso tool to create the selection.

FIGURE 12.91 Transforming the sky.

FIGURE 12.92 Selecting the problem area of the mask.

9. Click on the mask (circled in red in Figure 12.93) to activate it. Choose Filter > Other > Maximum. Raise the radius to enlarge the mask. By enlarging the mask, more of the Clouds image becomes visible around the edges of the building, giving a better blend!

FIGURE 12.93 Enlarging the mask with the Maximum command.

Because we created a selection first, the Maximum Filter will only enlarge within the selected area, as shown in Figure 12.93. For images whose masks need to be shrunk, use Filter > Other > Minimum. If your entire mask needs enlarging or shrinking, click on the Mask Edge button in the Masks Panel. Move the Expand/Contract slider in the desired direction.

- 10. In many cases, this may be enough. If the edge now seems too sharp, apply a blur to the mask. First, feather the selection using the Edge Refine button. Click any selection tool, and then click the Refine Edge button.
- 11. Increase the Feather setting until the selection is blurred, as in Figure 12.94. Click OK.
- 12. Choose Filter > Blur > Gaussian Blur to blur the mask inside the selection. Figure 12.95 shows that a small radius of 0.4 was all that was needed. Figure 12.96 shows the final image.

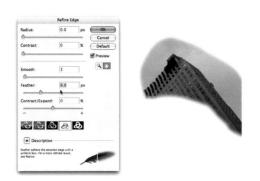

FIGURE 12.94 Feathering the selection.

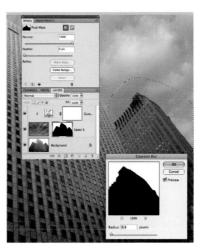

FIGURE 12.95 Blurring a section of the mask.

FIGURE 12.96 The final image.

COLLAGING TECHNIQUES AND BLENDING MODES

So far, you have been combining images into a single document. You are now going to take those principles a bit further and use features such as layer masks and blending modes to produce some artistic collages.

A Blended Collage Using Layer Masks

First a little review from Chapter 6. A layer mask can be applied to a layer. By default, the mask is filled with white, which has no effect on the host layer. When the mask is filled with black, it causes the host layer to be rendered invisible. Different levels of grayscale affect the host layer as levels of transparency. For example, if the mask were filled with 50% gray, the layer would render at 50% transparent. You might ask, "Why use a mask and not simply adjust the opacity of the layer?" You can paint onto a mask with a paintbrush or gradient, thus changing the transparency of any part of the layer you choose. Because of this, you can have different levels of transparency on a single layer.

TUTORIAL 12.11

BLENDING BETWEEN IMAGES

- 1. Open three images from the CD-ROM: ch_12_Stars.jpg (see Figure 12.97), ch_12_Moon_surface.jpg, and ch_12_Telescope.jpg. Choose Stars.jpg as your base image, inside which you will perform the collage.
- 2. Position the moon surface image so that you can see the stars image at the same time.
- 3. Choose the Move tool. Click your mouse inside the moon image, hold down the mouse button, and drag the moon image into the stars image. The moon image will now become a new layer in the stars image, as shown in Figure 12.98. (If you hold down the Shift key as you move the image, the layer will be perfectly centered in the new document.)
- 4. Click the New Layer Mask icon in the Layers Panel. You will now blend the two images together smoothly.
- 5. Choose the Gradient tool. Press the D key to reset the colors. Select the Linear option and Foreground to Background from the option bar.
- 6. Click from the top of the moon image, and drag most of the way to the bottom of the page. You should now see a smooth blend, as shown in Figure 12.99. If you don't, try dragging the gradient in the opposite direction.

FIGURE 12.98 Adding a photograph to an existing image. (Royalty-free image from Hemera.)

- 7. Drag the telescope image into the working document and make sure it's on the top of the layer stack (see Figure 12.100). To move a layer up or down the stack, just click and drag the thumbnail in the Layers Panel. Think of the top of the Layers Panel as the front of the image stack and the bottom of the layer as the back. The higher on the Layers Panel a layer appears, the more to the front of the document the layer will appear.
- 8. Add a layer mask to the telescope, and create a diagonal gradient to blend it in, as shown in Figure 12.101.

Figure 12.102 shows the completed collage after some slight touch up on the edges of the mask with a soft black brush. You can take it a bit further if you want.

FIGURE 12.99 Blending the image.

FIGURE 12.100 Inserting the telescope. (Royalty-free image from Hemera.)

FIGURE 12.101 Blending a mask.

FIGURE 12.102 The finished collage.

A variation of the collage is the use of color to pull everything together. When an adjustment layer is added, it will affect everything underneath it.

- 1. Choose the New Adjustment Layer button in the Layers Panel. Choose the Hue/Saturation option.
- 2. Click the Colorize option and adjust the hue, as shown in Figure 12.103. Figure 12.104 shows the result of the Hue/Saturation Adjustment Layer.

Whenever an Adjustment Layer is created, it comes with a built-in layer mask.

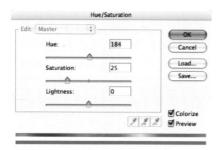

FIGURE 12.103 Hue/Saturation with Colorize checked.

FIGURE 12.104 Colorized effect.

3. Click on the Adjustment Layer's mask. Choose a black brush and paint inside the image. Notice that the black hides the effects of the Adjustment Layer. In Figure 12.105, the telescope's color is painted back in using the Adjustment Layer's mask. This provides one more creative option for collaging.

FIGURE 12.105 The hue mask painted back in.

ADVANCED BLENDING

You are now ready to jump into advanced blending. This is a lot easier than it sounds. You choose a range and adjust a threshold level, and this level measures the color of the top layer versus the layer underneath, assigning transparency to the top layer.

TUTORIAL 12.12

ADVANCED BLENDING

- 1. Open ch 12 advanced-blending.psd from the CD-ROM. This file on the CD-ROM has Figures 12.106 and 12.107 already layered together for your convenience.
- 2. Select the top layer, and click on the Layer Styles button in the Layers
- 3. Choose Blending Options from the menu (see Figure 12.108).
- 4. You will now see the advanced blending options in the Layer Style dialog box (see Figure 12.109). The only area that concerns us is the bottom Blend If section. Choose Blue as the Blend If color to replace the blue from the sky with the nebula in the top image.

ON THE CD

FIGURE 12.106 Background. (Royalty-free image from Hemera.)

FIGURE 12.107 The top layer. (Royalty-free image from Hemera.)

FIGURE 12.108 Choosing Blending Options.

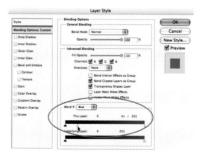

FIGURE 12.109 Advanced blending options.

- 5. Hold the Alt key (Option key for Mac) and drag the top-right slider toward the left, as shown in Figure 12.109. Pressing the Alt/Option key will cause the slider to split, providing a smoother transition.
- 6. Move the slider until the sky is replaced with the field of stars and the bridge is still visible (see Figure 12.110).
- 7. Choose Image > Adjustments > Levels.

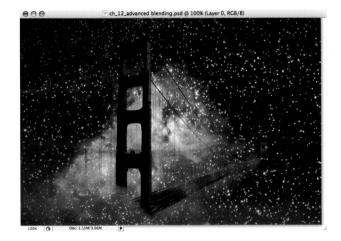

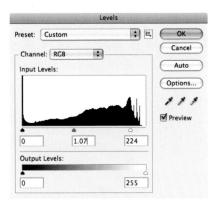

FIGURE 12.110 The image being blended.

FIGURE 12.111 Fine-tuning with levels.

8. Slide the Midtones and White Point sliders to fine-tune the blend, as shown in Figure 12.111. As you slide, you will notice that the transition between the layers changes.

As shown in Figure 12.112, the blended layers provide a nice fantasy sky to the Golden Gate Bridge, making it look like it is in space, without the need for any selections or extracting.

FIGURE 12.112 The finished blend.

SUMMARY AND CONCLUSION

In this chapter, you learned some creative uses of multiple images. We hope that you have enjoyed reading this book and learned some new techniques that will help you to create new and exciting things with your photographs or perform some old tasks more efficiently. No one expects you to remember everything you have read on these pages. That's why it's a good idea to keep this book handy for future reference. Nor do we think that this book has exhaustively covered everything there is to know about Photoshop and photography. You have a good start, though, and are pointed in the right direction. The next step is up to you. Experiment and unleash your creativity. The best way to improve is through practice, and the more you perform the tasks you have learned, the faster and better you will become at them. Visit Colin's Web site at www.photoshopcafe.com or Tim's at www.timcooperphotography.com for many more Photoshop resources, including tutorials and forums, that will help you improve your skills. Drop by the forums and tell us you have purchased this book.

INDEX

Numbers

1×1.5 aspect ratio, origin of, 265 5×7 proportions, 265 8×10 proportions, 265 8-bit depth, confirming, 370 8-bit images, color tones in, 54 16-bit images, 54–55 32-bit photo, merging, 436–437 35mm proportion, example of, 265 72 ppi resolution, use of, 252, 260 150 ppi, using, 266 180 ppi, using, 266 200%, increasing image size beyond, 264-266 240 and 300 ppi resolution, use of, 252 240 ppi, using, 266 300 ppi resolution, using, 259–260 360 ppi resolution, using, 259, 266

Symbols

[] (bracket) keys, using with selections, 227
\ (backslash) key, using with masks, 242
~ (tilde) key, using with masks, 411

Α

a channel, blurring, 292 acne, cleaning up, 301–303 actions loading, 264–265 running, 265 additive color, 176. See also colors Adjustment Brush mode, 89 undoing steps for, 90 using in Camera Raw, 84 Adjustment Layers activating, 132 adding, 133 advantages of, 131–132 anatomy of, 133-134 changing blending modes on, 208 creating, 132 creating masks with, 133 ignoring for Healing Brush, 303 masking out, 240 reducing opacity of, 310–311 turning on and off, 133 using, 134 using for color adjustments, 179 using masks with, 213

adjustments localizing with selections, 218–221 painting away, 216 visibility of, 247 Adjustments Panel location of, 129 saving settings in, 209–210 Adobe Bridge. <i>See</i> Bridge Adobe Camera Raw. <i>See</i> Camera Raw Adobe RGB color space, using, 94, 267	Background Layer activating, 181 duplicating, 284 duplicating for use with healing tools, 299 explained, 132 backslash (\) key, using with masks, 242 banding, occurrence of, 137 barrel distortion, fixing, 120–122 batch processing in Bridge, 98–99 Batch Rename feature, using, 38–39
advertisement, adding text for, 423	Bevel and Emboss style, applying to matte,
Alienskin Blow Up Web site, 265	350
"All Rights Reserved" notice, including, 8–9	Bicubic interpolation
alpha channel	explained, 256
adding for depth map, 382 adding gradient onto, 377	use of, 260 Bilinear interpolation, explained, 256
removing from backgrounds, 420	birthmarks and tattoos, removing, 320–321
Alt/Option key, using with Curves feature,	bit depth
172. See also keyboard shortcuts	accessing, 93–94
aspect ratio, defined, 265	importance of, 54
Auto Color Filter, using, 180–181	black
Auto Levels effect, using, 154	painting, 217
Auto Mask option, using with Local Adjust-	setting darkest point as, 153
ment Brush, 87	Black and White adjustment, using, 359-361
Auto settings	See also Channel Mixer
getting good results from, 155	black and white, mixing with color, 364-366.
using, 153–155	See also grayscale images
Auto-Align blending mode, using, 443–446	black background, previewing, 236
Auto-Align command, using, 438–442	Black Clip setting, using with
Auto-Align Layers feature, using, 447	Shadows/Highlights, 147
Auto-Blend command, using, 438–439, 447	black point, setting, 202–204
automated tasks	Black slider, using in Camera Raw, 63–65
contact sheets, 41–45	blank layers, working on, 304
Output pane, 40–41	blemishes and moles, removing, 299–303.
PDF (Portable Document Format)	See also Healing tools; skin
creations, 40–41	blending, advanced, 457–459
В	blending modes Auto-Align, 443–446
b channel, blurring, 293	changing, 284–285
background color	changing for layers, 387
resetting, 377	changing for Smart Filters, 369
restoring default for, 346	changing on Adjustment Layers, 208
Background color chips, accessing, 190	changing to Color Dodge, 374–375

for collaging techniques, 454-457	regions of, 10
Color Dodge, 397	resizing panes in, 12–13
Overlay for gritty looking photos, 395–396,	resizing thumbnails in, 14
398	Review mode in, 20–21
Stacks, 443–446	saving customized views in, 22
blue, cyan, and green, decreasing, 359–360	Slideshow mode in, 20
Blue channel, blurring noise in, 287–288	viewing images at actual pixels in, 16
blue color cast, correcting, 182–183	viewing images in Preview pane, 14–15
blur	viewing images side-by-side in, 14
double exposure, 394–395	Bridge views
painting away, 315	Essentials, 14
Blur Focus Distance slider, using with depth	Filmstrip, 14–16
map, 382	Folder, 19–20
blur process, reducing noise with, 287–289	keyboard shortcut for, 13
blurring	Keywords, 18
adjusting strength for noise reduction, 294	Light Table, 19
channels, 295	Metadata, 17–18
controlling amount of, 277	Preview, 19
masks, 247–249	bright sky, darkening, 218–221. <i>See also</i> sky
See also Gaussian Blur Filter	brightness
borders	altering in Camera Raw, 71
film, 344–346	changing, 171
simple, 343–344	Brightness slider, using in Camera Raw, 65
Bounding Box check box, resizing images	Brightness/Contrast, adjusting, 144–145
from, 270	brush size, controlling, 302
bracket([]) keys, using with selections, 227	Brush tool
bracketing shots for HDR, 435	choosing, 214–215, 219
Bridge	versus making selections, 366
applying presets from, 78	painting foreground color with, 364
batch processing in, 98–99	using with eyes, 310
collapsing panes in, 12–13	brushes
Content View control in, 21–22	hardening, 306
controlling thumbnail quality in, 20	resizing, 301, 306
determining sharpness of, 16	resizing for selections, 226–227
downloading images into, 7–8	See also Healing Brush; Local Adjustment
examining folders and images in, 20–21	Brush
expanding panes in, 12	burning and dodging, examples of, 212
features of, 6–7	burning and doughig, examples of, 212
launching, 9–10	C
launching slideshow in, 20	Cache Level histogram statistic, explained,
navigating, 11–12	142
opening images with, 26	Calibrate tab in Camera Raw, options on, 76
recalling customized views in, 22	calibration, color, 178–179
recanning customized views in, 22	Cambration, Color, 176-177

Camera Raw	Channel Mixer
adjusting image color in, 58-61	using with color and grayscale images,
adjusting image tone in, 62–63	356–357
adjusting lens vignetting in, 75–76	using with sepia tone, 358
adjusting luminosity in, 62–63	See also Black and White adjustment
Blacks slider in, 63–65	Channel Overlaps box, options in, 171
Brightness slider in, 65	channels
Calibrate tab in, 76	adjusting, 207–208
Contrast slider in, 65	altering from Curves Panel, 171
creating grayscale images in, 70–72	blurring, 289, 295
creating vignette with, 341–342	creating composites from, 356
cropping images in, 79–80	creating for depth of field effect, 377
darkening shadows in, 63-65	creating selections from, 318
Detail tab in, 68–69	keyboard shortcuts, 318
dialog box, 57	splitting images into, 199–201
Exposure slider in, 62–63	using for noise reduction, 287–289
Fill Light slider in, 66	viewing, 354, 356
HSL/Grayscale tab in, 69-72	Channels Panel, on state of eyeballs in, 354
increasing exposure in, 85	chromatic aberration
Lens Corrections tab in, 74–76	fixing, 116
opening images into, 57	occurrence of, 74–75
Presets tab in, 76–78	Click and Drag tool, using, 207
Recovery slider in, 65	Clip Layer icon, using with sky, 450
Red Eye Removal tool in, 82–83	clipping
regions, 56	accessing in Curves feature, 172–173
resetting sliders in, 67	defined, 137
Saturation slider in, 66	occurrence of, 61
setting clipping warnings in, 64	turning off, 422
setting highlights in, 62–63	clipping warnings, setting in Camera Raw,
Split Toning tab in, 72–74	64
straightening images in, 79	Clone Source panel, options in, 300
Tone Curve tab in, 67–68	cloning
Vibrance slider in, 66–67	in perspective, 401–402
See also RAW format	with Rectangular Marquee tool, 403
Camera Raw dialog box, closing, 95	Cloudy white balance, explained, 52
camera settings, choosing, 53–54	Cmd key. See keyboard shortcuts
Canon printers, choosing ppi for, 266	collages, creating with blending modes,
canvas size	454–457
expanding with Crop tool, 346, 350	collections, working with, 33–35
increasing with Crop tool, 112–113	color and tonal contrast, applying to images
cast shadow, creating, 424-427. See also	388–390
shadows	Color Balance tool
CD-ROM, exporting images to, 39–40	using, 181
channel colors, viewing histograms in, 140	versus Variations tool, 184–186

color balancing	Color Range command
with Auto Color Filter, 180–181	making selections with, 228-235
skin, 331–334	using to remove objects from
color calibration, 178–179	backgrounds, 408–412
color casts	color regions, sampling, 206-207
adjusting, 182–183	color space, accessing, 93-94
creating presets, 186–189	Color square, loading color into, 423
defined, 176	colored labels, applying, 27
removing with Match Color, 194-195	Color/Hue match, evaluating in composited
color changes, isolating, 187	images, 418
color channels, seeing changes in, 171. See	Colorize box, using with sepia tone, 358
also channels	colorizing effects
color correction, Auto setting for, 153	altering color locally, 361–363
color correction tools	applying, 456
Auto Color, 180–181	color to grayscale, 354–357
Color Balance, 181	converting to sepia tone, 357–359
color calibration, 178–179	using Black and White adjustment,
Curves, 206–209	359–361
LAB color mode, 199	using spot color, 364–366
Levels Adjustment Layers, 202–205	colors
Match Color, 194–197	adding to images, 386-388
Photo Filter, 186–189	adjusting in images, 179–180
Variations, 184–186	adjusting with curves, 206–209
Color Dodge blending mode, using, 397	altering brightness with Camera Raw, 71
Color Handling option, setting for soft	altering locally, 361–363
proofs, 270	choosing for gradients, 93
color images, converting to grayscale,	components of, 190
354–357	creating from RGB layers, 259
color management, 267	darkening, 191
color noise	decreasing brightness of, 359
explained, 286	desaturating, 188–189, 374
reducing with LAB mode, 292–293	maintaining when changing contrast, 155
removing with Reduce Noise Filter, 294	mixing with black and white, 364–366
See also noise	printing accurately, 267–268
color opposites, examples of, 181	sampling with Color Range eyedropper,
color palettes, applying to images, 196–197	230
Color Picker	separating in images, 361
accessing, 190	washed out and shifted, 198–199
launching for foreground color, 220	See also additive color; hue; subtractive
using with borders, 343	color
color pictures, anatomy of, 135–136	compositing images, 418–419
color profiles	composition
creating, 179	changing, 105
using, 267	and exposure, 4
4011.5, 401	and enposare, r

computer screens, resolution of, 261	curves
Constant slider, using with mixed channels,	adding points to, 158
357	adjusting contrast with, 163-165
Constrain Proportions option, described, 259	adjusting midtones with, 168
contact sheets, creating, 41–45	brightening images with, 166-169
Contract/Expand slider, using with masks,	changing, 158
245	choosing presets for, 160–162
contrast	correcting tonal problems with, 163
adjusting, 144–145	creating, 158
adjusting relative to color, 155	creating bends for, 174
altering in masks, 246	darkening shadows with, 168
changing, 171	drawing with Pencil tool, 158–159
correcting with curves, 163–165	getting original references for, 170
and saturation sandwich technique,	lightening highlights with, 167
392–393	locking down, 388
Contrast slider, using in Camera Raw, 65	moving in HDR images, 436
Convert Profile to sRGB box, checking, 263	navigating adjustment points on, 174
cooling filters, availability of, 186–187	Parametric versus Point in Camera Raw,
copying	67–68
eyes to new layers, 325	placing points on, 164
images, 29, 344	removing points from, 158
objects to new layers, 411	sampling midtones with, 167
selected areas, 316	saving as presets, 209–210
copyright notice, filling out, 8–9	tips for use of, 174
correcting images. See local adjustments	tracking alterations of, 170
Count histogram statistic, explained, 142	types of, 159–162
crooked pictures, straightening, 107–110	using to adjust color, 206–209
Crop tool	Curves Adjustment Layer
expanding canvas with, 346	creating, 214, 219
increasing canvas size with, 112–113	using with classic vignette, 337
using, 103–104	Curves adjustment options, showing, 133
cropping	Curves box, revealing for HDR images, 437
auto, 110–111	Curves Display Options dialog box, opening
for emphasis, 106	169–170
images, 103–104	Curves drop-down menu, options in,
images in Camera Raw, 79–80	170–172
for perception, 105–106	Curves feature
practicality of, 107	applying to midtones, 387
reasons for, 102–103	capabilities of, 156–159
and straightening photos, 108–111	drawback to, 156
Ctrl key. See keyboard shortcuts	input and output tones for, 156–158
Current & Below option, using on wrinkles,	lightening sky with, 450–451
304–305	using with eyes, 310

Curves Panel	distortion
altering channels from, 171	fixing, 120–122
Intersection Line feature of, 170	removing with Lens Correction Filter,
new features in, 169–170	115–119
opening, 156, 163	DNG (digital negative) file format,
Curves versus Levels commands, 170	availability of, 56
Customize Proof Condition dialog box, dis-	documents
playing, 268	creating for scan lines, 384
cyan, green, and blue, decreasing, 359-360	selecting, 385
	dodging and burning, examples of, 212
D	Done button, clicking, 92, 95
dabbing technique	Doorway image, opening, 114
using on blemishes, 301	double exposure blur, 394-395
using on wrinkles, 304	double matte effect, creating, 350-353
dark foreground, correcting, 147-148	download workflow, 249
darkening, changing level of, 338	for printing images, 273
darkest point, setting as black, 153	for selections and masks, 249
Daylight white balance	See also workflow
example of, 58	downsampling versus upsampling, 253
explained, 52	dpi (dots per inch) versus ppi (pixels per
Defringe option, using with objects, 421	inch), 252, 266
degradation, monitoring, 262	duplicate images, inverting, 396. See also
Density option, using with Local Adjustment	images
Brush, 87	Duplicate Layer option
density selections, making, 234	using with Auto Color Filter, 181
Density slider, using with masks, 242-243,	using with Variations tool, 184
365	duplicate layers, merging, 397
depth maps, using Lens Blur Filter with,	dust, cleaning up, 80–82
378–383	
depth of field effects	E
with layer masks, 376–378	Edge effect, creating with Quick Mask tool,
using Lens Blur and Depth Map, 378-383	346–350
maximizing, 446–448	Edge Extension option, using, 119
detail, recovering in RAW images, 328	edges, refining with Color Range, 411
Detail tab in Camera Raw, options on, 68-69	edges of selections
Device to Simulate drop-down, options in,	seeing, 235–236
269	softening, 308–309
Digimarc Web site, 8–9	editing, nondestructive, 130, 368
digital cameras	editing workflow, local, 250
creation of images by, 53	effects. See special effects
ISOs for, 5	Elliptical Marquee tool
digital files, layers in, 259	using with eyes, 309–311
digital zoom, effect of, 4	using with vignettes, 336, 339
display, calibrating and profiling, 178	

email	F
batch sizing images for, 263-264	F keys. See keyboard shortcuts
sizing prints for, 261–263	Fade Amount slider, using with Smart
emphasis	Sharpen, 282
changing, 105	Fade slider, adjusting skin tone with,
cropping for, 106	332–333
enlarging images, 264–265	faded images, fixing, 198-199
Epson printers, uploading profiles for, 268	Favorites, using, 30–31
Essentials view, accessing in Bridge, 14	Feather option, using with Local Adjust-
Essentials workspace, panels in, 129–130	ment Brush, 86–87
etched effect, producing, 375–376	Feather slider
Exif data, storing, 36	using with classic vignette, 337
exporting images to CD-ROM, 39–40	using with masks, 244
exposure	using with vignettes in Camera Raw, 341
and composition, 4	using with white vignette, 340
increasing in Camera Raw, 85	feathers, applying to selections, 228
See also overexposure; underexposure	file formats
Exposure Panel, making tone adjustments	JPEG (Joint Photographic Experts
with, 152–153	Group), 3
Exposure slider	JPEG and RAW, 51
darkening sky with, 90	RAW, 3
using in Camera Raw, 62–63	TIF, 4
exposures	file information, searching in Bridge, 17
changing, 436	file sizes
range of, 436	decreasing, 262
Extract tool, using with images, 413–417	printing faster, 266
eye color, increasing, 310	files
eyeballs	opening as Smart Objects, 146
clicking on and off, 133	saving as JPEGs, 262–263
turning on in Channels Panel, 354	Fill Light slider
Eyedropper tool	using in Camera Raw, 66
activating, 206	using with tuxedo, 328-329
changing paintbrush to, 443	film border, using, 344–346
using to change color locally, 361	film cameras, ISOs for, 5
using with Color Range, 409	film grain, evaluating in composited images,
using with curves, 164	418
eyes	Filmstrip view, accessing in Bridge, 14–16
copying to new layers, 325	Filter Gallery, using for watercolor effect,
darkening pupils of, 310	372
enhancing iris of, 309–311	Filter pane, displaying images in, 28
opening and enlarging, 324–327	filters
removing red from whites of, 308-309	applying to Smart Objects, 330, 368-369
2	applying with Quick Mask, 348
	Auto Color Filter, 180–181

cooling, 186–187	film borders, 344–346
High Pass, 284–286	simple border, 343–344
Lens Blur, 376–383	vignette created with Camera Raw, 341–342
Lens Correction, 115–119, 122–124	white vignette, 339–341
Noise Reduction, 294–296	Frame image, activating, 344
Reduce Noise, 294–296	frames
Smart, 330-331, 368-370	creating as separate layers, 345
Smart Blur, 288–291	resizing and repositioning, 345
Smart Sharpen, 281–284	freckles, cleaning up, 301–303
Soft Focus, 314–318	Free Transform tool
Unsharp Mask, 276–278, 280, 282	using to create double matte, 353
warming, 186	using to enlarge eyes, 325
See also Gaussian Blur Filter; Photo Filter	using with cast shadow, 424
tool	Freeze Mask tool, using with noses,
fine-art images, converting photos to,	322–323. See also masks
370–376	fringe, removing from around objects, 421
Fix Red/Cyan Fringe slider, using, 74	Fuzziness slider
fixing images. See local adjustments	versus Clusters, 231
flash, overview, 4–5	raising, 232
Flash white balance, explained, 52	using with Color Range, 410
Flow option, using with Local Adjustment	using with Color Range command, 230
Brush, 86	
Fluorescent white balance, explained, 52	G
focus points, variations in, 446	Gaussian Blur Filter
folder contents, organizing, 29–31	softening skin with, 314, 317–318
folders	using for gritty look, 397
batch renaming, 38–39	using with depth maps, 380
cleaning up with stacks, 22–23	using with double exposure, 395
setting as favorites, 30–31	using with fine-art effect, 374–375
foreground, fixing underexposure of, 152–153	using with masks, 247–249
foreground color	using with sandwich technique, 392–393
changing, 220	using with sky, 453
resetting, 377	See also blurring; filters
restoring default for, 346	Genuine Fractals Web site, 265
setting, 214–215	gradient mask, creating for split neutral den-
foreground darkness, correcting, 147–148	sity effect, 399–400
Foreground/Background Color Picker,	Gradient tool
opening, 190	using to blend images, 454
Forward Warp tool, using to enlarge eyes,	using with depth of field effects, 377
326–327	gradients
frame effects	creating, 92
classic vignette, 336–339	rotating, 91
Double Matte, 350–353	tips for use of, 93
Edge, 346–350	undoing steps for, 93

Graduated Filter tool combining effects with local adjustments, 92 using in Camera Raw, 84	Healing tools capabilities of, 302 overlay of, 300 using, 299
using with local adjustments, 90–93	See also blemishes and moles; skin
grain, simulating for depth map, 383	Height, setting for images, 258
Grain layer, lowering opacity of, 395–396	hiding selections, 245
graphs, appearance in histograms, 137	high dynamic range (HDR), explained, 43
gray areas, painting, 442–443	High Pass Filter, nondestructive sharpenin
Gray Point eyedropper, using, 205	with, 284–286
grayscale, relationship to curve, 158–159	highlight detail, recovering, 328–331
Grayscale channels, applying sharpening to,	highlights
280	adjusting, 145–148, 151
grayscale images	adjusting for color casts, 182–183
combining with color, 135	adjusting with curves, 165
converting color images to, 354–357	brightening up, 388–389
creating in Camera Raw, 70–72	clipping with Curves feature, 172–173
tone in, 135–136	examples of, 137–138
See also black and white	finding, 204
green, cyan, and blue, decreasing, 359–360	isolating with Smart Sharpen Filter,
Green channel, blurring noise in, 288	281–282
green color cast, removing, 180	lightening with curves, 167
grids, changing for curves, 174	sampling with curves, 165
gritty looking photo, creating, 395–398	setting in Camera Raw, 62–63
ш	Histogram Panel, options in, 140
H	histogram statistics, reading, 141–143
halos	histograms
appearance in HDR images, 436	8-bit versus 16-bit, 55
described, 146–147	behind curves, 169–170
fixing, 246	brightness levels in, 137
Hard Mix blending mode, using, 375–376	common type of, 136
HDR (high dynamic range) images, creat-	examples of, 139–140
ing, 434–435	regions of, 137–138
Heal option	representing tonalities in, 61
using with Rectangular Marquee tool, 403	sampling, 142
using with Vanishing Point tool, 402	using in Levels Panel, 149
Healing Brush	viewing in channel colors, 140
accessing, 298–299	well-balanced, 137–139
cleaning up tattoos with, 320–321	horizons, straightening, 122–124
ignoring Adjustment Layers for, 303	Horizontal Perspective slider, adjusting,
options for, 303	117–118
Spot, 301–303	HP printers, choosing ppi for, 266
See also brushes	

HSL/Grayscale tab in Camera Raw, options	extracting, 413–417
on, 69–72	launching into Photoshop, 95
hue, controlling in Camera Raw, 70, 76.	molding and shaping, 405–406
See also colors	moving to folders, 29
hue mask, painting in, 457	opening as Smart Objects, 96, 328
Hue slider	opening with Bridge, 26
choosing tint from, 358	panoramic, 428–434
using with Photo Filter, 188–189	previewing accurately, 267
Hue/Saturation adjustment, applying,	processing, 95
190–193	putting in stacks, 22–25
Hue/Saturation layer, lowering opacity of, 365	rating and labeling, 27–29
	reducing size on screen, 345
I	resizing, 94
ICM option, choosing for soft proofs, 272	resizing from Bounding Box option, 270
image interpolation	rotating, 25–26
overview of, 254–257	scanning together, 110–111
Stair Step, 264	selecting, 7, 26
for upsampling and downsampling, 260	selecting for collections, 34
Image Processor, using, 263	selecting for contact sheets, 42
Image Size dialog box, options in, 258, 262	sizing for print, 258–261
image size, increasing beyond 200%, 264–266	splitting into channels, 199–201
Image Warp tool, using, 405–406	straightening, 107–110
images	straightening in Camera Raw, 79
adding life to, 196–197	tagging with labels, 27–28
adding photos to, 454–455	watermarking, 8–9
adjusting, 130–131	zooming in and out of, 278
aligning, 438–442	See also duplicate images; objects; photos
batch sizing for email, 263-264	pictures; prints; RAW images
blending, 435, 446-448	inkjet printers, ppi used by, 252
blending between, 454–457	intensity slider, using with Variations tool,
brightening with curves, 166–169	185
combining, 420–423	interpolating. See resampling
compositing, 418–419	interpolation
converting to outlines, 371	overview of, 254–257
copying, 29, 344	Stair Step, 264
creation by digital cameras, 53	for upsampling and downsampling, 260
cropping, 103–104	Inverse option, using with selections, 349
cropping in Camera Raw, 79–80	Invert button on Masks Panel, using, 217,
describing tonalities in, 61	339
downloading into Bridge, 7–8	Invert option, using with selections, 336
editing pixels of, 131	IPTC tab, displaying, 9
enlarging, 264–265	ISO (International Standards Organization
exporting to CD-ROM, 39–40	rating, overview of, 5, 50–51

J	selecting images for collections, 34
"jaggies," occurrence of, 253	selecting mask layers, 382
JPEG (Joint Photographic Experts Group)	Slideshow mode in Bridge, 20
format	soft proofs, 269
choosing, 51	stroke history, 343
making adjustments for, 54	transforming layers, 394
overview, 3	undoing spots, 82
saving files in, 262–263	undoing steps for Adjustment Brush, 90
JPEG artifacts, removing with Reduce Noise	undoing steps for gradients, 93
Filter, 294	viewing images side-by-side in Bridge, 14
	views in Bridge, 13
K	See also Alt/Option key
Kelvin white balance, explained, 52	keywords
keyboard shortcuts	assigning, 32
background color default, 377	organizing, 31–32
channels, 318	searching, 32–33
copying eyes to new layers, 325	8, 2 2 3
copying images, 344	L
copying objects to layers, 411	LAB mode
copying selected areas, 316	converting to, 280
curve navigation, 174	reducing color noise with, 292-293
desaturating images, 396	using, 199–201
Filmstrip view in Bridge, 14	using for sharpening, 280–281
Folder view in Bridge, 19	labeling images, 27–28
foreground color default, 377	Lasso tool
Free Transform tool, 424	using, 218–219
grid changes for curves, 174	using to enlarge eyes, 324–326
hiding selections, 245, 337	using with Edge effect, 347
inverting selections for split toning, 391	Launch Bridge button, identifying, 9
Keywords view in Bridge, 18	layer duplication
launching Bridge, 10	for Auto Color Filter, 181
loading selections, 420	for Variations tool, 184
Loupe tool, 16	Layer Mask Display Options dialog box,
Luminance selection, 390	opening, 242–243
masks loaded as selections, 366, 390	layer masks
Metadata view in Bridge, 17	using with Adjustment Layers, 213
moving points for curves, 174	using with depth of field, 376–378
Quick Mask tool, 348, 411	See also masks
Red channel as selection, 316–318	layers
resizing brushes, 301	activating, 132
Review mode in Bridge, 20	aligning, 440
Select All Layers, 343	blank, 304
selecting documents, 385	blending, 457–459
selecting images, 7, 26	hlurring 397

changing blending modes for, 387	Liquefy tool
converting to Smart Objects, 445	versus Image Warp, 405
creating from backgrounds, 350	using to enlarge eyes, 326–327
desaturating for gritty look, 396	Local Adjustment Brush, using in Camera
duplicating and desaturating, 374	Raw, 84-87. See also brushes
hiding in natural media, 371	local adjustments
resizing for film borders, 345	combining effects with Graduated Filter
Retouched, 304	tool, 92
sampling for healing tools, 302–303	making, 214-217, 220-221
selecting all, 343	multiple, 87–93, 220
transforming for double exposure blur, 394	using Graduated Filter tool with, 90-93
using Auto-Align feature with, 447	local editing workflow, 250
Layers Panel, location of, 129	Localized Color Clusters feature, using, 231,
LCD technology, use with printers, 267	233–234
Lens Blur Filter	long lenses, distortion associated with,
removing depth of field with, 376-378	120–122
using with depth maps, 378-383	Loupe tool, using, 16–17
Lens Correction Filter	luminance, controlling in Camera Raw, 70
straightening horizons with, 122-124	Luminance selection, creating for split ton-
using, 115–119	ing, 390
Lens Corrections tab in Camera Raw,	Luminance slider, using in Camera Raw, 69
options on, 74–76	luminosity
lens vignetting	adjusting in Camera Raw, 62–63
adjusting in Camera Raw, 75–76	preserving, 187
fixing, 116	relationship to Curves feature, 157
lenses, distortion associated with, 120	Luminosity blending mode
Level histogram statistic, explained, 142	setting to fade sharpness, 279
Levels, using with masks, 246–247	using, 155
Levels Adjustment Layers, correcting colors	luminosity noise
with, 202-205	explained, 286
Levels Panel	reducing with Smart Blur Filter, 290–293
Auto button in, 153	
fixing overexposure with, 150–151	M
fixing underexposure with, 149-150	Magic Wand tool
Levels versus Curves commands, 170	using, 222–225
light, controlling sensitivity to, 5	using on sky, 449
lighting, overview of, 4–5	using on teeth, 312
lightness, defined, 190	Magnetic Lasso tool, using with eyes, 308
Lightness channel, example of, 200	mapping, relationship to curves, 158
Lightroom presets, converting to Camera	marching ants versus Refine Edge tool,
Raw, 78	235–236
Lightroom versus Bridge, 6–7	mask density, reducing, 365-366
Linear Gradient tool, using with cast	Mask Edge option, using with classic
shadow, 425–426	vignette, 337

mask layers	Masks Panel
creating for depth maps, 379–380	choosing color range from, 228
merging, 381	revealing, 241
selecting, 382	using, 217, 245–249
mask overlay, checking for local	Match Color
adjustments, 86	adding life to images with, 196–197
masked selection, applying filters to, 348–349	applying to skin tones, 333–334
masks	removing color casts with, 194–195
activating, 220, 241	Matte effect, creating, 350–353
adjusting, 246	
adjusting with selections, 441–442	Maximum command, using with mask, 452 Mean histogram statistic, explained, 141
altering contrast of, 246	
altering tones in, 246	Median histogram statistic cynleinod 142
blurring, 247–249	Median histogram statistic, explained, 142
combining selections with, 247–248	Merge Down option, using with layers, 397.
converting selections to, 339–340	See also Photomerge feature
creating with Adjustment Layers, 133	Merge to HDR feature, using, 436–437,
creating with shades of gray, 246	440–441 Margo Visible option, using with most leaves
displaying in black and white, 411	Merge Visible option, using with mask layers, 381
enlarging, 245	
enlarging black area of, 338	metadata
enlarging for sky, 451–452	adding information to, 37–38
inverting before painting, 217	defined, 35
loading as selections, 366, 390	Exif, 36
modifying, 241–242	viewing, 36–37
	Metadata pane, categories in, 37
overlaying in black and white, 241–242	metadata template
painting densities on, 90	applying, 38
painting in panoramic images, 430–431	customizing, 8–9
refining, 240–244	midtones
removing in Raw Converter, 90	adjusting for color casts, 182–183
seeing changes made to, 242	adjusting for Shadows/Highlights, 147
shrinking white area of, 338	adjusting with curves, 168
starting in Raw Converter, 87–88	brightening up, 388–389
using backslash (\) key with, 242	examples of, 137–138
using Density slider with, 242–243	lightening with Curves, 387
using Feather slider with, 244	sampling with curves, 167
using Gaussian Blur Filter with, 247–249	sharpening, 281–282
using Levels with, 246–247	Miranda, Fred, 264–265
using Refine area with, 244	moles and blemishes, removing, 299-300
using with Adjustment Layers, 213	monitors
viewing, 241–242	calibrating and profiling, 267
See also Freeze Mask tool; layer masks	resolution of, 261–262
masks and selections, download workflow	Monochrome option, choosing, 356
for, 249	Move tool, using to blend images, 454

N	P
Nearest Neighbor interpolation, explained,	Paint Daubs effect, applying, 372
256	paintbrush, changing to eyedropper, 443
No Color Adjustment option, displaying, 272	palettes versus panels, 128
noise	panels
appearance of, 50	displaying, 129
avoiding sharpening of, 281–282	in Essentials workspace, 129–130
defined, 5	opening, 129
introduction of, 286	versus palettes, 128
reducing in Camera Raw, 68-69	panorama, creating, 429–434
See also color noise	paper, choosing, 273
Noise options, using with grain, 383	Parametric curves, using in Camera Raw,
noise reduction	67–68
filter, 294–296	passwords, setting, 44
using channels for, 287–289	Patch tool
noise types, luminosity and color, 286	accessing, 298–299
nondestructive editing	using, 320–321
defined, 130	Pattern Library, adding selections to, 385
performing with Smart Filters, 368	Pattern Name dialog box, opening, 385
noses, shrinking, 322–323	patterns
	creating for scan lines, 384–386
0	using as fills, 385
objects	PDF files, creating and opening, 41
copying to new layers, 411	Pen Pressure, setting on Wacom tablet, 302
extracting and moving to other pictures,	pencil sketches, converting photos to,
412	374–376
removing fringes from, 421	Pencil tool
removing from backgrounds, 408–412	drawing curves with, 158–159 using with scan lines, 384
scaling down, 421	Percentile histogram statistic, explained, 142
See also images	perpendicular planes, creating, 401–402
offset printing, ppi used in, 252	perspective
Opacity, adjusting, 279	adding, 124–125
Open Copy option, effect of, 65	cloning in, 401–402
Open Shade white balance, explained, 52 outlines, converting images to, 371	explained, 113
Output function, features of, 43	fixing, 114–119
overexposure, fixing with Levels Panel,	Photo Downloader, using, 7–8
150–151. <i>See also</i> exposure; underexposure	Photo Filter tool, using, 186–189. See also
Overlay blending mode, using for gritty	filters
look, 395–396, 398	photographers, basic workflow for, 99–100
overlay feature, using with Healing Brushes,	Photomatrix plug-in, using for tone mapping,
300	438
overlays, hiding and showing, 93	Photomerge feature, using with panorama,
0.00010, 110000	429-430. See also Merge Down option
	-

photos	printing accurate colors, 267–268
adding to images, 454–455	printing images, download workflow for, 273
anatomy of, 135–136	printing photos, 266–273
changing exposures for, 436	printing proportions, 265–266
converting to fine-art images, 370–376	prints
converting to sketches, 374–376	enlarging, 253
cropping and straightening, 110–111	resizing images for, 258–261
gritty looking, 395–398	sizing for Web or email, 261–263
printing, 266–273	See also images; photos; test prints
resizing, 257	"Profile Mismatch" warning, displaying, 179
split toning, 389–392	profiles
turning into watercolor paintings,	creating, 179
370–373	using, 267
See also images; pictures; prints	proportion, evaluating in composited images,
Photoshop	419
interface, 128	Pucker tool, reducing noses with, 322-323
launching images into, 95	,
picture styles, applying, 53–54	Q
pictures, taking, 5-6. See also images; photos	Quick Mask tool
pincushion distortion, fixing, 120-122	creating Edge effect with, 346–350
pins, showing in Raw Converter, 89	using with Color Range, 411
Pixel Dimensions area, locating, 259–260	Quick Select tool, 308
pixelation, occurrence of, 253	Quick Selection tool, using, 226-227
Pixels histogram statistic, explained, 142	
plane, defining for vanishing point, 401	R
playback, specifying for slideshows, 45	Radius attribute, using with Smart Blur
Point curves, using in Camera Raw, 67–68	Filter, 288
Post Crop Vignetting feature, availability of,	Radius slider, using with shadows and
76	highlights, 330
posterization	Radius tool
correcting for split toning, 392	softening skin with, 317–318
occurrence of, 54, 137	using with Shadows/Highlights, 146-147
using as creative effect, 174	using with Unsharp Mask Filter,
ppi (pixels per inch) versus dpi (dots per	277–278, 280
inch), 252, 266	rating images, 27
Preserve Details slider, using with Reduce	Raw Converter
Noise Filter, 296	cleaning up dust in, 80-82
Presets tab in Camera Raw, options on,	showing pins in, 89
76–78	starting mask in, 87–88
preview, converting to grayscale, 356	using for color adjustments, 179
print quality, maximizing, 271	using to create panorama, 429
print sizes, matching up, 265–266	using with shadow and highlight detail,
Printer Settings, choosing for soft proofs, 271	328

RAW format	Resample Image option, described, 259
choosing, 51	resampling
overview, 3	advantage to, 254
shooting in, 53	defined, 253
See also Camera Raw	resetting in Preferences, 256
RAW images	Reset option, effect of, 65
making local adjustments in, 84	resizing algorithms, availability of, 254
multiple, 96–98	resizing images, 94
recovering detail in, 328	process of, 253, 257
See also images	third-party products for, 265
RAW settings, applying, 263	resolution
Recovery slider	accessing, 93–94
using in Camera Raw, 65–66	of computer screens, 261
using with shadows and highlights,	overview, 2–3
328–329	overview of, 252–253
Rectangular Marquee tool, cloning with, 403	targets for Photoshop files, 252-253
Red, Green, Blue layers, 259	Retouch tool, using to clean up dust, 81
red, green, blue (RGB), mixing, 176	Retouched layers
red and yellow, increasing, 359–360	naming, 304
Red channel, loading as selection, 316–318	reducing opacity in, 306
red eye	retouching, rule of, 312
removing, 318–319	RGB (red, green, blue)
removing in Camera Raw, 82–83	changing to LAB, 199–201
Red Eye tool, accessing, 298–299	mixing, 176
red fringe, fixing, 74	Rotate Canvas dialog box, opening, 110
Reduce Noise Filter, using, 294–296	rotating
Refine area, using with masks, 244	gradients, 91
Refine Edge tool	images, 25–26
advantages of, 235–236	<i>3</i> ,
Contract/Expand slider, 238–239	S
Contract slider, 237	sandwich technique, 392–393
Feather slider, 238–239	saturation
Preview mode, 237	adjusting for Shadows/Highlights, 147
Radius slider, 237	adjusting in Camera Raw, 76
saving changes made with, 238	avoiding overdoing, 192
Smooth slider, 237	changing for sepia tone, 358–359
softening selections with, 324	and contrast sandwich technique,
using with Color Range, 411	392–393
using with eyes, 308	controlling in Camera Raw, 70
using with Magic Wand, 225	decreasing, 193
viewing selections with, 235	defined, 190
reflection, creating, 420–423	evaluating in composited images, 418
Rendering Intent options, choosing, 269	increasing, 192–193
Reposition Layout option, using, 431	percentages of, 191
reposition Layout option, using, 451	percentages of, 171

Saturation slider, using in Camera Raw, 66	softening, 324
Save versus Save As option, 262	softening edges of, 308–309
saved settings, finding, 76-78	viewing, 235
saving	selections and masks, download workflow
changes, 92	for, 249
JPEGs, 262–263	sepia tone, converting to, 357–359
tab settings, 76–78	settings, finding after saving, 76-78
Scale option, using with objects, 421	shadow detail, recovering, 328-331
Scale slider, using, 117–119	shadows
Scale Styles option, described, 258	adjusting with curves, 166
scan lines, creating from patterns, 384–386	bringing back, 150–151
scan line pattern, applying to top layer, 385	clipping with Curves feature, 172
scanning images, 110–111	darkening in Camera Raw, 63–65
screen calibration, 178	darkening with curves, 168
screen resolution, defined, 252	examples of, 137–138
screens, resolution of, 261	fading with Smart Sharpen Filter, 282-283
Select Filter Color dialog box, opening,	finding, 204
188–189	isolating with Smart Sharpen Filter,
selected areas, copying, 316	281–282
selection tools	See also cast shadow
choosing, 234–235	Shadows/Highlights, adjusting, 145-148
Color Range command, 228–235	Shadows/Light Source, evaluating in com-
Magic Wand, 222–225	posited images, 419
Quick Selection, 225–228	sharpening
selections	applying to Grayscale channel, 280
adding to, 226, 234	avoiding overdoing, 279
adjusting masks with, 441–442	nondestructive, 284-286
applying feathers to, 228	performing in Camera Raw, 68–69
applying when straightening images, 108	with Smart Sharpen Filter, 281–282
combining with masks, 247-248	with Unsharp Mask Filter, 276–278
converting to masks, 339–340	using LAB mode, 280–281
creating, 218–221	workflow, 276
creating from channels, 318	sharpness, fading, 279–280
gritty looking photo, 395-398	Shield options, using with Crop tool, 104
hiding, 245, 337	Shift key. See keyboard shortcuts
Image Warp tool, 405–406	shooting scenes correctly, 435
inverting, 336, 349	Show Clipping option, using with Varia-
inverting for split toning, 391	tions tool, 185
loading, 420	sidecar file, generation of, 56
loading masks as, 366, 390	size of images. See image size
localizing, 231	sketches, converting photos to, 374-376
versus painting with Brush tool, 366	skin
refining, 235–239	color balancing, 331–334
repositioning while drawing, 336	removing red from 331-334

smoothing out, 314–318 See also blemishes and moles; Healing tools	depth of field with layer mask, 376–378 depth of field with Lens Blur and depth
skin tones	map, 378–383
sampling, 206	double exposure blur, 394–395
shifting colors of, 333	dramatic sky, 398–400
sky	high color and tonal contrast, 388–390
adding, 448–453	natural media, 370–376
adding drama to, 398–400	scan lines, 384–386
brightening, 165	slide sandwich technique, 392–393
lightening with Curves, 450–451	Smart Filters, 368–370
See also bright sky	split toning photos, 390–392
sky tone, adding to curve, 164	turning photos into sketches, 374–376
slide sandwich technique, 392–393	Vanishing Point tool, 400–405
sliders	split neutral density effect, applying to sky,
caution about, 361	398–400
resetting in Camera Raw, 67	split toning photos, 389-392. See also tone
returning to zero position, 89	adjustments
setting to fade sharpness, 280	Split Toning tab in Camera Raw, options on
using with Smart Sharpen Filter, 282–283	72–74
slideshows	spot color, using, 364–366
creating, 45–46	Spot Healing Brush
playing for images in stacks, 24–25	accessing, 298–299
Smart Blur Filter	options for, 302
reducing luminosity noise with, 290-291	using, 301–303
using, 288–289	spots
Smart Collections, creating, 34–35	cleaning up, 82
Smart Filters	undoing, 82
explained, 330–331	squinting, fixing, 324–327
using, 368–370	Stacks blending mode, using, 443–446
Smart Objects	Stacks feature, using, 22–25
accessing, 94	Stair Interpolation Action Web site, 265
applying filters to, 330, 368–369	Stair Step interpolation, 264
converting layers to, 445	Stamp tool, using with plane, 401–403
explained, 95	Std Dev histogram statistic, explained, 142
identifying, 130	straightening
opening files as, 146	and cropping photos, 110–111
opening images as, 96, 328	horizons, 122–124
Smart Sharpen Filter, using, 281–284	images, 107–110
Soft Focus Filter, using, 314–318	with Lens Correction Filter, 116
Soft Glow technique, applying to skin, 316–318	Stroke width, setting for border, 343
	strokes, accessing history of, 343
soft proof, setting up, 268–272 Source setting, using with Patch tool, 320–321	subtractive color, 177. See also colors
	Synchronize dialog box, using with RAW
special effects	images, 97
adding color, 386–388	images, 77

T	Total Indicator, using with mixed channels,
tab settings, saving, 76–78	357
taking pictures. See photos; shooting scenes	Transform settings
correctly	adjusting, 394
tattoos and birthmarks, removing, 320-321	resizing layers with, 345
teeth, whitening, 311–313	transition zone, adjusting, 91
Temperature slider, adjusting in Camera	tungsten light, use of, 186–187
Raw, 59–60	Tungsten white balance, explained, 52
test prints, creating, 272. See also prints	tuxedos, fixing, 327–331
text, adding for advertisement, 423	
Text Warp tool, comparing to Image Warp,	U
405	underexposure
Threshold attribute	fixing with Exposure Panel, 152–153
using with Smart Blur Filter, 288	fixing with Levels Panel, 149–150
using with Unsharp Mask Filter, 277–278	See also exposure; overexposure
thumbnails, selecting, 25	Underpainting effect, applying, 372
TIF (Tagged Image File) format, overview	undoing
of, 4	actions, 130–131
tilde (~) key, using with masks, 411	spots, 82
tint, applying for sepia tone, 358	Unsharp Mask Filter
Tint slider, adjusting in Camera Raw, 59	introducing noise with, 282
tonal contrast and color, applying to images,	sharpening images with, 276-278
388–390	using, 280
tonal problems, correcting with Curves	upsampling
feature, 163	versus downsampling, 253
Tonal Width, setting, 146	guideline for, 264
Tonal Width slider	result of, 259–260
using with shadows and highlights, 330	
using with Smart Sharpen, 282	V
tone adjustments	Vanishing Point tool, using, 400–405
Auto settings, 153–155	Variations tool, making color corrections
Brightness/Contrast, 144–145	with, 184–186
Curves feature, 156–162	Vertical Perspective slider, adjusting, 117
Exposure Panel, 152–153	Vibrance slider, using in Camera Raw,
Levels Panel, 149–151	66–67
Shadows/Highlights, 145–148	Vignette controls, using in Camera Raw,
See also split toning photos	341–342
Tone Curve tab in Camera Raw, options on,	Vignette Removal option, using with
67–68	panorama, 429
tone mapping, 436, 438	vignettes
tones	adding to images, 76
adjusting in Camera Raw, 61–62	classic, 336–339
altering in masks, 246	creating with Camera Raw, 341-342
viewing stats on range of, 142	white, 339-341
tools. See selection tools	

W

Wacom tablet, Pen Pressure setting on, 302 warming filters, availability of, 186 Warp tool, using, 405-406 washed out/shifted color, fixing, 198-199 watercolor paintings, turning photos into, 370-373 Web, sizing prints for, 261–263 Web Gallery, using, 46-47 Web sites Alienskin Blow Up, 265 Digimarc, 8-9 Genuine Fractals, 265 Photomatrix, 438 Stair Interpolation Action, 265 wedding dresses, fixing, 327-331 white painting, 217 producing from additive color, 176 producing from subtractive color, 177 white background, previewing, 236 white balance overview of, 51-53 setting in Camera Raw, 58-61 White Clip setting, using with Shadows/Highlights, 147 white point relationship to screen calibration, 178 setting, 203-204 white vignette, creating, 339-341 wide-angle lenses, distortion associated with, 120-122 Width, setting for images, 258 wind, evaluating in composited images, 419 window lights, revealing, 441 workflow basics for photographers, 99–100 local editing, 250 for sharpening, 276 See also download workflow Workflow Options dialog box, displaying, 93 - 94

working areas, dark marks in, 306 workspace, managing, 22–25 wrinkles, reducing, 303–307

Υ

yellow and red, increasing, 359–360 yellow cab, converting to red, 361–363 yellow color cast, fixing, 184–186

License Agreement/Notice of Limited Warranty

By opening the sealed disc container in this book, you agree to the following terms and conditions. If, upon reading the following license agreement and notice of limited warranty, you cannot agree to the terms and conditions set forth, return the unused book with unopened disc to the place where you purchased it for a refund.

License:

The enclosed software is copyrighted by the copyright holder(s) indicated on the software disc. You are licensed to copy the software onto a single computer for use by a single user and to a backup disc. You may not reproduce, make copies, or distribute copies or rent or lease the software in whole or in part, except with written permission of the copyright holder(s). You may transfer the enclosed disc only together with this license, and only if you destroy all other copies of the software and the transferee agrees to the terms of the license. You may not decompile, reverse assemble, or reverse engineer the software.

Notice of Limited Warranty:

The enclosed disc is warranted by Course Technology to be free of physical defects in materials and workmanship for a period of sixty (60) days from end user's purchase of the book/disc combination. During the sixty-day term of the limited warranty, Course Technology will provide a replacement disc upon the return of a defective disc.

Limited Liability:

THE SOLE REMEDY FOR BREACH OF THIS LIMITED WARRANTY SHALL CONSIST ENTIRELY OF REPLACEMENT OF THE DEFECTIVE DISC. IN NO EVENT SHALL COURSE TECHNOLOGY OR THE AUTHOR BE LIABLE FOR ANY OTHER DAMAGES, INCLUDING LOSS OR CORRUPTION OF DATA, CHANGES IN THE FUNCTIONAL CHARACTERISTICS OF THE HARDWARE OR OPERATING SYSTEM, DELETERIOUS INTERACTION WITH OTHER SOFTWARE, OR ANY OTHER SPECIAL, INCIDENTAL, OR CONSEQUENTIAL DAMAGES THAT MAY ARISE, EVEN IF COURSE TECHNOLOGY AND/OR THE AUTHOR HAS PREVIOUSLY BEEN NOTIFIED THAT THE POSSIBILITY OF SUCH DAMAGES EXISTS.

Disclaimer of Warranties:

COURSE TECHNOLOGY AND THE AUTHOR SPECIFICALLY DISCLAIM ANY AND ALL OTHER WARRANTIES, EITHER EXPRESS OR IMPLIED, INCLUDING WARRANTIES OF MERCHANTABILITY, SUITABILITY TO A PARTICULAR TASK OR PURPOSE, OR FREEDOM FROM ERRORS. SOME STATES DO NOT ALLOW FOR EXCLUSION OF IMPLIED WARRANTIES OR LIMITATION OF INCIDENTAL OR CONSEQUENTIAL DAMAGES, SO THESE LIMITATIONS MIGHT NOT APPLY TO YOU.

Other:

This Agreement is governed by the laws of the State of Massachusetts without regard to choice of law principles. The United Convention of Contracts for the International Sale of Goods is specifically disclaimed. This Agreement constitutes the entire agreement between you and Course Technology regarding use of the software.